Medieval Obscenities

YORK MEDIEVAL PRESS

Medieval Obscenities

Edited by
Nicola McDonald

THE UNIVERSITY *of York*

YORK MEDIEVAL PRESS

First published 2006
Paperback edition 2014

A York Medieval Press publication
in association with The Boydell Press
an imprint of Boydell & Brewer Ltd
PO Box 9 Woodbridge Suffolk IP12 3DF UK
and of Boydell & Brewer Inc.
668 Mt Hope Avenue Rochester NY 14620–2731 USA
website: www.boydellandbrewer.com
and with the
Centre for Medieval Studies, University of York

ISBN 978 1 903153 18 5 hardback
ISBN 978 1 903153 50 5 paperback

A CIP catalogue record for this book is available
from the British Library

This publication is printed on acid-free paper

CONTENTS

In Memoriam

Michael Camille
(1958–2002)

ILLUSTRATIONS

CONTRIBUTORS

Michael Camille†
Department of Art History, University of Chicago

Glenn Davis
English Department, St Cloud State University, Minnesota

Emma Dillon
Department of Music, University of Pennsylvania

Simon Gaunt
Department of French, King's College London

Jeremy Goldberg
Department of History & Centre for Medieval Studies, University of York

Eamonn Kelly
National Museum of Ireland, Dublin

Carolyne Larrington
St John's College, Oxford

Nicola McDonald
Department of English and Related Literature & Centre for Medieval Studies, University of York

Alastair Minnis
Department of English, Ohio State University, Columbus, Ohio

Danuta Shanzer
Department of the Classics, University of Illinois, Urbana-Champaign

Introduction

Nicola McDonald

From January to December 2001, the University of York's Centre for Medieval Studies hosted Medieval Obscenities, an international and interdisciplinary seminar series distinguished for its lively debates and capacity audiences.[1] Throughout that year, speakers from Europe and North America came to York to excite, challenge and no doubt sometimes offend those audiences (often comprised of interested lay people as well as conventional academics) with provocative analyses of topics as diverse as Norse defecation taboos, the Anglo-Saxon sexual idiom, bared ecclesiastical bottoms and sheela-na-gigs, impotence and pornography in the church courts, and Jerome's dubious domestic situation. The series aimed to be neither exhaustive nor intellectually coherent; it sought not to provide answers but rather to formulate questions and stimulate debate. Using primary evidence from the late antique period through to the late Middle Ages and beyond, fragments of textual and material culture, a divergent group of historians and art historians, classicists and musicologists, archaeologists and specialists of literature used their different methodologies and often conflicting ideologies to explore the complex and contentious role of obscenity – understood variously as that which is offensive, indecent or morally repugnant – in medieval culture.

Obscenity today is, if nothing else, controversial. Its definition, consumption and regulation fire debate about the very meaning of art and culture, law, politics and ideology. And commentators often assume that obscenity, alongside its sister vice pornography, is synonymous with modernity.[2] The seminar series was designed to challenge (as medievalists so often have to)

1 *Medieval Obscenities*, both the seminar series and this volume, could not have happened without the enthusiasm, forbearance and critical eyes of Louise Harrison, Jane Hawkes, Rosemary Hayes, Mark Ormrod, Matthew Townend, Hélène Tronc and Elizabeth Tyler; I am enormously indebted to them all. I am also grateful to Conrad Leyser and Jos Koldeweij who contributed to the success of the original seminar series.
2 See, for instance, Lynn Hunt's influential introduction to *The Invention of Pornography: Obscenity and the Origins of Modernity, 1500–1800*, ed. L. Hunt (New York, 1993), pp. 9–45.

our certainties about modernity and the newness of our anxieties. For all of the famed restrictions of Christian doctrine and medieval modes of social conduct, the Middle Ages was, perhaps paradoxically, a period that appears to have accommodated, in ways our liberal society does not or seems not to, what we might broadly call the rude, bawdy or obscene. But that does not mean that, at different times and in different ways, it was not contentious nor that it was devoid of the power to shock or offend, as well as to titillate and excite. The essays collected here all began as part of this forum (and almost all of the original contributors have agreed to appear here in print) but they have since been revised for publication. They are part of a collective and distinctly interdisciplinary effort – with all of the lack of consensus that entails – to detail diverse moments in the history of medieval obscenity, and sometimes its modern reception. Together, where the whole strives to be more than its individual parts, the essays seek to shed light on an inexhaustible and rich topic that unfortunately remains at the margins of medieval scholarship and is, in its medieval particularity, virtually ignored by non-medievalists.[3] The Introduction that follows serves to outline the key ideas and issues that animate the volume and to suggest a path through it that highlights a provocative dialogue that might not initially be apparent; but it begins first of all with what I have called 'the problem with obscenity', a consideration of the impediments that both distinguish and restrict research on this extraordinary, rewarding and important subject.

The Problem with Obscenity

Locked in a glass cabinet, safely out of curiosity's reach, 'Pussy Goes A'Hunting' (Fig. 1.1) provided an arresting contrast to the familiar reproductions and medieval-inspired products for sale in the gift shop dedicated to the Victoria and Albert Museum's (V&A's) monumental exhibition *Gothic: Art for England 1400–1547*.[4] Silk ties sporting stained glass window motifs and heraldic devices, at once 'dramatic' and 'sophisticated', like the 'exquisite'

3 J. M. Ziolkowski's excellent and landmark collection of essays, derived from a 1995 conference, remains the only book-length attempt to explore the diversity of medieval obscenity. *Obscenity: Social Control and Artistic Creation in the European Middle Ages*, ed. J. M. Ziolkowski (Leiden, 1998). *Carnivalesque*, an exhibition that toured to Brighton, Nottingham and Edinburgh in 2000, is likewise one of the very few attempts to bring rude or obscene medieval artefacts into dialogue with postmedieval and especially modern material; see the accompanying catalogue: *Carnivalesque*, ed. T. Hyman and R. Malbert (London, 2000).

4 *Gothic*, charting the art and architecture of England between the deaths of Richard II and Henry VIII, ran from 9 October 2003 until 18 January 2004; it is recorded in the V&A's comprehensive catalogue, *Gothic: Art for England 1400–1547*, ed. R. Marks and P. Williamson (London 2003).

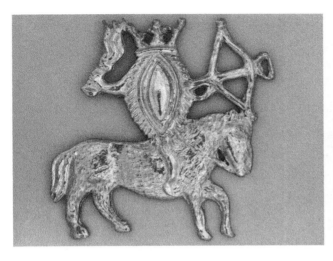

Fig. 1.1 Vulva on horseback or 'Pussy Goes A'Hunting'. Modern replica of a medieval secular badge that, like the others in this series, is produced by Steve Millingham

floral-embroidered lavender pillows and replicas of Dick Whittington's silver spoons, offered exhibition-goers affordable mementos of the kind of hackneyed medieval aesthetic that is promoted so vigorously by money-spinners like Past Times®.[5] But what did a crowned vulva, mounted on horseback and armed with whip and crossbow, have to do with the self-conscious harmonies of pseudo-medieval art elsewhere on display? A closer look revealed that she was not alone; two ambulant phalluses, both erect and belled, one winged and another surmounted by a woman pushing a phallus-filled wheelbarrow (Figs 1.2 and 1.3), plus a phallus–vulva pair, neatly arrested on the brink of penetration and subtitled 'madelin' in honour of the saintly prostitute (Fig. 1.4), were likewise under lock and key. Priced at £4 each, in comparison with £20-plus for the silk and silver-plate, commercial value was evidently not responsible for the purposeful sequestering of the genital brooches; backed with a pin and clasp, they are indeed designed, as in medieval times, to be worn.

Gothic, for all of its commitment to 'the good, the bad and the downright ugly' in late medieval English art,[6] included not a single example of the fifteenth-century sexual badges that have surfaced in archaeological finds in London and East Anglia and, with impressive variety, in the Netherlands, and on which 'Pussy' and her companions are modelled. Eleven pilgrim badges (including a tiny replica of the monstrance containing a phial of Our Lady's Milk from Walsingham Priory) and nine livery badges (predomi-

5 Descriptions of the *Gothic* souvenirs were taken from the V&A's online shop catalogue (www.vandashop.co.uk) where they were for sale both during and after the exhibition.
6 R. Marks, 'An Age of Consumption: Art for England *c*.1400–1547', in *Gothic*, pp. 12–25 (p. 14).

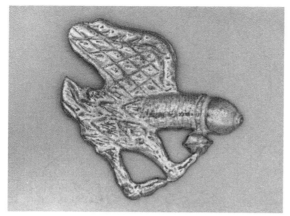

Fig. 1.2 Ambulant phallus
(modern replica)

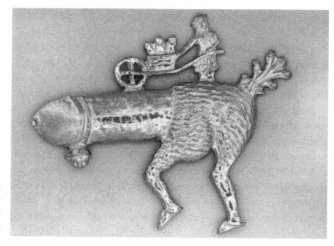

Fig. 1.3 Woman
pushing a phallus-
filled wheelbarrow
(modern replica)

nantly animal and vegetable) represented *Gothic*'s official collection of what is some of the most remarkable and heterogeneous iconography of the late Middle Ages.[7] Mass-produced, and of cheap material (usually lead or a tin–lead alloy), the extant corpus of medieval badges, numbering in the many

[7] See *Gothic*, catalogue entries 68, 324 and 325. The Dutch catalogues of, predominantly, the private collection of H. J. E. van Beuningen (containing 1,000 and 1,200 badges, respectively) provide the most complete inventory of extant badges: *Heilig en Profaan: 1000 Laat-middeleeuwse insignes uit de collectie H. J. E. van Beuningen*, ed. H. J. E. van Beuningen and A. M. Koldeweij (Cothen, Netherlands, 1993), hereafter *HP1*; and *Heilig en Profaan 2: 1200 Laatmiddeleeuwse insignes uit openbare en particuliere collecties*, ed. H. J. E. van Beuningen, A. M. Koldeweij and D. Kicken (Cothen, Netherlands, 2001), hereafter *HP2*. The most thorough guide to the English finds is B. Spenser, *Pilgrim Souvenirs and Secular Badges*, Medieval Finds from Excavations in London 7 (London, 1998), which supersedes the richly illustrated, but often inaccu-

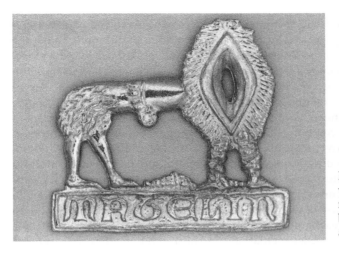

Fig. 1.4 Phallus-vulva pair (a modern replica that bears evidence of artistic licence)

thousands and mostly dating from the fifteenth century, provides a unique, and still largely untapped, perspective on late medieval devotional practice, the border between sacred and profane, the social as well as apotropaic function of ornament (especially for those other than the moneyed elite), patterns of cultural and iconographic exchange, as well as persistently enigmatic attitudes toward sex and the display of sexual organs and sexual acts. My interest here, however, lies less in why *Gothic*'s curators chose to exclude the sexual badges from the exhibition (evidence for them in England is comparatively slim), but rather in why the commercial arm of the V&A bought them in only to render them, if not invisible, literally untouchable. In order to buy one, or more, of the shiny pewter replicas, the customer required not only the assistance of a shop authority (whoever had the key to the glass cabinet or knew that a full basket of the badges was kept underneath the sales counter) but was forced to (try to) identify the *desiderata* by name, replicating thereby a shaming process, explicitly designed to discourage or monitor custom, that is usually reserved for the sale of taboo or socially suspect goods. Yet, the decidedly schizophrenic treatment of sexually explicit medieval badges, for sale (or not) at the V&A, is not finally reducible to the discrimination of individual museum curators, shop managers or sales staff; it is representative of academic as well as popular attitudes to what we might call the obscene in medieval culture.

Graphic representations of sexual organs, human as well as animal and usually in contorted, ludic or aggressive poses, alongside suggestively displayed bums and anal orifices, are reasonably familiar to both professional

rate, M. Mitchiner, *Medieval Pilgrim and Secular Badges* (London, 1986). A detailed catalogue of French finds has also been published: D. Bruna, *Enseignes de pèlerinage et enseignes profanes* (Paris, 1996).

and amateur medievalists from the manuscript marginalia and church architecture that are reproduced in popular and serious publications.[8] Like the 'bawdy' treatment of bodily functions in a few well-known literary works (most famously Chaucer's fabliaux), they form an integral part of the modern caricature of a foreign medieval world in which the body, in particular its primal needs and errant eruptions, has not been fully civilized. Yet, despite the reassuring strangeness of the in-your-face medieval body, few commentators are finally content to leave that strangeness unchecked. Modern viewers peeping voyeuristically at the 'eye-popping' antics of a pen-and-ink bum-licker (itself reduced to head and hindquarters) sketched in the margins of a fourteenth-century collection of saints' lives (and reproduced in a glossy British Library paperback on medieval monsters) are assured that although such drolleries resist easy interpretation, they can best be understood as counter exempla, teaching the medieval viewer that mortal flesh, grotesque and sinful, demands strict regulation.[9] In short, while medieval obscenities (verbal and visual) are enthusiastically invoked – and often with palpable relish for their surplus energies – their disruptive potential is quickly quelled: by the neat categories of interpretive order, the locked doors of glass cabinets, and sometimes even outright denial.

Secular, and especially sexual, badges comprise only a minority of the cheap lead trinkets that have survived from the late Middle Ages. The vast Dutch catalogues (which together provide 'as complete a survey as possible of badges found in the Netherlands'[10]) number them at just under half of the extant corpus, but for finds in France and England the predominance of

8 Michael Camille's *Image on the Edge: The Margins of Medieval Art* (London, 1992) effectively brought the audacity of marginal art, and the diversity of its representations, to the attention of a general audience of medievalists. L. Randall, *Images in the Margins of Gothic Manuscripts* (Berkeley CA, 1966) remains an important source of manuscript marginalia but it is less insistently interested in the obscene. C. Grossinger's catalogue of English misericords, *The World Upside-Down: English Misericords* (London, 1997), seeks to bring the provocative world of the cheat-seat to a mixed, academic and lay, audience; A. Weir and J. Jerman, *Images of Lust: Sexual Carvings on Medieval Churches* (London, 1986), incorporating material from churches across Europe, likewise attracts a mixed, yet predominantly specialist, readership. A. Bovey, *Monsters and Grotesques in Medieval Manuscripts* (London, 2002), produced by the British Library from its collections, aims explicitly at popular interest in the Middle Ages, while M. Harding, *A Little Book of Misericords* (London, 1998), which includes two bawdy images, is a small-format (big on pictures, short on text) Past Times® production.
9 See Bovey, *Monsters and Grotesques*, pp. 53–8; the bum-licker (London, British Library, MS Stowe 49, fol. 65r) is reproduced as Fig. 47, p. 55. For a more detailed discussion of the marginal imagery of Stowe 49, see L. F. Sandler, 'Pictorial and Verbal Play in the Margins: The Case of British Library, Stowe MS 49', in *Illuminating the Book: Makers and Interpreters. Essays in Honour of Janet Backhouse*, ed. M. P. Brown and S. McKendrick (London, 1998), pp. 52–68.
10 *HP2*, p. 5.

pilgrim badges (at once tourist souvenirs and devotional aides from shrines throughout Europe) is indisputable.[11] Yet within the secular corpus, badges representing ambulant genitals, detailed sexual scenes and sexually aroused animals are without doubt the most remarkable – for their innovative iconography and pure shock value. In addition to those reproduced by Steve Millingham (the replica professional who supplied the V&A), the corpus includes vulvas on stilts and ladders, both winged and crowned, vulva pilgrims complete with pilgrim staff and rosary (variously provided with a phallus-topped rod, phallic epaulettes, and a triple phallus crown), a diverse collection of exhibitionist women (reminiscent of the sheela-na-gig), mega-phallic beasts and wild men, plus phallus-crewed boats, phallic barbecues (where the roasted member is either basted by two female cooks or grilled over a reclining vulva), various hooded phalluses, phallus-filled purses and an extraordinary phallus-crowned vulva carried on a litter by three ceremonially dressed phalluses, an elaborately detailed vignette that seems, inescapably, to mimic popular Marian processions.[12] Steve Millingham's 'rude' reproductions are not unique, and many of the more racy medieval badges listed here are the standard stock of reproduction artists whose catalogues often have dedicated sections for 'carnival' or 'naughty bits'; the provocative playfulness of these modern reproductions will be discussed below.

There is little consensus on the function or meaning of the sexual badges (aside from the assumption that they had a broadly apotropaic significance[13]) but the scholarship is everywhere fraught with the kind of complex critical reception that I have suggested is endemic to modern analyses of the medieval obscene. In some respects, what is most remarkable is the way in which, for all of their rich iconography (which readily invites the insights of modern scholarship) and their lively disregard for the distinctions between popular and elite (one of the few remnants of a genuine 'mass culture', they invoke folk traditions as commonly as motifs from romance or fabliau), the sexual badges have attracted almost no attention beyond narrow archaeological and

11 The fragmentary nature of the surviving corpus (only a tiny portion of the original material is extant) makes firm conclusions difficult; the devotional function of the religious badges may have been influential in their survival, and if we compare the evidence from individual pilgrimage sites, rather than treating all religious badges as the same, interesting comparisons emerge. As D. Bruna notes, the more than one hundred surviving 'erotic' badges compare surprisingly favourably with the fifty that remain from the celebrated shrine at Rocamadour; Bruna, *Enseignes de pèlerinage et enseignes profanes*, p. 317.

12 Examples of all of these badges can be found in the Dutch catalogues. See especially *HP*1, pp. 255–64 and *HP*2, pp. 406–15. The satiric intention of the mock Marian badge, the shape of the vulva reminiscent of the Virgin's familiar mandorla, is discussed by M. Jones in *The Secret Middle Ages* (Stroud, 2002), p. 255.

13 For a discussion of the apotropaic function of rude gestures and the badges' suggestive association with classical material, see Jones, *The Secret Middle Ages*, pp. 249–53.

highly specialized art historical circles; most of the informed cultural analysis has been published by Dutch scholars and in Dutch.[14] Thus marginalized from mainstream academic discourse (whether wittingly or no), this extraordinary resource contributes not at all to current Anglo-American understandings of the complexity of medieval culture. Scholarship dedicated to the badges themselves is, likewise, often peculiarly silent and silencing in its treatment of the sexual material. The most recent compendium of badge finds from London excavations – effectively, the most complete catalogue of badges produced and/or circulating in medieval England and a magnum opus of its kind – completely obliterates all genital or sexual material from the visual record. For all the 'explicitly sexual medieval badges' found in London, Spenser directs the reader to illustrations in a little-known German publication (a purse filled with a phallus), an outdated (and out of print) catalogue of English finds (the belled phallus) and the British Museum's Accessions Register (belled and winged phalluses).[15] Branding the comparatively rich continental finds 'pornographic', he asserts that medieval Londoners 'preferred to reveal their attitudes to sex through subtler, less offensive motifs'.[16] Mitchiner, who reproduces just one sexual badge, is likewise quick to assert its essential foreignness; labelling the belled phallus a 'brothel badge', he remarks: 'at this period Paris was renowned for its brothels'.[17]

[14] The two Dutch catalogues, *HP*1 and *HP* 2, and the critical essays they contain are foundational to our understanding of the badges, especially the profane and erotic ones. A. M. Koldeweij's seminal work has recently been published in a series of English articles that have not yet had the circulation they deserve. See, for instance, 'A Bare-Faced *Roman de la Rose* (Paris, B.N. ms. Fr. 25526) and some Late Medieval Mass-Produced Badges of a Sexual Nature', in *Flanders in a European Perspective: Manuscript Illumination in Flanders and Abroad*, ed. M. Smeyers and B. Cardon (Leuven, 1995), pp. 499–516; 'Lifting the Veil on Pilgrim Badges' in *Pilgrimage Explored*, ed. J. Stopford (York, 1999), pp. 161–88; and 'The Wearing of Significant Badges, Religious and Secular: The Social Meaning of a Behavioural Pattern', in *Showing Status: Representation of Social Positions in the Late Middle Ages* (Turnhout, 1999), pp. 307–28.

[15] Spencer, *Pilgrim Souvenirs and Secular Badges*, p. 317.

[16] Ibid., p. 318. Other related evidence suggests we should not be too quick to assert that infamous English prudery; medieval English seals, designed like the badges for a non-elite audience, sometimes display similarly outrageous iconography. One found in Norfolk, the so-called Wicklewood seal matrix, is imprinted with an erect penis, possibly engaged in intercourse, and surrounded by a legend (ias:tidbavlcoc) that indicates not only ownership (James 'the little' Theobald), but a punning play on balls, cock, and possibly the Middle English 'tid', meaning quickly or urgently; see Jones, *The Secret Middle Ages*, p. 51. Another, now in the Museum at Malton (N. Yorks.), displays two breasts and a cross-hatched vulva that plays on the familiar shapes of the (inverted) fleur-de-lys; I am grateful to Irene Szymanski for her generosity in sending me images of, and information about, these and other suggestive seals.

[17] Mitchiner, *Medieval Pilgrim and Secular Badges*, p. 126.

Even Malcolm Jones, the most prolific English authority on the specifically profane badges (whose recent 'book with "attitude" ', *The Secret Middle Ages*, seeks to illuminate the hidden, purposefully forgotten and often obscene face of medieval art), evidences a peculiar logic in his determination to expose, in provocative detail, the vigorous excesses of the sexual badges only to then imagine that many of them were intended to be 'worn beneath the outer clothing and thus not visible to human eyes'.[18] At its most outrageous (and especially outside of the rarefied world of elite art) the medieval obscene – or so it seems – simply cannot be countenanced.

Academic prudery, as well as pervasive, if unspoken, social regulations about what kinds of subject matter can be legitimately and publicly discussed, are doubtless partly responsible for the absence of a sustained discussion of medieval obscenity. But it is, I think, finally too simplistic to judge scholarship's resistance to obscenity to be exclusively the product of conservative social mores. Equally, if not more, inhibiting is the lexical and semantic challenge inherent in the articulation of the obscene, especially when it emerges from a still dimly understood past. Faced with a vulva on horseback, for instance, our ability to analyse its function and meaning is severely impeded by our real difficulty in finding an appropriate vocabulary with which to discuss it, let alone one that might accurately reflect the kind of discursive – or visual – register in which (we can only imagine) it was originally understood. The divergent naming practices employed in the sale of modern replicas are instructive.

In addition to the Kent-based Millingham, I have located at least two other replica producers whose catalogues boast an extended range of profane and especially sexual badges: Fettered Cock Pewters (a Canadian enterprise) and Billy and Charlie's Pewter Goods (a New England team – a rare books librarian and an armourer – who take their name from two Victorian ditch-diggers (in)famous for their forgery of medieval artefacts).[19] All three have targeted a market of predominantly amateur medievalists, historic re-enactors and sometimes museums or heritage organizations; and, despite occasional artistic liberties,[20] their explicit commitment is to the 'faithful' reproduction of an 'authentic' material culture, purposefully augmented, at times, by full bibliographical references. All three producers separate the sexual badges from the rest of their stock in specially marked-out sections of the catalogue labelled, respectively, 'rude badges', 'naughty bits' and 'car-

18 M. Jones, 'The Secular Badges', in *HP1*, pp. 99–109 (p. 105).
19 All three producers have paper and web-based catalogues of their stock; the websites are, respectively, www.pewterreplicas.com, www.fetteredcockpewters.com, www.billyandcharlie.com.
20 Millingham's 'madelin', for instance, is a creative interpretation of a Dutch badge found in *HP2*, no. 1766 (p. 412); the original inscription reads 'pintelin' and is discussed by Jones, *The Secret Middle Ages*, p. 249.

nival brooches'; and all three offer replicas of the mounted vulva. Millingham (who highlights his museum credentials) opts for the apparent neutrality of Latinate vocabulary – 'Vulva on Horseback' – in a gesture that seeks, I think unsuccessfully, to distance the badge from the transgression it necessarily embodies – for how else are we to understand the representation of a personified, caricatured female sex that rides out hunting. Millingham identifies the vulva as 'rude' (and uses this designation to attract custom), but exploits the pseudo-scientific practice of 'objectively' naming parts both to assert his own authority (and that of his replicas) and to dissociate himself from accusations of prurience. On the other hand, the North Americans, whose genital stock is considerably more extensive, openly flaunt the obscene nature of both the medieval and modern artefacts. 'Pussy Goes A'Hunting' is just one of four pewter 'pussies' reproduced by Fettered Cock whose denomination of the sexual badges is at once playful and purposefully vulgar.[21] Pussy, like other diminutives used for the generative organs, works to deflect the vulva's blatant sexual charge, reducing, through humour, the potential for offence – Billy and Charlie's Dickie Bird (a winged, crowned and belled phallus) and Wienie Roast (a spitted phallus over a vulva dripping-pan) function in much the same way – while at the same time flirting with the very real taboo that adheres to this particular, and particularly offensive, euphemism – always secure in the knowledge that this is not in fact a modern pornographic pussy but a medieval artefact.

No matter how carefully we choose our words, our use of language, whether in popular or academic discourse, is never neutral; lexical choice, along with tone and register, always carries with it a complex set of cultural assumptions. When we talk and write about obscenity, in particular historic obscenities (or what we think are obscenities) whose import and significance we can never fully grasp, those assumptions and thinly veiled prejudices are more, and more intrusively, extreme. Until relatively recently, few academic publishers (at least of medieval scholarship) would condone the kind of language, whether popular argot or self-consciously 'scientific', that is regularly and liberally invoked throughout this volume. But licensed, as we increasingly now are, to articulate what polite discourse has heretofore judged unmentionable, we still cannot escape the radical interpretative weight that our words inevitably impose. A three-centimetre tall, crowned and mounted caricature of a vulva, armed with whip and crossbow, from the late fourteenth or early fifteenth century and designed to be worn, defies modern interpretation. It cannot simply have been used to ward off evil; it seems to be purposefully ludic, yet we do not know the gender, age or social

[21] Fettered Cock also offers 'Pussy Royale', a crowned and winged vulva (*HP2*, no. 1771, p. 412); the self-explanatory 'Pilgrim Pussy' (*HP1*, no. 663, p. 264); and 'Pussy Litter', the mock Marian procession (*HP1*, no. 652, p. 262).

identity of its wearers, whether it was festally specific or quotidian, whether it served to titillate or shock, excite or repulse; indeed, we do not really know whether it was obscene at all. And neither do we know what purpose it serves for the amateur medievalists who enthusiastically support the replica trade. But as soon as we give it a name – 'Vulva on Horseback', 'Pussy Goes A'Hunting' or simply 'Louise'[22] – and initiate the discursive process (as I have already done in this introduction), we immediately betray, and are in turn limited by, our own interpretation and our own agenda. Obscenity is culturally and temporally specific. According to the infamously inadequate and thoroughly modern legal view, obscenity is that which 'ordinary decent people' judge to contravene 'recognized standards of propriety'.[23] Or as right-wing American senator Barry Goldwater so memorably (and impossibly) put it: 'As a father and a grandfather I know, by golly, what is obscene and what isn't.'[24] At once beyond definition, obscenity is solely the product *of* definition, of the shared language (verbal, visual and sonic) of its representation.

Medieval Obscenities in Modern York

That said, this volume seeks, through the methodological and interpretative diversity of interdisciplinary scholarship, to articulate and probe the so-called obscene remnants of the European Middle Ages. It is this volume's contention that medieval obscenities challenge us, and demand our critical attention, because they arrest us with both their shocking modernity and their radical otherness. At the same time, the obscene is a category that demands that we rethink our own assumptions and preconceptions of the Middle Ages: of the predominance and peculiarities of medieval Christianity; of personal conduct, physical as well as moral, and the processes of civilization; of social control; of aesthetic and artistic licence; and of our own assured

22 According to Marian Hanson, one half of Billy and Charlie's Pewter Goods, 'Louise' was chosen as an alternative to vulva and pussy (thus 'Louise on Horseback' and 'Louise on Pilgrimage') precisely because of the difficulties inherent in naming the female genitalia: 'we picked a name that sounds like someone's middle-aged aunt or neighbor', a name that 'anyone could say without blushing' (personal correspondence); for Hanson and her partner Robert MacPherson, although the obscene is representable, it cannot be named.

23 G. Richardson, *Obscenity: An Account of Censorship Laws and their Enforcement in England and Wales* (London, 1979) provides a comprehensive account of the history of English obscenity legislation and the ideologies behind it (pp. 67, 206); the appeal to so-called 'community standards' is likewise a salient feature of American definitions of obscenity.

24 Barry Goldwater is cited by M. Leach in *I Know It When I See It: Pornography, Violence and Public Sensitivity* (Philadelphia, 1975), p. 15.

modernity. Medieval obscenities, for all of the cultural and chronological range that this volume encompasses (pan-European with a particular focus on England, Ireland, France and Scandinavia from the second to fifteenth centuries and beyond), remind us again and again why the Middle Ages matters and why our understanding, albeit always partial, of its limits and excesses, its perforated boundaries and its inalienable certainties, is so important to us, not just as academics but as actively engaged and responsible members of modern society.

Although I have so far used obscene and obscenity as if their meanings were self-evident, the obscene remains a loose and fuzzy category. Despite the apparent universality of sex and defecation as the natural or favoured spheres of the obscene, there is never any consensus – across time, cultures or even from one social group to another – about what is or is not acceptable and so what is or is not obscene. Definitions of the obscene are located at the juncture of what one group – usually the current dominant group – identifies, at a given moment, as decent and indecent. The boundary shifts ever backwards and forwards (there is no neat evolutionary trajectory to chart), and, as I have intimated, changing historical and cultural circumstances make it difficult to identify one person's (or culture's) obscenity from another's taboo, pornographic, erotic or merely 'talking about' the sexual or scatological. The different essays in this volume negotiate this conceptual and terminological minefield in very different, and sometimes contradictory, ways. As we would expect, given the contested nature of the subject, nowhere do we work with a single or straightforward understanding of what constitutes the obscene and what are its functions and values. Readers, with their own preconceptions and prejudices, are encouraged to stumble with us through the mire.

Nevertheless, for all of their diversity, the essays are animated by a set of shared preoccupations. Key to all discussion are, of course, questions of definition and category, of where the sexual or erotic ends and the obscene begins, whether such a distinction is actually productive, and indeed whether the obscene, as we understand it today, is a category that, finally, illuminates more than it obfuscates. Most of the authors agree that the obscene is designed to shock, either intellectually or sensually, but there is less consensus on the effects of that shock: fear, laughter, awe or excitement. Central too is the role of the medieval church in the production, regulation and consumption of obscenity, the contradictions inherent in church doctrine and clerical practice, and the relationship between obscenity and orthodoxy. Much of what we identify as obscene seems to emerge from an ecclesiastical context, and most of the rest exists explicitly in dialogue with it. Whatever their conclusions, the authors all demonstrate the complex ambivalence of the medieval church and of the clerical ideologies that sustain it. Several contributions examine the extent to which obscenity changes over time, how acts, images or discourses become or cease to be obscene and how the obscene can, again over time, be appropriated for very different purposes. The relation-

ship between medieval obscenity, its classical past and post-medieval future is a prominent theme as is the question of language. Authors interrogate the relationships between words and the things they describe, the function of double entendre in both poetic and more prosaic discourse, the role of genre in determining linguistic propriety, and divergent attitudes to so-called dirty words, usually sexual words that are purposefully offensive. And, although there is lively debate about medieval attitudes toward obscenity, almost all of the contributors point, often with real frustration, to the way in which past scholarship has sequestered, denied or white-washed medieval obscenity to the detriment of our understanding of the Middle Ages.

What I want, finally, to offer by way of introduction is a suggested order for reading the essays that follow. Collections of this sort are rarely ever read from start to finish; instead, we adopt conventional medieval reading practices and dip in here and there in accordance with our (already established) interests and needs. Yet, given the contested nature of obscenity and its complex manifestations over more than one thousand years, the volume rewards reading in full, to appreciate obscenity's vigour, its peculiarity and its persistence. The essays have been arranged alphabetically by author surname, which effectively accords primacy to the late Michael Camille, to whom this volume is dedicated and without whose inspiration, provocative scholarship and intellectual generosity it would never have been started. Camille's irreverent, politically engaged investigation of Dr Witkowski's anus, of the foundational nineteenth-century formulation of sexualities (especially homosexuality) and categorization of medieval church carving, and of a distinctly *not* obscene bum in Bourges cathedral (as opposed to the multiple and explosive rear ends and mooning gestures he identifies elsewhere in Bourges and across Europe) demands that we recognize what is at stake in our modern imagining of an obscene Middle Ages. He charts the medieval arse's plurality of meanings and questions the disparity between modern and medieval interpretations of anal display and so of the very category, as we use it to investigate the past, of the obscene. He confronts head on the central question of how the medieval church accommodates the graphic display of the sexualized body, in church carving and elsewhere, and of the function of that display – to inspire shame, fear, awe, delight? Camille makes an excellent starting point, but I think in fact he makes a better end: to shock us, to make us laugh, and to demonstrate to us how much our study of the Middle Ages and especially of its sexualities and their representations (as we imagine them) are intimately part of us and part of our future.

The place to start, rather, is in the depths of Dante's hell, in the unfulfilled promise of a trumpet-arsed devil's sonic obscenity. Emma Dillon, who provides the volume's most thorough consideration of what 'obscenity' might mean as a category of thought and analysis, draws from Dante's silence, and from the absence as well as the impossibility of a musically notated obscenity, a cacophonous soundscape of shocking dissonance.

Focusing on the capacity of obscene sound to shock and disturb the listener, she identifies obscenity as, and productive of, emotional and sensual excess and challenges us, alongside Augustine and other medieval authorities, to confront its proximity to ecstasy and rapture. In Dillon's charged analysis, obscenity, understood primarily as orthodoxy's counter-code, is paradoxically a vehicle of unfettered revelation and of the divine itself. She productively destabilizes our certainties about obscenity, clerical thought and aesthetic practice and sets up thereby a paradigm for reading what follows.

Questions of excess (formal and physical) and rapture (the achievement of a paradise that is at once sexual and spiritual) likewise animate Simon Gaunt's impressively detailed account of the hermeneutic processes encoded in troubadour verse, which culminates in his analysis of Arnaut Daniel's extraordinarily dense *sextina* 'Lo ferm voler' ('firm yearning' or 'hard desire', transcendental love or just a big erection). Gaunt articulates the proximities between courtly verse (in which obscene detail is apparently prohibited) and the so-called 'under the counter' productions that we find in the same and related *chansonniers* and whose dependence on the courtly model, for their obsessions as much as form, is complete. Desire for these medieval poets, Gaunt demonstrates, is located in and produced by language and their (and our) pleasure is in uncovering the seamily sexual meanings that lie behind the words. Turning finally to Lacan, who identifies the fundamental obscenity of Christian art, given its preoccupation with the body, as its refusal of copulation, Gaunt exposes the complex logic of troubadour poetry that, intrinsically and obsessively obscene, likewise precludes the achievement of desire.

The failure of desire, or at least one man's inability to produce an erection at the hands of known sex workers employed by a York church court, determines one of the more remarkable, and remarkably voyeuristic, narratives discussed by Jeremy Goldberg in his similarly eye-opening account of a rather different kind of textual erotics. The rich evidence provided by the York court records of the fourteenth and fifteenth centuries, in particular from cases detailing disputed marriages (including, in the case of John Skathelok, an impotence trial), offers us an illuminating snapshot of changing late medieval attitudes to the naked body and the sexual act (both of which Goldberg demonstrates are increasingly not seen and thus rendered more obscene and titillating) and of the ambivalent relationship between medieval clerics' sexual orthodoxies and their regulation of, and participation in, lay sexual practices. Goldberg advocates, finally, a reading of these sexually explicit legal documents (which often reduce participants to their genital functions) as pornographic texts for the sexually anxious men who not only staffed the church courts but were regularly brought before them, charged with their own sexual misdemeanours.

The kinds of contradictions that distinguish the practices, both sexual and textual, from the orthodoxies of Goldberg's clerics seem, when we turn to

Danuta Shanzer's survey of what we might call the originary moments of Christian obscenity in the late antique period, retrospectively familiar, something indeed of an occupational hazard. Shanzer's sharp eye for poetic detail, the traces of sexually explicit or erotically charged pre-Christian texts lurking in myriad Christian reformulations, and her alertness to the twists and turns of the early Christian ecclesiastical conscience provide us with a mind-boggling portrait of the early Christian writers (many of whom like Jerome, Augustine and Ennodius were late converts). While they sought, or so they would have us think, to suppress the sexual licence and obscene display characteristic of classical Greece and Rome, in accordance with newly restrictive Christian doctrine, they let it emerge, 'for those who read with open eye and dirty mind', not only in familiar genres (satire, epithalamium, etc.) but in places as apparently uncompromising as Biblical exegesis, hagiography, exhortations to virginity and the like.

Glenn Davis, likewise, takes us to a famously uncompromising (indeed seemingly sexually disinterested) body of texts that also date from a time of stringent ecclesiastic reform, this time the vernacular poetry of the Anglo-Saxons, where his sensitivity to the textures of poetic idiom searches out the disruption that the sexual, or echoes of it, effects. Davis demands that we put the so-called obscene Anglo-Saxon riddles, a small and usually marginalized group of poems that focus on the body in parts and that detail sexual acts and sexual fantasies through the play of double entendre and other word games, at the centre of the poetic corpus where indeed the Exeter Book, a poetic anthology housed in a cathedral library, so provocatively locates them. Dismissing the critical urge to sequester the riddles, based on early critics' repugnance for their taboo subject matter, he proposes a compelling reading of key and well-known events (like Grendel's entry into Heorot) in light of the distinctive resonance the riddles accord to the hands and manual gesture.

Where Davis identifies disgust (with the riddles' explicit reference to sexual acts) as critical prudery, and so dismisses it as outdated and inconsequential, Carolyne Larrington instead embraces the disgust, elicited by taboo food and defecation, that medieval Christian authors deployed to discourage the newly Christian Norse from indulging in the pleasures of pre-Christian story-telling, as key evidence in support of social-psychological theories of the universality of 'basic emotions'. Forging powerful connections between the insights of modern psychology and the moralizing processes of the Christian evangelists (whereby pre-Christian narratives are associated with tainted meat and the dangers of the privy), she details how an obscenity that is designed to condition behaviour, and with it morality, functions by means of direct sensual offence (literally turning the stomach) as well as, and simultaneously, through humour.

The moralizing function of the grotesque, this time with no sign of any intended humour, is again invoked at the outset of Eamonn Kelly's careful study of the thirteen sheela-na-gigs (sculptures of naked, emaciated and

deliberately ugly women displaying their genitals) that are today housed in the collections of the National Museum of Ireland. Surveying both etymology and the continental Romanesque tradition, where the sheela seems to function, like the hellish scenes of corporal punishment that decorate medieval churches, as a sign of human depravity and so a model to be rejected, Kelly proposes an alternative interpretation of some of the Irish sheelas that appear, not as part of a church's iconographic programme, but singly and on the exterior walls of castles and tower-houses. These, he argues, have been appropriated by secular authorities as symbols of power and status and are inextricably linked with the lord's function as a keeper of the land, which in Irish myth and folk tradition is female. Kelly effectively reminds us of the way that obscenity is neither fixed in time nor space, and that, despite an apparently unambiguous obscene origin, it may cease to be obscene at all.

Loathly old women, who display their genitals, both literally and metaphorically, are again the focus of Alastair Minnis's attention in his essay on the correlation between dirty words and dirty things. Analysing debates on linguistic decorum, in particular the practice of speaking plainly about the sexual organs, that are articulated in the *Roman de la Rose*, the *querelle* the *Rose* inspired and by Chaucer's Wife of Bath, among others, Minnis provides an engrossing account of the extent to which anxieties about obscenity, its definition and regulation as well as its social impact, are by no means modern preoccupations. Ranging authoritatively through the politics of euphemism, manuscript variation and medieval antifeminism, he offers a reading of the late medieval fascination with the dirty old woman – her words and deeds – that underscores its importance to our understanding of obscenity's long and still current history. And that brings us back to Camille, where we started and to whom contemporary research on medieval obscenities is deeply indebted, to his insistence on the irrevocable differences, the disturbing proximities, and the vital importance of our imagination and (re)construction of the Middle Ages.

2

Dr Witkowski's Anus:
French Doctors, German Homosexuals and the
Obscene in Medieval Church Art[1]

Michael Camille †

When Jules Michelet, one of the first generation of great French historians to be fascinated by the Middle Ages, visited Bourges cathedral on 22 September 1835 he wrote a long description in his journal. What he described was not any of the impressive architecture or the sculptures of the five western portals but a series of small obscene images he noticed at the cathedral's edges, 'grotesques' as he called them. These he described as adorning the staircase leading up to the tower and down in the crypt including 'one who touches himself indecently; two heads: one who laughs, the other of death, and another who pulls his tongue' ('l'un se touche indécemment; deux têtes: l'une qui rit, l'autre de mort, une autre qui tire la langue').[2] He did not mention the most striking of them all that is still there today; a bulbous bottom appears on the left as the very first console (Fig. 2.1). Its breeches are pulled down to hang below its round cheeks; it is wearing a belt to emphasize that this is a clothed figure who has uncovered himself. I say *him*self because the breeches and belt show this is a male posterior; in the pre-underwear age a woman would pull up her dress whereas a man would pull down his pants to reveal what should not be revealed – what we consider obscene. It is a genderless arse having no protruding genitals. It is, if you like, the very essence of arseness.

The Bourges carving was first reproduced in a line engraving in Champfleury's *Histoire de la caricature au moyen âge* but goes unmentioned in the text.[3] In the nineteenth century such images were at the centre of conten-

1 At the time of Michael Camille's untimely death in 2002, this essay was left unfinished. The editor is grateful to Stuart Michaels for his assistance in locating the text file and to Elaine Block and Hélène Tronc for crucial help with images. The essay, in particular the notes, has been fully edited but occasional ellipses no doubt remain.
2 J. Michelet, *Journal*, ed. P. Viallaneix, 4 vols (Paris, 1959–62), I, 213.
3 Champfleury [Jules Fleury], *Histoire de la caricature au moyen âge* (Paris, 1872), p. 241.

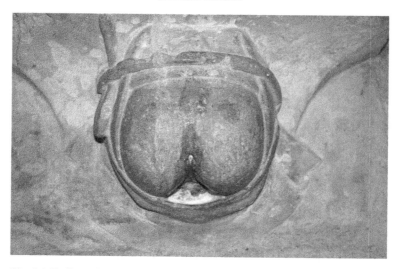

Fig. 2.1 Bulbous bottom, crypt console, Bourges cathedral (N. McDonald)

tious battles between pious scholars of the 'renouvellement catholique' like Auber, Didron and later Emile Mâle who saw Gothic art as pure and chaste, and those like Viollet-le-Duc, Michelet and Champfleury who, interpreting these images as anti-clerical satires, saw Gothic art as essentially democratic and lay-inspired. Influenced by Mâle's chaste and modern view of the cathedral, we have ignored the 'naughty bits' of these structures. For the Abbé Auber it was part of a category of religious art he called 'obscoena' about which he wrote a whole chapter in his *Symbolisme religieux* arguing their didactic role to warn the viewer against bodily sin.[4] Even today these parts of the structure go unexplained. The arse is reproduced in Kimpel and Suckale's otherwise brilliant 1980s sociological treatment of the cathedrals but it is the only image not discussed anywhere in the text.[5] Is the arse beyond or outside language? Why was it carved as part of the architectural structure of the cathedral if it cannot be contained by its meaning? Is it excessive or was it? What can the bum mean to us today? Did people of the thirteenth century laugh when they saw such things on the church? Were they considered obscene and did that category exist? What I want to show is that the plurality of significations that the arse had in medieval culture makes this image simultaneously one that can incite awe, shame, fear, delight and laughter. Our modern category of the obscene is not very helpful in penetrating the secrets of the Bourges bum.

4 C. A. Auber, *Histoire et théorie du symbolisme religieux avant et depuis le christianisme*, 4 vols (Paris, 1870–1), III, chapter 11, 'Des Obscoena' (pp. 404–38).
5 D. Kimpel and R. Suckale, *L'Architecture gothique en France 1130–1270*, trans. F. Neu (Paris, 1995; first published in German, 1985), Fig. 262 (p. 258).

The most startling interpretation of this lonely ecclesiastical anus is by a man who can be described as the first great iconographer of the medieval obscene, G. J. A. Witkowski in his *L'Art profane à l'église*.[6] At the end of the nineteenth century medical doctors were the greatest connoisseurs and the most powerful voices of authority in French society. Historians have charted this process of medicalization by which the power to name, control and incarcerate certain types of bodies, which during the Middle Ages was the prerogative of the Church and in the early modern period, the State, increasingly attached itself to their scientific gaze.[7] Dr G. J. A. Witkowski (1844–1923), the son of Polish immigrants, was a professor of medicine at the Faculty of Paris and an officer of the Academy of Medicine. His specialty was gynaecology. He published a series of widely used medical treatises illustrated with superbly detailed colour chromolithographs including the two-volume *Anatomie iconologique* in 1870 and, between 1873 and 1877, a collection of eight short fascicles on individual body parts, the *Anatomie iconoclastique*, which includes one on the male and another on the female genital organs.[8]

Witkowski is best known today for a series of volumes of what the French still call 'vulgarisation' and which he termed 'para-scientifiques', all focusing on the representation of medical subjects in art. He began with the iconography of childbirth in 1894,[9] and in 1898 two volumes comprising a fully illustrated eulogy to the female breast, the second of which also included a history of the corset. This was followed in 1903 by a more general work on the female breasts, *Les Seins dans l'histoire*, which utilized many reproductions of famous paintings and sculptures.[10] In 1908 Witkowski published his most important work in this vein, *L'Art profane à l'église*. These volumes, the first dealing with 'France' and the second with 'Étranger', are still often referred to. They are part of the great nineteenth-century urge to create a monumental past as a category of material to be restored, collected and studied.

6 G. J. A. Witkowski, *L'Art profane à l'église: ses licences symboliques, satiriques et fantaisistes, contribution à l'étude archéologique et artistique des édifices religieux*, 2 vols (Paris, 1908), I, 194 (Fig. 231).

7 T. Zeldin, *France 1848–1945*, 2 vols (Oxford, 1973–7), I, 23–42.

8 G. J. A. Witkowski, *Anatomie iconologique. Explications pratiques par planches coloriées et superimposées, texte inclus, des difficultés anatomiques*, 2 vols (Paris, 1870); G. J. A. Witkowski, *Anatomie iconoclastique. Atlas complémentaire de tous les ouvrages traitant de l'anatomie et de la physiologie humaines composé de planches découpées, coloriées et superimposées (texte inclus)*, 8 fascicles (Paris, 1873–7); fascicle III is dedicated to the female genitals, fascicle VII to the male.

9 J. G. A. Witkowski, *Les Accouchements dans les beaux-arts, dans la littérature et au théâtre* (Paris, 1894).

10 In sum, Witkowski published four volumes on the female breasts, all under the general title *Tetoniana: Curiosités médicales, littéraires et artistiques sur les seins et l'allaitement* (Paris, 1898); *Anecdotes historiques et religieuses sur les seins et l'allaitement comprenant l'histoire du décolletage et du corset* (Paris, 1898); *Les Seins dans l'histoire* (Paris, 1903); and *Les Seins à l'église* (Paris, 1907).

Witkowski, like many medical doctors of the period, was vehemently anti-clerical and he saw his own project as uncovering the hypocrisy of the Church, which had not only forgotten its medieval origins but which sometimes sought to cover up or even destroy images considered obscene. He always contrasts the prudery of the priest to his own post-Enlightenment, rational gaze. The history of art was, for Witkowski, a vast stone clinic where he was able to diagnose a thousand years of bodily function and dysfunction in the forms of overblown phalluses, trumpeting anuses and squirting breasts.

He reproduces the Bourges bum with two sculptures from around a window on the early sixteenth-century Château of Blois showing a man covering his face as he sees a woman's rear end. This is one of the very few representations I have come across of a female revealing herself (and we should note that she lifts up clothing rather than pulling it down).[11] His gaze most often focuses on that particularly phantasmic part of the fin-de-siècle female anatomy that he had already published in his serious medical studies. Just as Witkowski's medical map of the female sexual organs could only be published because it was presented as a sliced-up corpse with both legs amputated, so as not to suggest that he had gazed at that impossible, always incomprehensible secret of the hidden, living female organism, his medieval pudenda are permissible precisely because they are only fragments, cadavers of a medieval past. Witkowski could reproduce many images of this organ precisely because it was seen within the context of what he called a 'book of science'. My focus here though is on Dr Witkowski's anus rather than his vagina.

The arsehole is perhaps the obscene image par excellence. Jacques Merceron, in his useful essay on the *sermons joyeux*, remarks that the obscene 'only really becomes such when what normally should remain concealed becomes revealed'.[12] For Witkowski, the console carved in the shape of a pair of buttocks in the crypt of Bourges cathedral belongs either to a 'Vénus callipyge ou d'un homosexuel fessu d'outre-Rhin' ('a big-bummed Venus or a big-bummed German homosexual').[13] The Venus callipyge was a famous antique statue in Naples that had exaggerated *fesses*; the allusion to Germany, 'd'outre-Rhin', is not only a reference to the wide girth of this particular arse but to the German origin of the term 'homosexual', first coined in 1869 but first attested in a review of Krafft-Ebbing's *Psychopathia Sexualis* in 1891. French doctors continued to prefer the earlier term 'invert'. This term too was

[11] See Witkowski, *L'Art profane*, Fig. 231 (p. 194) for the Bourges bum; the two Blois sculptures are reproduced as Figs 232 and 233.

[12] J. E. Merceron, 'Obscenity and Hagiography in Three Anonymous *Sermons Joyeux* and in Jean Molinet's *Saint Billouart*', in *Obscenity: Social Control and Artistic Creation in the European Middle Ages*, ed. J. M. Ziolkowski (Leiden, 1998), pp. 332–44 (p. 334).

[13] Witkowski, *L'Art profane*, p. 193.

a German coinage, invented by the German magistrate Ulrichs and introduced to France around the same time. A current scandal that may have inspired the doctor to make these nationalistic associations was the Eulenberg scandal that shook Germany in 1907 in which the Kaiser was thought to be surrounded by a coterie of homosexuals, including Eulenberg and von Moltke, who were subsequently put on trial. Witkowski refers in his Introduction to the tradition in the 'virtuous country of "homosexuals" ' (i.e. Germany) of showing Bathsheba fully clothed as opposed to her fuller nudity elsewhere.[14] For this author the full display of the female body, especially the breasts, is part of a healthy Gallic appetite for natural male virility and the urge to procreate.

In his 1908 volumes, Witkowski also describes the sculptures of males grabbing each others' genitals in the stalls of Amiens cathedral using the medieval term 'sodomites' and the three new coinages: 'invert', 'homosexual' and 'uraniste'. Under the heading 'Les *Sodomites*' he describes the pendentive hanging down over the western stalls as 'Deux invertis ou homosexuels sont tenus embrassés par l'esprit du mal. Ils sont enlacés de telle sorte que les deux jambes visibles semblent appartenir aux trois uranistes' ('Two inverts or homosexuals are embraced by the spirit of evil. They are entwined in such a way that the two legs that are visible seem to belong to three uranists').[15] The term 'invert', meaning to turn upside down, was the term most often used by doctors in the late nineteenth century as a noun to refer to a man who was sexually attracted to other men. Putting aside for a moment the complex question of whether we see here a medieval image of sodomitical sexuality as condemned by the medieval Church, what fascinates me is how Witkowski describes these figures using late nineteenth-century physiognomical markers and categories. Later in the volume he finds another representation of homosexuals in the stalls of Amiens cathedral and cites the shocked words of the great Amiens scholar of the cathedral, Georges Durand. This author had admitted being embarrassed to describe certain pendentives carved as part of the great choir-stall complex created for the cathedral between 1508 and 1519; Durand writes of these figures 'making gestures that one has to refrain from describing'. This is the trope of the 'love that dare not speak its name' or what the medievals themselves called the *nefandum*. Witkowski loved to cite the refusal to name sexual acts among other writers; here, of the unnamable vice itself, he writes 'C'est sans doute la scène complétée de nos *Sodomites*' ('it is probably the complete scene of our *Sodomites*').[16] The sunken eyes, the pronounced nose and the fleshy body are all markers of effeminacy and part of the pathology of perversion described in legal and medical

14 Ibid., p. 7, n. 1.
15 Ibid., p. 412; see Fig. 518.
16 Ibid., p. 414 (Durand writes of 'des gestes qu'il faut rénoncer à décrire').

contexts. In one of his serious medical studies he cites a sonnet by a Dr Camuset describing homosexuals as 'hybrides dont la forme / A des rond-eurs de femmes' ('hybrids, whose form has feminine curves') and whose 'elephantine trousers' hide 'un organe infundibuliforme' or funnel-shaped anus. The invert was recognizable to the public at large, wrote this expert, by his ambiguous bodily shape, as well as by his gestures, which tended towards the feminine, especially his prominent arse.[17]

Dr Witkowski's finding homosexuals in medieval art through their traits and appearance is disturbingly akin to the medico-legal methods that were used, in the same period, to entrap and imprison actual bodies. The idea that the bodies of homosexual men were different from those of heterosexuals, displaying specific physical manifestations of inversion, was part of the new pathological medical discourse of the period. Iwan Bloch described in 1908 the 'considerable deposit of fat, by which the resemblance to the feminine type is produced, the contours of the body being more rounded than in the case of the normal male'.[18] When entrapped by the policemen, homosexuals were increasingly subject to medical examinations in order to determine whether they were 'true' pederasts. The famous forensic expert, Dr Tardieu, boasted of having undertaken three hundred anal examinations of pederasts and sodomites and divided inverts into passive and active types. The passive invert often displayed an infundibuliform or funnel-shaped anus like that of a cordonnier, referred to as B: 'after having spread the muscular masses which formed his arse-cheeks, one discovered a deep and profound hole, at the bottom of which opened the anal orifice forming a kind of funnel with a large, crater-like opening'.[19] This was even illustrated in the popular 1857 edition, an image that bears no relation to the expansive medieval anuses that we have been looking at. The shape of the buttocks of the Bourges sculpture is no different than those of the famous Adam, from Notre-Dame in the musée Cluny. Nothing anatomical marks these buttocks as those of a pervert. The ubiquitous medieval image of the anus, with its Rabelaisian associations of fecundity and its traditional apotropaic function (which I discuss below), is here quite anachronistically labelled in terms of this newly named 'perversion'.

In the rest of this essay I want to show how Witkowski and many of his

[17] The prominent arse is a common trope seen also, for instance, in nineteenth-century popular prints of the male prostitute, called a 'Jesus'.

[18] I. Bloch, *The Sexual Life of Our Time in its Relations to Modern Civilization*, trans. M. Eden Paul (London, 1908), p. 498.

[19] A. Tardieu, *La Pédérastie*, in *La Prostitution Antiphysique précédé de La Pédérastie*, ed. F. Carlier (Paris, 1981), pp. 11–83; *La Pédérastie* was first published in Paris in 1857. The citation reads: 'Après avoir écarté les masses musculaires qui forment les fesses, on découvre une sorte de cavité large et profonde, au fond de laquelle s'ouvre l'orifice anal, et qui constitue une sorte d'infundibulum à large ouverture et comme cratériforme' (p. 68).

followers today make the mistake of seeing a body part as a purely sexual rather than social sign. As a social sign it takes on meaning depending upon its location. The obscene is fundamentally dependent upon place. A gesture I might make in my bathroom mirror is not obscene but if I do the same thing on the street it would be considered offensive. The Bourges bum has to be placed not in a pathology of perverse bottom-types but in a typology of multifarious rear-ends that punctuated a range of sites in the Middle Ages. Witkowski, like so many art historians since, isolates the motif rather than thinking about it contextually. It is situationally meaningful in this particular site in the crypt, the very fundament of the church. Bayard argues that these elements are 'minor sculpture' carved 'in the 1230's' in a gallery that was made for those building the crypt; 'the same is true of the many corbel figures in the north tower (some of which are almost identical to those in the crypt)'.[20] But, as Dieter Kimpel and Robert Suckale show, 'Les nefs et les cryptes étaient des zones semi-publiques' ('naves and crypts were semi-public zones').[21] The consoles are extremely visible, located at about face-height, and most of them represent faces.

The arse is on the left, as one comes down the stairs, and faces a head with pointed demonic ears, and perhaps has to be seen in direct relation to it. Other themes of the crypt corbels include, in the opposite corner from the arse, a figure with a winged serpent emerging from its trousers, suggesting the vice of masturbation, and another male with his hand pointing to or touching his bottom or tail. Heads and tails; the joke is partly that one expects to see a 'face' here in the 'cul-de-lampe', as the French call this unit, and instead one sees that 'other' face, literally a 'cul'. This analogy of the 'other' face is common in later medieval art, as in the wonderful image of a bespectacled bottom carved into a side panel of a choir stall in Leon cathedral; when the stall was occupied, this face was squeezed up against a canon's big rear end (Fig. 2.2).

But the key to understanding the arse that is a face and simultaneously 'in your face' in the crypt at Bourges was first noted by Reinhard Steiner in an article of 1991.[22] These console figures are related to 'The Feast of Fools', celebrated in the cathedral primarily on 1 January (the feast of the Circumcision), but also during the other days of festive licence celebrated between 24 December and 6 January (including especially the feast of Stephen, the cathedral's patron saint, on 26 December and the feast of the Holy Innocents on 28 December); these latter festivities (28 December) were specifically dedicated

20 T. Bayard, *Bourges Cathedral: The West Portals* (New York, 1976), p. 76.

21 Kimpel and Suckale, *L'Architecture gothique*, p. 258.

22 R. Steiner, ' "Deposuit potentes de sede". Das "Narrenfest" in der Plastik des Hoch- und Spätmittelalters', in *Aufsätze zur Kunstgeschichte: Festschrift für Hermann Bauer zum 60. Geburtstag*, ed. K. Möseneder and A. Prater (Hildesheim, 1991), pp. 92–108 (especially pp. 96 and 100); the crypt carvings are reproduced as Figs 4 and 5 (p. 437).

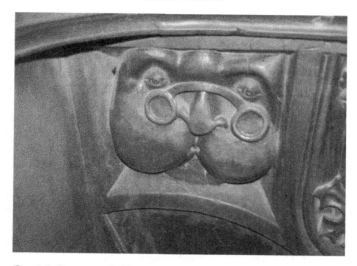

Fig. 2.2 Bespectacled bottom, detail of the side panel of a choir stall, Leon cathedral (E. Block)

to the young choirboys, but on all of these days the lower clergy performed indecently both inside and outside the church. The *festum stultorum*, or Feast of Fools, was specifically the feast of the subdeacons, which explains the youthful faces of the boys here and the plump round youthful bottom.[23] At the end of the feast, of course, the mighty are cast down from their seats and the humble exalted ('Deposuit potentes de sede et exaltavit humiles', as the Magnificat renders it). In 1207 Pope Innocent III called attention to the wearing of masks by the deacons and subdeacons, which are visible on the faces in the crypt. During the feast, a boy-bishop was elected who would preside over the collections and likewise this is reflected in the console carvings where two young boys, one holding a *baculus* or mock-rod of office, are visible.[24] During this feast of inversion, everything low was exalted. As Richard of St Victor described:

> But today, more than other days of the year, they concentrate upon fortune-telling, divinations, deceptions, and feigned madness. Today they outdo each other in turn with offerings by observation of silly or superstitious intent. Today, having been seized up by the furies of their bacchant-like ravings and having been inflamed by the fires of diabolical instigation, they flock together to the church, and profane the house of God with vain and foolish rhythmic poetry in which sin is not wanting but by all means present, and

[23] The youthful boys' faces are also reproduced in L. Brugger and Y. Christe, *Bourges: La Cathedrale* (Saint Léger-Vauban, 2000), Figs 55 and 56.
[24] See Steiner, ' "Deposuit potentes de sede" ', Fig. 5 (p. 437).

with evil sayings, laughing, and cacophony . . . and many applaud with the hands of priests, and the people love these things.[25]

The entire ecclesiastical establishment was turned upside-down. This is an ecclesiastically sanctioned arse and it is meant to evoke laughter on the day when the 'mighty are put down from their seat'.

The Bourges arse is also formally significant in terms of its architectural role. It is a *cul-de-lampe*; it is the arse of the arch architecturally speaking. Both on interiors of churches (Précy-sous-Thil, Picardy) and exteriors (the console of the west façade of Notre-Dame de l'Épine, Champagne-Ardennes) the idea is that it holds up something else, a kind of anal atlante. Common to these latter examples, and regularly depicted elsewhere, is the way in which the hand points into the arse-hole or pulls back the buttocks to draw attention to the gaping hole.[26] This gesture is crucial; obscenity is performative, and the gesture of 'baring the buttocks', as Malcolm Jones has recently described it, has been ubiquitous since ancient times as a way of warding off the evil eye.[27] In his study of medieval popular culture, A. Gurevich cites the example of an Italian nobleman, Alberico da Romano, who was so annoyed at losing his favourite falcon while out hunting that he 'dropped his trousers and exposed

25 Richard of St Victor, *Sermones centum* (XLIX 'In Circumcisione Domini') in *Patrologia latina* 177, col. 1036: 'Sed in hoc die, quem annum novum vocant, enormitatibus praeputiorum suorum viri Israel turpiter inveterascunt. Hodie namque sortilegiis et divinationibus, vanitatibus et insaniis falsis prae caeteris anni diebus intendunt. Hodie donis ad invicem vanae et superstitiosae intentionis observatione se praeveniunt; hodie debacchationis suae furiis rapti, et instigationis diabolicae flammis accensi ad ecclesiam convolant, et vaniloquiis ac stultiloquiis, quibus peccatum non deerit imo aderit rhythmicis quoque dictis nefariis, risibus, et cachinnis domum Dei profanant. Et qui malum melius dixerit, ille plus laudatur in desideriis animae suae (*Psal*. X). Hodie etiam quidam clerici, de quibus scriptum esse videtur, quod clerici eorum non proderunt eis, prophetant in Baal (*Jer*. II), et divinant mendacium (*Ezech*. XIII), et nonnuli sacerdotum plaudunt manu (*Thren*. II), et populus diligit talia.' For the ascription of the sermons to Richard of St Victor, see J. Chatillon, 'Le Contenu, l'authenticité et la date du *Liber exceptionum* et des *Sermones centum* de Richard de Saint-Victor', *Revue du moyen âge latin* 4 (1948), 23–51, 343–66.
26 The hand-held, gaping anus is prominent on the interior of the city gates of Semur-en-Auxois (discussed below; see Fig. 2.3); see also N. Kenaan-Kedar, *Marginal Sculpture in Medieval France* (Aldershot, 1995), Fig. 2.8, for a related, similarly performative corbel image.
27 See M. Jones, 'Baring the Buttocks', Appendix 2 of his 'Marcolf the Trickster in Late Mediaeval Art and Literature or: The Mystery of the Bum in the Oven', in *Spoken in Jest*, ed. G. Bennett (Sheffield, 1991), pp. 171–2; Jones provides the fullest set of references to a wide range of textual and pictorial examples. For the ancient associations between the evil eye and the anus, see F. T. Elworthy, *The Evil Eye* (London, 1895), pp. 137–9, and for medieval art the important article by J. Yarza Luaces, '*Fascinum*. Reflets de la croyance au mauvais œil dans l'art médiéval hispanique', *Razo* 8 (1988), 113–20.

his rear to the Lord as a sign of abuse and reviling'.[28] This helps explain the gesture as seen in so many exterior gargoyles of the late Middle Ages, such as the famous one at Fribourg cathedral where the running water spills from a man's boldly exposed anus.[29] The apotropaic function here is clear, the inversion of the body signalling the shaming of the onlooker, frightening them into submission. If this literal attack seems surprising today, we should not forget that 'mooning', as it is called in modern parlance, was used as weapon on the battlefield according to the chronicle of Peter Langtoft, which describes the English using this gesture to deride the Scots. German anti-nuclear protesters likewise 'mooned' the French gendarmes at the frontier post of Neuf-Brisach in June 1981, demonstrating that the same choric bottom-baring is still used as an instrument of radical social protest.[30] In the *Hours of Étienne de Chevalier* by Jean Fouquet, a fool scratches his bottom (through translucent underpants) in direct effrontery to St Apollonia as she is being horrifically martyred.[31] This miniature has been linked to the dramas performed on the medieval streets, which is another important aspect yet to be explored. It would be wrong, however, to react too much to the prudery of our own forebears by imagining medieval people to be bum-baring bon-vivants. As Hans Peter Duerr argues, citing the case of one Gerber Kratt imprisoned by the city fathers of Constance in 1436 for letting the people of the city see his arse, the gesture could only have a magical or apotropaic effect because it was perceived as shocking and shameful.[32]

The crypt bum does not display its genitals in comparison with, for instance, a striking carving in Leon cathedral, where the finger points inside and the genitals are clearly dangling in the sacred space. This lack is, I think, enormously significant in desexualizing its affront. Had it balls and a penis it would likely have brought to mind the popular legend of the trickster Marcolf, who duped the wise King Solomon into looking, not only at his exposed buttocks but the whole rear end, including 'nates et culus et gurgulio et testiculi' ('rump and anus and penis and testicles').[33] Despite the fact that

[28] A. Gurevich, *Medieval Popular Culture*, trans. J. M. Bak and P. A. Hollingsworth (Cambridge, 1988; first published in Russian, 1981), p. 197.
[29] See K. Kröll, 'Die Komik des grotesken Körpers in der christlichen Bildkunst des Mittelalters', in *Mein Ganzer Körper ist Gesicht: Groteske Darstellungen in der europäischen Kunst und Literatur des Mittelalters*, ed. K. Kröll and H. Steger (Freiburg, 1994), Fig. 23, p. 32; and M. Camille, 'Adam's House at Angers: Sculpture Signs and Contrasts on the Medieval Street', in *Kontraste im Alltag des Mittelalters*, ed. G. Jaritz (Vienna, 2000), pp. 143–78 (Fig. 9). For more illustrations, see A. Weir and J. Jarman, *Images of Lust: Sexual Carvings on Medieval Churches* (London, 1986), pp. 100–1.
[30] For more recent examples like this and an anthropological approach to the gesture, see H. P. Duerr, *Obzönität und Gewalt. Der Mythos vom Zivilisationsprozess*, Band 3 (Frankfurt 1993), pp. 148–57.
[31] G. Bazin, *Jean Fouquet: Le livre d'heures d'Étienne Chevalier* (Paris, 1990), p. 113.
[32] Duerr, *Obzönität und Gewalt*, pp. 149–50.
[33] For the Latin version of the text, see W. Benary, *Salomon und Marcolfus* (Heidelberg,

most visual imagery associated with Marcolf, the boorish dwarf who engages Solomon in a mock dialogue in which he subverts the wisdom of all of his pronouncements, has been discovered in Germany, England and even Spain, it has been suggested that the earliest written versions came from France where the trickster was known as Marcoul.[34] The climax of both the Latin and vernacular versions of the story involved Solomon banishing the trickster from his court with the words: 'Tho sayd the king salomon, go from hens out of my syghte: and I charge the that I se the no mere betwixt the yes [eyes].' The following day the king finds some strange footprints in the snow and following them finds an 'olde ovyn' and opens the door only to find that Marcolf has 'put downe hys breche into hys hammes that he myght se hys ars hole and alle hys othre fowle gere'. Marcolf explains that even though the king no longer sees him 'betwyxt myn yes', 'ye may se me betwene my buttockys in the myddes of myn arsehole'.[35] The king also looks at Marcoul's display across the bay of the second storey of a wooden house in Thiers.[36] But if this is the theme alluded to on the rich merchant's house it would be an unusual anti-establishment image for such an 'establishment' site as the cathedral crypt. As Malcolm Jones has argued, the disrespectful peasant in his dialogue with the biblical king 'is not likely to have appealed to the powers that be, either temporal or spiritual'.[37] Guy Hocquenghem has described the way in which the arse has become privatized only in modernity in a way it was not in pre-modern culture. In *Homosexual Desire* he writes: 'We only see our anus in the mirror of narcissism, face to face, or rather back to front, with our own clean, private little person. The anus only exists as something which is socially elevated and individually debased.'[38] Marcolf's bum said, not 'Fuck *me*' but 'Fuck *You*'.

An arse though is more than just two buttocks, whether or not it is the exterior 'face' that is represented or a deeper 'fond-de-cul' or 'arsehole'. The Bourges example lacks this depth in the tradition of the gaping anus as the

1914), p. 43; and for a full iconographic treatment of this ubiquitous story, see Jones, 'Marcolf the Trickster' and K. Kröll, 'Der schalkhaft beredsame Leib als Medium verborgener Warheit', in *Mein Ganzer Körper ist Gesicht*, ed. Kröll and Steger, pp. 239–94 (pp. 282–3). The full series of 1487 printed illustrations is reproduced in M. Curschman, 'Marcolfus deutsch. Mit einem Faksimile des Prosa-Drucks von M. Ayrer (1487)', in *Kleinere Erzählformen des 15. und 16. jahrhunderts*, ed. W. Haug and B. Wachinger (Tubingen, 1993), pp. 151–255 (facsimile on pp. 240–55).
34 See the introduction to the standard edition by Benary, *Salomon et Marcolfus*; and Jones, 'Marcolf the Trickster', p. 143.
35 *The Dialogue or Communing between the Wise King Salomon and Marcolphus*, ed. E. G. Duff (London, 1892), pp. 30, 32.
36 See Camille, 'Adam's House at Angers', Fig. 11.
37 Jones, 'Marcolf the Trickster', p. 157, quoting E. G. Duff facsimile edition of the *Dialogue*. I am indebted to Malcolm Jones's suggestive analysis of the story here.
38 G. Hocquenghem, *Homosexual Desire*, trans. D. Dangoor (London, 1978; first published in French, 1972), p. 86.

butt of vilification. In the eleventh-century Latin satire against the Irishman Moriuht ('Satyra contra Moriuht'), Moriuht not only offers his rear to everyone, male and female:

> Indeed, I may say that his genitals were entirely exposed, as well as the black piles of his anus and groin, and his rear was always so wide open that when he bent his head down to look at something on the ground, a cat who entered there could hibernate a year with his female cat, a large stork could build a nest in the forest of his groin, or a hoopoe could construct a comfortable home.[39]

Remember that this poem is formally addressed to Robert, archbishop of Rouen (996–1031)[40]; as with the Bourges bum, we are not in Bakhtin's market-place but in the realm of high ecclesiastical parody.

Now of course the bum in the crypt is related to the bum in the street, and indeed one might argue that its charge is to do exactly what the Feast of Fools did in inverting the order of things. Clerical critics of the feast argued that these rites demeaned the sacred space by bringing the sounds, smells and lubricious bodies of the marketplace inside the Church. The exposed anus appears in the streets of medieval towns, even as we shall see at Bourges. In 1436 in the city of Constance, a man called Kratt was imprisoned for half a year by the city authorities for displaying his behind in public on Ash Wednesday, while in France there are records of public exhibitionism by two men at Chartres, who in 1396 had staged a competition to see who had the 'plus belles couilles et les plus beaux génitoires' ('the most beautiful balls and the most beautiful genitals').[41] It was especially used in civic or secular contexts where power was an issue, such as on the interior of the fourteenth-century city gates of Semur-en-Auxois in Burgundy (Fig. 2.3). Whereas in the earlier Middle Ages it is the female sexual organs that play the crucial welcoming and protective warding-off role, by this period, and in a ruth-lessly male-dominated society, the phallic rules the gate. As E. Jane Burns has convincingly shown regarding the numerous descriptions of orifices in the French fabliaux, 'there could be no more tangible demonstration of the fabliau's tendency to erase female genitalia by imposing the model of a male

39 Warnerius of Rouen, 'Satyra contra Moriuht', in *Comic Tales of the Middle Ages: An Anthology and Commentary*, ed. M. Wolterbeek (New York, 1991), pp. 192–219 (p. 205).

40 Warnerius of Rouen, 'Satyra contra Moriuht', pp. 193 and 219.

41 For Chartres and other French examples, see J.-P. Leguay, *La Rue au Moyen Âge* (Rennes, 1984), p. 208. H. Maurer, *Konstanz im Mittelalter*, 2 vols (Constance, 1989), II, 184, cites the Constance example. For the licence given over to bodily display at carnival time in German cities, see the study by H. Moser, 'Städtische Fasnacht des Mittelalters', in *Masken zwischen Spiel und Ernst. Beiträge des Tübinger Arbeitskreises für Fastanchtsforshung* (Tubingen, 1967), pp. 135–202

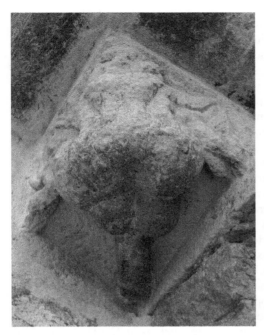

Fig. 2.3 Male exhibitionist, detail
of city gates, Semur-en-Auxois
(H. Tronc)

asshole'.[42] If the bum in the crypt was about inverting social and sacred power for a moment, this is a power-butt of a different order. Mooning figures occur on the town hall of Saint-Quentin (Picardy) and the famous Geldsheisher on the town hall of Goslar, 1449.[43] So far I have found dozens of examples of the sexualized bum-bearer on medieval civic buildings, which suggests it had a different set of associations there from in the church. The male sex is crucial both to the Marcolf story and to the apotropaic function of the image since the genitals were the original Roman *fascinum* hung outside every house to ward off evil. At Angers, the House of Adam has a wonderful carving of Marcolf that de-emphasizes the arse, which is half covered by the hand of the figure; it is more about what hangs beneath it.[44] This is sexuality and male virility. At Bourges there is just such a wooden bum celebrating Marcolf's resistance to authority on the so-called House of Reine Blanche only twenty minutes from the cathedral.[45] This little bum-barer has a totally

[42] E. J. Burns, 'Knowing Women: Female Orifices in Old French Farce and Fabliau', *Exemplaria* 4 (1992), 81–104 (p. 94). For sodomy, see B. J. Levy, 'Le dernier tabou? Les Fabliaux et la perversion sexuelle', in *Les Perversions sexuelles au Moyen Âge*, ed. D. Buschinger (Griefswald, 1994), pp. 107–24 (pp. 117–19).

[43] For Goslar, see C. Gaignebet and J.-D. Lajoux, *Art profane et religion populaire au Moyen Âge* (Paris, 1985), p. 57.

[44] See Camille, 'Adam's House at Angers', Fig. 8.

[45] See ibid., Fig. 12.

different set of associations because of his urban rather than liturgical context. I would go as far as to say that he loses his obscene charge here, so powerful is his anti-authoritarian but masculine power. As I have argued in a recently published article on Adam's house, this kind of arse is linked to the notion of private property as described by the recent theorists Deleuze and Guattari, who describe how, whereas the phallus is essentially social, the anus is essentially private. 'Control of the anus' is, in the words of Hocquenghem, 'the precondition of taking responsibility for property'; it gives privatization its model.[46]

Another register we might want to think about in exploring the isolated bum in the crypt, in its being part of the serious game of inversion associated with the Feast of Fools, is the scatological. Once again, in the sacred context this is less current, whereas in street sculpture it makes sense. There are many civic ordinances complaining of people using the street as a toilet and defecating directly out of their windows. Certainly this was a popular theme in the period attested by numerous manuscript images I published in *Image on the Edge*.[47] But as anyone who has ever been constipated knows, there is nothing wrong with shitting and most medieval sculptural representations concern inducing rather than stopping it. There are a number of sculptures on wooden houses associated with defecating but most are linked to the function of the ground floor as an apothecary's shop, such as at Nantes (now in the musée Dobrée there) where, in addition to the druggist grinding medicines, there is a rare image of a female shitter, a woman defecating after having taken a purgative. Likewise, on the *pignon* on the Maison de l'Apothicaire at Clermont-Ferrand, the patient bends over on one side of the roof across from where the doctor brandishes an ominous clyster about to probe his anus.[48] The arse is the focus of medical doctors searching for piles or probing for anal fistulas in many medical miniatures.[49] This is a different kind of medicalization than that I described for Dr Witkowski's researches. It is based on medieval notions of the body's openings, not on modern pathologies.

So far in this essay, I have argued against Witkowski's association of the Bourges bottom with the over developed buttocks of German homosexuals. But this register of associations is not totally lacking in late medieval culture. A late thirteenth-century miniature in a unique illustrated fabliau, the only

[46] Camille, 'Adam's House at Angers', pp. 155–6, citing G. Deleuze and F. Guattari, *Anti-Oedipus: Capitalism and Schizophrenia*, trans. R. Hurley, M. Seem and H. R. Lane (London, 1984; first published Paris, 1972); Hocquenghem, *Homosexual Desire*, p. 85.
[47] M. Camille, *Image on the Edge: The Margins of Medieval Art* (London, 1992).
[48] Camille, 'Adam's House at Angers', Fig. 10. The 'Maison de l'Apothicaire' is described in *Congrès archéologique de France LXXXVIIe session, Clermont-Ferrand, 1924* (Paris 1925), pp. 202–3.
[49] See L. MacKinney, *Medical Illustrations in Medieval Manuscripts* (London, 1965), p. 246, Figs 86–7a and b.

manuscript of 'Trubert', shows how a trickster demands payment (for a multicoloured goat) from the duke of Burgundy in the form of four of the duke's anus hairs, which he pulls, from the duke's anus, in public.[50]

> Li dus li a le cul tourné
> apareillié et descouvert
> si que toz li fenduz apert.[51]

This description of how the duke 'turned his bum to him, uncovered and exposed so much that the hole appeared in all its entirety' is interesting since this word ('li fenduz') suggests not the hole but the crack separating the buttocks, used more in reference to women than men, and thus serving to further feminize and humiliate the duke. The trickster in fact sticks a knife up the vulnerable anal opening in a humiliating gesture that mimics (for the recipient duke) passive homosexual submission; the trickster in effect 'fucks' his superior (the duke) just as he also fucks the duke's wife and daughter and avoids being fucked himself when, dressed as a woman, he has a king (to whom he, the trickster, is now married) fuck him, or rather a leather purse that he takes to bed in the dark. This shows that revealing the arse can be both shaming and shameful depending upon the context. This is a place where the anus is a sign not of power but of vulnerability and anxiety.

The city of Bourges was traditionally linked with sodomy during the later Middle Ages. Accusing someone of being 'from Bourges' was to accuse them of being a passive homosexual. Scattered all over the cathedral itself are numerous images that clearly relate to the sin of homosexuality. Take, for example, the isolated arse that sits outside, just around the corner from the Last Judgement portal to the south; it is on the first frieze that runs along the roof of a projecting chapel, built in the late fourteenth century (Fig. 2.4). In the far right corner, after a frieze of acanthus, a large bulbous bottom is displayed; when looked at from below it is clearly shown as an object of penetration, although the rendering is ambiguous and it could be that the penetration is effected by the testicles and phallus belonging to the figure itself. It is a kind of reprise of the crypt anus, bringing it out of the cathedral's fundament to get some air. The local legend surrounding this image is that it represents a bishop of Bourges, accused of buggery, who has been forever depicted in his shameful act, his fat round other face visible on the other side of the entablature. In 1232 Pierre de Chateauroux, archdeacon of the cathedral, was accused of the 'vice against nature'. But this chapel was built in the fifteenth century with money from one of Bourges' richest men and himself a

50 Paris, Bibliothèque nationale, MS fr. 2188, fol. 5v. The image is reproduced in K. Gravdal, *Vilain and Courtois: Transgressive Parody in French Literature of the Twelfth and Thirteenth Centuries* (Lincoln NB, 1989), Fig. 9, p. 116. Gravdal's discussion of 'Trubert' is on pp. 113–40.
51 *Trubert, fabliau du XIIIe siècle*, ed. G. Raynaud de Lage (Geneva, 1974), ll. 272–4.

Michael Camille

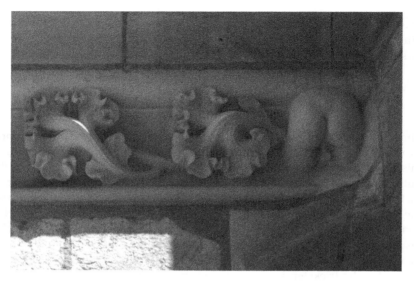

Fig. 2.4 Bottom with acanthus, detail of frieze, exterior of south side chapel, Bourges cathedral (N. McDonald)

renowned 'bougre de Bourges': Jean, Duc de Berry, who after his death in 1416 was accused by the historian Froissart of keeping a boy favourite, Tacque Thiebault at his castle at Nonette in 1389.[52] He actually now lies in marble down in the crypt and kneels in prayer alongside his wife at the east end of the church, but perhaps this exterior arse, which is plugged by something, was a joke on the part of later builders or even restorers – pillorying in eternity the man who was described in a poem written in 1406, *Le Songe véritable*, as having an obsession with a *paveur* or construction worker.[53] Fifteenth-century French culture, as has recently been shown by scholars trying to understand the metaphoric language of the poet François Villon's 'Sottie', is full of extreme anal imagery. In one of these poems there is even a comparison of the exposed buttocks of the passive partner to the 'large walls' of a city being battered down, playing on the notion of the architectural and bodily foundations, or 'fondement'.[54]

[52] Jean Froissart, *Œuvres*, ed. K. de Lettenhove, 29 vols (Brussels, 1867–77), XIII, 313. See also M. Camille, ' "For our devotion and pleasure": The sexual objects of Jean, Duc de Berry', *Art History* 24 (2001), 169–94.

[53] *Le Songe véritable: pamphlet politique d'un Parisien du XVe siècle*, ed. H. Moranvillé (Paris, 1891), ll. 1688–1706.

[54] P. Guirard, *Le Jargon de Villon ou le gai savoir de la Coquille* (Paris, 1968), p. 205 cites these lines from 'Les ballades de l'Amour noir': 'Et aussi destre sur les joncs / En mahes en coffres en gros murs' (ll. 23–4). Interpreted by Guirard, 'gros murs' refer to 'fondations' and thus 'fondement'. The lines might be translated as 'And also to be

Yet, the Bourges sculpture does seem precisely to avoid such overt homo-erotic overtones in its emphasis on the face rather than the penetrable opening. It contrasts with, for example, an extraordinary late fifteenth-century carving from the collegiate church of Saint-Wulfran at Abbeville (Picardy) that seems to represent directly the sin of passive anal sodomy. Here the point is made visually: the devilish man lies on his back and presents himself just like the sheela-na-gig and other vulva-exposing female figures in church art, as at Kilpeck (Herefordshire), Bruyères-et-Montbérault (Picardy) and on the interior of the women's monastery of St Radegonde at Poitiers.[55] This is an arsehole made into a sexual receptacle and it can clearly be associated with sodomy in a way that the Bourges bottom cannot.

The cathedral of St Stephen at Bourges is one of the great gothic churches of France; built during the thirteenth century, it remains one of the most superb assemblages of stone, sculpture and stained glass, like Chartres and Amiens. Even more forcefully than other cathedrals, however, Bourges can be seen as a cathedral constructed by a series of reforming bishops whose aims were to concretize in stone the edicts of the Fourth Lateran Council of 1215, which made the confession of sin a central part of the performance of Christian faith. I am interested in how the sculpture at Bourges cathedral, as a kind of awning to eternity, performs this new confessional psychology for those who came up to its portals and entered within. But in thinking about the cathedral as performance art, both in a liturgical and carnivalesque sense, I am interested in a different cathedral than that usually explored by historians of medieval art. I am interested in the cathedral's arse or rather arses *on* the cathedral and *as* the cathedral. The word cathedral, *cathedra*, means a seat of a bishop – where he sat – and here I am more interested in bishops' bottoms than bishops' benefices. Bourges is a cathedral that is filled with bottoms, some of them belonging to bishops, sticking out everywhere as strange signs of the sacred and for a long time considered obscene and other to it.

Carved only a decade after the crypt bottom there are many on the Last Judgement tympanum of the west façade that can be considered obscene but which serve to bolster the Church's punitive authority.[56] Here, various

stretched on a bed and stuffed behind in the fundament.' See also I. Nelson, *La Sottie sans Souci: Essai d'Interprétation homosexuelle* (Paris, 1977) for metaphors of the 'fondament of the arse' in Villon's poetry. I am grateful to Nancy Freeman Regalado for pointing out this rich deposit of anal-erotic imagery, as yet little explored by art historians, in late medieval French poetry. For an image with similar associations, interpreted by Paul Vandenbroeck, see Jones, 'Marcolf the Trickster', p. 146, reproduced in Gaignebet and Lajoux, *Art profane*, pp. 214–15.

55 For Kilpeck, see Weir and Jerman, *Images of Lust*, Plate 5; the St Radegonde image is reproduced in Kenaan-Kedar, *Marginal Sculpture in Medieval France*, Fig. 3.35 and in Weir and Jerman, *Images of Lust*, Plate 59 and Fig. 51.
56 The Last Judgement tympanum is reproduced in V. Minne-Sève and H. Kergall,

specific sins are being punished. The avaricious man, with the money-bag slung around his neck as a weight for eternity, is being fucked from behind by the phallic tail of one demon, while his own tiny penis is tickled by the feathery arse of the female demon in front of him. Aroused in eternal *jouissance* that can never reach orgasm, his torment is that of sexuality deferred forever. It is not so much the faces that are striking, radical and new in western art here at Bourges, but the bodies. In Caesarius of Heisterbach's description of how demons are located in men he describes how 'When the devil is said to be within a man, this must not be understood of the soul, but of the body, because he is able to pass into its empty cavities such as the bowels.'[57] There is an allusion to another sin, famous – or rather infamous – at Bourges, that of the sodomite, in the figure of a bishop lying on his back, being thrust into the hell mouth still wearing his mitre. He too is shown in a state of sexual arousal in hell. A male figure squeezed behind him is inserting his hand into his anus; this is one of the very first representations that I know of what is today called 'fist-fucking' but which is here depicted as an infernal prelude to his eternity of passivity in hell (Fig. 2.5). And the images on the Bourges tympanum are not unique. At Notre-Dame in Paris, the earlier sculpted archivolt shows a man who is being anally penetrated by a devil's club, linking hell with anal penetration. At Chartres, on the south portal, a plump boy is being thrown over the shoulders of a devil who grabs at his crotch. In a medieval poetic vision of hell, the *Apocalypse of Peter*, sodomites are described as 'the ones who defiled their bodies, behaving like women' and they are, in most visual and verbal representations of the period, singled out for shock-horror treatment.[58] The stone faces carved here cannot be separated from the fleshy ones that groaned and pleaded below in the realm of the real. For in the space of the *parvis* or 'paradise' that faced the west portals, punishment happened. Here was the town pillory where miscreants were exposed, their heads and arms pushed through holes to become living statues, like the hundreds of heads that protrude from the pinnacles and canopies of the cathedral. Here sinners were exhibited and subject to public humiliation. There are also accounts of actual legal proceedings taking place below the portals, becoming so noisy that they sometimes disturbed the liturgy going on within. In Jean Chartier's *Chronique de Charles VII* (1435), we read that men from Bruges who were found guilty of sodomy were executed in public after having been exhibited in the streets:

Romanesque and Gothic France: Architecture and Sculpture, trans. J. Hawkes and L. Frankel (New York, 2000), pp. 340–1.

[57] Caesarius of Heisterbach, *The Dialogue of Miracles*, trans. H. von E. Scott and C. C. Swinton Bland, 2 vols (London, 1929), I, 335.

[58] 'St Peter's Apocalypse', in *Visions of Heaven and Hell before Dante*, ed. E. Gardiner (New York, 1989), pp. 1–12 (p. 8).

Fig. 2.5 Naked bishop thrust into hell, detail of Last Judgement tympanum, Bourges cathedral; note the hand disappearing into the bishop's bottom (N. McDonald)

At the same time, it happened in the city of Bruges that someone called Jacques Purgatoire, offending God and the heavenly court, had committed the detestable sin of sodomy, also called buggery, and had experienced carnally, by force, domination and violence, copulation with several people by the behind. For which he was imprisoned by the officers of justice and after he was duly examined, and had confessed his crime, he was denounced in public and, so that it be an example for everyone, he was condemned by justice to be set on fire and burned in the accustomed place. For which punishment, he was delivered and handed over to the executioner of the said city who accomplished his duty in the presence of the people, which was a great benefit and good example for all.[59]

59 'En ce mesmes temps advint en la ville de Bruges que ung nommé Jacques Purgatoire, contempnant Dieu et la cour céleste, avoit commis ung détestable péché de sodomite, autrement dite bougrerie, en avoit eu charnellement, par force, maistrise et viollance, copulacion avec plussieurs personnes par le fondement. Pourquoy fut par les gens de justice emprisonné et après deument examiné, et le délit par lui confessé, fut presché en lieu publicque, et affin qu'il tournast à example à tous, fut condampné par justice à estre ars et brûlé au lieu et place en tel cas acoustumé. Pour laquelle exécution faire fut baillé et délivré au bourreau de ladite ville, qui en fist son devoir en la présence du peuple, qui fut ung grant bien et bel exemple à ung chacun'; Jean Chartier, *Chronique de Charles VII Roi de France*, ed. V. de

As I have suggested, we should not always link obscenity with the unofficial voice from below, the popular and resistant.

In summary, I have so far suggested there are four key problems with modern approaches to the obscene in medieval art. First: our use of modern medicalized and identity-based terminology for categories of experience that were culturally specific to the Middle Ages. Second: our assumption, following Bakhtin, that the obscene is marginal and other to the sacred; so-called 'profane' church art demonstrates instead that obscenity was produced from within the sacred and not always in opposition to it. Third: our imagining that the obscene, again like Bakhtin, is always socially recuperative and anti-establishment; much of what we now call obscenity in medieval sculpture is, rather, an integral part of the intended, official programme. Fourth: our failure to realize that the obscene is in fact a modern category, like the medical categories of Witkowski; the word 'obscene' did not exist in, for instance, French until the sixteenth century.

The obscene – in the realm of manuscript books, the private world where pornography begins – was created when, as I showed in my essay in Ziolkowski's volume, later people erased offending parts from manuscripts.[60] In the sphere of monumental art there are similarly many examples of sculptures being effaced. In the eighteenth century, the canons of Reims cathedral effaced an image of sodomites on the north portal; their shadowy remains today are not, like so much damage at Reims, the product of First World War shells but rather of the prudery of Enlightenment clerics. Misericords too have suffered as Elaine Block has shown; a misericord from St Martin aux Bois, for example, that showed two men copulating and being beaten by another figure was later erased.[61] This evidence suggests that the obscene, as a category, was invented in modernity, either by those who celebrated it, like Dr Witkowski, or those who destroyed it, but not by those who made and performed it. For the people of Bourges, images we now locate in the realm of perversity – as not seen, as obscene – were images that embodied their own performances and social life. They could be the focus of laughter and of fear.

The biggest difficulty we have as medievalists is forgetting Freud, with all the dark fear of the anal and its associations with death. Medievals saw death not as an arse but as a voracious mouth. The notoriously difficult problem of historicizing the anus fails for queer theory too; the idea that we can find sex

Viriville, 3 vols (Paris, 1858), I, 184–5; Chapter 103 is entitled 'Exécution d'un sodomite à Bruges, fait par justice'.

[60] M. Camille, 'Obscenity under Erasure: Censorship in Medieval Illuminated Manuscripts', in *Obscenity*, ed. Ziolkowski, pp. 139–54.

[61] See E. Block, 'The misericords of Saint-Martin-aux-Bois', *Arts profanes / Profane Arts* 7 (1997), 26–38; the mutilated carving is reproduced in E. Block, *Corpus of Medieval Misericords in France XIII–XVI century* (Turnhout, 2003), ill. CXVb (p. 352), with a brief description on p. 120.

redemptive as well as shameful is a modern notion. Whereas Robert Mapplethorpe's famous photograph, his 1978 'Self-Portrait' (with bullwhip), shocks us precisely because we have, since Freud, come to associate the anus with sex and death, and with the fear of penetration, the anus in the crypt was *not* shocking to its medieval audience, precisely because it did not represent the defiling or penetrating of the vulnerable and highly sexualized male body. It represented, instead, the metaphoric power of that body to threaten, to turn back, to cross boundaries and to construct limits.[62] I have argued here that for medieval people the arse was not redolent of death, but full of life. It was not obscene but seen; and rather than the hidden hole of the neurotic modern self it was the *scene* for playing out social issues and expressing certain social tensions. It was also a site of power and control, for I think it is too easy to sentimentalize medieval obscenity whether it be in Chaucer or these sculptures, to make them part of a 'weren't they open-minded then' sort of view. My last examples, I hope, have served to counter this view and show us how obscenity can be a form of social control and not always the freedom from constraint that we think it is, and that Witkowski sought to celebrate as anti-clerical. Only with the modern world's emphasis upon subjectivity is sexuality linked to freedom of expression. The sculpted Gothic arse was a performance but it was not just a laughing matter like the plastic buttocks one can still see for sale in Paris joke shops. The theatre of the anus was always open for performance, both inside and outside the Church, and it was a serious business even when it was meant to make us laugh.

This final point is made most clearly in the last arse I want to discuss from Bourges. It appears in a line-engraving on the back cover of Witkowski's wonderful if disturbing book. The arsehole has the last laugh, a belly laugh from deep in the guts breaks out of the stone flesh at the far right of the tympanum of the central Last Judgement portal; this laugh appears in the far-right corner of the second register and belongs to a devil who is stoking the mouth of hell with a pair of bellows (Fig. 2.6). The curvaceous buttocks of this hairy creature turn into the two cheeks of a merry round face that has two animated eyes that look out and a mouth splitting horizontally into a broad laugh, directly above the dangling hairy balls and thick penis. The great thigh of the devil is plunged into the rim of the elastic mouth of the upturned figure of hell. One anus fits into another. At the other extreme of the tympanum, we see the saved souls carried in Abraham's napkin like little babies. One saved soul, similarly infantilized, is welcomed into heaven by an angel, his cheeks broadening to a smile. Why does the devil's arse laugh when the saved soul only smiles? Was it because laughter could only take

62 For Mapplethorpe's famous photograph, see R. Meyer, 'Imagining sadomasochism: Robert Mapplethorpe and the Masquerade of Photography', *Qui Parle* 4 (1990), 62–78 (Fig. 1, p. 63); and for relations between anality and death in today's culture, L. Bersani, 'Is the Rectum a Grave?', *October* 43 (1987), 197–222.

Fig. 2.6 Devil with grinning bottom, detail of Last Judgement tympanum, Bourges cathedral (H. Tronc)

place in the noise of hell, amid the scream and sulphur of everlasting torment? Here the anus is literally demonized in a wonderfully imaginative image that makes all the other arseholes at Bourges – that in the crypt celebrating the Feast of Fools, that of Marcolf on the wooden houses and on the south chapel so proudly 'in your face', and even those of the damned sodomites on the same tympanum – seem innocent. Perhaps in this cruel and ironic laugh from within the sacred body of the demon – and from within the stone body of the sacred edifice itself – we have finally come face to face with something truly obscene.

The Exeter Book Riddles and the Place of Sexual Idiom in Old English Literature

Glenn Davis

I

The erotic riddles found in the Exeter Book (*c.* 1000) occupy a complex critical space in Anglo-Saxon studies. Early critics, fuelled by a combination of their own distaste for these riddles' salacious content and a belief in the homogeneously orthodox landscape of the late Anglo-Saxon church, worked hard to separate them from the rest of the Old English literary corpus, which is notoriously reserved on the subject of sex.[1] Yet, despite decades of historical, cultural and literary work that has illuminated the heterogeneity of England during and immediately after the Benedictine Reform, and also a general relaxation of what constitutes 'obscene', many of those early prejudices persist.[2] The erotic riddles are still frequently treated as alien invaders, texts

[1] On the sexual restrictions espoused in Anglo-Saxon penitential texts, see P. J. Payer, *Sex and the Penitentials: The Development of a Sexual Code 550–1150* (Toronto, 1984). Two pieces that identify the deletion of sexual subject matter in Old English translations of Latin originals are M. Donner, 'Prudery in Old English Fiction', *Comitatus* 3 (1973), 91–6, and A. R. Riedinger, 'The Englishing of Arcestrate: Woman in *Apollonius of Tyre*', repr. in *New Readings on Women in Old English Literature*, ed. H. Damico and A. H. Olsen (Bloomington, 1990), pp. 292–306. More recent studies on the absence of sex in Old English literature include H. Magennis, ' "No Sex Please, We're Anglo-Saxons"? Attitudes to Sexuality in Old English Prose and Poetry', *Leeds Studies in English* 26 (1995), 1–27, and A. Davies, 'Sexual Behaviour in Later Anglo-Saxon England', in *This Noble Craft: Proceedings of the Xth Research Symposium of the Dutch and Belgian University Teachers of Old and Middle English and Historical Linguistics, Utrecht, 19–20 January, 1989*, ed. E. Kooper (Amsterdam, 1991), pp. 83–105.

[2] This trend includes increased interest in the history of medieval sexual customs and practices, as seen in *Handbook of Medieval Sexuality*, ed. V. L. Bullough and J. Brundage (New York, 2000), J. E. Salisbury, *Sex in the Middle Ages: a Book of Essays* (New York, 1991) and J. E. Salisbury, *Medieval Sexuality: a Research Guide* (New York, 1990); in typically less sexually restrictive Anglo-Latin and contemporary Norman material, such as *Jezebel: a Norman Latin Poem of the Early Eleventh Century*, ed. J. M.

that somehow slipped into the corpus beneath the hawk-like gaze of the Reformers. As such, their apparently anomalous and heterodox content is typically explained away or otherwise neutralized. A useful, present-day analogue to this phenomenon can be found in Jan Ziolkowski's assessment of how 'obscene' material is dealt with in the modern research library: '[a]nyone who has consulted a major library in researching a topic connected with obscenity witnesses the pervasive tendency to quarantine the indispensable research tools'.[3] By limiting access to these texts, libraries impose artificial restrictions that appear to remove the 'obscene' sources from the cultures responsible for their production. The erotic riddles of the Exeter Book share a similar fate: they are, even today, viewed as exceptional texts that must be kept separate from Old English literature. Consequently, they have rarely been put into conversation with other literary products of Anglo-Saxon England. This essay, by acknowledging that the erotic riddles are impossible to isolate from their most immediate contexts – material, cultural, textual – attempts to demonstrate how their sexual idiom is a feature common to a wider range of Old English literature than has previously been recognized.

The distaste for the sexual material of the erotic riddles is, unsurprisingly, most apparent in the work of their earliest modern critics.[4] Frederick Tupper is the most influential of these scholars, and his discomfort with the erotic riddles suffuses the apparatus to his 1910 study. In cataloguing the different types of riddles present in the collection, for example, which include religious, literary and naturalistic, Tupper remarks that '[m]any others are upon a plane of everyday life and action, of humble trades and occupations, while a few descend into the depths of greasy *double entente*'.[5] Labelling the riddles' use of sexual euphemism as 'greasy' leaves little doubt as to Tupper's attitude toward them; however, it is his employment of the spatial metaphor of descent that is perhaps the more dangerous. By carving out a separate space for the erotic riddles, he reinforces the belief that they are not on the same plane as the other riddles, and, by extension, with the literary corpus as a whole. Additionally, to isolate the erotic riddles in this way is to try to render them harmless, since removed from the others their sexuality cannot threaten the corpus's perceived homogeneity.[6]

Ziolkowski (New York, 1989); and in drawing a more complete, complicated picture of the English Benedictine reform, as surveyed in a review article by Catherine Cubitt, 'The tenth-century Benedictine Reform in England', *Early Medieval Europe* 6.1 (1997), 77–94.

3 *Obscenity: Social Control and Artistic Creation in the European Middle Ages*, ed. J. M. Ziolkowski (Leiden, 1998), p. 12.
4 F. Tupper, *The Riddles of the Exeter Book* (Boston, 1910); *Old English Riddles*, ed. A. S. Wyatt (Boston, 1912); W. S. Mackie, *The Exeter Book: Part II*, EETS OS 194 (London, 1934).
5 Tupper, *Riddles*, p. xci.
6 Wyatt, for example, essentially denies the presence of erotic double entendre entirely

Scholars today know far more about the complex social, political and religious climate of late Anglo-Saxon England than Tupper did. Yet the desire to sequester the erotic riddles, to understand them as fundamentally *other*, is still present. M. J. Swanton, for example, remarks that these riddles 'should perhaps be placed in a distinct class of primitive erotica'.[7] Hugh Magennis likewise recognizes the riddles' erotic content as evidence of their alternate literary history: '[t]he sexual riddles may be seen as representing a traditional type of literature with its background in folk culture', and further, '[i]n acknowledging the interest in sexuality . . . the riddles identify themselves as representing a different literary strand from any of those discussed above'.[8] And in his study of Anglo-Saxon sexual practices, Andrew Davies states that 'Anglo-Saxon literature has next to nothing to say about sexual behaviour. The erotic double-entendre riddles are, of course, the major exception.'[9] While it may be true that the riddles' interest in sex appears unique, calling attention to their exceptional status without further discussion of the complicated cultural landscape in which they occur tacitly underscores their isolation.

There is, however, a group of scholars who have confronted the stereotypes surrounding the erotic riddles and taken an interest in their various cultural functions. Instead of understanding them as exceptional, these critics embrace the fact that, despite an apparently anomalous interest in sexuality, the riddles were still composed and disseminated within a living culture. As such, it is recognized that they may provide valuable information about Anglo-Saxon attitudes to sex and sexuality. Critics like Edith Whitehurst Williams, Jonathan Tanke, Seth Lerer, Sarah Higley and D. K. Smith all confront long-standing critical assumptions about the erotic riddles and have taken up the difficult but necessary project of attempting to understand how riddles that appear to celebrate sex could be part of an official culture and community that worked actively to repress it.[10] Even though the riddles are

in his notes to the riddles, where he studiously avoids the mention of possible sexual solutions. In his discussion of Riddle 45, whose solution oscillates between 'dough' and 'penis', Wyatt notes simply that '[a]ny one who has seen bread made will acknowledge the accuracy of the description: the dough swelling, making sounds (the curious little hissing explosions as the yeast works through the mass), raising the roof or surface, and being covered with a cloth' (*Riddles*, p. 104).

7 M. J. Swanton, '*The Wife's Lament* and *The Husband's Message*: A Reconsideration', *Anglia* 82.3 (1964), 269–90 (p. 271 n. 8).

8 Magennis, ' "No Sex Please" ', p. 18.

9 Davies, 'Sexual Behaviour', p. 96.

10 E. W. Williams, 'What's So New about the Sexual Revolution?: Some Comments on Anglo-Saxon Attitudes toward Sexuality in Women Based on Four Exeter Book Riddles', *The Texas Quarterly* 18.2 (1975), 46–55; J. Tanke, ' "Wonfeax wale": Ideology and Figuration in the Sexual Riddles of the Exeter Book', in *Class and Gender in Early English Literature: Intersections*, ed. B. J. Harwood and G. Overing (Bloomington, 1994), pp. 21–42; S. Lerer, *Literacy and Power in Anglo-Saxon Literature* (Lincoln NE,

now recognized as a viable subject of study and critics look to them as sources for an aspect of Anglo-Saxon culture that has been notoriously elusive, they have still not been fully incorporated into the corpus: studies of this variety, while culturally nuanced, rarely look beyond the text of the erotic riddles themselves. The next step, it would seem, is to reintegrate the riddles into their wider textual contexts, to determine whether their idiom is unique or part of a larger idiomatic system.

Some of the groundwork for a study of this kind has already been established, notably in the contributions of Ann Harleman Stewart, who identifies a lexicon of erotic double entendre in the riddles, and Mercedes Salvador, who breaks artificial generic boundaries in an attempt to reintegrate several of the erotic riddles into the Anglo-Saxon verse corpus.[11] However, analysis of the assumptions made by each of these critics reveals, albeit in two different ways, an adherence to the belief in the riddles' 'obscenity', and therefore in their alterity. In her study of the erotic double entendre riddles, Stewart catalogues a substantial list of lexical items that frequently recur there.[12] These items include words associated with aspects of male anatomy, such as *eage* (eye), *heafod* (head), *stiþ* (stiff), *heard* (hard) and *ruh* (rough); with female anatomy, such as *hol* (hole) and *womb* (womb, belly); and with the act of sexual intercourse, such as *fyllan* (to fill) and *hæmed* (marriage, fornication).[13] Stewart argues that, since these terms have multiple connotations that span sexual and non-sexual semantic ranges, they are particularly well suited to their project. To identify a conventional language of sex in the riddles is

1991), pp. 112–25; S. Higley, 'The Wanton Hand: Reading and Reaching into Grammars and Bodies in Old English Riddle 12', in *Naked Before God: Uncovering the Body in Anglo-Saxon England*, ed. B. C. Withers and J. Wilcox (Morgantown, 2003), pp. 29–59; D. K. Smith, 'Humor in Hiding: Laughter Between the Sheets in the Exeter Book Riddles', in *Humour in Anglo-Saxon Literature*, ed. J. Wilcox (Cambridge, 2000), pp. 79–98.

[11] A. H. Stewart, 'Double Entendre in the Old English Riddles', *Lore and Language* 3:8 (1983), 39–52; M. Salvador, 'The Key to the Body: Unlocking Riddles 42–46', in *Naked Before God*, ed. Withers and Wilcox, pp. 60–96.

[12] Stewart, 'Double Entendre'. See also M. Rissanen, '*Nathwæt* in the Exeter Book Riddles', *American Notes & Queries* 24.7–8 (1986), 116–19; Rissanen examines the use of indefinite pronouns *nathwæt* (something) and *nathwær* (somewhere) in these riddles and demonstrates how they are especially apposite to achieve the ambiguity necessary for effective double entendre. Rissanen notes that of the six occurrences of *nathwæt* in the Exeter Book riddles, five of them occur in those with erotic double entendre (p. 117). Of this particular fitness, Rissanen states: 'The composer of the riddle pretends that he does not know what the thing referred to is; at the same time, both the referential quality of the pronoun and the discourse setting – the presenting of a riddle – imply that he knows exactly what he is talking about' (p. 118). The author's conscious word-play signals his awareness of the conventions his riddle simultaneously obeys and bucks. See also J. Coleman, 'Sexual Euphemism in Old English', *Neuphilologische Mitteilungen* 93:1 (1992), 93–8.

[13] Stewart, 'Double Entendre', pp. 46–7.

undoubtedly an effective means of inquiry into the mechanics of erotic double entendre, and indeed the only way to begin to understand the nature of the sexual idiom at work in those texts. But Stewart uses this erotic idiom as an exclusionary device that distinguishes the riddles from other Old English texts: 'Taken together, the words cited constitute a special lexicon peculiar to these riddles – what we might call the vocabulary of double entendre.'[14] There is no effort made to determine whether this sexually euphemistic vocabulary found use in other works of Old English literature.

Like Stewart, Salvador identifies a sexual idiom common to some of the erotic riddles (42, 44, 45 and 46), which she labels a consistent pattern of 'metaphors and symbols'.[15] In a departure from Stewart's method, however, Salvador demonstrates how these potentially sexual metaphors and symbols occur elsewhere in the verse corpus, and in doing so moves beyond the artificial boundaries that usually surround these texts. Yet since Salvador's study begins from the premise that the Exeter Book was a product of a unified, sexually restrictive church that could not have licensed such erotic content, it displays shades of Tupper's early concern. As such, to be included in that manuscript, the erotic riddles must have reinforced orthodoxy, not challenged it. She concludes that because they would not have been preserved unless they had an identifiably edifying role, this sequence of riddles should be taken as allegorical: 'instead of being regarded as a sample of pornographic material deliberately concealed in the obscure context of a riddle collection, this series could have been designed to be read allegorically, presenting a warning against the dangers of the body, as expressed in Riddle 43'.[16]

What would happen if the formal methods of Stewart and Salvador, which identify a sexual idiom in the erotic riddles, were crossed with the more sexually liberal approaches of scholars like Lerer, Tanke, Smith, Williams and Higley? These texts could then be employed as a kind of laboratory for learning about the conventional language of sex. The 'metaphors and symbols' present in them could potentially provide insight into one way that the Anglo-Saxon literary corpus as a whole encoded sexual content. Freed of the suspicion cast on them by Tupper and others that has led to their isolation, the erotic double entendre riddles, as one of the few places in the corpus where we can be confident that sex is of primary interest, become valuable tools for understanding ways Anglo-Saxon poets had available to them to express erotic material – ways that may not be immediately transparent to the modern reader.

14 Ibid., p. 47.
15 Salvador, 'Key to the Body', p. 63.
16 Ibid.

II

One way that the erotic riddles successfully oscillate between their sexual and non-sexual solutions, as Stewart notes, is by avoiding the mention of body parts that would be unequivocally associated with sexuality. That is, even though Old English has the vocabulary to articulate explicit sexual subject matter, the erotic riddles make no mention of vaginas, breasts, penises, testicles, or any other positively identified sexual organs. The focus of these texts is still firmly on the human body, though: human anatomy features prominently, including body parts such as eyes, heads, thighs and hands. The fundamental ambivalence of these parts makes them prime candidates for sexual euphemism: they can easily skate the territory between the erotic and the mundane. Of these ambivalent parts, the hands – along with individual digits and the actions associated with them, like touching, grabbing and gripping – appear with the greatest frequency, in a total of seven of the erotic riddles: 12, 25, 44, 45, 54, 61 and 63.[17] One explanation for this concentration is simply the literal and metaphorical flexibility of the hands. More so than the other ambivalent anatomical features found in these texts, the hands possess a plasticity that allows them to function in a wide range of contexts, and therefore provides authors a greater freedom to press the limits of erotic double entendre.

Another reason why the hands are especially appropriate in this context is perhaps linked to their use in a group of texts that shares an interest in sexuality: homilies, penitentials and hagiographies, which are concerned with the regulation of lay and clerical sexual activity. As in the erotic riddles, the hands in these overtly restrictive texts are used literally or euphemistically as an operative sexual force. In the *Old English Penitential*, for example, in a section delineating a variety of transgressions committed by young men (*De iuvenis*), there is a canon against masturbation: 'Gyf þes ylca mid his handa hine besmite, fæste XX daga' ('If the same one should sully himself with his hands, he should fast for twenty days').[18] A section concerned with the punishments levelled against priests (*De sacerdotibus*) exhibits a similar use of the hands and of touching in its exploration of sexual offences, such as physical contact with a woman and masturbation:

Sacerd gif he besmiten sy þy ðe he wife onhrine, fæste XL nihta, sume willað XXX . . . Gyf he mid handa hrine, fæste ðreo wucan.[19]

A priest, if he should sully himself by touching a woman, should fast forty

[17] The numbering of the riddles throughout this essay follows that of *The Exeter Book*, ed. G. P. Krapp and E. V. K. Dobbie, *Anglo-Saxon Poetic Records* 3 (New York, 1936).
[18] R. Spindler, *Die altenglische Bussbuch* (Leipzig, 1934), p. 177 at l. 38.
[19] Ibid., p. 178 at ll. 49–54.

nights; some will fast for thirty . . . If he touches himself with hands, he should fast for three weeks.[20]

Specific sexual acts of this kind, while fairly common in penitential texts, are rarely described in saints' lives or homilies, which were intended for a broader audience and had a preventative, not a remedial goal. These texts more frequently employ actions like touching, gripping and grabbing to allude to specific sexual acts or to describe more general states of sexual purity and impurity. In the Old English *Life of St. Mary*, for example, Mary is prompted under duress to make known her virginal state, which she accomplishes with the verb *gretan* (to touch): 'Ne gewurð þæt næfre swa, þæt ic wer grete oððe wer me' ('It never happened as such, that I touched a man or a man me').[21]

The occurrence of *æthrinan* (to touch) later in the same homily provides more evidence of this perceived connection between the act of touching and sex:

Ða wearð æfter þisum mycel hlysa on þan folce, þæt Maria wæs geeacnod. Ða sume dæge namon hine þa þegnas þæs temples and læddon hine to ðam biscope and to þam heahsacerdum and cwædon to him: To hwan forhæle ðu us þine gemænunge swa clænre fæmnan, þe godes englas hy feddan swa swa culfran on þam temple, and heo næfre nolde were æthrinan, ac heo wæs on godes æ seo getydeste fæmne, and gyf ðu nedinga hyre on ne sohtest, þonne wære heo clæne. He ða Iosep hine ladode and cwæð, þæt he hyre næfre ne æthrine.[22]

Then after this there was a great noise from the people, that Mary was pregnant. Then on a certain day the servants took him [Joseph] from the temple and led him to the bishop and the high priests, and said to him: "Why did you hide from us your union with such a pure woman, whom the angels of God fed just like the doves in the temple, so that she would never be touched by a man? But she was in the law of God the cleanest of women, and if you had not sought her out in need, then she would be still be pure." Joseph responded to him and said that he never touched her.

Similar use of words associated with touch as markers of sexual purity occurs elsewhere in this *vita*, and as well in several others.[23]

20 See also F. J. Mone, *Quellen und Forschungen zur Geschichte der teutschen Literatur und Sprache* (Aachen and Leipzig, 1830), p. 520 at canon 127: 'Gyf he gehrine þa breost mid his hand, fæste III wucan' ('If he should touch the breast with the hand, he should fast for three weeks').

21 'Nativity of Mary the Virgin', in *Angelsächsische Homilien und Heiligenleben*, ed. B. Assmann (Darmstadt, 1889; repr. 1964), pp. 117–37 at l. 403.

22 Ibid., ll. 643–60.

23 See also, for example, 'Vitae Patrum', in *Angelsächsische Homilien und Heiligenleben*, ed. Assmann, pp. 195–207 at l. 303: ' "And ic næfre ne geseah hire nacode lichama, ne

Words like *hond* or *folm* (both meaning hand), *finger*, *gripan* (to grip, grasp) and *gretan* (to touch) also proliferate in the erotic riddles, in contexts similar to those found in the prose material just examined. Importantly, these words function as the operative sexual force as well, either initiating or participating actively in the riddle's sexual solution. For example, in Riddle 12, the hand in line 12a functions simultaneously as the agent responsible for cleaning a leather object and, likely, engaging in masturbation with a leather dildo created from the hide of an ox[24]:

> Fotum ic fere, foldan slite,
> grene wongas, þenden ic gæst bere.
> Gif me feorh losað, fæste binde
> swearte Wealas, hwilum sellan men.
> Hwilum ic deorum drincan selle
> beorne of bosme, hwilum mec bryd triedeð
> felawlonc fotum, hwilum feorran broht
> wonfeax Wale wegeð ond þyð,
> dol druncmennen deorcum nihtum,
> wæteð in wætre, wyrmeð hwilum
> fægre to fyre; me on fæðme sticaþ
> hygegalan hond, hwyrfeð geneahhe,
> swifeð me geond sweartne. Saga hwæt ic hatte,
> þe ic lifgende lond reafige
> ond æfter deaþe dryhtum þeowige.[25]

I travel by foot, I tear through the earth, through green plains, while I bear spirit. If life departs from me, I bind dark slaves fast, sometimes better men. Sometimes, from my stomach, I give drink to a bold man; sometimes a haughty young woman treads upon me with feet; sometimes, in dark nights, a dark-haired slave woman, a foolish drunken maid brought from far away, lifts and presses me, wets me in water, sometimes warms me well at the fire; the hand of the wanton one sticks me in a bosom, frequently

ic næfre ne æthran hire nacodum leomum" ' (' "And I never saw her naked body nor ever touched her naked limbs" '); and 'Saint Agnes', in *Ælfric's Lives of Saints*, ed. W. W. Skeat, EETS OS 76, 82, 94, 114 (London, 1881–1900; repr. in 2 vols, 1966), I, 170–94 at ll. 148–52: 'Hi tugon ða þæt mæden to þæra myltestrena huse ac heo gemette þær sona scinende godes encgel swa þæt nan man ne mihte for ðan mycclum leohte hire on beseon oððe hi hreppan for þan þe ðet hus eall scean swa swa sunne on dæg' ('They led that maiden to their brothel, but she soon met there a shining angel of God so that, on account of the great light, no man was able to look upon her or touch her because that house shone just like the sun in the daytime').

24 For a complete exposition of this riddle, see Tanke, 'Wonfeax Wale', and Higley, 'The Wanton Hand'.

25 This and all following citations of the Exeter Book Riddles are taken from *The Exeter Book*, ed. Krapp and Dobbie. Translations from the Old English are my own.

moves me about, swirls me through a dark place. Say what I am called, which alive plunders the land and after death serves men.

The riddle begins with an exploration of the utility of the ox as a plough animal during its life and as leather (in a variety of uses) after its death. Yet with the introduction of the girl in line 8, the tone of the riddle palpably shifts, as the reader begins to learn of another possible use that leather might have, as some kind of masturbatory device. In a departure from the leather's treatment to this point in the riddle, in which its use is described succinctly and without embellishment, the guesser is witness to an elaborate preparation ritual that heightens the possibility of a sexual solution. The object is carried and pressed, wet with water and then warmed by the fire – suspense is built because we still do not know exactly what is going on, unlike in the first half of the riddle where the leather's use was made transparent within one or two half-lines. (Indeed, for this reason, some critics do not recognize Riddle 12 as fully participating in double entendre since its first half is relatively straightforward.) The 'hygegalan hond' ('the hand of the wanton one'), introduced in line 12a is the precipitating agent of three actions that can all be understood as sexual: the penetrative 'sticaþ' ('she sticks') and 'hwyrfeð' ('she moves') and 'swifeð' ('she swirls'), both of which describe the object's movement once it has been inserted.

The female hand serves a similar purpose in Riddle 45, commonly solved as 'dough' and 'penis':

> Ic on wincle gefrægn weaxan nathwæt,
> þindan ond þunian, þecene hebban.
> On þæt banlease bryd grapode,
> hygewlonc hondum, hrægle þeahte
> þrindende þing þeodnes dohtor.

> I heard that something grows in a corner, swells and protrudes; it raises its covering. A young woman grabbed on to that boneless thing, the proud-minded one, with hands. The prince's daughter covered the swelling thing with a garment.

Midway through the riddle there is the introduction of a female character, 'bryd', who grabs on to the thing 'with hands' ('hondum'). The focus on the hands is further amplified by mention of the action associated with them: 'grapode' ('she grabbed'), in 3b. The riddle's sexual alignment is fully realized in these two lines, when the reader learns not just what the object does on its own, but what other people – in this case, a young woman – can do with it when it is brought to hand. The hands or fingers function in a similar capacity in Riddles 54, 61 and 63.

Two more riddles, 25 and 44, use actions associated with the hands in their sexual exposition, as seen in the *Life of St. Mary*. In Riddle 25, for example, 'gripeð' ('she grabs') appears in a prominent position:

Ic eom wunderlicu wiht, wifum on hyhte,
neahbuendum nyt; nængum sceþþe
burgsittendra, nymþe bonan anum.
Staþol min is steapheah, stonde ic on bedde,
neoþan ruh nathwær. Neþeð hwilum
ful cyrtenu ceorles dohtor,
modwlonc meowle, þæt heo on mec gripeð,
ræseð mec on reodne, reafað min heafod,
fegeð mec on fæsten. Feleþ sona
mines gemotes, seo þe mec nearwað,
wif wundenlocc. Wæt bið þæt eage.

I am a marvellous creature, a joy to women, useful to neighbours. I
harm no village-dweller except my slayer alone. My base is high; I
stand on a bed, shaggy somewhere underneath. Sometimes a very
comely churl's daughter, a proud woman, ventures to grab onto
me, rush upon me in pleasure, ravage my head, fix me in a fast-
ness. She who confines me, the woman with woven hair, soon
feels the meeting – that eye is wet.

The opening lines of this riddle offer a general description of the unnamed
object's physical characteristics and its relationship to those with which it
comes in contact. The reader's expectation of a sexual solution builds slowly,
perhaps piqued by the phrase 'wifum on hyhte' ('a joy to women') and the
metaphorical slaying in lines 2b–3, and then strengthened upon learning of
the object's shaggy base and its proximity to a bed. With the introduction of
the 'ceorles dohtor' in line 6b, however, the pace of the riddle quickens
considerably and its sexual potential becomes clearer. The arrival of this
figure corresponds with the beginning of a frenzy of activity that has until
this point only been hinted at. In marked contrast to the predominantly
intransitive and copular verbs of the first four and a half lines, a series of tran-
sitive verbs follows in rapid succession beginning in line 7b, which together
describe the variety of actions the woman performs with the object and the
result of her experience with it: 'gripeð' ('grips'), 'ræseð' ('rushes'), 'reafað'
('ravishes'), 'fegeð' ('fixes'), 'feleþ' ('feels') and 'nearwað' ('confines'). This
delayed but eagerly anticipated activity bursts out in a great rush, leaving
little doubt as to the sexual solution of the riddle.

The action that initiates this flurry of motion and sensation is 'gripeð' ('she
grips/grabs onto') in line 7b. Grabbing the object is the physical deed that
allows more intimate, suggestive activities to occur later in the riddle. With
the object in hand, the woman is able to manipulate it to enact the motions
described in the lines that follow; the presence of this manual activity brings
the sexual nature of the solution into sharp focus. It is important to note that
none of the potentially sexual actions described necessarily requires an overt
statement of manual contact for their realization; little of the riddle's meaning
would be lost if line 7b were not there. But the presence of 'gripeð' in this

prominent position, at the turning point in the exposition of the riddle's sexual solution, mirrors the practice of other erotic riddles, where words in this class also trigger or enable the activities crucial to the development of the sexual answer. Riddle 44, for example, which is commonly solved as 'key' or 'penis', employs the verb *gretan* (to touch) in an equally important position: 'wile þæt cuþe hol / mid his hangellan heafde gretan / þæt he efenlang ær oft gefylde' (5b–7; 'he wishes to touch with the head of his hanging thing that well-known hole, which he has often filled before in equal measure').

III

The erotic riddles appear to participate in a sexual idiom that is not unique to that group, as evidence from the homiletic, hagiographic and penitential records suggests. It stands to reason, then, that other works of Old English literature might employ that idiom as well, including verse, which, as discussed in the introduction to this essay, has resisted modern inquiries into its use of sexual content. Certainly, no other poem or group of poems in the verse corpus addresses sex as openly as the erotic riddles do. But using the hands and actions associated with them as an index of sexual potential can offer a new lens for reading poetry. There is, for example, a section of *Beowulf* that some have already recognized as possibly having erotic connotation: the episode narrating the fight between Beowulf and Grendel's mother. Jane Chance has provided one of the most thorough and effective analyses of the erotic potential of this passage by demonstrating how the poet 'exploits the basic resemblance between sexual intercourse and battle to emphasize the inversion of the feminine role of the queen or hall-ruler by Grendel's Mother'.[26] In the end, Chance interprets Grendel's mother as a parody or perversion of the 'woman as peace-weaver' topos found in other poems – including *Beowulf*'s Wealtheow and Hygd – which narrowly circumscribes their behaviour. This entire episode, then, with its portrayal of a monstrous woman as a martial and at least metaphorically sexual aggressor, can be read as an expression of anxiety about untamed, unconstrained female sexuality that is ultimately resolved by the reassertion of masculine dominance through penetration.[27]

The circumstances and events of this episode all suggest the potential for an erotic reading: the presence of two gendered beings, male and female; the

26 J. Chance, *Woman as Hero in Old English Literature* (Syracuse, 1986), p. 102.

27 Even the setting of the encounter takes on sexual significance. Of this, Chance writes: 'And even the mere itself, in whose stirred-up and bloody waters sea monsters lurk and the strange battle-hall remains hidden, and the approach to which occurs only through winding passageways, slopes, and paths, symbolically projects the mystery and danger of female sexuality run rampant.' Ibid., pp. 103–4.

intensely physical nature of the combat they engage in, including full-contact wrestling; and the culmination of the mêlée with the piercing through of Grendel's mother by Beowulf's new-found (and newly bloodied) sword. Since it appears to operate in at least two areas, the sexual and the non-sexual, this section of the poem can be read as a lengthy erotic double entendre riddle fused into a longer narrative poem. And the diction of the passage demonstrates an affinity with the other, more overtly enigmatic erotic riddles of the Exeter Book. The hands and actions like gripping and grabbing occur throughout this passage, and are used in similar ways as they are in the erotic riddles: initiating or participating in potentially sexual activities. The first five lines, for example, which describe the first meeting of Grendel's mother and Beowulf, contain a cluster of four words associated with touching: 'grap', 'gefeng', 'clommum', and 'fingrum':

> Grap þa togeanes, guðrinc gefeng
> atolan clommum; no þy ær in gescod
> halan lice; hring utan ymbbearh,
> þæt heo þone fyrdhom ðurhfon ne mihte,
> locene leoðosyrcan laþan fingrum.[28] (1501–5)

> Then she grasped towards him, seized the battle-warrior with terrible grips, but none the sooner harmed the healthy body: rings surrounded him from without so that she was not able to pierce the armour, the locked mailcoat, with hostile fingers.

As in the erotic riddles, the reader's gaze is led away from the total body and encouraged instead to attend to its parts. The monster's physical form is blurred here as the narrator concentrates on the monster's manual activity – especially her desire to grasp and grip – and on the instruments responsible for these actions. Even her initial approach to the warrior is described in manual terms: 'she grasped towards him'. This curious description of the monster's locomotion draws the reader's attention straight to the monster's hands, which retain the narrative focus for the remainder of the passage. In these last lines Grendel's mother seizes Beowulf ('gefeng') and grabs onto him with 'terrible grips' ('atolan clommum'); she then attempts to penetrate Beowulf's mailcoat with her fingers ('fingrum'). In this last part, the affinity with the idiom of the erotic riddles is most clear: in Riddles 12 and 44, for instance, we find similar penetrative attempts by, or at least enabled by, the hands of the sexual agents of the poems.

This focus on Grendel's mother's hands continues as the fight progresses: 'heo him eft hraþe handlean forgeald / grimman grapum on him togeanes feng' (1541–2; 'she quickly gave him back a hand-gift, seized toward him

[28] All *Beowulf* citations are from *Beowulf and The Fight at Finnsburg*, ed. F. Klaeber, 3rd edn (Boston, 1950); translations are my own.

with fierce grips'). Here we find three words related to the hands – 'handlean' ('hand-gift'), 'grapum' ('with grips') and 'feng' ('seized') – all of which sustain the interest in manual imagery that began in line 1501. The second two words, 'grapum' and 'feng', do not pose much interpretive difficulty. The compound 'handlean', however, is most often translated as simply its second element, 'requital', with the 'hand' aspect disregarded. Yet in the context of this fight, perhaps reference to the hands is not out of place, and a more appropriate translation would incorporate both aspects of the compound, such as 'hand-gift'.

In line 1557, the perspective shifts from the monster to Beowulf as he first begins to even the fight before finally overpowering his adversary. Despite the change in narrative focus, though, hands remain at the centre of the conflict:

> He gefeng þa fetelhilt, freca Scyldinga
> hreoh ond heorogrim hringmæl gebrægd
> aldres orwena, yrringa sloh
> þæt hire wið halse heard grapode,
> banhringas bræc; bil eal ðurhwod
> fægne flæschoman; heo on flet gecrong;
> sweord wæs swatig; secg weorce gefeh. (1563–9)

> He seized the belted hilt, the warrior of the Scyldings, fierce and savage, swung the ringed sword without regard for life, angrily struck so that the cruel blade reached through her neck, broke joints; the sword pierced completely through the doomed body; she fell on the ground; the sword was wet with blood; the man rejoiced that deed.

Beowulf seizes ('gefeng') the hilt of the giant's sword in line 1563a before striking through the neck of Grendel's mother and ending the battle. This final strike is described in manual terms – 'grapode' – even though the verb appears out of place in this section, which clearly describes a striking, penetrative motion. And indeed, translators and editors of the poem typically define 'grapode' as 'struck', 'bit' or some other action that captures the nature of the attack. However, recognizing the hands and their actions as important elements of a sexual idiom provides modern readers with an interpretation of this passage. While Chance identifies the physical potential of the hands as sexual agents here, she does so only insofar as they might actually be used in sexual acts.[29] She does not recognize them as part of a larger system, though taken as such they could carry even more dangerous, transgressive weight than she realizes, adding yet more strength to her already persuasive argument.

[29] Chance, *Woman as Hero*, p. 102.

In the riddles, sex is clearly a primary subject; likewise, it is not difficult to imagine that eroticism may be present in a passage such as the one just examined, where physical struggles of two sexed beings feature so prominently. But the examination of words associated with the hands as initiating potentially sexual activities leads the reader to a number of places where the external trappings of such activity are absent, and yet the evocation of sexuality does not seem out of place. Take for example another passage from *Beowulf*, which recounts Grendel's entrance into Heorot on the night following Beowulf's arrival in Denmark:

> Com þa to recede rinc siðian
> dreamum bedæled. Duru sona onarn
> fyrbendum fæst, syþðan he hire folmum æthran;
> onbræd þa bealohydig, ða he gebolgen wæs,
> recedes muþan. (720–4a)

> The warrior came journeying to the hall, separated from joys. The door, fastened with iron-forged bands, opened suddenly after he touched it with his hands; the evil-minded one, while he was angry, then swung open the mouth of the hall.

Grendel's invasion of the hall marks a turning point in the poem, acting simultaneously as the end of the monster's suspenseful and terrifyingly slow introduction into the narrative, and as the beginning of a vicious blood feud that dominates the poem's next 800 lines. Grendel's violent and rapacious bearing has been clearly established. In earlier passages, for example, he is described, albeit at second hand, as having ravaged the hall and mauled its inhabitants. The manner of entry described in these lines, then, seems curious. Rather than smash his way in, as might be expected, Grendel simply touched ('æthran') the door with his hands ('folmum'). This single touch triggers its opening and allows him to enter the hall, where he becomes both instigator and victim of horrific violence. The narrative impact of this passage would be substantial regardless; understanding the collocation of manual words and penetration as a feature of a sexual idiom provides a richer way of reading, however. By employing words like *folm* (hand) and *æthrinan* (to touch) to describe a critical and explicitly penetrative moment in the poem, the poet finds a way to amplify its nearly palpable tension. This passage's participation in the sexual idiom can be further identified by its conspicuous use of an anatomical metaphor to describe the door: *recedes muð*, 'the mouth of the hall'. Ascribing metaphorical life to the non-living is one technique frequently employed in the erotic double entendre riddles, one that allows them to shift between their multiple solutions. The *Beowulf* poet taps into the power of eroticized language – used elsewhere in the literary corpus to titillate, to challenge orthodoxy, to transgress – in this provocative passage to emphasize Grendel's violation of the presumed sanctity of Hrothgar's hall.

A passage in *Genesis B*, an Old English verse retelling of the fall of Man, offers another glimpse of the use to which the sexual idiom was put. In the depiction of the moment when Adam succumbs to temptation and eats the apple – a moment of undeniable crisis in both the narrative and, of course, in the history of Judeo-Christian religion – the narrator stresses above all the corporeal internalization of the fruit:

> hit wæs þeah deaðes swefn and deofles gespon,
> hell and hinnsið and hæleða forlor,
> menniscra morð þæt hie to mete dædon,
> ofet unfæle swa hit him on innan com,
> hran æt heortan.[30] (720–4a)

> It was nevertheless a dream of death and the devil's deceit, hell and death and the loss of men, the death of humankind that they made as their food, the unholy fruit, as it came into his innards, touched him at heart.

The fruit entered into Adam – 'hit him on innan com' – and touched him, 'hran', at the heart. The poet describes a visceral act of penetration in these lines, of the movement of the apple from without to within. And he describes the culmination of that penetrative act with a verb of touching – 'hran', past tense of the infinitive *hrinan*. There is no overtly sexual act of entry here. However, the collocation of the act of penetration, manual symbol, and the evocation of the interior of the human body by mention of its heart, evoke sex just as they did, more obviously, in the riddles. The eroticized connotation of the verb *hrinan* lends affective weight to this already weighty occasion. Additionally, one consequence of Adam's consuming the fruit is the introduction of carnality into his relationship with Eve. The collocation of penetration and touch, just as in the eroticized battle between Grendel's mother and Beowulf, sets off a number of potentially sexual references. For example, following this passage the narrator emphasizes the human, corporeal aspect of their relationship, referring to them twice as 'sinhiwan' ('a married couple'; 778a, 789b). In addition, the narrator makes several references to their newly recognized nudity and their concomitant desire to cover their newly sexed bodies. This is done, however, without explicit detail. Such detail would perhaps be out of place in this, or, as we have seen, in almost any poem. The subtly eroticized touch, however, serves as a powerfully evocative surrogate.

What is it about sex that would make the *Beowulf* and *Genesis B* poets want to work it covertly into their texts? What is the nature of the affective power it seems to produce? It is certainly likely that the absence of obvious representations of sexual activity in Old English verse would make auditors of that verse especially sensitive to any suggestion of sexuality. This would make its

[30] *The Saxon Genesis*, ed. A. N. Doane (Madison, 1991).

unlikely, though still conventional, appearance in these poems all the more affecting. The Church's outward prohibition against most forms of sexual expression is surely one motivation for incorporating it more subtly into works of literature. Thus, invoking sex at all in this officially repressive culture may have added some rebellious charge to their work as well. Regardless of the answers to these questions, the narrative prominence of the passages surveyed suggests that poets did not employ sexual language lightly: occurrences of it appear during heated and intensely personal battles, physical in *Beowulf*, moral and spiritual in *Genesis B*.

In order to explore the possible meanings of this idiom, however, we must first continue to challenge our understanding of the interrelatedness of Old English literature. The boundaries that surround the erotic riddles – artificial boundaries established by modern critics because of those riddles' perceived obscenity – have obscured important connections among Old English texts. By pushing beyond these boundaries and challenging accepted notions of Anglo-Saxon literary history, it becomes possible to appreciate with greater subtlety the craftsmanship of Old English literature. We see that the sexuality that tempts critics to set the erotic riddles apart is actually a point of contact. Recognizing this connection allows us to challenge our conception of the ways that Anglo-Saxons wrote about, and perhaps understood, their experience with sex. This supposedly demure literature may have more to say about the sexual body than we thought.[31]

[31] I would like to thank Nicola McDonald, Elizabeth Tyler and Mary Blockley for their generous and insightful comments on early drafts of this essay.

4

Representing Obscene Sound

Emma Dillon

My exploration of obscene sound begins in an unlikely place: a locus of eerie silence.[1] This mute soundscape is all the more surprising as it is host to a detailed, even excessive, performance of medieval obscenity. The action occurs deep in the infernal world of the *Divina commedia*, in a demon-packed enclave of Malebolge. As Dante and Virgil trudge along the ridges of that pitiful valley, winged devils flit back and forth transporting sinners into a cauldron of bubbling tar. Other demons loiter at the rim clutching pronged forks, prodding at the buttocks to push them back under the sticky surface:

> Non altrimenti i cuoci a' lor vassalli
> fanno attuffare in mezzo la caldaia
> la carne con li uncin, perché non galli. (*Inferno* XXI.55–7)

> Just as cooks made their scullions plunge the meat down into the
> cauldron with their forks, that it may not float.[2]

As with so many scenes in *Inferno*, the reader is assaulted by a kind of visual overload: seen through the eyes of the watchful Dante, the offensive abundance of suffering and debasement translates into language that is grotesquely swollen in detail, the poet piling simile upon simile, metaphor upon metaphor, to find, in literary surplus, an equivalence for the excess of the spectacle.

The pictorial detail that Dante furnishes, however, is miraculous given that the pilgrim's first impressions, noted in the opening lines of the Canto, are of darkness: 'e vidila mirabilmente oscura' ('I saw it strangely dark'),[3] he

1 I wish to thank Caroline Walker Bynum, Vahni Capildeo, Cynthia Hahn, Roger Parker
 and Gary Tomlinson for their many insightful comments and suggestions as this essay
 took shape. It was written while I was a member of the Institute for Advanced Study in
 Princeton, 2003–4, and I warmly thank the Institute for its support.
2 Quoting translation and edition from Dante Alighieri, *The Divine Comedy*, trans. with
 commentary by C. Singleton, 6 vols, Bollingen Series 80, 7th edn (Princeton, 1989).
3 *Inferno* XXI.6.

tells us. It is thus even more curious that, according to the poet's account, Malebolge is, with one memorable exception, silent. Sound is only implied: a soundtrack the reader might supply to the eminently audible sights (the beating of the air by the winged devils; the jostling crowds around the cauldron; and the screams of the sinners). Only in the very last lines of the Canto, as the devils themselves are caught in a moment of aural suspense, is Dante forced to listen. As the demonic army readies itself for another hunting expedition to seek out straggler souls, they fall silent, sticking their tongues between their gnashing teeth, waiting for the signal to advance. And for a brief moment we join the congregation, pilgrim and guide, and listen intently to the text:

> Per l'argine sinistro volta dienno;
> ma prima avea ciascun la lingua stretta
> coi dentri, verso lor duca, per cenno;
> ed elli avea del cul fatto trombetta. (*Inferno* XXI.136–9)

> They wheeled round by the bank on the left, but first each pressed his tongue between his teeth at their leader for a signal, and he had made a trumpet of his ass.

Dante's dirty devil seems to furnish us, finally, with the perfect soundtrack to the depravity of Malebolge. Yet the sound dies no sooner than it begins to reverberate in the text. The very next lines, the opening to Canto XXII, begin not with an account of what Dante heard, but rather with what he saw. 'Io vidi', begins Dante, as he embarks on a lengthy comparison, contrasting the trumpet-bottom of the devil with all the other strange signals he has seen (not heard) on his travels in the 'real' world:

> Io vidi già cavalier muover campo,
> e cominciare stormo e far lor mostra,
> e talvolta partir per loro scampo;
> corridor vidi per la terra vostra,
> o Aretini, e vidi gir gualdane,
> fedir torneamenti e correr giostra;
> quando con trombe, e quando con campane,
> con tamburi e con cenni di castella,
> e con cose nostrali e con istrane;
> né già con sì diversa cennamella
> cavalier vidi muover né pedoni,
> né nave a segno di terra o di stella. (*Inferno* XXII.1–12)

> Ere now have I seen horsemen moving camp, and beginning an assault and making their muster, and sometimes retiring to escape; I have seen coursers over your land, O Aretines, and I have seen the starting of raids, the onset of tournaments, and the running of jousts, now with trumpets and now with bells, with

drums and castle-signals, with native things and foreign – but never to so strange a pipe have I seen horsemen or footmen set forth, or ship by sign of land or star!

Concerned with what his eyes have seen (underscored by the echoing 'vidi'), Dante never refers to what he and the devils heard in that dark valley. As we press the text further, ask it to yield up its sound (however gross), it retreats into silence.

What are we to make of so determined an evasion? Why did Dante so stubbornly strain his eyes in the obscurity, when his ears would have been more ready witnesses to the catastrophes around him? Even though the poet's efforts to suppress sound seem deliberate, I do not think his intention was consciously proselytizing: there is little theoretical support to suggest the poet was responding to a formal dictum about sonic taboos. Instead, I would like to allow Dante's devil to sketch for us a much less contrived, more unpredictable story about the sound of obscenity in the later Middle Ages; and about the very category of obscenity itself. First, Dante's peculiar deafness throughout the Canto may be interpreted as an ingenious rehearsal of the most pervasive (and stable) definition of obscenity: or rather its effects – offence; repulsion.[4] That the two witnesses did indeed find the torments of Malebolge offensive is confirmed in Virgil's words of comfort to his frightened ward: 'e per nulla *offension* che mi sia fatta, / non temer tu' ('and whatever *offence* is done to me, do not be afraid').[5] Might we not then read Dante's refusal to represent *any* sound in this horrifying valley – and in the wake of aural assaults earlier in *Inferno* that, as shall later see, leave the pilgrim trembling and weeping – as the quintessential response to obscenity: a fearful, quiet recoiling from what so deeply offends?

The story of sound in Canto XXI underscores a second feature of the discourse, one unique to sound: namely, the precariousness of obscene sound. As we shall see, sounds that are out of the ordinary, that surpass convention and expectation, and, more specifically, that surpass musical expectation, have the most power to offend or shock. And the problem with such sounds is also, invariably, the near impossibility of representing them. If they eschew a conventional system of musical notation, it falls to words or images to preserve their traces: and as they materialize into representation (in word, in image), they are also frequently soundproofed in accounts that seek to visualize their effects rather than to reproduce their resonances. Furthermore, an attendant characteristic of these sounds is their complicated, often

4 The *Oxford English Dictionary*'s comprehensive overview of the history of the word 'obscene' characterizes one of its most stable meanings thus: 'offensively or grossly indecent, lewd . . . tending to deprave and corrupt those who are likely to read, see, or hear the contents'.
5 *Inferno* XXI.61–2.

57

antithetical and sometimes offensive relationship to 'music': that is, the notated, notatable repertories, endorsed by theorists and codified in the great *chansonniers* of the period. What is (not) heard in Malebolge is thus one component of a fragile part of the sound spectrum – sounds that, in conventional approaches to the past, we rarely listen for, and thus, when Dante's devil produces that nether trumpet, the sound he will produce is, of course, anything *but* musical.

Before we venture further into these risky and unstable soundworlds, I must comment briefly on the place of those more traditional musical categories in the culture of the obscene. For the relatively small space for song in my discussion seems at odds with modern representations of the past, from Orff's famous recasting of *Carmina burana* to cinematic legends such as *Excalibur* (with its fantasy mix of Orff, Wagner and medieval pastiche soundtrack), that have led us to believe in a culture ever ready for a medley of noisy, bawdy song. Such songs certainly existed. Indeed, many sources for civic unrest or liturgical parody cite 'obscene' or 'lewd' song as one of many obscene offences[6]; the gluttonous and sexually explicit lyrics of the *Carmina* may be highly stylized remnants of a living tradition hinted at in those documents.[7] But it is notoriously difficult to pinpoint ways in which *melody* can be obscene, or indeed, in which it can *represent* anything concrete.[8] That time-old question is, moreover, complicated by the fact that many obscene lyrics are

6 Fourteenth- and early fifteenth-century accounts of *charivari*, for instance, the raucous parade of masked, noisy citizens protesting dubious martial unions, include allusions to 'bruits scandaleux', 'injurias, carmina, libellos diffamatorius' and 'obscoena loquacitate'. See F. Lebrun, 'Le Charivari à travers les condemnations des autorités ecclésiastiques en France du XIVe au XVIIIe siècle', in *Le Charivari: Actes de la table ronde organisée à Paris (25–27 avril 1977) par l'Ecole des Hautes Etudes en Sciences Sociales et le Centre National de la Recherche Scientifique*, ed. J. Le Goff and J. Schmitt (Paris, 1981), pp. 221–8.

7 The *carmina*, containing both Latin and German lyrics, survive in an early thirteenth-century manuscript, thought to originate either in Seckau or the Tyrol. For a complete facsimile, see *Carmina burana*, ed. B. Bischoff (Brooklyn NY, 1967); for a modern edition, see *Carmina burana*, ed. A. Hilka and O. Schumann, continued by B. Bischoff (Heidelberg, 1930–70); and for an edition with English translation of the lyrics, see *Love Lyrics from the Carmina Burana*, ed. P. G. Walsh (Chapel Hill NC, 1993). For a useful outline of the tradition of secular Latin song, including the so-called goliard repertories best known for their controversial, often obscene lyrics, see G. A. Anderson and T. Payne, 'Early Latin Secular Song', in *New Grove Dictionary of Music and Musicians*, ed. S. Sadie, 20 vols, 2nd edn (London, 2001), VII, 828–30. An excellent comprehensive account of medieval song remains J. Stevens, *Words and Music in the Middle Ages: Song, Narrative, Dance and Drama, 1050–1350* (Oxford, 1986).

8 For a discussion of melodic expressivity and meaning in medieval song, see Stevens, *Words and Music in the Middle Ages*, pp. 372–409. The question of how melody can represent verbal meaning is also addressed in Bruce Holsinger's recent re-evaluation of the songs of Hildegard of Bingen: see B. Holsinger, *Music, Body, and Desire in Medieval Culture: Hildegard of Bingen to Chaucer* (Stanford, 2001), pp. 87–136.

set to old melodies, borrowed from the vast repertory of sacred song, a form of recycling that clearly demonstrates that there was no agreed musical 'style' serving obscene lyrics.[9] Certainly, the convention of contrafacting melodies may open up a potentially paradoxical relationship between a mobile melody and its multiple texts: there is ample evidence to suggest medieval music-makers delighted in playing the memory of a text that had once been there with the meaning of the new text that took its place, with often parodic, sometimes obscene effects.[10] But these, again, are textually driven instances of obscenity. In such cases, the music, far from being offensive, is more likely deployed as a stabilizing force, serving as a mnemonic frame in which to cast and easily recall shocking new lyrics. Thus, although medieval songs may seem a more immediate and audible way to recuperate the sound of the obscene, and while they may tell us a great deal about the *poetic* tradition of the obscene, they are however more reticent about *sound's* potential to truly unsettle and shock.

In pursuing sonic obscenity at the periphery of musical category, I should like in what follows to focus on two recurring and related themes. The first concerns the problem of representation: partial though the traces of obscene sound may be, they nonetheless have crucial things to impart about the very nature of representation, or, rather, about its limitations, contrived and literal. While in one sense the problems of representing obscene sound can be attributed to the limitations of a notational system (that is, a system exclusive to pitched sounds), I will suggest that the challenge to make sound concrete simultaneously marks an opportunity to experiment with musical category and with the contours of material production of sound. The possibility that writers, artists and music-makers were, in tackling the challenge of representing the unrepresentable, experimenting with the potentialities of their media is all the more pertinent in the period leading up to Dante's infernal creation. For the mid twelfth to the fourteenth centuries, in France, and later in Italy, are well-known as a period of intense innovation and rumination in the realms of poetry and music. This was a time when artists famously redefined the technical and aesthetic boundaries of their materials: in poetry, with the authorizing of new vernacular literary traditions; in music, not least with the creation of more prescriptive systems of modal and mensural musical

[9] Several songs from the *Carmina burana*, for instance, derive their melodies from pre-existent St Martial and Notre Dame repertories.

[10] A common site for such play was in the polytextual thirteenth-century French motet, a genre famous for its experimentation with parody and allegory, often setting Latin devotional texts against sometimes risky or controversial courtly love lyrics. It was also a genre well-known for its relentless musical and textual recycling, and there are several cases where composer/poets appear to overwrite courtly lyrics with Latin devotional lyrics or vice versa. For an in-depth exploration of the kinds of textual play possible in the form, see S. Huot, *Allegorical Play in the Old French Motet: The Sacred and the Profane in Thirteenth-Century Polyphony* (Stanford, 1997).

notation. It is thus possible that as well as harnessing the expressive power of sonic offence, artists used the topic of obscenity to push themselves to define and critique the very materials through which they were creative.

The second tale I wish to tell is born of a desire to find other ways of connecting with what is no longer there: the original sounds around which the broader discourses of medieval obscenity entwine themselves. If obscene sound, its transmission from resonance to record, and its function within a given artistic context, can reveal insights into later medieval attitudes towards artistic production, I believe that the category of obscenity itself can help us to understand better the primary experience of sound's capacity to shock and disturb. We will thus also consider more closely an aspect of medieval obscenity that has received relatively little attention: namely, how medievals defined obscenity in a more experiential sense, as a series of emotional or sensual excesses. In the discourse of obscenity into which abstract sound was imported and made to signify, we may find a concrete and vivid vocabulary of human emotion and sensation to help us explain how medievals experienced their more extreme sounding worlds. Just as it silences sound in transmission, so, I will suggest, does the category of obscenity open our ears a little wider, to catch hints of a much more complicated and emotive sound world than we more normally imagine.

Contexts for obscenity

By way of establishing a broader context in which to explore sound, I need to address some fundamental questions about the nature of obscenity in the medieval period. What signified as obscene in the period leading up to Dante? If medieval and modern writers alike found consensus on the *effects* of the obscene – offence, outrage, shock – the *causes*, beyond a general sense of sexual or scatological excess, of sensual extremes such as pain, are much more fluid. Indeed, the most recent interdisciplinary treatment of the topic, far from reaching firm conclusions about medieval definitions of the obscene, rather emphasizes richly diverse meanings and functions the shocking could serve.[11] For example, James Brundage's exploration of censorship of the lascivious or sexually risky in canon law consistently applies the classification of 'obscene' to behaviour for which he openly admits there is no medieval category. For Brundage, 'obscenity and pornography (a subset of obscenity) exist in the mind of the beholder' and thus 'since the limits of what is acceptable or tasteful vary substantially from one observer to the next, defi-

[11] See J. Ziolkowski, 'Introduction', in *Obscenity: Social Control and Artistic Creation in the European Middle Ages*, ed. J. Ziolkowski (Leiden, 1998), pp. 3–18.

nitions of obscenity and pornography must necessarily be vague, fuzzy, and susceptible of a wide range of interpretations'.[12]

By contrast, Michael Camille's essay on visual censorship in the later Middle Age understands obscenity as a universal, borrowing from the concept of Mary Caputi: it is 'the violation of boundaries, the exceeding of subconscious consensual limits'. For Camille, the art historian's job is to trace how these boundaries change over time, and 'to be sensitive not only to what is made visible and represented but also to what has been obfuscated, effaced, and rejected as overstepping the bounds of what it is permissible to picture'.[13] We thus encounter a problem: if medieval writers, artists and law-makers rarely themselves defined 'obscena' as a category or genre and never sought to control it through established law, can we approach the bawdier, more shocking remnants of the past as part of a contrived discourse?[14] Is it possible – or indeed useful – to explore obscenity as a category in the Middle Ages?

There are a couple of ways to recuperate a more precisely medieval sense of the obscene, and, not only that, to see how, for medieval writers and artists in particular, the more shocking aspects of their culture could be deployed for specific and repeatable effect. One approach, as Camille suggests, is to understand obscenity as a universal function: the offensive working in opposition to the acceptable – as one writer puts it, as 'counter-code to wherever orthodoxy prevails'[15] – thus, in a sense, helping to make apparent the orthodox. There are ample examples to support that view. For example, the liturgy for the Feast of Fools, abounding with lewd and dissolute behaviour, prescribes the very kinds of antics ecclesiastical authorities so vehemently tried to forbid in the liturgy 'proper'[16]; or *charivari*, which one writer describes as 'an

12 J. Brundage, 'Obscene and Lascivious: Behavioral Obscenity in Canon Law', in *Obscenity*, ed. Ziolkowski, pp. 246–59 (p. 246, n. 2).

13 M. Camille, 'Obscenity Under Erasure: Censorship in Medieval Illuminated Manuscripts', in *Obscenity*, ed. Ziolkowski, pp. 139–54 (p. 139); and quoting M. Caputi, *Voluptuous Yearnings: A Feminist Theory of the Obscene* (Lanham MD, 1994), p. 5.

14 A. Minnis's essay in this volume suggests that glosses and etymologies may offer valuable information about medieval attitudes and understandings of the word 'obscena', even though those definitions as yet did not amount to a standardized or enforceable definition.

15 R. Hartogs and H. Fantel, *Four-Letter Word Games: The Psychology of Obscenity* (New York, 1967), p. 20, quoted here from Ziolkowski, 'Introduction', in *Obscenity*, ed. Ziolkowski, p. 4.

16 The ritual took place on 1 January, with the tradition thought to spring in part from older pagan practices celebrating the god Janus, and the arrival of the New Year. Early accounts of the ritual at the cathedral of Notre Dame in Paris date from the twelfth century and persist well into the fifteenth century. Accounts report the donning of masks, cross-dressing, playing dice at the altar, singing lewd songs and an abundance of 'indecent' gestures. For a detailed account, including translations of several contemporary reports of the ritual, see C. Wright, *Music and Ceremony at Notre Dame of Paris, 500–1550* (Cambridge, 1989), pp. 237–43.

ordered representation of disorder'.[17] In these instances, sexual and scatological excess are used to protest, but ultimately to reinforce, specifically medieval institutions and ideologies.

In the century before Dante, one still more uniquely medieval rendition of obscenity as boundary-tester emerged, in the domain of language and artistic production. If medievals (building on classical models) did not regard sexual organs or the sexual act as intrinsically obscene, they worried considerably about their representation. There were dangers in making sex public in language and performance, not least because of the possibility that it might excite audiences to lewdness.[18] The debates over what sexual vocabulary was permissible moreover intensified in the twelfth and thirteenth centuries with the emergence of new vernacular literary culture, reaching its apotheosis, perhaps, in the famous *querelle* of the *Roman de la Rose*, and its relentless and scandalous naming of testicles in the mock-disputation of the appropriateness of their naming in language.[19]

By extension, obscenity was used to explore the frontiers of literary genre itself. The thirteenth-century comedic genre of fabliaux offers perhaps the most memorable example. The poems were rampantly obscene, obsessively representing the bawdy and crude, with common themes being prostitution, sex, tricks and deception, so much so that their nineteenth-century editors dismissed them as the pornographic outbursts of the 'primitive' past. But a more nuanced reading suggests sexual or scatological outrage was not intended as a politicized breaking of taboos, but was rather a means of exploring the possibilities of literary representation and narrative. R. Howard Bloch's reading of a poem such as *De la damoisele*,[20] in which direct sexual reference is supplanted by an outpouring of bawdy innuendo, posits the poem as a precocious linguistic experiment to conjure euphemism and metaphor so that, albeit sex is never actually named in the poem, it saturates each line. The poem, Bloch concludes, is about narrative desire, rather than the shocking referent: 'The preoccupation with sexual members is at once the product of and a fascination with narrative and not its referent.'[21] Many other

[17] C. Karnoouh, 'Le charivari ou l'hypothèse de la monogamie', in *Le Charivari*, ed. Le Goff and Schmitt, pp. 33–43 (p. 38).

[18] On which see J. Ziolkowski, 'Obscenity in the Latin Grammatical and Rhetorical Tradition', in *Obscenity*, ed. Ziolkowski, pp. 41–59.

[19] There are several recent studies of this phenomenon. See, for example, R. Howard Bloch's work on the fabliaux, where he argues the fluid boundaries between eroticism and obscene diction are symptomatic of obscenity's proximity to lust and desire: 'Modest Maids and Modified Nouns: Obscenity in the Fabliaux', in *Obscenity*, ed. Ziolkowski, pp. 293–307 (especially pp. 297–9). For a useful outline of the *querelle*, and its reception among later medieval writers, see D. Robinson, *A Preface to Chaucer: Medieval Perspectives* (Princeton, 1962), pp. 361–3.

[20] Bloch works from *Recueil général et complet des fabliaux des XIIIe et XIVe siècles*, ed. A. de Courde de Montaiglon and G. Raynaud, 6 vols (Paris, 1872–90), V.

[21] R. Howard Bloch, *The Scandal of the Fabliaux* (Chicago, 1986), p. 90. For an alternative

literary genres – from the retexting of troubadour lyrics with the antithesis of courtly diction, to the scatological outbreaks in genres such as *fatras* and *fatrasie* – testify to a growing role of obscenity in poetry's self-conscious critique of the manner and matter of its production.

Thinking about obscenity as function – the ethical foil to the accepted – and particularly in contexts of artistic production, is thus one framework in which we might approach sounds that shock. But there is a second, more experiential approach to obscenity I would also like to suggest. Surprisingly, perhaps, obscenity is rarely thought about for the potency of the sensations or emotions it provoked – as lived, human experience. Although, as Minnis demonstrates in this volume, writers occasionally glossed the word 'obscena', such glosses were relatively rare, and, outside that tradition, there is little evidence of a systematic or continuous tradition of writing about obscenity. This may suggest that the sensational, felt dimensions of the discourse were rarely consciously defined and ruminated upon, and are thus inaccessible from our much later vantage point. However, traces of obscenity's primary powers may linger in the uses to which the word itself was put. For the term 'obscena' was extremely mobile, cropping up incidentally, to lend drama and rhetorical weight to descriptive writing. On its journey as semantic adjunct to arguments whose emphasis lay perhaps elsewhere, we get the sharpest sense of how medievals might have *felt* things to be obscene.

It will be helpful to illustrate obscenity's semantic life with some specific examples. Familiar hosts to recurring use of the term are the myriad sermons, spiritual handbooks and polemics of the Middle Ages, places in which anxieties about sexuality and bodilyness – the most obvious recurring topos of obscenity – were commonplace. They demonstrate vividly the emotional and physical spectrum of its meaning. I quote here from two famous Cistercians, Bernard of Clairvaux and his follower, Aelred of Rievaulx. I select them first, for chronological reasons: both write in the middle to third quarter of the twelfth century, thus casting a shadow over the period with which I am primarily interested from a sonic perspective. In addition, both are writing within a context of anxious reform, an attempt to curb monastic offences, and with a fervent desire to convert their brothers to a more righteous model of devotion and belief. Both, then, seek to create a new monastic orthodoxy. Given what we already know of the function of obscenity, it is little wonder both had frequent recourse to the term.

Obscenity appears in a number of guises, but most frequently it is used adjectivally, often in proximity to words that conjure more concrete emotions and physical sensations. One of the most common conjunctions links obscenity (and its attendant concepts of lewdness and lasciviousness) with

perspective on the fabliaux see C. Muscatine, *The Old French Fabliaux* (New Haven, 1986), and his essay 'The Fabliaux, Courtly Culture, and the (Re)Invention of Vulgarity', in *Obscenity*, ed. Ziolkowski, pp. 281–92.

pleasures or desire: indeed, as we shall see, the consistent proximity in language of 'obscena' and 'voluptas' are almost a commonplace of the period, catching echoes as far back as Augustine. If the connection between obscenity and pleasure may come as no surprise, a closer look at some of the uses reveals what, precisely, it was about sensual pleasure that led to the desire to censure. For it was not merely that sexuality was in itself explicitly offensive: it was rather the nature of the sensations associated with erotic experience that was cause for anxiety. More specifically, it was the sense of being out of control, of exceeding the familiar, that was pinpointed as the problem.

Two examples will illustrate the importance of excess in defining obscenity. The first occurs in Bernard of Clairvaux's treatise *De conversione*, a long meditation on the process of conversion. In the early part of the text, Bernard explains that to embrace God demands a kind of forgetfulness of the former pleasures of the body; to control the memory demands a taming of the will (*domina*). Playing on the double meaning of 'domina', the will becomes a voracious old woman, who gluttonously clings to past excesses. In recalling her vile delight, the sensual appetites of the body are characterized as obscene:

> Nunc autem si tibi forsitan morbi huius pessimi, quo laboro, triplex malignitas excidisse potuit, sed non mihi. Siquidem voluptuosa sum, curiosa sum, ambitiosa sum, et ab hoc triplici ulcere non est in me sanitas a planta pedis usque ad verticem. Itaque fauces, et quae obscena sunt corporis, assignata sunt voluptati, quandoquidem velut de novo necesse est singula recenseri. Nam curiositati pes vagus, et indisciplinatus oculus famulantur. [22]

> If now the sickness of this three-fold malignancy from which I suffer is able to escape you, perhaps, it is not so for me, since I am given to pleasure, am acquisitive, am grasping, and from the bottom of my feet to the top of my head, these three wounds leave me no health. Thus if it is necessary that they be reviewed afresh, the throat, and those parts of the body which are obscene, are given over to pleasure; the wayward foot and the indiscreet eye to curiosity. [23]

Revealing, here, are the powerful string of sensations – characterized by Bernard as a three-fold malignancy – that are brought forth by the 'obscene body': 'voluptuosa sum, curiosa sum, ambitiosa sum'; and finally, 'assignata sunt voluptati'. These words speak of a kind of surplus: a moving beyond, through desire, the normal bounds of bodily sensation. The body is acquisitive – curious, even – reaching out of itself for more pleasure.

The same dynamic of excess finds even more dramatic formulation in the writings of Bernard's close associate, Aelred of Rievaulx. At the end of the

[22] Bernard of Clairvaux, *Le précepte et la dispense: la conversion*, ed. J. Leclercq, H. Rochais and Ch. H. Talbot, trans. F. Callerot, J. Miethke and C. Jaquinod, *Sources chrétiennes* 457 (Paris, 2000), p. 350.

[23] My thanks to Shane Butler for help with translating this passage.

Speculum caritatis, written at the urging of Bernard, Aelred reflects on the ideals of friendship. Good friendships are born of justice, wisdom and sanctification; good friendship models itself on one's relationship with God – that is, chaste, and free of human desires. It is in his evocation of bad friendship that the term 'obscene' is deployed, again in the context of an excess of physical sensation:

> Hi non se fruuntur in sapientia, ac proinde non in illo qui Dei virtus est et Dei sapientia. Alii etsi non deteriores, certe sordidiores, quibus pene de homine nihil est, quos obscoena turpitudo transformavit in bestias, qui se in luxuriosis conviviis et immundis fruuntur desideriis, quia se non in sanctificatione, quae in castitatis suavitate consistit fruuntur, utique in Domino, qui factus est nobis a Deo sanctificatio[24]

> They do not enjoy themselves in wisdom, nor in him who is the strength of God and the wisdom of God. Others, although not worse, are certainly more vile. In them there is almost nothing human. Obscene depravity has transformed them into beasts who find enjoyment in self-indulgent banqueting and impure desires. Since they do not enjoy themselves in sanctification which consists of the gentleness of chastity, they do not, of course, enjoy the Lord who has made our sanctification by God.[25]

Striking in Aelred's rehearsal of the virtues of chastity is not only how clearly obscenity is set up as an opposite to the orthodox; it is also that the sensation of desire is so powerful as to effect a transformation – man into beast. Here the same sensation of extremity I suggested as a defining quality in Bernard's deployment of 'obscena' takes on a more vivid and literal meaning: it is an exceeding of the very category of being human. A few lines later, we come to the true source or impulse for that powerful metamorphosis: what leads the body to obscenity is not simply pleasure, but passion. In Aelred's final rendering of how people should love one another, he compels his readers to find love in a place that is perhaps poignantly strange to our modern sensibilities – in the *absence* of the passion of desire:

> Fruamur invicem in sanctificatione, ut sciat unusquisque vas suum possidere, id est proprium corpus in sanctificatione et honore, non in passione desiderii.[26]

> Let us enjoy one another in sanctification, so that each may know how to possess his vessel – that is to say, his own body – in sanctification and honor, and not in the passion of desire.[27]

24 *Speculum caritatis*, III.40. Quoting from Aelredi Rievallensis, *Opera omnia*, ed. A. Hoste and C. H. Talbot (Turnholt, 1971), p. 160.
25 Aelred of Rievaulx, *The Mirror of Charity*, trans. E. Connor (Kalamazoo, 1990), p. 300.
26 *Speculum caritatis*, III.40. Quoting *Opera omnia*, ed. Hoste and Talbot, p. 161.
27 Aelred of Rievaulx, *The Mirror of Charity*, trans. Connor, p. 300.

Taken to its logical conclusion, the most turbulent and most erratic of human emotions – passion, pleasure and desire – appear the most dangerous agents of the obscene.

In what follows, I shall examine three contrasting manifestations of obscene sound, using the frames of function (as opposition to the orthodox) and sensation suggested above as an interpretative guide. We shall begin with the role of obscene sound in the *Divina commedia* itself: the devil's foul eruption in Canto XXI is, we shall see, the cue to an overarching discourse of good and bad sounds that mimics the pilgrim's conversion trail. If Dante recreates the affront of his infernal musicalities by conjuring them as being literally beyond literal reproduction, our second example of sonic obscenity is emphatically material, unavoidably visual: the grotesque symphonies, sawings, brayings and hootings that are painted in the margins of devotional manuscripts from the latter part of the thirteenth century. We shall revisit the paradoxical relationship between orthodox, prayerful centre and outrageous margins but with a particular focus on the question of sound. Centrally, what are we to make of the contradiction between the riveting visuality of obscene sound in these images, and the absence of real, sounding correlates? To end, we will return to the question of what the obscene sounded like in the unlikely site of music itself – the terrain of sacred song: building on a discourse that began with Augustine, I explore a passage from Aelred of Rievaulx's *Speculum caritatis* that appears to offer us, finally, a concrete, recuperable moment of the musically shocking.

Sounding *Inferno*

There is perhaps no simpler demonstration of sound's ability to signify, through opposition, as obscene or ecstatic, affronting or inviting, immoral or moral, than in the structure of the *Divina commedia*. Even the almost incidental intrusion of foul sound in the example with which we began prompts a flurry of classificatory activity. Recall the scene: running through a catalogue of more orthodox signals – the onset of warrior raids, tournaments, jousts and so on – Dante quickly puts the devil's signal to good use, as the deplorable opposite to the acceptable way of things.

That structure of oppositions plays out at a much more complex level to become an organizing feature of the entire *Commedia*. Each of the realms through which Dante travels has its own, unique soundscape that, read sequentially, mirrors the narrative of the poet's spiritual pilgrimage.[28] The conversion route begins with the sound of *Inferno*, a chorus of wailing,

[28] N. Pirrotta, 'Dante *Musicus*: Gothicism, Scholasticism, and Music', in N. Pirrotta, *Music and Culture in Italy from the Middle Ages to the Baroque: A Collection of Essays* (Cambridge MA, 1984), pp. 13–25.

shrieking, and howling; of terrifying noises from sometimes unknown sources. Indeed, it is paradoxically sound, not sight, that shapes Dante's first impression of Hell as he and Virgil pass through its gates. Here, again in the dark, the tearful poet is overwhelmed by aural experience:

> E poi che la sua mano a la mia puose
> con lieto volto, ond'io mi confortai,
> mi mise dentro a le segrete cose.
> Quivi sospiri, pianti e alti guai
> risonavan per l'aere sanza stelle,
> per ch'io al cominciar ne lagrimai.
> Diverse lingue, orribili favelle,
> parole di dolore, accenti d'ira,
> voci alte e fioche, e suon di man con elle
> facevano un tumulto, il qual s'aggira
> sempre in quell'aura sanza tempo tinta,
> com la rena quando turbo spira. (*Inferno* III.19–30)

> And when he had placed his hand on mine, with a cheerful look from which I took comfort, he led me among the secret things. Here sighs, laments, and loud wailings were resounding through the starless air, so that at first they made me weep. Strange tongues, horrible outcries, utterances of woe, accents of anger, voices shrill and faint, and the beating of hands among them, were making a tumult that swirls unceasingly in that dark and timeless air, like sand when a whirlwind blows.

In *Purgatorio*, the domain closest of the three to the 'real' world, song is heard for the first time as sinners chant well-known liturgical chants and hymns, doing musical 'time' as they would in real life: these are melodies that would have been utterly quotidian to Dante and his audience – the soundtrack to their lived, religious experience.[29] Finally, in *Paradiso*, Dante experiences musical bliss so intense that, he tells us repeatedly, no description can do it justice. Yet despite that claim, he does a precise job of suggesting sights that mimic musical textures: most famously, the three-fold structure of dancing lights swirling round Beatrice in Canto XXIV mirror the pattern of movement and structure of a polyphonic motet – the most elite and complex musical genre emanating from France, and finding its way into Italy even as Dante was writing:

> Così Beatrice; e quelle anime liete
> si fero spere sopra fissi poli,

29 The only time song is referenced in *Inferno* is in the final Canto, where Virgil quotes a parodied version of the Holy Week hymn, *Vexilla regis*, as they approach Satan: it is thus a textual, more than a musical allusion, and a symbolic reminder that the king of the infernal realm is not Christ, but Satan.

fiammando, volte, a guisa di comete.
E come cerchi in tempra d'orïuoli
si giran sì, che 'l primo a chi pon mente
quïeto pare, e l'ultimo che voli;
così quelle carole, differente –
mente danzando, de la sua ricchezza
mi facieno stimar, veloci e lente. (*Paradiso* XXIV.10–18)

Thus Beatrice; and those glad souls made themselves spheres
upon fixed poles, flaming like comets, as they whirled. And as the
wheels within the fittings of clocks revolve, so that to one who
gives heed the first seems quiet and the last to fly, so did those
carols, dancing severally fast and slow, make me judge their
riches.

Each realm's music thus mutually reinforces the sense of progression and
devotional discovery that marks Dante's spiritual ascent. Moreover, what
contributes to creating musical perfection in *Paradiso* is its profound opposi-
tion to the debased musicality of *Inferno*. Thus, the offensive here is simulta-
neously revelatory of the musical rectitude to which one must aspire.

The story does not end here, however: other more uniquely musical char-
acteristics animate the schema. In his exploration of Dante's relationship to
contemporary musical thinking, Nino Pirrotta argued that the poet undoubt-
edly had in mind a definition of *musica* as a liberal art,[30] thereby endorsing his
cosmic creation with allusion to a philosophical notion of the universe in
which 'the mathematical appraisal of music appeared to be the clue to an
all-pervading system of numerical relationships, underlying, signifying, and
unifying the physical and metaphysical structure of the universe'.[31] Dante's
use of *musica* goes beyond simple analogy, and deploys the familiar three-
fold theoretical breakdown of *musica*, known to poets from Boethius's sche-
matic. Thus, in *Paradiso*, the persistent reminder that musical experience here
transcends anything fully audible on earth makes clear the analogies between
the ineffable, conceptual music of the heavens and *musica mundana*. Mean-
while, *musica instrumentalis* manifests in *Purgatorio* as the endless singing of
psalms purging the souls of the sinners, preparing them for 'the highest
values of *musica humana*'[32]; and, from time to time, *musica humana* (the most
perfect, harmonious music to be heard on earth) itself makes an appearance –
hymns are sung that work upon the souls to bring comfort and diversion
from temptation.

According to the Boethian scheme, *Inferno* is thus cast not simply as the
opposite of celestial bliss: it is simultaneously set outside *musica* altogether,

[30] Pirrotta, 'Dante *Musicus*'; for an excellent account of the place of music in other of
Dante's writings see, too, J. Stevens, 'Dante and Music', *Italian Studies* 23 (1968), 1–18.
[31] Pirrotta, 'Dante *Musicus*', p. 14.
[32] Ibid., p. 14.

and consequently is displaced from the universe itself. Nor is that exile merely conceptual. For Dante creates a sonority for Hell that is outside a formal musical system in more literal ways. A closer examination reveals that uniquely musical dimensions are enlisted to animate the distinctions between the obscene and the orthodox. First, most obviously, there is no singing at all in *Inferno*: the singing voice, the voice that articulates *musica*, is reserved only for *Purgatorio* and is evoked in the polyphonic texture of the dancing spheres in *Paradiso*. But we may take this further: it is not simply that the voices in Hell do not sing, it is that they are often *incapable* of song. On several occasions, the sounds suggested are those produced by bodies that are ghastly and debased by suffering, but yet desperate to communicate: these are entities that aspire to voice and to song, but grotesquely fail.

To a musical ear, then, *Inferno* is in fact haunting and horrifying not for the ostentatiously shocking, but rather for the more subdued soundtrack of those who long for voice. Thus, for example, Canto VII is saturated by the low-level murmuring of the barely audible sinners who are confined for eternity in a dark, murky bog: Dante heard them confess their sin from the slimy surface, but, he says, 'Quest'inno si gorgoglian ne la strozza, / ché dir nol posson con parola integra' ('this hymn they gurgle in their throats, for they cannot speak it in full words').[33] The desire to utter is even more harrowing in Canto XIII, where the souls transformed into tree stumps communicate by puffing out their messages with anguished effort from the twigs and branches that shoot from their trunks: 'Allor soffiò il tronco forte, e poi / si convertì quel vento in cotal voce' ('then the stump puffed hard, and soon that breath was changed into this voice').[34] Voices break through bark, so that what eventually bursts forth amid the hissing and puffing is not just voice, but also blood:

> Come d'un stizzo verde ch'arso sia
> da l'un de'capi, che da l'altro geme
> e cigola per vento che va via,
> sì de la scheggia rotta usciva insieme
> parole e sangue. (*Inferno* XIII.40–4)

> As from a green brand that is burning at one end, and drips from the other, hissing with the escaping air, so from that broken twig came out words and blood together.

And if *Inferno* resounds with the desire for voice, that desire's accompaniment is a medley of other terrifying, non-human sounds; for example, the terrible crashing and trembling that distracts Dante from the furies in Canto IX:

> non altrimenti fatto che d'un vento
> impetüoso per li avversi ardori,

33 *Inferno* VII.125–6.
34 *Inferno* XIII.91–2.

che fier la selva e sanz'alcun rattento
li rami schianta, abbatte e porta fori. (*Inferno* IX.67–70)

a sound as of a wind, violent from conflicting heats, which strikes
the forest and with unchecked course shatters the branches, beats
them down and sweeps them away.

It is little wonder, then, that as the pilgrims proceed through the underworld,
Dante appears to become deafer and deafer, blocking – recoiling from – the
offences, until, by Canto XXI, he (we) cease to hear any sounds at all. There,
even in the darkness, the ears refuse to engage with the soundworld of
Malebolge.

It is not just in general, shocking effect, and in their terrifying intensity,
that the sounds of *Inferno* are different from the higher realms. We can also
pinpoint some more precise musical differences: what they all have in
common is that they shun any kind of fixed system of pitch and rhythm, and
are unruly, unpredictable sounds, more heightened than speech, but not
quite fully fledged into song. Their occupancy of a category of sound that
lurks at the edges of the established modes of utterance has other ramifica-
tions. Most important is that they are beyond the system of contemporary
musical notation. That exclusion is further underscored by the unambiguous
notatability of the music of *Purgatorio* and *Paradiso*, which mark a progression
from neumatic to the highly complex, theoretically endorsed system of
mensural notation associated with celestial polyphony. In other words, what
makes *Inferno* obscene, in purely musical terms, is its play against the theoret-
ical system of the liberal arts, the evocation of a sonic vocabulary that
eschews pitch and rhythm, crucially distancing it from the orthodox, theo-
rized system of musical writing. And yet, paradoxically, as Dante and Virgil
feel their way through the 'blind world' ('cieco mondo')[35] of Hell, the poet is
pressed to virtuosic poetic evocation of those unpredictable, ghastly sounds;
and caught up in the synaesthetic potentialities of language, the reader, like
Dante himself, may wish to sit and weep for the ghastly suffering of Hell's
inhabitants.

Musical obscenity in the margins of prayer

If obscene sound manifests as a resistance to musical notation, it paradoxi-
cally surfaces as stunning graphic excess in other systems of visual represen-
tation. Trumpet-assed devils were not unique to Dante. They were merely
members of the congregation of foul-sounding bodies who crowd into the
margins of devotional manuscripts (commonly Psalters and Books of Hours)

[35] *Inferno* IV.13.

in the final decades of the thirteenth century across Northern Europe, and France in particular.[36] There were many other perverse varieties of music-making, with, for example, two-faced hybrids with trumpets growing from their mouths, or apes banging cymbals or playing vielles.[37] There are horrifying parodies of musical instruments, with figures sawing at their stringed instruments with rakes and tongs.[38] If these books are a major source for sonic obscenity, their evidence is not confined to sound alone. Our noisy performances take their place alongside other less sonorous displays of the obscene: shaggy beasts mounting one another; nuns and priests excreting into the corners of folios: the list could go on.

Not surprisingly, the margins have been subject to intense investigation by art historians, prompting often conflicting ideas about the purpose such images serve. While many agree that some marginal monsters can be tied to the meaning and association of specific words or themes in the texts they adorn, other images seem to have no literal correlation to texts.[39] Broader theories about the relation between edge and centre oscillate between viewing marginalia as incidental or secondary decoration, or as much more

36 The bibliography on this topic is vast. See the following footnotes for essays relating to specific manuscripts discussed. Indispensable guides to the image-text relationship in medieval manuscripts include C. Hahn, *Portrayed on the Heart: Pictorial Effect in the Lives of Saints from the Tenth through the Thirteenth Century* (Berkeley, 2001) and W. Noel, *The Harley Psalter* (Cambridge, 1995), both dealing with the tradition of illuminating devotional texts up to the thirteenth century; perhaps the most vital and stimulating discussion of the thirteenth- and early fourteenth-century tradition of marginal obscenity remains M. Camille, *Image on the Edge: the Margins of Medieval Art* (London, 1992). An indispensable guide to the variety of marginalia is L. Randall, *Images in the Margins of Gothic Manuscripts* (Berkeley, 1966). In the examples that follow I refer the reader wherever possible to images reproduced in Randall's catalogue. There are numerous representations of trumpet-assed men and monsters. For example, an image of a naked man holding a trumpet to his ass occurs in Paris, Rothschild Private Collection, Canticles of the Virgin ('Rothschild Canticles'), fol. 134r, reproduced in Randall, no. 543; in Baltimore, Walters Art Gallery, MS 88, fol. 157r, a man is depicted blowing a horn with his mouth and holding another to his ass.

37 The double-faced hybrid trumpeter in Walters MS 88, fol. 185v occurs in a manuscript whose margins are packed with trumpet players. Many examples of monstrous music-making are given in Randall, *Images in the Margins*: see in particular her catalogue nos 485–523.

38 This was a much-repeated image. For example, a man draws a rake over the strings of his vielle in Chantilly, Musée Condé, MS 62, fol. 117r, reproduced in Randall, *Images in the Margins*, no. 517. For other images of parodies of musical instruments, see ibid., nos 508–20.

39 For examples of competing interpretations of the word/image relationships in these manuscripts, see in particular recent studies of the Luttrell Psalter: M. Camille, *Mirror in Parchment: The Luttrell Psalter and the Making of Medieval England* (London, 1998) and L. Freeman Sandler, 'The Word in the Text and the Image in the Margin: the Case of the Luttrell Psalter', *Journal of the Walters Art Gallery* 54 (1996), 87–99.

seriously contrived, with margins working to a more didactic end, serving as a strenuous opposition to the prayerful centre of the page.[40]

In light of the considerable attention focused on margins, it is surprising, perhaps, that despite the pervasive presence of noise-making, the images are rarely considered for what they might tell us about sound, or for the effect such sonic evocation may have on reading. Nor have the images fared any better outside the discipline of art history: they have yet to receive more than passing attention from musicology. While there is not space here fully to address the meanings of the margins, I would nonetheless like to explore two issues relating to the sounding aspect of the images: first, to look more closely at how, in the medium of image, sound is constructed as obscene; and second, to offer some tentative suggestions about how the sonic aspect of the images might impact on their readers' relationship to their prayers.

These questions may best be answered by first accounting for the compli-cated relationships between medieval images and the real, experienced world of objects and signs to which they may refer. Indeed, I would suggest that the very fact the sonorous dimension of the images defies easy disciplinary cate-gorization exposes the animating semantic dynamic of the margins. On the one hand, despite their specific musical information, the images never offer prescriptive information: they may indicate a certain kind of sound (the musical instruments may conjure a particular timbre, or a certain volume), but it is coded in only the most general sense. If musicologists might thus regard the images as being only minimally informative about music, sound is still further tuned out by common art historical approaches to literalness and representation in image-making. Several recent studies of the margins argue that we need to approach the images not as literal representation, but as the product of an internal, closed system of visual self-referencing. That view is most strenuously advocated in Lucy Freeman Sandler's reading of the Luttrell Psalter, a famous English manuscript from the second quarter of the fourteenth century, one abounding in marginal monstrosities that connect in apparently specific and precise ways to the words and sentiments of the psalms they decorate. Having illustrated the many intricate ways in which images take their cues from words, Sandler ends with some reflections on the nature of reading (reading aloud; looking at the text and so on). Sight and the primacy of a purely visual system of meaning-making are, she argues, the dominant aesthetic of such a manuscript: 'it should be recognized that words in the texts and images in the margins – even when apparently opposed – both belong to a *visual* system. . . . marginal word-images – and perhaps all

40 For example, the margins of the early fourteenth-century prayer book of Jeanne d'Evreux, the young bride of the French king, Charles IV, le Bel, make images from the prayers that are sexually explicit, often aggressive reminders of marital duty for the young reader, on which see M. Caviness, 'Patron or Matron?: A Capetian Bride and a *vade mecum* for her Marriage Bed', *Speculum* 68 (1993), 333–62.

marginal images – in contemporary books intended for individual use, whether sacred or secular, gave focus and rewarding depth of meaning to reading, a visual activity that increasingly characterized the mental culture of the thirteenth and fourteenth centuries'.[41] In arguing for a visuality of reading, then, the possibility that part of the purpose of a sound image was to conjure up or represent literal sound, and that such sounds might be a vital dimension to the construction of an image's meaning, is passed over. And yet, regardless of whether the images function symbolically more than literally, the material contexts of such images are anything but void of musicality.

In fact, marginal music-making adorns books that abound with sonic contradictions, sparked, I would argue, by the pervasiveness of sound images. A little discussed point about prayer books is that, almost without exception, their texts lack any formal musical notation, despite the fact that many were known from other, chanted sources in the Office and Mass.[42] Moreover, situated in the larger context of meditative reading and writing in the later Middle Ages, prayer books stand out as among the noisiest in a community of texts that were similarly imagined to have audible voices. As Mary Carruthers, Paul Saenger and others remind us, medieval reading was oral/aural, even when it was apparently silent; in the imagination of the reader, authorities spoke, and had voices as distinctive in timbre as the style of a scribe's hand.[43] In decorated prayer books, where there is, often, the suggestion not just of speech but also of song, there are multiple tensions between the texts' call for melody in spite of the absence of prescriptive notation, and the presence of images that suggest sound utterly unlike the absent melodies of the text. I would tentatively suggest that such tension may be a vital clue for better understanding how the many seemingly random sound images could make sense.

I shall return to the sounding dimensions of the text–image relationship

41 Sandler, 'The Word in the Text', p. 97.
42 For two useful studies of the readership and reading habits of the owners of devotional manuscripts, see M. Parkes, 'The Literacy of the Laity', in *The Mediaeval World*, ed. D. Daiches and A. Thorlby, *Literature and Civilization* 2 (London, 1973), 555–77, and P. Saenger, 'Books of Hours and the Reading Habits of the Later Middle Ages', in *The Culture of Print: Power and the Uses of Print in Early Modern Europe*, ed. R. Chartier (London, 1989), pp. 141–73.
43 See P. Saenger, *Space Between Words: the Origins of Silent Reading* (Stanford, 1997); M. Camille, 'Seeing and Reading: Some Visual Implications of Medieval Literacy and Illiteracy', *Art History* 8 (1985), 26–49; J. Coleman, *Public Reading and the Reading Public in Late Medieval England and France* (Cambridge, 1996); M. Carruthers, *The Book of Memory: A Study of Memory in Medieval Culture* (Cambridge, 1992); M. Carruthers, *The Craft of Thought: Meditation, Rhetoric and the Making of Images, 400–1200* (Cambridge, 1998). All these accounts remind us that to medieval readers writings were 'representations both of a voice ("speaker") and of words spoken', the commonly invoked *dictum* of Isidore of Seville on the meaning of 'litterae' (discussed in Carruthers, *Book of Memory*, p. 190).

presently. First, however, let us consider more closely how sound is coded as obscene in the images themselves. Albeit, as we have seen, some interpretations of the margins minimize the possibility that sound images have a more literal function – to evoke the sounds they represent – I would like to try and reintroduce a literalness into a reading of the images. Indeed, I would suggest that it is the sonic actuality represented, in an artistic medium of considerable semantic freedom, that makes the sounds of obscenity more startling and offensive than perhaps any other context. In one sense, as I have suggested, images of musical instruments or sound-making are literal representations, with real correlates; as such, we could understand them as a form of partial notation – a trumpet evokes the timbre of a trumpet, a harp the strum of strings, and so on. But, as suggested by Sandler's emphasis on the visual priority of the page, the very medium of image also enables a move beyond literal prescription: image symbols flit across the boundary of literal representation, and stray into the imaginary, invented realm of images for which there are no real correlates. Indeed, it is this kind of mixing up, or redeploying of visual symbols that many art historians understand to be the central creative dynamic of the medium. Michael Camille argues, for instance, that 'the medieval artist's ability was measured not in terms of invention, as today, but in the capacity to combine traditional motifs in new and challenging ways'.[44]

The result of such combinations and recombinations is monstrous sonic hybrids: a mix of lived, sonic reality with pure fantasy. Some examples will illustrate. In the margins of the early fourteenth-century Hours of Jeanne d'Evreux, one of the most sonically imbued manuscripts in this tradition, (real) trumpets project from the mouths of terrifying monsters; scaly creatures mould their bodies around the harps they strum; mouths burst out of line endings, quite literally shouting their heads off.[45] Reality can also become reconfigured in grotesque ways, so that sound can be displaced to entirely inappropriate places. Again in the Hours of Jeanne d'Evreux, in the margins of an Annunciation of the Shepherds, at Lauds for the Hours of the Virgin, a man looks up at the scene, casually blowing on the tail of a dog he holds as he would a bagpipe (fol. 62r). A similar mis-arrangement of sonic tropes is seen in British Library, MS Stowe 17 (fol. 92v), a Book of Hours dated *c.* 1300 produced in Maestricht, where a hybrid man bows a cockerel (its beak held in the man's mouth) with a pair of tongs; meanwhile, a harp-playing bunny looks on.[46] It is with the possibility of sound displacement that the most

[44] Camille, *Image on the Edge*, p. 36.

[45] Images of this kind recur throughout the manuscript and, indeed, throughout countless other books of the period. For a facsimile of the manuscript, see *Die Stundenbuch der Jeanne* (Lucerne, 1998).

[46] London, British Library, MS Stowe 17, fol. 92v (image reproduced in Randall, *Images in the Margins*, no. 514).

obscene images are invented. And very often, we also see sound conjoined with other, more familiar sites of the obscene: thus, for example, men frequently blow on bagpipes or other forms of pipes that appear to sprout from where their genitals should be. In Walters Art Gallery, MS 87 (fol. 87v), for example, a man blows a trumpet while defecating.[47] There is, in other words, the free exchange between reality and unreality, literalness and abstraction, permissible by the medium of image. It is that freedom – that potential for surpassing the familiar – that encourages obscenity.

The shocking power of marginal sound images is thus founded on their being neither simply precise literal representations of musical reality nor existing only in a visual system divorced from a real correlate. Their power is rather an ability to be both literal and abstract, and to mix up reality and fantasy, to relocate shocking (real) sound in shocking (unreal) locations. I would suggest that sound's representation intensifies the abrasive encounter of the eye, for it allows for the situating of real, remembered and precise sound in new, unsettling, and indeed, often non-existent signs. In other words, it instils in the monstrously unreal a shard of lived experience: it brings to life, like the electrical charge of Frankenstein's monster, the fantastical and offensive. Not only that, certain types of sound, particularly trumpets, horns, bagpipes and drums – sounds that were, in the real world beyond the folios, abrasive, noisy and sometimes terrifying – amplify sites that were already understood to be obscene: with the recurrence of bagpipes as genitalia, the offence, then, is quite literally amplified by reference to the wheezing wail of one of the noisiest and most unsettling sounds of the period.[48]

If my reading offers a tentative way of inserting literal sound back into the meaning of the images, can we move any closer to an understanding of how that sonic dimension plays out within a more complete reading of prayer books? I do not suggest there is a universal code for all books with sonic marginalia: rather, I would suggest some tentative models for reading sound in prayer, models that might be configured in different ways from book to book, even from folio to folio. Although Sandler and others argue that reading was a predominantly visual activity, I suggested earlier that the words of prayer carry with them the connotation of sound, perhaps a recollection, or even a performance, of other chanted contexts for the text. Reading the frantic immediacy of image production, and the often disturbing or surprising sound emblems they concoct, against the monotonous, entirely predictable sequence of the words they adorn, we might suggest that the margins act on the texts they surround in a sonorous as well as in a material sense.

47 Baltimore, Walters Art Gallery, MS 87, fol. 87v.
48 I am indebted to Peter Stallybrass for this observation.

In the context of the implied musicality of the text, ought we not to allow the aural associations conjured by the obscene margins to play out more literally? For although the noisy beasts who stalk the edges of prayer are worlds apart from real experience, they are constant reminders that prayer is to be heard as well as seen, even if the words lack formal notations to prompt the reader to envoice their prayers. If the power of sounding obscenity in prayer grips the eye more than the ear, it is still, in blurring the senses, a stern, even terrifying reminder to deploy sound efficaciously. Thus although the obscene images are themselves quiet, muted by being only vague prescriptions for sound, their presence is no less challenging to the orthodox voice of prayer: a challenge, then, to sounding, quotidian reality. The implication of sound in the margin threatens to interfere with, or intrude upon, the real voice of supplicants uttering their prayers. It represents the oral counter-code to the voice of prayer itself.

Polyphonic obscenity

Even the most morally unequivocal realm of medieval song – the music of the liturgy – had a risky limit, a 'counter-code'. From the earliest records of psalm singing to accounts of elaborate organum, we catch echoes of an anxiety about dangers in the real, lived experience of music: centrally, that singers and listeners might get caught in the ambiguous sensation of musical pleasure, and lose sight of the purpose of their song – to articulate the words of the liturgy. While commentators interpreted these dangers in a number of ways – as divine revelation, demonic possession – they did on occasion turn to the vocabulary of the obscene to formulate their anxiety.

We shall in a moment see how Aelred of Rievaulx deployed the discourse of obscenity to record his anxiety about the startling effects of the increasingly popular polyphony that began filling the churches of Europe in the later twelfth century. But before we do so, we must look a little further back, to the origins of a tradition of writing about musical effect that leant on the lexicon of the obscene. Casting a long shadow over all the writers we shall explore was Augustine. He returned often to the problems (and benefits) of musical pleasures[49]: and even in *Confessions*, where he half-heartedly eschewed musical delight, his evocation aligns sound with sensual, even erotic, experience. As we saw with those Cistercians explored earlier in the essay, the illicit resides at the cusp of pleasure. Bruce Holsinger's recent rereading of the key passage in Chapter 10 of *Confessions* reminds us of the crucial frame in which musical discussion is situated: a discussion of 'bodily temptations to

[49] For a detailed account and interpretation of the theme of musical experience in Augustine, see Holsinger, *Music, Body, and Desire*, pp. 61–83.

pleasure'[50] – the physical, visceral distraction of the senses away from the proper activity of making sense of the sacred. The 'pleasure of the ears' ('voluptates aurium') is so tantalizing and intense as to make Augustine wish he had never heard the singer at all.[51]

In a lesser-known passage, from a commentary on Psalm 18, the dangerous qualities of song resurface in a slightly different guise: Augustine makes a distinction between intelligent and unintelligent singing – singing that is born of understanding God, and senseless singing, that makes no effort to meditate upon God. With song – the psalm chanted just prior to his sermon – still reverberating in his ears (and imagined in the minds of his readers), Augustine works up a metaphor of opposition that unequivocally situates the senseless song not merely as more sensual, but also, explicitly, as obscene:

> Deprecati Dominum, ut ab occultis nostris mundet nos, et ab alienis parcat seruis suis, quid hoc sit intellegere debemus, ut humana ratione, non quasi auium uoce cantemus. Nam et meruli et psittaci et corui et picae et huiusmodi uolucres, saepe ab hominibus docentur sonare quod nesciunt. Scienter autem cantare, naturae hominis diuina uoluntate concessum est. Et quam multi mali et luxuriosi sic cantant digna auribus suis et cordibus, nouimus et dolemus. Eo enim peiores sunt, quo non possunt ignorare quod cantant. Sciunt enim se cantare flagitia, et tamen cantant tanto libentius, quanto immundius; quoniam tanto se putant laetiores, quanto fuerint turpiores. Nos autem qui in ecclesia diuina eloquia cantare didicimus, simul etiam instare debemus esse quod scriptum est: *Beata populus qui intellegit iubilationem.*[52]

> Having implored the Lord to cleanse us from our secret sins and spare His servants from those of others, we ought to understand the meaning of this petition, so as to sing like reasonable beings and not like birds. For blackbirds, parrots, ravens, magpies and suchlike birds are often taught by men to utter sounds they cannot understand; but to sing with intelligence is a God-given endowment of human nature. And we know to our sorrow how many evil men of dissolute lives thus sing ditties in keeping with their ears and hearts. They are all the more blameworthy in that they cannot help being aware of what they are singing. They know perfectly well they are singing obscene songs, yet the lewder the songs the more lustily they sing, for the murkier their souls the merrier they suppose themselves. But we, who have learnt in the church to chant the oracles of God, should at the same time do our best to fulfill the words: Blessed is the people that knoweth jubilation.[53]

50 Ibid., p. 73, referring to *Confessiones* X.29–34.

51 *Confessiones, Corpus Christianorum, Series Latina* 27 (Turnhout, 1983); for a translation, see *Saint Augustine: Confessions*, trans. Henry Chadwick (Oxford, 1991).

52 *Enarrationes in Psalmos, I–L*, ed. E. Dekkers and J. Fraipont, *Corpus Christianorum, Series Latina* 38 (Turnholt, 1956), p. 105.

53 *St. Augustine on the Psalms*, trans. S. Hebgin and F. Corrigan, 2 vols (Westminster MD, 1960–1), I, 182.

The alignment of disturbing musical effect with obscenity resurfaces time and again after Augustine: we see it from Boethius's categorization of certain categories of mode as 'lascivious', and capable of inspiring lascivious behaviour in those that hear it,[54] to Jacques de Liège's much later condemnation of lascivious singers, to explain his dismay as performers of *ars nova* motets delighted in singing, despite rendering blatantly inaudible the motet's words: 'Ad quid tantum placet cantandi lascivia curiositas?' ('Wherein does this lasciviousness in singing so greatly please?')[55] But if the discourse of obscenity facilitated a critique of how music could unsettle, the accounts are, for the main, frustratingly general. Were there more precise ways in which the category of obscenity was applied, to indicate more exactly where that fraught, tense area of musicality resided? In which notes, rhythms and meters did it lurk?

Aelred of Rievaulx's famous diatribe against polyphony from his *Speculum caritatis* offers us a seemingly more precise account about what could make music obscene. Witness to the new tradition of discant-style polyphony that was an increasingly fashionable embellishment to the liturgy, where an original chant melody was entwined with new elaborating voices, Aelred, echoing Augustine's older complaints, was unsettled by what he heard. Here is the account in full:

> Ad quid illa uocis contractio et infractio? Hic succinit, ille discinit, alter supercinit, alter medias quasdam notas diuidit et incidit. . . .
> Aliquando, quod pudet dicere, in equinos hinnitus cogitur, aliquando virili vigore deposito in femineae vocis gracilitates acuitur, nonnunquam artificiosa quadam circumuolutione torquetur et retorquetur. Videas aliquando hominem aperto ore quasi intercluso halitu exspirare, non cantare, ac ridiculosa quadam vocis interceptione quasi minitari silentium; nunc agones morientium, vel exstasim patientium imitari. Interim histrionicis quibusdam gestibus totum corpus agitatur, torquentur labia, rotant oculi, ludunt humeri, et ad singulas quasque notas digitorum flexus respondet. Et haec ridiculosa dissolutio vocatur religio; et ubi haec frequentius agitantur, ibi Deo honorabilius seruiri clamatur. Stans interea uulgus sonitum follium, crepitum cymbalorum, harmoniam fistularum tremens attonitusque

[54] 'Lascivius quippe animus vel ipse lascivioribus delectatur modis vel saepe eosdem audiens emollitur ac frangitur' ('a lascivious disposition takes pleasure in more lascivious modes or is often made soft and corrupted upon hearing them'). From *De institutione musica* I. Latin quoted from Severini Boethii, *De institutione musica*, ed. G. Marzi (Rome, 1990), p. 92. The English translation from which I quote is *Fundamentals of Music: Anicius Manlius Severinus Boethius*, trans. C. Bower and ed. C. Palisca (New Haven, 1989), p. 3.

[55] Jacobus Leodiensis, *Speculum musicae*, VII.48, ed. E. Coussemaker, 4 vols, Scriptorum de musica medii aevi nova (Paris, 1865–76), 4; English translation from O. Strunk, *Source Readings in Music History*, rev. edn L. Treitler, 7 vols, 2: *The Early Christian Period and the Latin Middle Ages*, ed. J. McKinnon (New York, 1998), p. 168.

miratur; sed lasciuas cantantium gesticulationes, meretricias uocum alternationes et infractiones non sine cachinno risuque intuetur, ut eos non ad oratorium, sed ad theatrum, nec ad orandum, sed ad spectandum aestimes conuenisse. . . .
Ideoque talis debet esse sonus, tam moderatus, tam grauis, ut totum animum ad sui rapiat oblectationem, sed sensui maiorem relinquat portionem. Ait nempe beatissimus Augustinus: Mouetur animus ad affectum pietatis diuino cantico audito: sed si magis sonum quam sensum libido audiendi desideret, impronatur.

Why that contraction and subdivision of the notes? One voice joins in, another sings discant, another enters on a higher note, yet another divides and subdivides certain middle notes. . . . Sometimes, and this is shameful to say, the voice is distorted into horses neighing, sometimes manly strength is set aside and it is sharpened into the high pitch of the female voice; sometimes by a kind of artificial rolling the voice is twisted forwards and backwards. At times one might see a man gasping for breath with an open mouth as if suffocating, not singing, and ridiculously interrupting the song as if to threaten silence, and then imitating the agonies of the dying and the terror of those enduring eternal torment. Sometimes the entire body is agitated in actors' gestures: the lips twist, the eyes roll, the shoulders heave, and at every note the fingers are flexed to match. This laughable dissipation of the voice is called religion, and where these things are performed and most frequently is it proclaimed that God is served with more honour. Meanwhile, the common people stand around trembling and terrified, and wonder at the noise of the bellows, the rattling of the bells, the harmony of the singers, the harlot-like alternations and subdivisions of the voices, so that you would think they had assembled not at an oratory, but at a theatre, not for praying but for watching. . . . And therefore should the sound be so restrained, so dignified, that it does not ravish the entire soul to delighting in itself, but leaves the greater part to understanding. As the most blessed Augustine said: The soul is moved to a disposition of piety when it hears divine song, but if the lust of hearing desires the sound of the song more than the sense of the words, it is condemned.[56]

Aelred is encouragingly precise about discant: he codifies the musical texture with great accuracy – the multiple upper voices embellish an original chant tenor with often lengthy melismatic lines. He is also explicit about what offends. It is not just the music but the style of singing and its effect on the melodic lines: singers bray like horses, adopt an unmanly falsetto range, twist their vocal lines this way and that. In those allusions to gender and species swapping we hear traces of those comments that would come later in the treatise where, recall, obscenity in human relations was characterized as a

56 *Speculum caritatis*, II.23, in *Opera omnia*, ed. Hoste and Talbot, pp. 97–9. The Latin is reproduced with an English translation by R. A. Rosenfeld in T. McGee, *The Sound of Medieval Song: Ornamentation and Vocal Style According to the Treatises* (Oxford, 1998), pp. 23–4.

transformation, man into beast. Aelred's experience furthermore leans on another recurring trait of obscene representation: namely, his focus on effect, rather than on cause. Thus, the account moves swiftly to sound's more tangible, visible effects – on the theatrical bodies of the singers (gasping for air, twisting of the lips, flexing of the fingers, enacting death throes and so on); no less important is the corrupting effect such a sight will have on the congregation watching. But, with that focus on effect, the entire account inexorably shifts into a visual, more than an aural analysis, sound manifesting in its embodied consequences, so much so that Aelred wonders whether the congregation have come to pray or to *watch* – 'nec ad orandum, sed ad spectandum'. What, though, of the sonorous *causes* of the singerly degeneracy?

In fact, the precise cause of the transgressions remains blurry. The most we can say is that the sounds that precipitate such wretched pleasures among the singers seem to derive from spontaneously taken performance decisions: allusion to the dividing and subdividing of notes suggests excessive vibrato, or a kind of vocal ornamentation. If that points to what makes music obscene, we might turn to extant contemporary written sources of the music for further information. But we would find that such effects were rarely tangible or visible in the notational systems that recorded these repertories. Indeed, whereas earlier records of chant notation from the tenth century had frequently sought to encode information not only about pitch, but also information about performance style (vocal timbre, ornamentation and so on), in the later period, such symbols became increasingly rare. By the thirteenth and fourteenth centuries, they were all but extinct, giving way to a notion of 'music' that was determined by precise pitch and rhythm – those aspects which, by contrast, were becoming increasingly more precise. In other words, the very facets of music that Aelred hints at in his diatribe as giving offence were the very facets that were fast fading from written record, and were thus fast evaporating from a literate and theoretical sensibility of what music was. Indeed, it may not be too much to suggest that accounts of sound that resist precise description are additionally energized by a new, uniquely musical discourse about musical literacy. Thus, even if the contorted shapes of Aelred's singers seem immediate – documentary, even – the vocal colours and ornamental risks that once filled the church, driving singers and audience wild, remain just beyond the reach of our ears. In those shadowy, now silent forms, though, I think we may sense if not musical effect, then at least the visceral cause of their ecstasy: lost in performance, forgetful of their bodily and vocal limits, their rapture is born, surely, of an intense and eerily familiar musicality.

Obscene rapture: 'hearing' obscene sound

Aelred's muted choir brings us full circle: to a place of silence from which we have never fully departed. But it is paradoxically in the quietness of these representations that we can 'hear' elements of medieval musical experience that are absent from the music on which we more traditionally focus our scholarly attentions. For although few of the texts we have explored here can offer concrete prescriptions for sound, they are nevertheless vividly communicative about the sounds they take as their starting point. But they ask us to listen in new ways. In explaining what that new mode of listening to the text may entail, let us return to Holsinger, who appeals to modern listeners to broaden their expectations of how medievals experienced music:

> Musicality might also serve . . . as a convenient analytical term embracing the embodied, experiential aspects of any given musically induced or inducing discourse, whether it involves identifiable notated music or not. In this sense, a devotional poem, an exegetical treatise, or indeed a manuscript illumination or statue that contain what we would usually term 'representations', or 'images of', or 'ideas about' music will be understood to possess a certain 'musicality'[57]

Holsinger's call for a more holistic, experiential encounter with the resonant records of the past applies well to the traces of sonic obscenity, given its tendency to eschew prescriptive record. But how and what do we hear in these texts? First, we experience sonic obscenity as an intensive creative energy and inventiveness: in some of the examples it surpasses literal sounding referents altogether, to become a product of the specifics of a given artistic medium. What we feel, even if we cannot hear it, is the energy of artistic production: in the ceaselessly mobile marginal sound machines of Books of Hours, mimetic of the force of the sounds they represent and reinvent; in the pressure on language to find new means of signifying the unrepresentable as in Dante.

We experience sonic obscenity, too, as a positive agent of revelation. As it fulfils the function of counter-code of the orthodox, it takes us in often exhilarating ways to the very limits of musical category. Thus the fantastical and frightening utterances of Dante's *Inferno* accrue an added potency as they make more vivid the definition of *musica*. Or, the exaggerated vocal gestures of Aelred's singers remind us that there were, in medieval imaginations, disturbing and unpredictable sonorities in the blank parchment spaces beyond the inscribed texts of music.

But still, these representations feel far removed from their once resonant

[57] Holsinger, *Music, Body, and Desire*, p. 199.

source. Is there anything more specific these kinds of records can tell us about how medieval men and women heard the originary soundworlds? One way forward may be in better understanding the semantic shades of obscenity – to focus on the sensations prompted by that which offended. Although the evidence for what obscenity felt like is, as I suggested earlier, far from codified, medievals did, from time to time, verbalize the flighty, intangible realm of extreme sensation – the meeting point of sound and obscenity. In the intensity of those feelings we may, I suggest, begin to draw closer to a vocabulary of the ineffable, abstract sensation of sonic extreme. Earlier, I suggested obscenity was synonymous with emotional and physical excess, frequently folded into metaphors of transformation and surplus. It is routinely characterized as the outer limits of physical and emotional sensation – excessive pleasure, excessive fear, excessive passion, excessive desire. Excess and surpassing of boundaries is also a recurring theme in all the sonic representations discussed here. At the most basic level, sonic obscenity's evasion of musical category and written representation is powerfully mimetic, albeit in the inner logic of a musical language, of the larger discourses of the obscene. We catch traces of its sensation in the bodies of Aelred's singers, who, in their lascivious pleasures, are pressed again to monstrous transgressions, their voices floating at the boundaries of gender and of species.

Amid the growing evidence that medievals construed obscenity as the outcome of a sensual or emotional excess or surplus, there are echoes of another, perhaps more familiar discourse. For clues of a fundamental tension in the obscene – borne at the extreme limits of positive, pleasurable sensation – I turn to that saint, long fascinated by those dangerous edges of sonic experience, whose presence hovers over all the later medieval writers and artists we have explored, and who, on occasion, contemplated the nature of excess itself. In 'excessus', he located a place that, curiously perhaps, had a great deal in common with 'obscena'; and in the centuries that followed, it would become an increasingly familiar member of the language of musical aesthetics. Hidden in the semantic currency of excess was also a place of superlative experience, of unfettered revelation, and unchecked emotion. That place resides in the origins of the word itself – in *ecstasis*:

> *Psalmus David ecstasis.* Verbum ecstasis graecum, latine, quantum datur intellegi, uerbo uno exponi potest, si dicatur excessus. Excessus autem mentis proprie solet ecstasis dici.

> Unto David a psalm in ecstasy. The Greek word *ecstasis*, as far as one can translate it into Latin, may be expressed by the use of the single word 'excessus', an excess; for, strictly speaking, a mental excess is usually termed an ecstasy.[58]

[58] *Enarrationes in Psalmos*, ed. Dekkers and Fraipont, p. 191; English translation from *St. Augustine on the Psalms*, trans. Hebgin and Corrigan, II, 9.

The context for Augustine's definition is the nature of divine revelation, sparked by the opening line of Psalm 30. And in his lengthy rumination on the properties of ecstasy, Augustine evokes a series of sensations that describe, almost perfectly, those of the obscene. If ecstasy presses the mind beyond itself, it can engender quite conflicting emotions. In the ensuing gloss, the saint associates ecstasy with feelings of fear, dread and panic, but also with joyful revelation. Not only do those contrasting emotions mirror the similarly heightened sensations of obscenity: they more importantly elide and conjoin what we might see as opposites (the proximity of panic, dread and revelation of spiritual truth is as startling as the constant proximity of passion and obscenity). Ecstasy is like obscenity in other ways too. In ecstatic revelation, the mind quite simply loses control, as 'things of earth slip away from consciousness' ('In excessu uero mentis duo intelleguntur: aut pauor, aut intentio ad superna, ita ut quodam modo de memoria labantur inferna').[59] Indeed, it is a word laden with associations of sensations of movement away from something: and sometimes, in the meaning of the attendant '*raptus*', those sensations of motion are violent, or physically jarring. All are relived in obscene experience. The most famous love affair of the Middle Ages illustrates: Abelard revisits the frightening and violent sensations of physical desire he felt for Heloise, sensations so powerful that they surpassed all reason and control, leading him to a state of forgetfulness that transports him not just beyond himself, but also beyond God. So powerful, too, that they lead to a more literally physical kind of rapture:

> Sed et te nolentem, et prout poteras reluctantem et dissuadentem, quae natura infirmior eras, saepius minis ac flagellis ad consensum trahebam. Tanto enim tibi concupiscentiae ardore copulates eram, ut miseras illas et obscenissimas voluptates, quas etiam nominare confundimur, tam Deo quam mihi ipsi praeponerem: nec tam aliter consuere posse divina videretur clementia, nisi has mihi voluptates sine spe ulla omnio interdiceret.

> Even when you were unwilling, resisted to the utmost of your power and tried to dissuade me, as yours was the weaker nature I often forced you to consent with threats and blows. So intense were the fires of lust which bound me to you that I set those wretched, obscene pleasures, which we blush even to name, above God as above myself; nor would it seem that divine mercy could have taken action except by forbidding me these pleasures altogether without future hope.[60]

My desire to fold the semantic resonances of ecstasy into our under-

59 *Enarrationes in Psalmos*, ed. Dekkers and Fraipont, p. 191; English translation from *St. Augustine on the Psalms*, trans. Hebgin and Corrigan, II, 9.
60 Edited in J. T. Muckle, 'The Personal Letters Between Abelard and Heloise', *Mediaeval Studies* 15 (1953), 47–94, quoting from letter 4; translation from *The Letters of Abelard and Heloise*, trans. B. Radice (London, 1974), p. 147.

standing of medieval obscenity may seem an unnecessary complication. However, by illustrating some of the connective threads between these two concepts, I hope to define more sharply some of the uniquely medieval currencies of obscenity. In its proximity to the sensations of excess, medieval obscenity is often far removed from the more modern preoccupations of taboos and censorship. Instead, the consonances between the obscene and ecstatic remind us that obscenity was also a way of articulating the dimensions of human experience that were so intense, embodied and alluring as to be unbearable. It is in accessing that more dynamic, sensational element of the obscene that we may make better sense of sound's compatibility with the discourse of obscenity. Indeed, in allowing for the more ecstatic properties of obscenity, we open up an inherent musicality within the category: for the rapturous forgetfulness of self, time, place and even human category are reminiscent of a portrayal of musical experience that haunts music criticism even to the present day.

In the ecstatic realms of the obscene, then, I believe we may finally begin to account for the affinities between sonic experience and discourses of obscenity. In one sense, sound serves the discourse extremely well. By summoning memory of shocking sounds into their representations of the obscene, writers and artists harnessed potent sensations and emotions, thereby deepening the experiential dimension of their creations. In another sense, by focusing on obscenity itself not as cause or effect, but as pure sensation, we may tentatively begin to reassemble a vocabulary of sonic experience. For it was in the language of obscene sensation that writers like Aelred, Augustine and many others found analogy or equivalence for recording musical or sonic experiences that lay literally outside a system of sonic prescription. If Aelred's singers are muted in translation and with the passage of time, the contours of their bodies, contorted and transported in the sensual act of performance, may be made more audible to the reader by their creator's recourse to the vocabulary of obscene and lascivious sensation. If such a record fails as an audible witness, does it not, in the act of translation, capture something of the visceral energy of the dangerous and exciting soundworlds that rang out in the medieval past? If we cannot hear, we can somehow learn how to feel or to experience through visual or verbal equivalence the traumatic, exhilarating and sometimes joyful aftershock of those lost sounds. Thus, in perhaps the strangest twist of all in the unexpected tale of sonic obscenity, it is in history's silences that we are brought to the edgy, exhilarating limits of what we can know about the musical past, and at that edge catch an echo of the rapture that lies just beyond.

Obscene Hermeneutics in Troubadour Lyric

Simon Gaunt

This essay is in three parts. In the first section I give some general orientation on obscenity in the troubadour tradition and in the *chansonniers* that transmit the tradition to us. The second section sketches the relationship between erotics, or what sometimes amounts to little more than sexual or obscene innuendo, and poetics in troubadour lyric.[1] The third section explores this question further through an analysis of a lyric that represents a high point of troubadour art: Arnaut Daniel's famous *sextina*. My approach to the *sextina* will be guided by a number of Lacanian insights on sexual language.

Obscenity in troubadour lyric

At first blush, the troubadour lyric seems like poor hunting ground for obscenity. There are some 2,500 or so troubadour lyrics from the twelfth and thirteenth centuries surviving in some thirty *chansonniers* (or songbooks) dating from the thirteenth to the fifteenth centuries. Although there is a sizeable corpus of satirical material, a clear though not overwhelming majority of surviving lyrics are *cansos*, that is courtly love songs, and the genre apparently prohibits obscenity, at least in the first sense with which I will be using the term, that is, a word or expression that designates explicitly, possibly even with vulgarity, sex or a sexual part of the body, in a way that some at least are likely to find offensive.

The injunction not to talk about sex explicitly in courtly texts is clear from the outset, and we can adduce evidence for this from contemporary texts. Not only can it not be accidental that explicit sexual language is almost entirely

[1] In an earlier article on obscenity in troubadour lyric, I concentrated on aesthetics and looked at the use of obscenity to generate humour and satire; the present essay represents an attempt to think through the problems from a different perspective, that is in relation to hermeneutics rather than aesthetics. See 'Pour une esthétique de l'obscène chez les troubadours', in *Atti del secondo congresso internazionale della AIEO*, ed. G. Gasco Queirazza, 2 vols (Turin, 1993), I, 101–17.

absent from courtly texts,[2] we might also consider the debates about euphem-
ism, such as the tongue-in-cheek section of the *Roman de la Rose* where Amant
chides Raison for using dirty words (which she does with relish) and is then
trounced by her in their argument about the value of courtly euphemism.[3]
Consider also these lines from Chrétien's *Charrete*, which immediately
precede the consummation of Lancelot and Guinevere's love[4]:

> mes toz jorz iert par moi teüe,
> qu'an conte ne doit estre dite.
> Des joies fu la plus eslite
> et la plus delitable cele
> que li contes nos test et cele.

> But that which should not be recounted in a tale will always be
> silenced by me. It was the most precious and delicious of joys that
> the tale silences and conceals from us.

Good courtly poets are not supposed to talk explicitly about sex or use rude
words.[5]

This is not to say, however, that the troubadour tradition is bereft of
obscenity. The satirical tradition contains high-profile and choice examples.
For instance, the widely disseminated lyrics of the influential twelfth-century
Gascon poet Marcabru (active between *c.* 1130 and *c.* 1150) are strewn with
obscenities that are deployed as part of his attack on the mores of the aristoc-
racy, who from his clerical perspective use courtly language as a cover for
their dissipated sexual practices[6]:

> Puois q'ieu vei qu'ella no·n crei chastiador,
> anz de totz malvatz pren patz cals l'a groissor?
> A la den torna soven la lenga on sent la dolor.

> Denan mei n'i passon trei al passador;
> no·n sai mot tro·l quartz la fot, e·l quinz lai cor;
> enaissi torn' a decli l'amors e torna en peior.

> Aquist con son deziron e raubador;
> tuit cill gartz i clamon partz et ill en lor:
> e qui mieills fa, sordeitz a, cum de l'agol' an pastur.

2 See below p. 90 and note 14.
3 I shall refer to Guillaume de Lorris and Jean de Meun, *Le Roman de la Rose*, ed. A.
 Strubel (Paris, 1992). For the passage in question, see 7102–38.
4 Chrétien de Troyes: *Le Chevalier de la Charrete*, ed. C. Méla (Paris, 1992), 4680–4.
5 See also the advice given to use only 'seemly' words in *cansos*: e.g. Raimon Vidal, *The
 Razos de Trobar of Raimon Vidal and Associated Texts*, ed. J. H. Marshall (Oxford, 1972),
 Razos, 451–3.
6 *Marcabru: a Critical Edition*, ed. S. Gaunt, R. Harvey and L. Paterson (Cambridge,
 2000), XXIV, 16–24.

> Since I see that she does not believe an instructor, rather she takes her pleasure with all evil men, who then has the biggest? The tongue is often drawn to the tooth where the pain is felt. / Three pass before me up the passage-way; before I know where I am the fourth fucks her and the fifth comes running up: thus love declines and gets worse. / These cunts are lusty and rapacious: all those ruffians demand their share, as do they of them: and a man who behaves best has the worst share, just as the shepherds have of the lamb.

On the one hand we should take this altogether typical misogynist and crude language in which women are spoken about as cunts, represented as whores with queues of men waiting to fuck them, and caricatured as only being interested in the size of a man's penis, simply for what it is: Marcabru was steeped in the worst forms of clerical misogyny. On the other hand, his use of obscenity interestingly points towards the theme I will take up in the next section, that is the sexually charged nature of all courtly discourse: Marcabru is not talking about whores and their tricks in the stanzas just quoted; on the contrary it is clear from context (as it is throughout his work) that he is attacking rather courtly ladies and their admirers. Often Marcabru's satire amounts to a gloss on the language of courtiers, their 'falsa razos daurada' ('false gilded speech') as he puts it.[7] His obscenity underscores a general, constantly repeated, point that the beguiling, seemingly respectable speech of these people is in fact a linguistic smoke screen for carnal desires and lewd acts. Marcabru's corpus is large and sits alongside the courtly canon in most of the major *chansonniers* as a counterpoint to, and demystification of, courtly language.

Not all obscenity in the troubadour tradition, however, has such a clear satirical point. There is a small surviving body of obscene or scatological comic material, and some of this material is helpfully brought together in an anthology by Pierre Bec, which contains some fifty lyrics, of which many are obscene.[8] There are some well-known highlights in this alternative tradition: the first troubadour, Guilhem IX's account of his sexual torture at the hand of two ladies and their monstrous red cat[9]; blood-thirsty Guilhem de Berguedà's scurrilous account of the sodomitical exploits of his alarmingly well-hung archbishop[10]; the so-called *affaire Cornilh*, which arises from a sequence of four poems in which the question debated is whether a knight who truly loves his lady should 'cornar lo corn' ('blow up her arse'), when she sets this

7 See S. Gaunt, *Troubadours and Irony* (Cambridge, 1989), p. 59 and *Marcabru* XXV, 24.
8 P. Bec, *Burlesque et obscénité chez les troubadours: Le Contre-texte au moyen âge* (Paris, 1984).
9 See *Guglielmo IX d'Aquitania: Poesie*, ed. N. Pasero (Modena, 1973), Poem V.
10 See *Guillem de Berguedà*, ed. M. de Riquer (Abadía de Poblet, 1971), Poem VII.

as the test of their love.[11] However, texts such as these are 'kept under the counter', as it were, in that they mostly survive in just one or two manuscripts, which are often not the canonical sources used by editors of major troubadours. They exist therefore on the margins of the tradition.

However, these overtly obscene texts are nonetheless part of the tradition and dependent upon it. Indeed, it is likely that a much larger body of such material once existed, but that it was not thought suitable for writing down alongside the more decorous work of the great troubadours. Nonetheless the dependence of this obscene material on the more canonical poetry does not stem simply from the fact that it survives – albeit sporadically – in the same manuscripts. Its reliance on the canon is much more profoundly *formal* in that often obscene lyrics will redeploy, mimic and parody forms and structures of the dominant tradition. This is what Pierre Bec means when he speaks of these lyrics as *contre-textes*.

An example of this formal mimicry of the dominant tradition is this *tenso* (debate poem), which follows the traditional pattern of alternating participating voices from stanza to stanza, and maintains the formal modes of address that are usual in *tensos* between men and women[12]:

> Eu venh vas vos, Senher, fauda levada,
> Qu'auzit ai dir c'avetz nom En Montan,
> C'anc de fotre non fui asazonada,
> Et ai tengut dos ans un capelan,
> E sos clergues e tota sa masnada;
> Et ai gros cul espes e tramejan
> E mager con [que] d'autra femna nada.

> Et eu vas vos, Domna, ab braga baissada,
> Ab mager viet de nuill ase en despan,
> E fotrai vos de tal arandonada
> Que los linçols tergeretz l'endeman
> – E pos diretz qu'ops i es la bugada;
> Ni mais no·m leu ni [mais] mei colhon gran
> Se tan no·us fot que vos jairetz pasmada.

> I come to you, my lord, with my skirt raised, / for I have heard that your name is Sir Stiffy / and have never been able to get enough fucking / even though I retained a chaplain for two years / his clerks and all his retinue; / and I have a juicy, round and buxom arse / and a bigger cunt than any other woman born.
> And I come to you, lady, with my pants down, / with a bigger

11 See Bec, *Burlesque*, nos 28–31. The *affaire Cornilh* has fascinated modern scholars and thinkers, medievalists and non-medievalists alike. For example, see J. Lacan, 'L'amour courtois en anamorphose', in *Le Séminaire VII: L'Éthique de la psychanalyse* (Paris, 1986), pp. 167–94.

12 Bec, *Burlesque*, no. 34, 1–14.

cock than any rutting donkey, / and I will fuck you so soundly that / you will need to change the sheets the next day / pretending that it is time to do the laundry; / and neither I nor my huge balls will leave / unless you have been fucked into a stupor.

The formal dependence of this obscene and comic poetry on the conventional canon (i.e. its use of the same stanzaic forms, rhyme schemes, modes of address etc.) is even clearer when we turn to the rare surviving obscene parodies of specific courtly lyrics, such as this imitation of a well-known lyric by Bernart de Ventadorn, whose quintessentially courtly style was to be widely imitated in Northern France and Germany[13]:

> Quan la freid' aura venta
> Deves vostre païs,
> Vejaire m'es qu'eu senta
> Un vent de paradis
> Per amor de la genta
> Vas cui eu sui aclis,
> On ai mesa m'ententa
> E mon coratge assis
> Car de totas partis
> Per leis, tant m'atalenta. (Bernart)

When the cold wind blows / from your land, / it seems to me that I feel / a wind coming from paradise / because of the sweet lady / before whom I bow, / in whom I have placed my faith / and with whom I have lodged my heart, / for I would leave all others / for her, so much does she please me.

> Quan lo petz del cul venta
> Dont Midonz caga e vis,
> Vejaire m'es qu'eu senta
> Una pudor de pis
> D'una orrida sangnenta
> Que tot jorn m'escarnis,
> Qu'es mais de petz manenta
> Que de marabodis
> E quan jatz [sus] son pis,
> Plus put d'autra serpenta. (parody)

When the fart blows from the arse / from which my lady shits and has the runs, / it seems to me as if I can smell / the aroma of piss / from a hideous hag / who always manages to trick me, / who is richer in farts than in jewels / and when she is lying in her piss / she stinks more than any other serpent.

[13] Ibid., no. 38.

However, as I have already noted, the use of overt obscenity in surviving troubadour lyric is rare. There are in fact only four instances of the word *viech* (prick/cock) in the entire corpus (one of which occurs in the Montan *tenso* cited above). Similarly, there are only thirty-two occurrences of the verb *fotre* (to fuck) in its various forms in the corpus, more than one-third of which come from the same poem, which plays endlessly on the radical *fot*.[14] There is apparently not a single incidence of this kind of obscenity in any courtly *canso*. Its language is, as I have said, on one level at least, beyond reproach.

Erotic poetics

On another level, however, this may not be the case. If, from the outset, there seems to have been a tacit prohibition on the use of obscene words in the *canso*, there seems equally to have been a tradition of reading the *canso* – and perhaps courtly language more generally – as shot through with obscene metaphors.

A clear, if prosaic and tongue-in-cheek, instance of this comes in the following interpolation to the *vida* (or biography) of Bernart de Ventadorn, at the point when we are being told about the famous troubadour's stay at the court of Eleanor of Aquitaine[15]:

> E apelava la Bernart 'Alauzeta', per amor d'un cavalier que l'amava, ella apelet lui 'Rai'. E un jorn venc lo cavaliers a la duguessa e entret en la cambra. La domna, que·l vi, leva adonc lo pan del mantel e mes li sobra·l col, e laissa si cazer el liech. E Bernart vi tot, car una donzela de la domna li ac mostrat cubertamen; e per aquesta razon fes adonc la cançon que ditz:
>
>> Quan vei l'alauzeta mover . . .
>> [De joi sas alas contra·l rai,
>> Que s'oblid' e·s laissa chazer . . .].

> And Bernard called her 'Alauzeta' [lark] because of a knight who loved her, whom she called 'Rai' [ray]. And one day the knight came to the duchess and entered her bedroom. The lady, when she saw him, raised the skirt of her gown and put it round his neck and then allowed herself to fall onto the bed. And Bernart saw all this, for one of the lady's maids had allowed him to spy upon her; and this is why he composed the song that says:
>
>> When I see the 'lark' move
>> its wings with joy against the ray [of sunlight]
>> so that it forgets itself and allows itself to fall

14 This data is drawn from the CD-ROM, P. T. Ricketts (with the collaboration of F. R. P. Akehurst, J. Hathaway and C. van der Horst), *COM: the Concordance of Medieval Occitan* (Turnhout, 2001).

15 Bec, *Burlesque*, no. 21.

'Can vei la lauzeta mover' is possibly the most successful of troubadour lyrics both in the Middle Ages and today: it survives in twenty-two manuscripts and was translated in the Middle Ages into a number of other languages. After the initial delicate and moving imagery of the lark so dazzled by the object of his desire that he falls into oblivion, the poet likens his lady's eyes to Narcissus's fountain and portrays himself as drowning in them. The poem ends with the poet again depicting himself as 'falling', only this time into a coterminous silence and exile. This is troubadour poetry at its most delicate and sophisticated. The spoof *vida*, however, misreads (deliberately, one assumes) the opening metaphor, since in the lyric it is fairly clear that the lark represents the lover, not the lady. The *vida* then goes on to produce an interpretation that is radically different from the one suggested by our usual apprehension of the lover as an agonized martyr to love. The *vida*'s scabrous reading is of course rather ridiculous, but it does show that seeking and finding obscene metaphors in troubadour poetry, proposing therefore obscene interpretations, is not simply a modern preoccupation.

Indeed, the spoof Bernart de Ventadorn *vida* makes interesting reading alongside the lines from Chrétien and the Marcabrunian satire I have already quoted. Chrétien, for example, may be read not as saying that he *expunges* sex and does not speak about it at all, but rather that he speaks about it indirectly, in an encoded and muted way. The verbs he uses, *taisir* and *celer*, may in fact suggest muted presence as much as absence. *Taisir*, for example, may mean 'to silence', but it can also mean 'to muffle the sound of' or 'to lower the volume of', while *celer* (to conceal) does not suggest that something is absent, but rather that its presence is concealed. And since, as Chrétien suggests, the greatest *joie* of all is concealed, his comment could be read as an invitation to seek out this *joie* in its hiding place. And whose *joie* does Chrétien have in mind when he writes '*nos* test et cele'[16] (my emphasis): that of the characters enjoying sex, or that of the readers reading about it? The concealing and yet finding of *joie*, in line with literary propriety, veers towards the hermeneutic process here, by which I mean the process of interpreting encoded or metaphoric language: hidden meanings will be concealed and then uncovered; these meanings will be sexual; they will give all concerned pleasure.[17] The pleasure associated with uncovering in Marcabru is of course different, but some of the same mechanisms are nonetheless at work in that courtly language is portrayed as by its nature containing sexual meaning which Marcabru's discourse then 'uncovers'.

The 'uncovering' of sexual meaning behind or underneath courtly

16 Chrétien, *Le Chevalier*, 4684.
17 On these lines see further, S. Gaunt, *Gender and Genre in Medieval French Literature* (Cambridge, 1995), pp. 99–100.

discourse is a preoccupation from the very beginning of the troubadour tradition, as we see in this lyric by Guilhem IX, the first troubadour[18]:

I Ben vueill que sapchon li pluzor
 d'un vers, si es de bona color,
 qu'ieu ai trat de bon obrador;
 qu'ieu port d'aicel mester la flor,
 et es vertatz, 5
 e puesc ne trair lo vers auctor,
 quant er lasatz.

I indeed want people to know whether my *vers*, which I have brought out of a good workshop, is of a good colour; for I bear the flower in this craft, and this is true, and I can summon the *vers* as proof of this when it is laced up.

II Eu conosc ben sen e folor,
 e conosc anta et honor,
 et ai ardiment e paor; 10
 e si·m partetz un joc d'amor,
 no soi tan fatz
 no sapcha triar lo meillor
 d'entre·ls malvatz.

I am well aware of the difference between sense and folly, and know shame and honour, and feel boldness and fear; and if you propose a game of love to me, I'm not so simple-minded as not to know how to choose the better from the bad ones.

III Eu conosc be sel que be·m di 15
 e sel que·m vol mal atressi;
 e conosc be celui que·m ri,
 e sels que s'azauton de mi
 conosc assatz:
 e atressi dei voler lur fi 20
 e lur solatz.

I well recognize one who speaks well of me, and similarly the one who wishes me ill; and I am well aware of the one who smiles at me, and I know very well indeed those who take pleasure in my company: and similarly I ought to desire their trust and their conversation.

IV Ben aia cel que me noiri,
 que tan bon mester m'escari
 que anc a negun no·n failli:
 qu'ieu sai jogar sobre coisi 25
 a totz tocatz;
 mas no sai de nuill mon vezi,
 qual que·n vejatz.

Blessed be the one who brought me up, for he endowed me with such a good craft that I never failed anyone in it: for I know how to play all pillow games; I know more about it than any of my neighbours, however it may seem to you.

V Deu en laus e saint Julia:
 tan ai apres del joc doussa 30
 que sobre totz n'ai bona ma;
 ja hom que conseill me querra
 no l'er vedatz,
 ni nuils de mi non tornara
 desconseillatz. 35

I praise God and St Julian that I have learned so much of the sweet game that I have a better hand than anyone; if ever any man asks me for advice, he will not be refused it, and no-one will turn away from me deprived of counsel.

VI Qu'ieu ai nom maistre certa:
 ja m'amigu' anueg no m'aura
 que no·m vueill' aver l'endema;
 qu'ieu soi be d'est mester, so·m va,
 tant ensenhatz 40
 que be·n sai gazanhar mon pa
 en totz mercatz.

For my name is 'expert master': my girlfriend will never have me at night without wanting to have me the next day; for I can boast that I am so skilled in this craft that I know how to earn my bread in all markets.

[18] *Guglielmo IX*, ed. Pasero, Poem VI.

VII Pero no m'auzes tan gaber
 qu'ieu no fos rahuzatz l'autrer,
 que jogav' a un joc grosser 45
 que·m fo trop bos al cap primer
 tro fo entaulatz;
 quan gardei, no m'ac plus mester,
 si·m fo camjatz.

Yet despite such boasting I was defeated the other day, when I was playing a coarse game which went very well for me at first until it was set out on the table; then when I looked, I was of no service any more, the game had so changed for me.

VIII Mas ela·m dis un reprover: 50
 'Don, vostre datz son menuder
 et ieu revit vos a dobler!'
 Fis·m ieu: 'Qui·m dava Monpesler
 non er laisatz!'
 e levei un pauc son tauler 55
 ab ams mos bratz.

But she reproached me thus: 'Sir, your dice are too small, and I invite you to double your stake!' Said I: 'I'll not fail, even if I were given Montpellier instead!', and I lifted her table a little with both my arms.

IX E quan l'aic levat lo tauler
 espeis los datz:
 e·l dui foron cairat nualler,
 e·l tertz plombatz. 60

And when I had lifted her table I cast the dice: and two of them were shapely, and the third weighted.

X E fi·ls ben ferir al tauler,
 e fon jogatz.

And I threw them hard onto the table, and the game was played.

Of course the last stanzas here are all rather obvious: it is the first few stanzas and how we might read them in the light of what follows that interest me. The first few stanzas are a boast of poetic prowess, the sort of poetic boasting poem or *gap* that will become standard as the tradition advances. Guilhem's knowledge and deployment of Latin rhetorical terminology in stanza I suggest a poet well aware of his craft: consider the rhyming of 'color' and 'flor', the metaphor of the workshop and therefore of the poet as craftsman or as 'weaver of words' (suggested by 'lasatz' in the last line), and also the use of the term 'auctor', which in Occitan probably has learned overtones.[19] To the assertion of poetic craft and refinement is added, in stanzas II and III, a claim to discernment, and if 'joc d'amor' may hint at what is to come, the expression *partir un joc d'amor* may be poetic rather than erotic, suggesting an invitation to compose love poetry, since a *joc partit* is in fact a type of poem at a later stage in the tradition.

The scabrous, seamily sexual thread in this poem does not in fact surface explicitly until line 25 in the middle of stanza IV, when 'jogar sobre coisi' ('pillow games') seems unambiguous. Similarly, the 'joc doussa' ('sweet game') in line 30 is clearly sexual, and if any listeners or readers had really not yet got the point, their doubts would surely be dissipated by the reference to 'my girlfriend at night' in stanza VI, by the 'joc grosser' ('coarse game') in stanza VII and by the crude gaming metaphors. There are no obscene words

[19] On this stanza, see L. T. Topsfield, *Troubadours and Love* (Cambridge, 1975), pp. 14–15.

here, but the sexual content is nonetheless obvious, its concealment designed to be humorous and revealing rather than mysterious. So the poetic boast has become an erotic boast (albeit a humorous, self-deprecating one). But does an erotic boast displace a poetic boast here, or are they rather two sides of the same coin?

Guilhem in fact seems to suggest that the poetic and the erotic in this poem are part of the same impulse by his use of the word 'mester' ('craft' or 'profession') to designate both: see lines 4 (where he is clearly talking about poetry), 23 (where the referent is indeterminate but could, by this stage in the poem, be either), and 39 (where clearly he is talking about sex).[20] It may also be significant that in proximity to this last use of the word 'mester', the poet designates himself as 'maestre certa' and describes himself as 'ensenhatz' ('expert master'). These are both terms that would more normally be associated with rhetoric and poetics, but which here are clearly used to describe the poet's sexual prowess.

The leakage of one semantic field into another (the poetic or rhetorical into the sexual) surely invites us to read stanzas I–III retrospectively in the light of the end of the poem so that the rhetorical terms of stanza I become indeterminate sexual metaphors, while the sexual metaphors of the end then serve as a demonstration of the poet's command of poetic craft. The play of meaning and the sexual play become profoundly imbricated and we end up with various types of 'play' at play in this poem: the poetic ('joc d'amor'), the erotic ('jogar sobre coisi'), the amorous ('joc doussa'), the crudely sexual ('joc grosser'), and gaming ('e fon jogatz'). It becomes impossible to keep them separate. The generation of layers of meaning thus becomes a playful libidinal activity while the uncovering or peeling back of these layers of meaning by Guilhem's audience – whether these be listeners or readers – is also implicitly portrayed as pleasurable. Since pleasure in this poem is always implicitly, but ambiguously sexual, hermeneutics becomes erotic.

Guilhem's poem lays down a marker, as it were, for an important seam in subsequent troubadour poetry, both in terms of poetics and its eroticization. But should poetry such as this be considered obscene? Clearly there are no obscene words. And yet the sexual content of such a poem is perhaps more dangerous (if one is minded to consider sexual content dangerous) than that of a text like the Montan *tenso*, in that it is present and yet concealed at the same time. Indeed, to appreciate (or indeed to attack) a poem such as this as obscene is to admit to having a mind that works in the same way as those that enjoy it, since one has decoded it for oneself, while the processes in which the poet and his listeners/readers are implicated raise the possibility that the kind of semantic indirection in which the poem indulges may be more interesting, perhaps more titillating than outright obscenity. Moreover, obscene

[20] The connotations of *mester* may therefore be something like 'on the job'.

metaphors sometimes seem to enable more outrageously detailed descriptions of sex than the use of explicit sexual language.

This is certainly the implication of other examples of extravagant sexual metaphors in medieval texts. Consider, for example, the fabliau, *La Damoisele qui ne pooit oïr parler de foutre*,[21] and then the *Roman de la Rose*. In the former, a damsel and her partner get each other worked up by constructing elaborate sexual allegories involving horses grazing in meadows and drinking at fountains, while avoiding at all costs dirty words, since these make the damsel faint. This is juxtaposed with the narrator's crude language. But whereas the narrator's prosaic account of the sexual act lacks detail (204: 'A tant li met el con lo vit', 'he shoves his prick in her cunt'), the allegory constructed by the characters gives us a detailed topography of their genitals, their movements, their speed and so on. It gradually emerges that it is not sex that the damsel so dislikes (as had been implied at the beginning of the fabliau), but rather a particular way of talking about it; indeed, she clearly finds talking about sex metaphorically arousing. *De la damoisele* is thus not simply a satire on courtly euphemism, it is a shrewd, and very funny, text about the social and erotic effects of different ways of talking about sex.

Similarly, the *Roman de la Rose*, while on one level possibly eschewing explicit sexual language, *invites* its readers to interpret it as a sexual allegory, in which case the conclusion offers us an astonishingly detailed account of sex – probably even rape – and possibly not just the vanilla sex of which Nature and Genius approve: when treacherous Faus Semblant and Astinence Contrainte enter the castle in which the Rose is hidden, they do so by 'a secret and small back door' which La Vieille tells them about, and the lover, when entering the Rose's 'sanctuary' at the end bows down and kisses, in a lingering manner, 'relics', which may be significant in that 'relics' have been specifically marked as an alternative word for *coilles* (balls) at an earlier stage.[22]

Thus sexual metaphor or 'euphemism' (if this is the right word) can indeed be as obscene as overt obscene language. But there is more at stake in troubadour poems such as the lyric by Guilhem that I have just examined. If sexual metaphor is indeed pleasurable and possibly *more* titillating than explicit obscenity, then this points us towards language rather than the body as being the site of desire, suggesting, as Jacques Lacan and others have argued, that desire and indeed the social manifestations of our sexual drives are generated and driven by our being caught up in the signifying chain, in other words that desire is generated and driven in and by language.[23]

21 See *Fabliaux érotiques*, ed. L. Rossi and R. Straub (Paris, 1992), pp. 92–105.
22 See S. Gaunt, 'Bel Acueil and the improper allegory of the *Roman de la Rose*', *New Medieval Literatures* 2 (1998), 65–93.
23 See, for example, J. Lacan, *Le Séminaire livre II: Le Moi dans la théorie de Freud et dans la technique de la psychanalyse*, 2nd edn (Paris, 2001), p. 308: 'Les relations entre les êtres

This is certainly the implication of the playful erotic grammars that occur in many languages in the Middle Ages. In this Occitan example, copulating bodies are figured by copulating words; corporeal and sexual morphologies are figured by verbal morphologies; passion and reproduction are analogous to the power of *langue* to generate *paroles*, sexual couplings are analogous to grammatical structures[24]:

Pelh beutat nominativa,		Because of your nominative beauty and
Que avetz, e·lh gran valor,		your great worth, oh lady of genitive
Dona, de pretz genetiva,		renown, anyone who thinks that you will
Mal cuja de ma dolor		be dative with me thinks ill of my pain,
Crezens que·m seretz dativa,	5	fair one, and of your power since you are
Bella, de vostra ricor,		not accusative towards me on the advice
Pois non m'es acusativa		of men given to accusations.
Per conseil d'acusador.		
E s'ieu ja, bella, tan valh		And if, fair one, I am sufficiently worthy
Ch'amdui sïam conjuntiu,	10	for us to conjugate and for our true
Nostre ferm cor optatiu,		hearts to be optative, I would then not
Pois non prezarai un alh		care a fig about those of active disposi-
Cels, c'ab voluntat activa		tion who seek to harm and damage me
Pauzan contra mi error		and put all their energy into making our
E pugnon che disjuntiva	15	true love disjunctive.
Sia nostra fin' amor.		
Fama es indicativa		Fame is indicative of joy following
Que ven gaugs apres dolor,		sorrow, which is why my heart feels so
Don mon cor se' n substantiva		substantively that my pain decreases.
Tan que n'ai mon mal menor.		When our love becomes copulative and
Quan sera copulativa	20	cherished, I will no longer suffer from
Cartenguda nostr'amor,		being passive. I speak the truth, so why
Ja non er de mal passiva.		should I be afraid?
Ieu dich ver; per qu'ai paor?		
E car etz nominativa,		And since you are nominative, I would
volgr' aver un genetiu	25	like to have a genitive with you, since
de vos, qui es imperativa!		you are imperative!

The structure of language thus becomes a way to think about how desire is structured.

humains s'établissent vraiment en deçà du champ de la conscience. C'est le désir qui accomplit la structuration primitive du monde humain, le désir comme inconscient.' This statement needs to be read in the light of Lacan's repeated equation of the unconscious with language, for instance see J. Lacan, *Le Séminaire livre IV: La Relation d'objet* (Paris, 1994), p. 431.

24 Bec, *Burlesque*, no. 25.

Obscene hermeneutics

Of course there are plenty of other examples of this in medieval culture. An obvious Old French example is the elaborate metaphor of writing 'properly' in Jean de Meun's part of the *Roman de la Rose*, in which linguistic and sexual 'propriety' are imbricated, though the imprecation to write 'properly' (that is with respect for literal meaning) is confounded by the fact that Jean's own writing seems so 'improper' by this definition.[25] In the troubadour tradition, the eroticization of the hermeneutic process is overtly theorized from the mid-twelfth century in and through debates about the so-called *trobar clus* and *trobar leu*, the 'closed' or 'easy' styles of poetry.[26]

To the extent that it is possible to define the *trobar clus*, it is an hermetic, 'closed' style of poetry, characterized by difficult rhymes and rare sounds; its execution often seems to involve rhetorical embellishment and different levels of meaning – sometimes three for obvious reasons – that are slowly revealed during the course of the lyric.[27] Unsurprisingly, the final layer of meaning sometimes turns out to be erotic rather than ethical or moral, as in the Guilhem IX lyric examined above.

One of the most extensive commentators on the *trobar clus* is Raimbaut d'Aurenga, who died in 1162 and whose corpus as a whole is riddled with smutty innuendo. He is most adept at what I am calling obscene hermeneutics:[28]

I	Una chansoneta fera	I would willingly compose a little song
	Voluntiers laner' a dir;	to be sung in a vile way, but I am afraid
	Don tem que m'er a murir	that this would be the death of me and so
	E far l'ai tal que sen sela,	I will compose it in such a way that it
	Ben la poira leu entendre 5	conceals meaning, but it will be easily
	Si tot s'es en aital rima;	understood even if it is written in such a
	Li mot seran descubert	rhyme; the words will be uncovered for
	Al quec de razon deviza.	those who are good at discerning a theme.
II	Bo·m sap car tan m'apodera	I like this because my heart so controls
	Mos cor que non puesc sufrir 10	me that I cannot but uncover my desire;
	De mon talan descubrir;	for now it rises to its full extent (whom-
	C'ades puech a plena vela	soever sees their own joy deflating),

25 See *Roman*, 7059–238 and Gaunt, 'Bel Acueil', pp. 87–93. Jean is drawing, of course, on Alan of Lille.

26 On the *trobar clus* and *trobar leu*, see most recently S. Spence, 'Rhetoric and hermeneutics', in *The Troubadours: An Introduction*, ed. S. Gaunt and S. Kay (Cambridge, 1999), pp. 164–80 (pp. 171–6).

27 See L. Paterson, *Troubadours and Eloquence* (Oxford, 1975), pp. 207–12.

28 Cited from *The Life and Works of Raimbaut d'Orange*, ed. W. T. Pattison (Minneapolis, 1952), Poem III.

(Qui que veya joy dissendre)	which is why I can find nothing to
Per que no·y puesc nulh' escrima	conceal it; rather I have suffered too
Trobar; ans m'ai trop sufert 15	much from having allowed my conquest
De far parer ma conquiza.	to be seen.

This song mixes signals concerning the hermetic and more transparent styles irreverently. Raimbaut's song will be easy, but on the other hand it will conceal its true meaning, which will be uncovered only by those well-equipped at 'reading'. The appeal to the discerning audience who will realize what a song is *really* about is absolutely typical of troubadour poetry from the outset (for instance in Guilhem IX). But what is being concealed and what will be uncovered here? Raimbaut labours the notion of uncovering in this poem with the repetition of the word *descobrir* (lines 7 and 11). He also stresses the image of rising and falling and his own inability to conceal something, which is coyly, possibly euphemistically, referred to as his 'talan', his desire. Subsequent references in the poem to the poet's 'night-service' (lines 33–5) and to his need to please the lady with 'my body' (lines 41–2) might suggest retrospectively that what the poet is in fact unable to conceal here, his desire that is risen to its full extent is in fact an erection. The allusive language suggests a high-minded and serious love song, but there is at last the possibility that this is a cover for something quite different.

Although he does not use the *clus/leu* terminology much himself, one of the foremost practitioners of the *trobar clus* is thought to be Arnaut Daniel.[29] I myself doubt whether many troubadours ever theorized the *trobar clus* as seriously as modern scholars have done,[30] but it is clear that Arnaut is an enthusiastic practitioner of hermetic poetry, as we see when we turn to his famous *sextina*.[31]

A *sextina* is a poem made up of six six-line stanzas. Throughout the poem six rhyme words move position following a set pattern so that each occupies each possible position in the course of the lyric.[32] In this instance, the words are 'intra' ('enters'), 'ongla' ('fingernail'), 'arma' ('soul', but also possibly 'weapon'), 'verga' ('rod', but also 'virgin'), 'oncle' ('uncle') and 'cambra' ('chamber') and the pattern is determined in part at least by the fact that the stanzas are *capcaudadas*, which means that the last rhyme word of each stanza becomes the first of the next. Throughout the twelfth century the troubadours indulge in complex formal experimentation and this form – the *sextina* –

[29] See Paterson, *Troubadours*, pp. 193–201, 202–6.

[30] See Gaunt, *Troubadours*, pp. 122–6, 167–78; also S. Gaunt and J. Marshall, 'Occitan grammars and the art of troubadour poetry', in *The Cambridge History of Literary Criticism: II The Middle Ages*, ed. A. Minnis (Cambridge, 2005), pp. 472–95 (pp. 473–82).

[31] I refer to *Arnaut Daniel: canzoni*, ed. G. Toja (Florence, 1960), Poem XVIII.

[32] On the form, see A. Roncaglia, 'L'invenzione della sestina', *Metrica* 2 (1981), 3–41 and L. Lazzerini, *Letteratura medievale in lingua d'oc* (Modena, 2000), pp. 117–18. It is quite likely that Arnaut invented the form.

represents troubadour art at its most elaborate. Arnaut's small surviving corpus of lyrics has other examples of technical wizardry, but 'Lo ferm voler' is nonetheless the best example of his proclivity for fiendish formal complexity. Commentators agree that the *sextina* seeks to weave together different levels of meaning, most notably the spiritual and the erotic, even if they disagree on the extent to which the content of this opaque lyric is subordinate to form:[33]

I Lo ferm voler q'el cor m'intra
no·m pot ies becs escoissendre ni ongla
de lausengier, qui pert per mal dir s'arma;
e car non l'aus batr' ab ram ni ab verga,
sivals a frau, lai on non aurai oncle, 5
iauzirai ioi, en vergier o dinz cambra.

The firm yearning that enters my heart cannot be torn apart by the beak and nail of a slanderer, who loses his soul through calumny; and since I dare not beat him with switch or rod, unless in secret, there where there will be no uncle I'll delight in joy, in an orchard or in a chamber.

II Qan mi soven de la cambra
on a mon dan sai que nuills hom non intra,
anz me son tuich plus que fraire ni oncle,
non ai membre no·m fremisca, neis l'ongla, 10
aissi cum fai l'enfas denant la verga:
tal paor ai no·l sia trop de l'arma.

When I remember the chamber where, to my misfortune, I know that no man enters, but rather all are more to me than brothers or uncles, I have no part of me that does not tremble, even the nail, just as the child does before the rod: I fear so much I shall be hers too much in soul.

III Del cors li fos, non de l'arma,
e cossentis m'a celat dinz sa cambra!
Que plus mi nafra·l cor que colps de verga 15
car lo sieus sers lai on ill es non intra;
totz temps serai ab lieis cum carns et ongla,
e non creirai chastic d'amic ni d'oncle.

Would that I were hers in body and not in soul, and that she allowed me secretly into her chamber! For it wounds my heart more than blows from a rod that her servant does not enter where she is; I'll be with her for ever like flesh and nail, and pay no heed to reproof of friend or uncle.

IV Anc la seror de mon oncle
non amei plus ni tant, per aqest'arma! 20
C'aitan vezis cum es lo detz de l'ongla,
s'a liei plagues, volgr' esser de sa cambra;

I never loved my uncle's sister more or as much, by this soul! For as close as the finger is to the nail, if it pleased her, I should like to be of her chamber;

33 Roncaglia, 'L'invenzione', sees Arnaut's *sextina* primarily as formal experimentation. The erotic dimensions of the lyrics are stressed by C. Jernigan, 'The Song of Nail and Uncle: Arnaut Daniel's Sestina "Lo ferm voler qu'el cor m'intra"', *Studies in Philology*, 71 (1974), 127–51 and R.C. Cholakian, *The Troubadour Lyric: a Psychocritical Reading* (Manchester, 1990), pp. 138–47. Paterson, *Troubadours*, pp. 193–201, concentrates on the interweaving of different levels of meaning. Lazzerini, *Letteratura medievale*, pp. 118–21, stresses the religious imagery. Meanwhile, Michelangelo Picone, ' "Versi . . . di romanzi": Una lettura semantica della sestina di Arnaut Daniel', in *'Canterem d'aquestz trobadors': studi occitanici in onore di Giuseppe Tavani*, ed. L. Rossi (Alessandria, 1995), pp. 113–26, argues that Arnaut's poem stages a conflict between lyric and romance horizons of expectations by concentrating on the obstacle (the 'oncle') to the satisfaction of the poet's desire, but his *lettura semantica* contains virtually no consideration of form.

de mi pot far l'amors q'inz el cor m'intra
mieills a son vol c'om fortz de frevol verga.

> the love which enters my heart can do
> more with me according to its will than
> a strong man can do with a frail rod.

V Pois flori la seca verga 25
 ni d'en Adam mogron nebot ni oncle,
 tant fin' amors cum cella q'el cor m'intra
 non cuig fos anc en cors, ni eis en arma;
 on q'ill estei, fors en plaz', o dins cambra,
 mos cors no·is part de lieis tan cum ten
 l'ongla. 30

> Since the dry rod blossomed and from
> Adam sprang forth nephews and
> uncles, such a fine love as the one that
> enters my heart never was, I believe, in
> body or in soul; wherever she/it is, in
> the open square or within a chamber,
> my heart does not leave her a nail's
> length.

VI C'aissi s'enpren e s'enongla
 mos cors en lei cum l'escorss' en la verga;
 q'ill m'es de ioi tors e palaitz e cambra,
 e non am tant fraire, paren ni oncle:
 q'en paradis n'aura doble ioi m'arma, 35
 si ia nuills hom per ben amar lai intra.

> For my heart/body grafts and implants
> itself in her like the bark on the rod; for
> she is my tower and palace and
> chamber of joy, and I love neither
> brother, parent nor uncle so much: for
> in paradise my soul will have double
> joy, if ever a man enters there for
> loving well.

VII Arnautz tramet sa chansson d'ongle' e
 d'oncle,
 a grat de lieis que de sa verg' a l'arma,
 son Desirat, cui pretz en cambra intra.

> Arnaut sends his song of nail and uncle
> for the pleasure of her who has the soul
> of his rod, his Desired One, whose
> reputation enters the chamber.

Clearly this text revels in opacity. One way of reading such a poem is to begin with the form and therefore to follow each of the rhyme words through the poem.[34]

'Intra' – the only one of the rhyme words to be a verb form, indeed the third person present indicative of *intrar* (to enter) – occurs three times in the collocation 'el cor m'intra', twice in 'non intra', then 'lai intra' and finally 'dins cambra intra'. Thus three times it is Arnaut who is entered: by the 'ferm voler' (1), by 'amors' (23) and 'fin'amors' (27). Twice he is prohibited entry, implicitly by his 'uncle', or by someone designated metaphorically as such (8, 16): finally he enters Paradise and the 'chamber'.

The 'oncle' ('uncle') prohibits (stanzas I and II), and this is implicitly associated with the *lauzengiers*, the slanderers who police and prohibit the desire and pleasures of courtly lovers.[35] Joy is only possible in the place where uncle is not (5–6); the uncle is seen in relation to a mother figure (19) and kin-group; his authority is to be challenged (34) in that loyalty to him must be subordinated to love. As Rouben Cholakian suggests, the uncle might be viewed as a father figure within an Oedipal scenario.[36] Associated with prohibition as he is, he also repre-

[34] Paterson, *Troubadours*, pp. 199–201, proposes this approach.

[35] On the *lauzengiers*, see S. Kay, 'The Contradictions of Courtly Love and the Origins of Courtly Poetry: the Evidence of the *Lauzengiers*', *Journal of Medieval and Early Modern Studies* 26 (1996), 209–53.

[36] Cholakian, *Troubadour Lyric*, p. 141. On this point, see also R. Dragonetti, 'The double play of Arnaut Daniel's Sestina', in *Literature and Psychoanalysis. The Question of Reading:*

sents a threat of castration, the wielder of the rod ('verga') that will punish the desiring subject if his desire is not regulated.

'Verga' is one of the two most semantically ambivalent of the six rhyme words. It can mean rod, which is also slang for the penis (as in modern French *verge*), but at the same time it is a homonym for virgin.[37] In Cholakian's psychoanalytic reading, then, the child trembling before the 'verga' in line 11 could be the child trembling before the primal scene of his parent's sexual relations and the threat of castration that the father's sexual potency represents. 'Colps de verga' (15, 'blows from the rod') is then ambiguous. If 'verga' is not only a rod/penis, but also the phallus (that is the symbol of the father's authority), it is not then clear whose 'rod' is at issue here. In line 25 the 'seca verga' ('dry rod') that flowers could evoke the virgin, with 'dryness' connoting infertility and therefore virginity, but with 'flowering' suggesting fruitfulness. In the *tornada* (shorter final stanza), it is the poet's lady, here rendered masculine by the *senhal* (or code-name) 'son Desirat', who seems to possess the poet's own *verga* and who therefore seems to have appropriated the phallus.[38]

The other semantically ambivalent of the six rhyme words is 'arma'. As Linda Paterson suggests, its most obvious meaning is 'soul', but this sense is nonetheless unusual in Occitan.[39] Cholakian, following Jernigan, suggests another sense: *arma*, derived from *armar* can mean 'weapon'.[40] *Arma* 'weapon', if implied, has a clear sexual sense related to the connotations of *verga*. This would collapse the apparent opposition of line 13 ('Del cors li fos, non de l'arma'), as 'arma' would not then be opposed to body, but on the contrary would be the most sensual part of the body (i.e. as a metaphor for the penis). This would also render tautologous line 38 where 'verga' and 'arma' could mean the same thing.

But if 'verga' and 'arma' are ambivalent, both mean neither one thing nor the other, but rather both at the same time. The same ambivalence may occur with 'cambra': on the one hand the 'cambra' would seem to be the erotic *locus amoenus* (6, 7, 14),[41] on the other it is used in a way that is analogous to the metaphoric use of buildings to denote the Church's power to protect the faithful: in the 'cambra' the lover will be protected (22); it is a stronghold (33),

Otherwise, ed. S. Felman (Baltimore, 1982), pp. 227–52 (pp. 238–45). Roncaglia ('L'invenzione', p. 33), Picone ('Lettura semantica', pp. 118–21) and Lazzerini (*Letteratura medievale*, pp. 118–19) all see in the *oncle* a reference to the Tristan story and/or to Chrétien de Troyes' *Cligès*.

37 See Jernigan, 'Song of Nail and Uncle', p. 132 for the former; Paterson, *Troubadours*, p. 197 and Picone, 'Lettura semantica', pp. 121–2 for the latter.

38 On the *senhal* Desirat used by Arnaut and other troubadours, see S. Kay, 'Desire and Subjectivity', in *The Troubadours: An Introduction*, pp. 212–27.

39 Paterson, *Troubadours*, p. 197.

40 Cholakian, *Troubadour Lyric*, p. 140; Jernigan, 'Song of Nail and Uncle', pp. 133–4.

41 For Jernigan ('Song of Nail and Uncle', p. 132) and Cholakian (*Troubadour Lyric*, pp. 141–2) the 'cambra' connotes the beloved's sexual organs.

comparable to the *hortus conclusus* of the Song of Songs, which also, of course, is ambiguous in its figuring of Christ's relation with the Church as a physical love affair. The final implied wish to enter the 'cambra' with his 'Desired one', perhaps desire itself, could therefore evoke alternatively an idea of penetration thanks to the lover's 'ferm voler', or perhaps an image of a spiritual stronghold, figured by proximity to the beloved (lady or Christ), which in turn is figured throughout by the 'ongla', the nail.

Arnaut Daniel thus exploits here an ambivalent metaphoric field that is also exploited in a good deal of medieval religious writing. The *sextina* ends on a note of profound ambiguity. Has he used erotic language to enrich a spiritual message, or does he conclude by suggesting that profane love or more particularly the sexual union with the beloved (31–2) can allow one to enter heaven, and if so is this 'Paradise' the Christian paradise, an alternative vision of it, or simply a sexually induced oblivion? Is this a serious poem about the transcendental possibilities of love, in which case is this love physical or spiritual? Or is the whole poem a laboured, elaborate joke about having an erection, since the poet's 'ferm voler', which I have translated as 'firm yearning', could also be rendered 'hard desire'?

This ambivalence is no doubt deliberate, and there are a number of ways of thinking about this. First, ambivalence serves to evade the policing of desire, which may be construed both politically or psychoanalytically. Secondly (though this is not unrelated), Arnaut's ambivalence can be considered in relation to poetic prowess. Finally, it encourages reflection on the obscene nature of desire and hermeneutics generally.

I have already mentioned the importance of the *lauzengiers* and the uncle figure in this lyric. In contemporary court culture the poet's rivals and his *segner* would represent powerful figures of prohibition, thwarting his desire; in psychoanalytic terms, we might think of the Uncle here as the Other, the super-ego, who prohibits and regulates desire, channelling it into socially acceptable forms and away from that which is prohibited. Ambivalence is then important in relation to the way that desire is policed for two reasons. First, because ambivalence is a way of escaping control, of eluding the censorship or attempt at circumscription constantly sought by the *lauzengiers* and the 'uncle'. Secondly, because ambivalence shows how what we think we want is never what we really want: in other words, when we seek oblivion in physical pursuits (such as the erotic) what we really seek may be something else, such as power, recognition or spiritual enlightenment.

This relates to poetic prowess in that Arnaut revels in deliberate ambiguity and difficulty here. There is a strong, I would suggest, libidinal investment in language in this poem, a desire to possess and dominate it, to produce an excess of abundant meaning that is in some respects at odds with the rigid control implied by the form. The poem engages in a kind of linguistic *jouissance* that is comparable to the sexual or spiritual *jouissance* the lyric often seems to evoke.

However, if *jouissance* is used with its full Lacanian sense, the idea of *jouissance* being contained is oxymoronic. *Jouissance* entails a complete break-down of meaning; it is a destructive force that completely dissolves the self as inscribed in the symbolic order of language.[42] Lacan's theory of *jouissance* is closely related to the death drive, which for Freud lies beyond the pleasure principle: from within language *jouissance* can only be glimpsed and its partial symbolization in language becomes an ambiguous *lure* in that it both beckons us towards *jouissance*, while also holding it at bay.[43] This is precisely how the tension between the excessive surfeit of meaning that translates into possibly meaningless opacity and the rigid form of a poem like 'Lo ferm voler' works. But let's not forget the body in all of this since Arnaut's poem is nothing if not profoundly corporeal and physical with its rods, nails, weapons, penetrations and bedrooms.

In a tantalizing passage towards the end of *Encore*, one of his most gnomic and difficult seminars, Lacan talks about the function of obscenity in Christian culture. His starting point is what he considers to be Christianity's obsession with representing the body, starting with Christ's. Christian culture produces, he says, an 'orgy' of exhibited bodies that evoke *jouissance* – thus, for example, the cover of *Encore* shows Bernini's 'The ecstasy of Saint Teresa' upon which Lacan comments at various points in his seminar. But what is always *excluded* from this orgy of bodies is copulation: 'Elle est aussi hors champ qu'elle est dans la réalité humaine, qu'elle sustente pourtant des fantasmes dont elle est constituée.'[44] This ubiquitous *exclusion* points for Lacan to the fundamental *obscenity* of Christian art, which is characterized by a prurient obsession with the body that forecloses copulation while creating an unhealthy preoccupation with an *amorous pleasure* that is nonetheless grounded in representations of the body. Lacan punningly calls this the *dit-mension de l'obscénité*, by which I take him to be alluding to the way this preoccupation with the body as the site of necessarily thwarted desire is trapped in the dimension of speech (*dit* + *mention*) and other forms of representation. This resonates with his description of courtly love, which he sees as simultaneously sustained and thwarted by a desire that has discourse as both its origin and destination. The point is that courtly love is a mechanism not to fulfil desire, but to perpetuate it through sublimation.

In this account, as in Arnaut's lyric, human desire gets fatally caught up in the mechanisms of language, as if in a spider's web. If the *relation sexuelle* is evoked, its representation means that this is done indirectly and opaquely. It

42 See Lacan, *Ethique*, pp. 225–7 and J. Lacan, *Encore: Le Séminaire livre XX* (Paris, 1975), pp. 9–22.
43 Sigmund Freud, 'Beyond the Pleasure Principle', in *On Metapsychology: the Theory of Psychoanalysis* (*The Penguin Freud Library* 11), ed. A. Richards, trans. J. Strachey (London, 1984), pp. 269–338.
44 Lacan, *Encore*, p. 144.

is not confronted directly, but displaced and screened off, with enjoyment/*jouissance* sublimated into the deferred pleasure of metaphor and linguistic play and in some ways rendered impossible outside this sublimation. Arnaut's poem, it seems to me, is a good example of what Lacan means by *la dit-mension de l'obscénité*. And if it is true that sexual urges in Christian culture – or courtly love – are sublimated discursively into spiritual quests and that this affects profoundly the way the troubadours talk about love and their poetic practice and theory, then the fact that sex is not spoken about explicitly in the troubadour lyric may occlude quite another picture of the surviving corpus: if the troubadours do not talk about sex explicitly, one could nonetheless claim that their penchant for metaphor in fact means that they rarely talk about anything else and that often their poetic practice is therefore *intrinsically* obscene despite the superficial lack of obscenity because it obsesses about the representation of the sexualized body while simultaneously and necessarily excluding copulation. And once their audience – including us – is drawn into the hermeneutic process of interpreting their texts sexually, we too become caught up in this spider's web.

John Skathelok's Dick:
Voyeurism and 'Pornography' in Late Medieval England

Jeremy Goldberg

Among the most valuable sources available to the social historian of the English later Middle Ages are the records of the church courts. The Church enjoyed jurisdiction over a range of matters – the probate of wills, defamation, sexual conduct, marriage, to name the most obvious – that impinged directly and even intimately on the lives of the laity. Some of the business was *ex officio*, that is the church courts acted in a policing function, as in respect of presentments for fornication and adultery; this has tended to generate only fairly bald records in the form of act books. Disputes about alleged defamatory words or the validity of marriage, however, were liable to be initiated by an aggrieved party. In such private litigation, known as instance actions as opposed to court-initiated *ex officio* actions, evidence was taken from witnesses called by the plaintiff and defendant respectively. Sometimes the resultant depositions were recorded in a special book used over a period of time, sometimes on individual membranes relating to specific cases. Unfortunately much of this material has been lost. Though some deposition material survives for the diocese of Canterbury for the thirteenth century and again for the second decade of the fifteenth century, some London material for the later fifteenth century, and some Norwich material from the end of the same century, only for York does a substantial body of deposition evidence survive for most years from 1301.[1]

This rich archive of what have come to be known as cause papers has hitherto been of primary interest to historians of canon law. A substantial

[1] Although evidence relating to several hundred cases survives for the fourteenth and fifteenth centuries, this represents only a proportion of the likely business of the York courts, including the capitular and audience courts. Invaluable handlists for the main series, the Court of York, are D. M. Smith, *Ecclesiastical Cause Papers at York: The Court of York 1301–99*, Borthwick Texts and Calendars 14 (York, 1988); D. M. Smith, *The Court of York, 1400–1499: a Handlist of the Cause Papers and an Index to the Archiepiscopal Court Books*, Borthwick Texts and Calendars 29 (York, 2003).

body of cases pertain to disputes concerning the validity of marriages, but incidentally many other facets of medieval life are also reflected.[2] We must not, however, read these documents as simple mirrors of daily life. The cause papers in fact create a sort of virtual world. The documents purport to relate to real events, but the events described by one party seldom correlate with those told by the opposing party. Witnesses give sworn testimony to what they supposedly saw and heard, but closer reading shows that all too often their memories are selective and deceptive, being shaped not so much by what happened, but what needed to have happened in order to make or break a case according to the precepts of the canon law. We are thus furnished with many narratives, but each narrative may itself have many readings. Noel James Menuge, for example, has shown how court narratives may parallel romance narratives.[3] My own interest is in the way some of these narratives appear voyeuristic and some could be read as a form of pornography, that is, writing that tends to reduce the subjects to sexualized objects for the reader's sexual gratification.

My concern here is to use this source in two different ways. First, I want to explore how far and in what ways depositions reflect, and thus allow us to reconstruct, contemporary attitudes to nakedness and sexual activity. This, however, is to read the depositions essentially as documents of social and cultural history, just as some other scholars have read them as evidence for the functioning of the canon law courts. It is, nevertheless, to ignore their function as literature. Consequently, my second approach is to ask how the depositions, which were compiled in the first instance as an integral part of the legal process, were read at the time. In particular, how far may texts describing intimate sexual activity have been open to readings that we might today label as voyeuristic or even pornographic?

Making medieval marriage

As I have intimated, my focus is on cases concerned with the validity of marriages. From the later twelfth century the Church placed consent rather than consummation at the heart of marriage. A couple could be lawfully

[2] R. H. Helmholz, *Marriage Litigation in Medieval England* (Cambridge, 1974) represents the most useful introduction to this kind of material from a canon-law perspective. Numbers of fourteenth-century York cases are discussed (not always accurately) in F. Pedersen, *Marriage Disputes in Medieval England* (London, 2000). See also C. Donahue, 'Female plaintiffs in marriage cases in the Court of York in the later Middle Ages: what can we learn from the numbers?', in *Wife and Widow in Medieval England*, ed. S. S. Walker (Ann Arbor, 1993), pp. 183–213. In *Women, Work, and Life Cycle in a Medieval Economy: Women in York and Yorkshire, c.1300–1520* (Oxford, 1992), I attempt to use the source from social and economic perspectives.

[3] N. J. Menuge, *Medieval English Wardship in Romance and Law* (Cambridge, 2001).

married by exchanging words of matrimony so long as they were of age, not too closely related to one another, and not pre-contracted. So long as these words were in the present tense and indicative of an immediate intent to be married – I take you to my husband/wife etc. – such a contract was alone sufficient. Witnesses were not necessary so long as both parties were prepared to acknowledge that they had exchanged such words. This, for example, was the case in respect of Margery Paston and the Pastons's highly capable, but socially inferior agent, Richard Calle. Much to the family's ire, the bishop of Norwich could only uphold the canonical teaching and rule that a valid marriage had been made.[4] Only where one party denied such a contract did witnesses become necessary. The church courts, to which disputes concerning the validity of marriage were routinely directed, operated a simple yardstick of proof in such cases: two witnesses were required to the same contract. It mattered not whether these were persons specifically called to hear the words exchanged by the couple or others who heard the words by chance. What mattered was that they heard the same words on the one same occasion. Nor did it matter whether the couple subsequently consummated the relationship or not, for the marriage between Joseph and the Virgin was unconsummated, but necessarily valid. Sex, or its absence, was only an issue if the man later proved physically incapable of sexual intercourse. In such rare cases an annulment was possible.

Not all marriages were made by words of present consent alone. Some were initiated by what in canon-legal parlance is a future contract, that is one entered into not by words of present consent (*verba de presenti*), but by words of future consent (*verba de futuro*). Such a contract fell short of an actual marriage, but it could be made into an immediately binding contract if the couple ratified the earlier intention to marry either by exchanging words of present consent or by consummating the relationship. Here the sexual act was deemed to constitute a non-verbal assertion of a desire to make immediate what previously had been merely future intent. Marriages made in this way were very much frowned upon: canon 51 of the Fourth Lateran Council required marriages to be confined to the actual solemnization *in facie ecclesie* (conventionally understood as at the church door) following the pronouncement of banns. In much of Western Europe, moreover, young people, but especially daughters, were socialized to avoid intimate contact with the opposite sex and to defer to their parents or male siblings in so important a matter as choice of spouse. Thus, though future contracts are common enough (and indeed the subject of litigation), since these often represent marriages that have been arranged, but not brought to a conclusion, allegations of marriages made as a result of consummating a future contract are

4 *The Paston Letters and Papers of the Fifteenth Century*, ed. N. Davis, 2 vols (Oxford, 1971), I, 341–4.

rare within this wider European perspective. This is not so true, however, of the English courts, though it is tempting to suppose that this may be part of a wider north-west European pattern.[5]

Where both parties willingly confess to having consummated a future contract, then the courts had no problem in declaring the couple married. This is precisely what we find in numbers of what are technically known as *ex officio* presentations of couples for fornication. Thus Marjory, the servant of William Marsschal, and John de Neuton acknowledged that they were contracted to marry when presented for fornication before York's capitular court in 1363.[6] Equally we find cases where the man, since it invariably is the man, admits to sex, but denies having made any verbal contract.[7] Here the court required two witnesses to the future contract in precisely the same way as with a present contract. But what of cases where one of the parties denied sex? To prove the case, the court would need evidence that the couple had in fact had sex. This was, to state the obvious, no easy matter. Much the same is true of the small number of cases where the court is asked to enforce a contract of marriage consequent on a couple reneging on an abjuration *sub pena nubendi*, that is a promise to refrain from continued fornication.[8] The conditional clause of such a promise was that if the couple were to have sex again, it was because they wished to be married, hence evidence of sex was evidence of marriage.

Naked bodies and seeing sex

It was not enough to show that the woman was pregnant or had given birth since this was evidence only that she had had sexual relations, not that she had had sex with any specific individual. Nor was it sufficient to show that the couple had enjoyed a sexual relationship prior to the alleged contract. To prove such an allegation required actual witnesses to the couple having sex with one another, or at least being placed in a position where sex would seem a likely eventuality, at some point after the contract. The usual formula found in disputed marriage cases is that the couple were seen naked together in bed. The Latin phrase is *solus cum sola, nudus cum nuda* ('alone and naked

5 Cf. C. Donahue, 'The Canon Law on the Formation of Marriage and Social Practice', *Journal of Family History* 8 (1983), 144–58.
6 York, York Minster Library (hereafter YML), M2(1)f, fol. 6v.
7 Shannon McSheffrey translating like material from the diocese of London presents a striking example from 1477. Here one Robert Allerton denied any intention of marriage to Katherine Aber by whom he had a daughter, claiming to have given her gifts 'only because of desire of his body and satisfying his lust': S. McSheffrey, *Love and Marriage in Late Medieval London* (Kalamazoo, 1995), p. 43.
8 E.g. York, Borthwick Institute for Archives (hereafter, BI), CP.E.135, CP.E.202, CP.E.211.

together'). Its frequent repetition is evidence that this is indeed formulaic and hence we must suspect that the actual words of the witnesses or deponents are not merely being translated from the vernacular, but are actually being obliterated. This is frustrating, but there is no reason to think that the deponents' actual meanings are similarly being obliterated. Rather the likelihood is that if a naked couple of the opposite sex shared a bed together they were presumed also to be sexually intimate and that this was not merely a canonical convention, but a commonplace within lay culture also. To 'go to bed' or to 'lie in bed' were common euphemisms for sexual intercourse, and this convention informs graphic representations of sex also.[9]

What may be more surprising to a modern audience is the relative frequency with which couples were allegedly observed naked in bed. A number of examples will be given shortly, but I know of only five cases within the York consistory where the actual sexual act was supposedly witnessed. In a case dating from 1337 a woman remembering back sixteen years to her teens told of an unmarried couple she saw one night making love in bed. Another woman lying sick in an adjacent cellar allegedly accidentally witnessed a couple have sex in a cowshed. In a third case, Idonya Bower claimed to have shared a bed with a couple whom she overheard, rather than saw, having sex during the night. In a fourth, drawn from an impotence case, Thomas son of Stephen de Wele claimed he witnessed one John Saundirsun attempting sex with his wife Tedia Lambhird in his father's barn, but that Saunderison failed to achieve an erection. Bizarrely we are told that John's brother then felt his penis.[10] I want to begin with the fifth exceptional case.

The case of John Marrays *contra* the legal guardian of Alice de Rouclif must be one of the causes célèbres of the extant collection of matrimonial causes from the York consistory.[11] Marrays brought an action for restitution of conjugal rights over the heiress bride he had betrothed when she was still a child, but who had subsequently been forcibly abducted from his married sister's house by Sir Brian de Rouclif, the senior male member of her family and, we may surmise, a claimant to rights of wardship over her.[12] Marrays's claim to be Alice's lawful husband depended on his showing that he had consummated their earlier contract some time after Alice had reached her canonical majority. The 'defence', if we may so term the counter-arguments

9 *Middle English Dictionary* entry for 'bed' 2b, a. Such readings are documented back to the early thirteenth century.
10 BI, CP.E.33 (1337), CP.E.70 (1356), CP.E.105 (1370), CP.E.126 (1382).
11 BI, CP.E.89 (1366). This case is substantially translated in *Women in England c. 1275–1525: Documentary Sources*, ed. P. J. P. Goldberg (Manchester, 1995), pp. 58–80. Alice de Rouclif is formally represented by a court-appointed guardian since she would have had to have been of canonical age to act in her own right and this case in fact rests or falls on whether Alice was indeed of sufficient age.
12 John Marrays's own age is not known, but his conduct suggests he was an adult and certainly above the canonical minimum of fourteen.

that seem to have been managed on behalf of Sir Brian, circumvented the alleged consummation, attempting instead to show that Alice had not reached her canonical majority before her abduction and so could not lawfully have ratified the earlier contract.[13] Much of the action as it was played in court, therefore, revolved around large numbers of deponents bringing testimony as to Alice's precise age. Only one witness testified specifically to the consummation, though William Pottell, who appears to have been employed by Marrays, stated that he made the bed in which the couple lay together alone and naked, i.e. the conventional formula, and Marrays's sister, Anabilla, related that the couple had spent the night together using the same terms.

The crucial deponent for the actual consummation was not in fact a first-hand witness. Rather he ventriloquized the words and recollections of one Joan de Rolleston who normally shared Alice's bed, but was displaced on the night in question to elsewhere within the same room. The reason she was not called to give first-hand testimony is easy: she was below canonical age (i.e. twelve) and thus debarred from testifying. Thus the only witness to the crucial act cannot speak. John Marrays gets around this obstacle by calling upon a senior ecclesiastic, who must also have been a kinsman both to John himself and to Joan de Rolleston, to give voice, and hence legitimacy, to the testimony of a young girl, who in legal terms was literally an infant. That person was no less than the mitred abbot of St Mary's Abbey, York, one William Marrays.[14] From the church court's perspective, therefore, we have a deponent of impeccable credentials giving testimony that may make or break the case. From a different perspective, we have the distinctly uncomfortable phenomenon of a senior male cleric describing the sexual initiation of a girl of no more than twelve years. To the modern reader, encumbered by the sexual anxieties of our own age, what purports to be an account of consensual sex appears more akin to an account of child rape.

These impressions are in no way mitigated by the abbot's actual account. He describes what Joan de Rolleston told him 'in the fields of Grimston and elsewhere'. The circumstances are not explained, but we must suppose that the abbot was visiting his kinsfolk and while visiting he went out walking or riding with Joan from the house at Kennythorpe (near Malton) where Alice and Joan were staying.[15] We cannot know whether they were accompanied or not, but implicitly the conversation was private. Joan told the abbot how:

[13] It was also alleged that Alice never willingly consented to the marriage, but no testimony was brought to show this.

[14] St Mary's Abbey was one of the wealthiest Benedictine houses in England and certainly in the north. Mitred abbots were summoned to parliament as if peers of the realm.

[15] North Grimston lay on the Yorkshire Wolds, south-east of Malton and a few miles east of Kennythorpe.

she saw John and Alice lying together in the same bed and heard a noise from them like they were knowing one another carnally, and how two or three times Alice silently complained at the force on account of John's labour as if she had been hurt then as a result of this labour.

These are supposedly Joan's words as reported to Dom. William Marrays, rendered into Latin by the clerk, and which I have then retranslated into the vernacular. Despite all the filters, they still have a disturbing immediacy. But that is the point. They were designed to convince the court that the event described had really happened. They are designed to demonstrate not only that John Marrays and Alice de Rouclif shared a bed, not only that they had intended sex or even attempted sex, but that John had actually penetrated Alice. This clinical detail, which is surely the implication of the references to force and to labour, clearly matters more than the implication that Alice was coerced.

A number of observations and questions are prompted. We need not be surprised that a monk should realize the implication of Joan's words. Nor perhaps should we be surprised that Joan, a girl implicitly below the age of twelve, should have realized what was going on in the adjacent bed. But why does so much trouble need to be taken to show that a couple directly known by other witnesses to have shared a bed 'alone and naked together' actually had sex? One answer is simply that John Marrays's claims over this girl and her inheritance rested on proving consummation; he simply had too much to lose. Another is that there was a recognized difference between what a couple of consenting and sexually experienced adults might be presumed to get up to if given the opportunity to spend the night alone together naked and what was true of an adult male and a girl of no more than twelve. Alice would have been a virgin. She would have been socialized not to have wanted sex save out of duty to her husband.[16] The court would, therefore, have expected the alleged consummation neither to have been mutually pleasurable nor painless. The entrance to a virgin's body was, in medieval thought, protected by her maidenhead (hymen) and this barrier had to be broken down to facilitate penetration. Three points may thus be read out of Joan's reported account: Alice was a virgin; penetrative sex occurred; Alice considered herself married to John Marrays and consequently allowed him to have sex with her.

The reading just offered makes sense of why the abbot's testimony was so important to John Marrays's case, but we need to ask another question. Why did Marrays choose to consummate his marriage to Alice when she was still no more than twelve? It is not because the couple were starting their new life

16 These certainly are the values Alice would have been taught as a child. Beatrix de Morland, a family acquaintance, testified that Alice 'was obedient to John as to her husband because she lay with him in one bed alone and naked together'.

together and that cohabitation was a simple corollary of this; it is implicit that Alice's residence with John Marrays's married sister at Kennythorpe was intended to be of some duration, even that she would live with her and learn how to run a household by way of preparation for their life together when she was some years older. Such arrangements are not uncommonly set out in aristocratic marriage contracts where the bride is still a child. Such contracts, moreover, invariably state that the couple shall not lie together until the bride is sixteen or thereabouts. Likewise we are told that when in 1453 Elizabeth Clifford was married at the age of twelve to William Plumpton, his father 'Sir William promised the seid Lord Clifford that they shuld not ligge togedder till she came to the age of xvi yeres'.[17] Cohabitation, therefore, was not thought appropriate until after the woman had achieved sexual maturity and was old enough to bear children without serious physical risk.

It could be that John Marrays wished to secure his marriage against a background of family discord. It is indeed evident from the action in the consistory that there had been a parallel action ongoing before the king and his council relating to Sir Brian's abduction of Alice, and hence over who controlled her marriage. But John surely did not lie with her specifically because he feared that she would be abducted by Sir Brian. Rather, I would suggest, it was because she had (or at least was thought to have) near enough reached her canonical majority. By taking her maidenhead and by his act of penetration, Marrays was asserting his authority over – in a sense his owner-ship of – his child bride. Klapisch-Zuber has elsewhere observed that Tuscan child brides were regularly sexually initiated at twelve. The issue here is not sexual gratification, but power. Normal cohabitation could wait for several more years. The concern was not to impregnate the young bride – indeed she was most probably too young to conceive – but literally to impress upon her his authority.[18]

That sex can be about power, and specifically the power of men over women's bodies, is made explicit in two other cases from the York consistory. In both, strikingly similar language and sentiments are recorded within the space of a single year. It may even be that the form of one, in fact, influenced that of the other. In 1354 John de Walkyngton was in bed in Maud de Bradelay's house in North Street, York. He called to Maud to come to bed and when she refused, declared:

> You are mine. I am yours, as well you know. And I refuse to seek permission from you to do my will with you.

[17] Account written in 1504 published in *Plumpton Correspondence*, ed. T. Stapleton, Camden Society, OS 4 (1839), p. lxiv.

[18] Menarche appears normally to have occurred a couple of years or so after canonical majority, i.e. at about fourteen or fifteen years: J. Post, 'Ages at menarche and meno-pause: some mediaeval authorities', *Population Studies: A Journal of Demography* 25 (1971), 83–7.

Although John draws upon the canonical theory of mutual debt, which could imply a degree of equality, this is not the implication of his heated words. Maud, however, insisted (so the witness claimed) that John exchange words of future consent before she agreed to get into bed with him and allow him to know her carnally.[19] The next year Robert Smyth of Bolton Percy (Yorks., W.R.) was in the byre that formed part of his house with Maud Schipyn with whom he designed to have sex. She retorted angrily, 'God forbid that you should have the power to know me carnally unless you intend to take me to wife!' When, however, Robert promised that he would indeed marry her, she told him, 'Here is my pledge that I want to be subject to your will (*ego volo esse ad voluntatem vestram*)'. Upon these words, Robert immediately took Maud in his arms, lay her down on the ground and had sex with her.[20]

Neither of these alleged incidents need have occurred. That is not the issue. What matters is that sexual relations are here constructed in terms of power relations and ownership. As John de Walkyngton allegedly told Maud de Bradelay, 'You are mine. I . . . refuse to seek permission from you to do my will with you'. I shall go on to argue that such ownership could be also gained vicariously from possession of the manuscript depositions themselves and could be enjoyed voyeuristically from a reading of the same. For the moment, though, let us now look more closely at cases where a couple are merely observed 'alone and naked' together. There are a number of these. Maud Katerforth deposed in the case just discussed that she had seen Maud de Bradelay and John de Walkyngton alone and naked in bed together in Maud de Bradelay's home in York and her son, Robert, a youth of fifteen, also heard the sound of their having sex.[21] Alice de Harpham likewise testified in 1358 that she had seen her mistress Alice de Wellewyk and Robert de Midelton naked in bed together in her Beverley home.[22] John Dogeson related how he had returned to his home to find John Boton and Alice Roding naked in bed, though he qualified this by observing that John had not discarded his upper garments. 'This is a pretty coupling of the two of you,' he is said to have remarked, going on to demand unsuccessfully that John promise to marry his lover.[23] A similar scene confronted Alice de Baumburght in 1381, but on this occasion Robert Peper was cowed into contracting his lover, Agnes Besete.[24] In a *sub pena nubendi* case Maud Hird, who made the couple's bed, claimed to have seen Alice de Holm and John Chambleyn spend the

19 BI, CP.E.82.

20 BI, CP.E.70, deposition of Margaret, wife of William Theker, who was lying ill in the adjacent cellar (see above). The Latin reads 'misit eam deorsum', which could be construed as a more violent action.

21 BI, CP.E.82, translated in *Women in England*, ed. Goldberg, pp. 156–7.

22 BI, CP.E.79.

23 BI, CP.E.92.

24 YML, M2(1)f, fols. 17–17v, translated in *Women in England*, ed. Goldberg, pp. 117–18.

night together unclothed. Marion Herforth likewise testified to seeing Agnes Horsley and Master Thomas Cleveland naked in bed together because she made the bed in Agnes's house in Ampleforth. She also heard them 'making love together and climaxing (*climagitantes*)'.[25] Roger Wilferton likewise saw Joan de Brerelay naked in bed with Thomas Bakester in her own home; Joan Bever claimed that Isabel Wakfeld spent six nights 'lying alone and naked in the same bed' with Thomas Fox while lodgers in Joan's house; and Joan Awnetrons testified in 1411 that Joan Tyndyn spent many nights naked in bed with William Farlam in Awnetrons's house in Brougham (Westmorland).[26]

The foregoing represents a fairly comprehensive account of such testimony extant from the York consistory before the sixteenth century. In other instances evidence for intercourse rested solely on assertion or report rather than actual observation of naked couples. In the 1439 case of Margaret Thweng c. John Kirkeby, for example, both of Whitby, Margaret's brother merely asserted that they had sex and Edmund Whipp claimed that he had heard from others that they had.[27] There are some striking features apparent in this pattern. First, the observation of couples in bed seems to peter out by the early years of the fifteenth century. Second, the observations cease in respect of urban locales rather sooner than those for rural locales. It is not possible to explain this solely in terms of the broader pattern of litigation. Consummated *de futuro* contracts are certainly not being pursued in the York church courts by the second half of the fifteenth century, but, as we have seen, they are the subject of litigation through the first part of that century. Nor is it likely that the courts came to demand a less rigorous standard of proof. The conclusion that the evidence suggests is rather that naked couples simply became less visible. Two factors may impinge upon this: the proliferation of bed hangings and the growing demand for separate sleeping accommodation, which last may have been a feature of urban housing stock from an earlier date than was generally true of peasant housing.

I have elsewhere suggested that by the later years of the fifteenth century in an urban context a growing social distance between employer and servant was beginning to be reflected in the provision of separate sleeping accommodation for servants.[28] Probate inventories would suggest that peasants tended to be slower to invest in household goods and furnishings than their urban counterparts, so we might expect them also to be slower to adopt bed hangings. Bed hangings and curtains are, however, specifically noted in the inventories and wills of several York, Bristol and Beverley artisans from the earlier

[25] BI, CP.E.135, CP.F.63.

[26] BI, E.255, CP.F.23, CP.F.41.

[27] BI, CP.F.182.

[28] P. J. P. Goldberg, 'What was a Servant?', in *Concepts and Patterns of Service in the Later Middle Ages*, ed. A. Curry and E. Matthew (Woodbridge, 2000), pp. 1–20 (p. 19).

fifteenth century. Thus the girdler Robert Talkan had in his chamber a bed, tapet and three curtains valued at £2 in 1415.[29] Evidence from standing buildings does not allow new internal divisions or evidence for hangings to be located in time. Likewise the sort of close dating that the cause paper evidence demands in respect of building types is not yet possible, but it is at least very plausible that provision of 'private' chambers became more widespread among the more well-to-do levels of bourgeois and peasant society by the early fifteenth century.

These observations have certain implications for the way in which people thought about and reacted to the naked body. To put the argument rather crudely, where privacy was not physically manifested in the form of curtains, screens or walls, and in the context of a culture where it was normal not to wear any kind of nightwear, medievals must regularly have been visible to one another unclothed. It is hard not to be startled by the apparently unabashed way in which Master Thomas Cleveland disrobed in front of two female witnesses, one a married woman, the other a girl of fourteen (perhaps a servant of the first woman) in order to rejoin his lover who was already lying naked in his bed.[30] The fifteen-year-old Robert Katerforth claimed that he had seen Maud de Bradelay and John de Walkyngton step naked from their bed in the morning.[31] Children, who slept in the same room as their parents, would have grown up seeing them naked. The same may be true of servants. Once physical expressions of privacy became more common among the more well-to-do in peasant and urban society alike, the occasions on which adults would have been seen unclothed by persons of the opposite sex, other than spouses, would have been greatly reduced. These may have included kin, close friends, or perhaps servants. We may cite the example of Agnes Grantham, a prosperous York widow temporarily resident for her own safety in the house of the draper, William Pountfret. She shared for the duration of her stay a bed with Dame Christiana, a vowess. Agnes Kyrkeby, a servant in William's employ, remembered that 'frequently she went over to the bed with her, often covering her naked in bed with sheets, as at times in like manner other women and servants of the same house often did in the sight and knowledge of this same witness'.[32]

If the adult naked body came to be hidden from the gaze of the opposite

29 *Probate Inventories of the York Diocese, 1350–1500*, ed. P. M. Stell and L. Hampson (York, n.d.), p. 73. See also Thomas Baker, stringer (1436) and John Cadeby, mason (1430x39): ibid., pp. 124, 135; Thomas Bathe (1420): *Fifty Earliest English Wills in the Court of Probate, London*, ed. F. J. Furnivall, EETS OS 78 (1882), p. 46.

30 BI, CP.F.63. Master Thomas was an advocate of the Court of York and this incident allegedly took place in his room in York. The woman, who was godmother to his lover's daughter, was calling on him to take her back to her lodgings. Master Thomas has already been noticed having enthusiastic sex in Ampleforth.

31 BI, CP.E.82, translated in *Women in England*, ed. Goldberg, p. 157.

32 BI, CP.F.36, translated in *Women in England*, ed. Goldberg, p. 154.

sex, but particularly the female body from the male gaze, may it not also have become eroticized because forbidden? There is probably also a status dimension to be considered here. The aristocracy, whose wealth enabled them to enjoy their own bedrooms and curtained beds from a rather earlier date than the levels of society we discussed earlier, may similarly have come precociously to expect a higher degree of privacy when undressing, sleeping or engaging in sexual activity. The Limbourg brothers' calendar illumination for August in their sumptuous *Très Riches Heures*, made for the Duc de Berry in the early fifteenth century, shows a group of elegantly dressed young aristocratic lovers riding by a river; in the near distance an apparently mixed group of peasants swim in the river totally unclothed. Better known, however, is the illumination for the month of February in which a peasant group is represented in the foreground. Here a young peasant woman is shown modestly averting her eyes while a peasant couple behind her seated around a fire raise their garments to warm themselves, but in so doing expose their genitals. The young woman thus cleverly embodies the supposed response of the refined reader to nudity apparent to their gaze alone.

By the later fifteenth century 'prive fare', 'prive pleie' or 'prive solas' are found among vernacular terms for sexual intercourse.[33] These usages construct the act as intimate and unwitnessed while masking its physicality. These are again clues to contemporary 'polite' attitudes. The corollary is that for couples who had sex, so to speak, behind closed doors, the sexual act itself could become the object of prurient and voyeuristic interest. Much the same might be said of childbirth, from which men were excluded, but which is a common subject for graphic representation. Camille has observed 'the beginnings of a prurience in representing the sexual act' by fifteenth-century artists, and cites as an example the representation of coitus in a French manuscript of Bartholomew Anglicus. But in shrouding the copulating couple behind the partly drawn curtains of the bed, the artist in fact eroticizes the image.[34] The two figures peeping through a gap in the curtains are transformed from dispassionate scientific observers, as seen in another manuscript of the same text, to voyeurs, a common ploy in pornographic illustration. That they are also conspicuously both a male and a female voyeur no doubts adds a certain frisson to the depiction.

[33] *Middle English Dictionary* entry for 'prive' (adj. (1)) 4a.
[34] M. Camille, 'Obscenity under Erasure: Censorship in Medieval Illuminated Manuscripts', in *Obscenity: Social Control and Artistic Creation in the European Middle Ages*, ed. J. M. Ziolkowski (Leiden, 1988), pp. 139–54 (pp. 151–2).

Getting a rise out of the audience:
John Skathelok's dick in and out of court

Thus far our analysis has treated the cause papers and their associated depositions primarily as evidence for sexual behaviour and attitudes to nakedness. Our concern has been with the evidence these texts provide rather than the texts themselves. I now want to shift gear and focus instead on the contemporary reception and consumption of these depositions by the members of the court. I will start with an impotence case from 1432. There are several extant cases where a woman petitioned the York consistory to grant an annulment of her marriage on the grounds of her husband's impotence. Such cases were doubly problematic. First, they undermined the canonical principle that it was consent, not sex that made a marriage. Against this, however, was set the Pauline understanding that women might be saved in childbearing; a woman married to a man who was incapable of consummating the union was thus a woman cheated of the opportunity to fulfil her proper function in life. Second, proof that the husband was, had always been and would always be incapable of sex was difficult to establish. The courts of York and Canterbury seem to have adopted the entirely pragmatic approach of employing a 'jury' of women to arouse the man sexually and to report back on their findings. The examination was conducted without the involvement of any other parties, so their verdict was reported to the court in the form of verbal testimony recorded as written depositions in the same way as other witnesses' testimonies. We are thus vicariously and voyeuristically party to two different events. The first is the actual examination of the man as reported in the women's depositions. The second is the use of those depositions in the court in determining the merits of the petition. It is the second that is perhaps of particular interest here.

The procedure described in such cases was for the man and the female jury to meet in a semi-public location – the kitchen of a guildhall or, in the case I shall focus on, a room above a pub – which was provided with a warm fire and refreshments.[35] The man would be made to expose himself while the women likewise exposed their breasts and lifted their skirts at the same time making lewd jokes and inciting the man to have sex with them. I have elsewhere identified some of these women as engaging in prostitution; they were as such expert witnesses.[36] We know all this because the women reported it in

35 BI, CP.F.111 (1432), partly translated in *Women in England*, ed. Goldberg, pp. 219–22. The guildhall kitchen case is BI, CP.F.224 (1441). The couple concerned in this last were seen together naked in bed on their wedding night by a witness in her home in the hamlet of Winestead (Yorks., E.R.).

36 Karras argues that medieval culture recognized the use of lewd speech by women to arouse men as an extension of women's supposed disposition to garrulousness: R.

some detail in their depositions. The same or similar observations are thus repeated between seven depositions. There are of course good procedural reasons for this repetition. The canon-legal courts used consistency of testimony as one of its key criteria in determining the reliability of the evidence given. To have seven deponents all saying essentially the same thing made for a powerful case.[37] It could likewise be argued that the more detail that was provided, the more credible the testimony would appear. These arguments cannot detract, however, from the salacious, even pornographic nature of the depositions that were compiled.

We may take this reading a little further. The role of the women jurors was to determine whether or not the man was capable of having penetrative sex. Their testimony could have stated fairly baldly 'yea' or 'nay'. If more detail was needed, it could have stated that during the course of the investigation the man achieved or failed to achieve an erection. We get in fact much more. The testimony is essentially pornographic, literally because it is 'writing about harlots', but more generally in that it reduces the women to their sexual attributes – 'tits and arse', to use a modern pornographic discourse – and the man to his genitals. Much the same device is used in the rather later *Sonetti lussuriosi* of Pietro Aretino.[38] We even, as is normal with pornographic literature and in Aretino, have colloquial euphemisms to describe genitalia rather than Latin anatomical terms: penis or phallus is rendered as *virga* or yard, a usage that is at least ironic if not mocking in the context of this case, and harness (ME 'harneis'), Latinized as *hernesea*, rather than pudendum or vulva. Thus Joan Semer, possibly the same person as the known sex worker Joan Semster:

> . . . displayed her bared breasts to the said John [Skathelok] . . . and held the said John's yard and testicles. The said witness raised her clothes as far as the

M. Karras, 'Leccherous Songys: Medieval Sexuality in Word and Deed', in *Obscenity*, ed. Ziolkowski, pp. 233–45, (especially p. 237). No doubt sex workers cultivated a form of erotic or obscene discourse as part of their profession. Murray has previously cited this same case in her discussion of the role of 'wise women' as witnesses in such cases, but the York evidence suggests that these women were in fact experienced sex workers: J. Murray, 'On the Origins and Role of "Wise Women" in Causes for Annulment on the Grounds of Male Impotence', *Journal of Medieval History* 16 (1990), 235-49; P. J. P. Goldberg, *Women, Work and Life Cycle in a Medieval Economy* (Oxford, 1992), p. 151.

37 The testimony of seven jurors was a canonical requirement, though the *Decretals* anticipated that it would be the woman who would be examined to ascertain whether she were still a virgin. The same text also indicated that the jurors would be neighbours, though the authority cited talks of women *expertis in opera nuptiali*, which in a sense fits with what we actually find (see note 35 above): *Decretalium Gregorii Papae IX Compilitationis*, X 4.15.7.

38 Aretino was a satirist and man of letters. In 1524 he published in Rome these sonnets to accompany a notorious series of graphic engraved representations of copulating couples by the artist Giulio Romano, popularly known as *I Modi* or *The Postures*.

navel and made John put his hand under and feel this witness's belly and said to John that for shame he should display his manhood and find out whether there was any harness there that could please him and prove himself a man.

Margaret Bell, a known prostitute, likewise described how:

> . . . each in turn fondled and held the yard and testicles, and displayed their breasts to the same John and, embracing the same John around the neck, kissed him and spoke various jestful words to the same John telling him that he should for shame show these women his manhood if he were a man

The twin foci are repeatedly the female breasts and genitalia, and the male member. The female genitalia are here constructed in terms of an invitation to penetrate or, in the words of Joan Laurence, another known sex worker, to 'see whether there was anything between her legs that could please the same John and gladden his heart', an invitation that the clerical male reader could indulge in his imagination, but to which the John of the case was unable to respond. The male member on the other hand was not the erect phallus, such as the male readers might experience, but, again to quote Joan Semer, 'as if empty skin having no substance in it'. It 'was scarcely four of this witness's fingers in length' and it 'hung down at the end'. Interestingly, one fifteenth-century term for an impotent man was 'cunte-beten', a singularly apposite usage in this case.[39]

At the conclusion to their inquest, the women jurors 'cursed with one voice the same John and his "rod" because he should presume to take to wife any young woman by cheating her unless he were better able to serve and please her'. If we had not already noticed the rather staged proceedings thus far, the Greek chorus of the cursing women must surely warn us that the depositions offer us no simple mirror of the events in 'a certain upper room in John Bulmer's house in Fishergate'. Rather the women's testimony, itself guided no doubt by the prior briefing of legal counsel, framed by the questions (or interrogatory) drawn up by legal counsel, and shaped by the process of rendering the vernacular responses into the Latin deposition, ventriloquizes a pornographic text. The women, in this sense, were providing another professional, because paid, service, offering the court the vicarious pleasure of pornography rather than the actual carnal pleasures otherwise purchased by their clients.

What then of the deposition made by Abbot William Marrays? Here the testimony of a senior ecclesiastic takes on a new meaning. What previously appeared to modern eyes as a disturbing account of the sexual initiation of a girl by an older man with its implications of coercion or rape, now reads as a particularly distasteful form of pornography, obscenity even. The reader of

39 *Middle English Dictionary*, citing 'Lyarde' in *Reliquiae Antiquae*, ed. T. Wright and J. O. Halliwell, 2 vols (1845), II, 280–2.

the text becomes a vicarious witness to the seduction of a young virgin. That the scene is relayed indirectly through the witness of another young girl enhances the sense of violation. Her account of events taking place in an enclosed chamber in the darkness of night, and which are as much heard as seen, likewise emphasizes that the reader is privy to dark secrets, an integral part of the pornographic lure of the text. In these terms, Dom. William Marrays becomes at least as complicit in the fashioning of a form of pornography as the female sex workers discussed previously.

Our discussion thus far has offered some very particular readings of depositions as texts. Before we can match texts to readers, we need to consider the actual availability of these texts. Depositions were drawn up by a clerk acting for the court's examiner, whose job it was to put pre-prepared questions to witnesses examined individually and privately. Once the initial depositions made in support of the plaintiff had been taken, these were published in order to allow the defendant to determine what questions to pose to their own witnesses. This process of publication must have involved making copies of depositions available to the legal counsel – the proctors – acting for one or other party. The full set of depositions were brought together at the conclusion of the process of examining witnesses and were perused by the presiding officer of the court – often known as the Official – in determining the merits of the case made by the opposing parties and so reaching a judgement. It follows that the depositions would have been available at varying stages at least to the Official and the proctors acting for plaintiff and defendant, but also to the advocates who presented legal argument prior to judgement. [40] It is even possible that more than one set of depositions may in fact have circulated. In a very small number of instances bills detailing expenses incurred by individual litigants have been preserved among the extant litigation material. In two instances these provide for payments for copies (*pro copiis*) of depositions, whereas one further instance details only payment for a copy (*pro copia*).[41] Whereas this last could be understood as payment for the expense of producing a unique set of depositions to be used by the presiding officer, the two other examples tend to imply the production of more than one copy. This is likely since the proctors acting on behalf of the litigants would almost certainly have wanted their own copies of the depositions made by their clients' witnesses.

Another consideration is that, however circumscribed the circulation of depositions while cases where ongoing, it is evident from the survival of so extensive an archive of depositions to this day that the depositions were archived and so may have been available to members of the court as a legal

[40] For a discussion of the personnel of the church courts and their roles, see Helmholz, *Marriage Litigation*, pp. 141–54.

[41] BI, CP.E.196, 228, 233/1. I am indebted to Dr Philippa Hoskin for finding these examples.

resource. Once accessible in this way, it would hardly have been possible to police how the material was used. How they were in fact used must remain a matter of speculation. There is perhaps some merit in Paul Saenger's attempt to relate the development of silent reading to the production of erotic writing and sexually titillating illustrations.[42] Certainly the personnel of the Court of York could be construed as silent readers, but there is little reason why such a close-knit community as the membership of the Court of York may not have shared these texts as a group.

As always, at least before the later fifteenth century, the vernacular of the witnesses has been rendered into abbreviated Latin to create the resultant depositions. It follows that not only did these texts have a limited circulation, but that they would only have been readily comprehensible to the Latin-educated clerical personnel associated with the court. Here we enter the sexually anxious world of the clerk that Patricia Cullum has elsewhere described.[43] The court's officers were invariably university-educated, but not necessarily in major orders.[44] These were men who were uncertain as to whether to follow the celibate life of the priest or to marry. But if lay masculinity was associated with a degree of violence and womanizing, then, she argues, some clerks may have been tempted to compensate for the potential effeminacy of their clerical status. We have already encountered Master Thomas Cleveland, advocate of the York court, allegedly enjoying orgasmic sex in Ampleforth, but denying marriage. Only a few years later Master Richard Burgh, newly promoted from the York consistory to the position of Official of the court of Durham, similarly appeared to defend another suit to enforce a contract of marriage to a woman by whom he had allegedly had a child.[45] It is the contention here that men who may have pursued active sex lives, as Cullum has argued, partly to affirm a masculine identity that was otherwise undermined by their clerical status, may have been aroused by accounts of married men unable to have sex being humiliated by groups of women whose livelihood depended in part on providing for the sexual demands of men. Indeed it is possible that some of these women were already known, both metaphorically and physically, by members of the court. We may imagine the clerical readers of these depositions smugly contrasting their own sexual prowess, their own supposed capacity to

42 P. Saenger, 'Silent Reading: Its Impact on Late-Medieval Script and Society', *Viator* 13 (1982), 367–414 (pp. 412–13). I am grateful to Dr Nicola McDonald for drawing this article to my attention.

43 P. H. Cullum, 'Clergy, Masculinity and Transgression in Late Medieval England', in *Masculinity in Medieval Europe*, ed. D. Hadley (London, 1999), pp. 178–96.

44 Although the presiding officers were invariably graduates, few proctors can in fact be positively identified as graduates of the two English universities. It is, however, likely that most had spent time at university: Helmholz, *Marriage Litigation*, pp. 148–9.

45 BI, CP.F.129.

pleasure women – remember again the orgasmic sex in Ampleforth – with the humiliated and emasculated John.

If we extend this reading of depositions not as documents of social history, but as Latin texts consumed by the clerks associated with the consistory, then we can see some of the cases already discussed in a slightly different light. Many of the accounts of couples seen together naked in bed now appear as voyeuristic erotica. The account of the York advocate's sexual escapade in Ampleforth, likewise, may be seen to valorize the sexual prowess of the personnel of the court. The account of sex in the byre likewise assumes the overtones of voyeurism and creates a distance between the sexual behaviour of the clerks of the court, who have sex between sheets, and the animal-like couplings of the peasantry. Dom. William Marrays's account of Alice de Rouclif's sexual initiation can now be seen to contain elements of paedophilia, of sadism, and of voyeurism.

The present chapter has stressed the growing fashion for separate chambers and beds with curtains in the context of later medieval English society. Intimacy and privacy came within the grasp of the bourgeoisie and, latterly, the well-to-do peasantry. Silent reading could be seen as another facet of such a growing taste for intimacy just as Colin Richmond has elsewhere argued for a privatization of religion at the end of the English Middle Ages.[46] The corollary of this trend was that mundane activities like dressing and undressing, bathing, sleeping, or even lovemaking came to be hidden. The more such activities were concealed, the more they were eroticized and hence subject to voyeuristic imagining. The York cause papers must be read within this context. They were not primarily compiled as pornography; their purpose was not solely to titillate and arouse. They were, however, sometimes open to quasi-pornographic readings, and indeed this secondary function may sometimes inform the manner in which the documents were compiled. The consumers of this literature were highly educated clerics and their use of such material could be seen as part of their self-fashioning of a masculine identity. We may suggest a parallel here with a different, later, and better-known pornography, namely Giulio Romano's erotic drawings and the prints made from these, notably the notorious *I Modi*.[47] Talvacchia argues polemically that the earliest consumers of this self-consciously pornographic material were probably 'the elite of Rome's papal curia'.[48] On the one hand

[46] C. F. Richmond, 'Religion and the Fifteenth-Century English Gentleman', in *The Church, Politics and Patronage in the Fifteenth Century*, ed. R. B. Dobson (Gloucester, 1984), pp. 193–208.

[47] See note 38 above. The engravings were banned by the pope and no complete prints now survive.

[48] B. Talvacchia, *Taking Positions: On the Erotic in Renaissance Culture* (Princeton, 1999), p. 72.

the material is learned in its allusions to classical culture, but, by its deliberate perversion of normative Catholic teaching on the 'natural' position for sexual intercourse, would appeal to the clerical mind. Reference to 'unnatural' sexual positions and voyeurism had also formed part of the erotic humour of *The Decameron*.[49] Again, voyeurism is integral to the 'enjoyment' of this graphic material. Drapes and bed hangings, designating intimate space, feature prominently in most of the drawings and engravings, but some even contain a voyeur figure within the representation itself.

For Lynn Hunt and other commentators, pornography was 'invented' in the context of early sixteenth-century Italian humanism with the work of Giulio Romano and Pietro Aretino.[50] As medievalists, however, unconstrained by the paradigm of the 'great transformation' or the need to see the 'early modern' era as intrinsically different, we should hardly be surprised to see Romano and Aretino in the context of a longer pedigree.[51] Nor was it necessary for medieval artists, writers and readers to look to classical models to find erotic or pornographic inspiration. Of particular interest here, and deserving further research, is the clerical interest in sexual morality. This is reflected in pastoral manuals and in the *Somme le Roi* tradition, represented in English by the *Ayenbite of Inwite* and the somewhat later *Book of Vices and Virtues*, which, for example, discuss in almost fetishistic detail the vice of lechery and its many branches.[52] It could be that such texts created a certain vicarious frisson for their predominantly clerical and supposedly celibate readers. The depositions from the church courts, seen as a quasi-pornographic discourse, represent but another related facet of this clerical culture.

49 Bocaccio, *Decameron*, I.4 (where an abbot is secretly observed by a young monk having sex with the woman on top), IX.10 (where a husband is tricked into watching a man have sex from behind with his wife). For a discussion of canonical teaching on sexual positions, see J. A. Brundage, 'Let me Count the Ways: Canonists and Theologians Contemplate Coital Positions', *Journal of Medieval History* 10 (1984), 81–93.
50 *The Invention of Pornography: Obscenity and the Origins of Modernity, 1500-1800*, ed. L. A. Hunt (New York, 1996), esp. introduction.
51 For a discussion of this paradigm, see J. M. Bennett, 'Medieval Women, Modern Women: Across the Great Divide', in *Culture and History, 1350-1600: Essays on English Communities, Identities and Writing*, ed. D. Aers (Hemel Hempstead, 1992), pp. 147–75.
52 *Dan Michel's Ayenbite of Inwyt*, ed. P. Gradon, EETS OS 23 (1965), 46–50; *The Book of Vices and Virtues*, ed. W. N. Francis, EETS OS 217 (1942), 43–6.

Irish Sheela-na-gigs and Related Figures with Reference to the Collections of the National Museum of Ireland

Eamonn Kelly

The collections of the National Museum of Ireland contain thirteen medieval carvings known as sheela-na-gigs.[1] These are grotesque sculptures of naked females posed in a manner that displays and emphasizes the genitalia.[2] The name by which the figures have come to be known was recorded in 1840 as the name for an exhibitionist carving on the wall of Kiltinane church, Co. Tipperary.[3] It is an Irish name; however, we do not know its antiquity or how widely it was used. Margaret Guest provides evidence from the early twentieth century that 'Sheela-na-gig' was used in County Cork as a pejorative term for an ugly old woman, it being equivalent to 'hag'.[4] Anderson cites a mid-nineteenth-century manuscript reference also relating to County Cork, which records that certain sheela-na-gigs were referred to as 'Hags of the Castle'.[5]

Although its meaning is uncertain, the most likely interpretation of 'sheela-na-gig' is *Síle-ina-giob* meaning 'Sheela on her hunkers'.[6] *Síle* is the Irish form of the personal name Cecilia (Latin Caecilia), which was brought into Ireland by the Anglo-Normans.[7] From the nineteenth century Síle has also been used as an equivalent for Julia, Judy, Judith, Jenny, Selia, Celia,

1 E. P. Kelly, 'Sheela-na-gigs in the National Museum of Ireland, together with a brief description of their origins and function', in *Irish Antiquities: Essays in memory of Joseph Raftery*, ed. M. Ryan (Bray, 1998), pp. 173–84.
2 E. P. Kelly, *Sheela-na-gigs. Origins and Functions* (Dublin, 1996), p. 5.
3 Dublin, National Museum of Ireland, typed copy of J. O'Donovan, Ordnance Survey Letters, Tipperary, II.
4 E. M. Guest, 'Irish Sheela-na-Gigs in 1935', *Journal of the Royal Society of Antiquaries of Ireland* 66 (1936), 107–29 (pp. 127–8).
5 J. Andersen, *The Witch on the Wall. Medieval Erotic Sculpture in the British Isles* (Copenhagen and London, 1977), p. 14.
6 Ibid., p. 23.
7 D. Ó Corráin and F. Maguire, *Irish Names* (Dublin, 1981), p. 165.

Sabina and Sally and the Anglicized forms are Sheila, Shiela, Sheela and Shelagh.[8] Ó Dónaill in his Irish–English dictionary defines 'Síle' as meaning an 'effeminate person, a sissy' while 'Síle an phíce' ('Síle of the two pronged fork') is given as the name for an earwig and 'Síle na bportach' ('Síle of the bogs') is the name for a heron.[9] Dinneen defines 'Síle' as the equivalent of 'Julia' as well as meaning 'an effeminate or uxorious man; a boy too fond of girls' society, a girl too fond of being with boys'.[10] He also provides an entry for 'Síle na gcíoc' ('Síle of the breasts') as referring to a sheela-na-gig. His definition is 'a stone fetish representing a woman, supposed to give fertility, *gnly.* thought to have been introduced by Normans'.[11] Other definitions provided by Dinneen are of relevance. '*Síle an ragaid*, a bird of the crane species'[12] with 'ragaid' elsewhere defined as 'unsatisfactory behaviour or condition, loose living, anything coarse or unmanageable, tough meat, *etc*'.[13] From *ragaid* comes *ragairne* meaning 'late hours, keeping late hours, living a fast life; dissipation, wantonness; a nervous feeling as from dissipation, *etc*; row, upset, tribulation, fuss, excitement, contention, heated discussion'.[14]

The definitions associated with *Síle*, as provided by both Ó Dónaill and Dinneen, relate generally to concepts of wanton or inappropriate sexuality. However Dinneen also provides an entry for 'Síle ní Ġadra', which is defined as meaning 'a personification of Ireland'.[15] 'Sheela na Guira' is the Anglicized form and this was the name attributed in the late nineteenth century to a sheela-na-gig in Cullahill Castle, Co. Laois, which local tradition held was the figure of the former head of the O'Gara family and an oppressor of the people.[16] The linguistic and folklore evidence also suggests therefore that sheela-na-gigs may have been associated with the protection and control of land and lordly status; this possibility will be explored later.

It is a view widely held that sheela-na-gigs form part of a tradition of exhibitionist carving that developed in Western Europe within the Romanesque architectural tradition and that the figures are based ultimately on clas-

8 Ibid., p. 166.
9 N. Ó Dónaill, *Foclóir Gaeilge-Bearla* (Dublin, 1977), p. 1092.
10 P. S. Dinneen, *Foclóir Gaedilge agus Béarla an Irish-English Dictionary* (Dublin, 1927), p. 1027. The use among Australians of the term 'Sheela' meaning a woman or an effeminate man is obviously an importation by Irish settlers. During the nineteenth century a preponderance of free settlers from Ireland came from the counties surrounding the lower River Shannon, which, coincidentally or otherwise, is also an area that has a high concentration of sheela-na-gigs.
11 Ibid., p. 1027. It seems probable that Dinneen's definition is based on academic speculation rather than traditional knowledge.
12 Ibid., p. 1027.
13 Ibid., p. 872.
14 Ibid., p. 872.
15 Ibid., p. 1027.
16 W. Carrigan, *History and Antiquities of the Diocese of Ossory* (1905), p. 232.

sical representations of fertility goddesses.[17] Romanesque architecture prevailed throughout Western Europe from the middle of the tenth century to the middle of the twelfth century and its forms were largely determined by Roman prototypes. Characteristic of the style was the semi-circular arch, frequently used in elaborate doorways, as well as wide pillars with decorated capitals. The period from the second half of the eleventh century to the end of the thirteenth century was a time of economic and social development throughout Europe that led to increased urbanization and population growth. This coincided with the growth of papal power and the proliferation of new monastic orders under papal direction and protection. Especially along pilgrim routes – which attracted huge numbers of the faithful – new churches, cathedrals and religious houses were built in the Romanesque style. Throughout the medieval church, the sin of lust was given particular prominence and the church considered pilgrims to be vulnerable, especially from the attentions of prostitutes who thronged the pilgrim routes.[18] In the Romanesque art of the period, lust was often portrayed as a naked woman whose breasts and genitalia were eaten by toads and serpents.[19] This was an adaptation of an image, known in antiquity, of *Tellus Mater*, the Earth Mother, who was represented suckling snakes, ancient symbols of the earth. Church buildings along the pilgrimage routes such as that at Santiago de Compostela in Spain and elsewhere depicted a range of exhibitionist figures, both male and female, together with related carvings whose function was to alert the faithful to the dangers of the sin of lust. The emphasis on the genitalia – which are usually enlarged – related to the Church's teaching that sinners were punished in hell through the bodily organs by which they had offended.

It might be argued that there are problems in identifying transition mechanisms that link late classical images with images of the Middle Ages. However two interesting ceramic exhibitionist figures in the National Museum of Ireland's Egyptian collection, one female[20] and one male,[21] may help establish such a link. The female figure (Fig. 7.1) was excavated at the settlement of Naukratis, a Greek trading settlement in the Nile Delta dating

[17] The Romanesque background of the figures have been accepted by a number of authors including A. Weir and J. Jerman, *Images of Lust: Sexual Carvings on Medieval Churches* (London, 1986); S. Cherry, *A Guide to Sheela-na-gigs* (Dublin, 1992); C. E. Karkov, 'Sheela-na-gigs and Other Unruly Women: Images of Land and Gender in Medieval Ireland', in *From Ireland Coming. Irish Art from the Early Christian to the Late Gothic Period and its European Context*, ed. C. Hourihane (Princeton, 2001), pp. 313–31; Andersen, *The Witch on the Wall*; Kelly, *Sheela-na-gigs. Origins and Functions*.

[18] J. A. Jerman, 'The Sheela-na-gig carvings of the British Isles: Suggestions for a Re-classification, and other notes', *Co. Louth Archaeological and Historical Journal* 20.1 (1981), 10–24 (p. 22).

[19] Weir and Jerman, *Images of Lust*, Pl. 28.

[20] Dublin, National Museum of Ireland, Reg. no. NMI 1911:394.

[21] Reg. no. NMI L661:3.

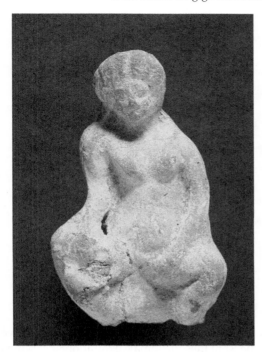

Fig. 7.1 Baubo figure connected with a women's cult concerned with childbirth and fertility found in a Greek trading settlement, Naukratis, Egypt. (National Museum of Ireland)

back to at least 630 BC. Now measuring 13.5 cm. in height, the figure, which appears to be naked, is that of a young woman squatting with the legs splayed. The right hand rests on the right knee while the left hand gestures towards the genitalia. The posture relates the image to the so-called Baubo figures that were commonplace in Ptolemaic Egypt during the third to second centuries BC. Baubo appears in Greek mythology in a story in which she is associated with Demeter, goddess of fertility. According to Andersen, where represented, Baubo 'is inclined to touch herself as part of a specific sexual purpose'. Connected with a women's cult concerned with childbirth and fertility, the figures were often in the form of small amulets, and they are found in or near the women's rooms in Egyptian houses.[22]

One of the early Fathers of the Church, born around AD 150, St Clement of Alexandria, was extremely knowledgeable about Greek myths and cults. He gives an account of Baubo in which she displays her private parts to Demeter to induce laughter designed to banish her depression over the kidnapping of her daughter. Clement's account is provided in full by Weir and Jerman who conclude that this was an attempt by Clement to distort and trivialize an important ritual of the Eleusian Mysteries. Clement's account of Baubo appears to have been known in medieval times, and its inclusion in Christian

22 Andersen, *The Witch on the Wall*, p. 134.

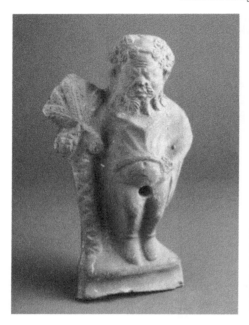

Fig. 7.2 Greco-Roman figure of
the satyr Silenus from Fayum,
Egypt; the figure was formerly
endowed with a phallus, now
missing. (National Museum of
Ireland)

writings, together with knowledge of the figures themselves, may have
played a part in the creation of the Romanesque female exhibitionist carvings
that in turn gave rise to the Irish sheela-na-gigs. [23]

The male figure referred to is an earthen-red terracotta of the Greco-
Roman period (Fig. 7.2). It is a statuette in Hellenistic style of a drunken
bearded man who supports himself against a palm tree while raising his
garment to expose his genitals and buttocks. There is a hole for the attach-
ment of a phallus, now missing. Found at Fayum, Egypt, it measures 17.5 cm
in height. Despite his emasculation and the absence of any tail at the rear, the
pot-bellied, ugly figure with pronounced ears may be identified as Silenus,
the oldest, wisest and most drunken of the satyrs in whom intoxication
inspired his wine-hazed mind with a special knowledge and powers of
prophecy. Silenus is a companion and tutor of Dionysus, god of vegetation,
wine and ecstasy who, in his earliest manifestation appears to have been a
male fertility equivalent of Demeter.[24] In the Roman world, Dionysus is
equated with Bacchus, god of wine and master of the revel.[25] Fertility images
of the pagan classical world such as the Silenus statuette may have come to
inspire medieval depictions of sinful sensuality. St Clement attacked pagan
licentiousness as well as the shamelessness of the Greeks in displaying sexual
organs, naked girls, drunken satyrs and erect phalli. As Weir and Jerman

[23] Weir and Jerman, *Images of Lust*, pp. 111–12.
[24] A. Cottrell, *The Encyclopedia of Mythology* (Godalming, 1996), p. 37.
[25] J. Hall, *Dictionary of Subjects and Symbols in Art* (London, rev. edn, 1979).

point out: 'In other words he is preparing the ground for the Christian view of sex which will permeate the carvings of the Romanesque masons.'[26]

A century before the invasion of Ireland, the Hiberno-Norse towns came under the influence of the Anglo-Norman church centred on Canterbury. Concerned particularly with seeking reform of the ecclesiastical organization of the Irish church, English churchmen also sought reform of the customary Irish laws on divorce and remarriage – as well as the married status of Irish churchmen. The Synod of Cashel in 1101 partially reformed Irish law by forbidding marriage among close kin but, by failing to address the practices of concubinage and divorce, fell short of the requirements of Rome. Nevertheless, through the efforts of reforming Irish churchmen such as St Malachy, a degree of reorganization of the Irish church took place during the first half of the twelfth century. There was also renewed contact with the Papacy, and continental orders such as the Augustinians and Cistercians were introduced. In the period immediately prior to the Norman invasion of Ireland in 1169, renewed contact with Europe led to changes in Irish religious architecture and sculpture. This was partly through the pilgrimages of Irish kings, aristocrats and prominent churchmen to continental shrines where they became familiar with Romanesque architecture with its exhibitionist and related figures. As a consequence, in Ireland, the earliest exhibitionist figures appear to be those associated with pre-Norman Romanesque buildings, one of the best known of which is that on the chancel arch of the Nun's Church, Clonmacnoise, depicting a naked figure whose face is embraced by the legs (Fig. 7.3). However, the vast majority of true sheela-na-gigs found in Ireland appear to date to the period after the Norman invasion of 1169 and are found mainly within or adjoining areas where there was heavy Anglo-Norman settlement.[27] The greatest concentration is in north Munster, Ossory and the midlands, being virtually absent from the far west and north of the island. One of the most westerly examples, that from Aghagower, Co. Mayo, is, perhaps significantly, located along a pilgrims' road to Croagh Patrick (Fig. 7.4). Whereas the earlier Romanesque exhibitionist figures tend to form part of a larger decorative scheme, post-invasion sheela-na-gigs tend to be single figures that were carved to be set in isolation, usually on a wall near a window or door or on a gable quoin stone. However, this is not always the case as the Birr, Co. Offaly, sheela-na-gig is carved on a corbel (Fig. 7.5) very much in the European tradition.

Generally, sheela-na-gigs are stolid forms with large heads, often with bulging eyes, gaping mouths and jug ears. The majority are carved on rectangular blocks of stone, which are twice as high as they are broad, ranging in height between 40 cm and 60 cm. Many are carved roughly but some are excellent examples of the stonemason's craft. Some variations in pose exist,

[26] Weir and Jerman, *Images of Lust*, p. 112.
[27] Kelly, *Sheela-na-gigs. Origins and Functions*, Fig. 1.

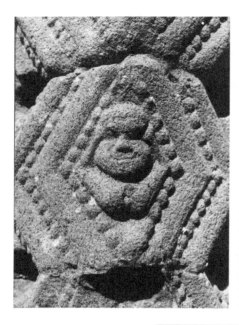

Fig. 7.3 Exhibitionist or acrobat figure carved on the chancel arch of the Nun's Church, Clonmacnoise, Co. Offaly. (National Monuments Service, Department of the Environment, Heritage and Local Government, Dublin)

Fig. 7.4 The small sheela-na-gig from Aghagower, Co. Mayo, located along a pilgrims' road leading to the shrine of the national saint on the summit of Croagh Patrick, Co. Mayo. (National Museum of Ireland)

on the basis of which the figures have been arranged into classes,[28] but it is by no means certain whether these have any real significance. In general, sheela-na-gigs appear to be evenly divided between those that seem to be standing and those that may be seated. The legs may be widely splayed or, alternatively, the thighs may be splayed but with the heels together. In some cases the legs appear not to have been represented at all. The commonest position of the arms is that whereby the hands are placed in front with a gesture towards the abdomen or, more explicitly, towards the pudenda. The

[28] Guest, 'Irish Sheela-na-Gigs in 1935', pp. 107–29; Jerman 'The Sheela-na-gig carvings of the British Isles', pp. 13–14.

Fig. 7.5 Sheela-na-gig carved on a
corbel from Birr, Co. Offaly.
(National Museum of Ireland)

hands may join in front of the genitalia or may be shown gripping the
pudenda. In some instances the arms are placed behind the thighs. On the
sheela-na-gig believed to have come from a Dominican friary in Clonmel, Co.
Tipperary, the right arm is behind the thigh while the left is in front, with
both touching the pudenda. The right hand rests on the right leg, with one
finger of the left hand resting on the pudenda in what may be a masturbatory
gesture on the carving from Ballylarkin church, Co. Kilkenny (Fig. 7.6). A
deliberate effort appears to have been made to represent sheela-na-gig as
grotesque, hideous and ugly. A particularly terrifying example is that from
Cavan, Co. Cavan (Fig. 7.7). The tongue protrudes from a large head and a
series of emaciated ribs are shown. Breasts are rarely represented but in those
cases where they are present they are small and usually accompanied by ribs
indicating emaciation. A small number of sheela-na-gigs show striations on
the cheeks or brows that may represent wrinkles or perhaps tattoos; teeth are
also sometimes depicted.

Like the earlier Romanesque figures, sheela-na-gigs are to be found
located on churches, generally placed high up on the walls. However, exam-
ples carved on pillar-like stones at Tara, Co. Meath, (in the graveyard of a
medieval church) and Swords Glebe, Co. Dublin, probably once flanked the
doorways of medieval churches. More often, however, Irish sheela-na-gigs
are to be found on the walls of castles and tower houses where they may have
functioned as protective carvings and symbols of lordly status. Generally

131

Fig. 7.6 The figure from a thirteenth century church at Ballylarkin, Co. Kilkenny, is one of the best carved Irish sheela-na-gigs. (National Museum of Ireland)

Fig. 7.7 There has been a deliberate attempt by the carver to represent the sheela-na-gig from a church at Cavan, Co. Cavan, as ugly and threatening. (National Museum of Ireland)

speaking, it may be the case that the figures found on castles tend to be later in date than those occurring on churches, thus indicating a change through time in their perceived meaning and function. The reasons for this may be found in the cultural assimilation of the Anglo-Normans in all areas outside the Pale during a time of Gaelic resurgence from the late thirteenth to the sixteenth century.[29] The Pale was a fortified earthwork surrounding an area extending about thirty miles from Dublin outside of which the authority of the English crown was weak and power rested in the hands of local lords of both Irish and Norman ancestry. During the Middle Ages, the adoption of Irish ways, laws, language and literature made a deep impact upon the worldview of the Anglo-Norman settlers living beyond the Pale, of whom it was said they became 'more Irish than the Irish'. In the Irish tradition, the land was a female entity to which the lord was wedded metaphorically and therefore responsible for its protection, wealth and fecundity. Elements of ancient pre-Christian beliefs were embedded within these concepts of lordship, and these elements found reinforcement in the Irish literary and intellectual tradition that the newcomers adopted. Important components of the tradition were the ancient epic tales and mythology, versions of which continued to be compiled in manuscript form throughout the Middle Ages. Even into the seventeenth century compilation continued to be undertaken by Gaelic scholars who made a conscious effort to record the history and traditions of a civilization that they recognized as doomed. In the tales female characters appear, such as Medb, warrior Queen of Connacht, and the war-goddess Morrigan, who are literary personifications of the ancient earth goddess.[30]

To these literary images, sheela-na-gig supplied a readymade visual image that could be expropriated and displayed on a lord's residence to provide validation of his role and status. The fifteenth and sixteenth centuries were the period when the power of the Gaelic and Gaelicized Anglo-Irish lords was at its greatest and the most typical buildings of the time were tower houses. The Irish masons who built these fortified residences of the gentry produced their own style, which was an amalgam of past and present and there is little evidence of English influence.[31] Unlike earlier castles, tower houses were an internal development, the architectural characteristics of which were essentially Irish,[32] and it was on such buildings that powerful lords displayed sheela-na-gigs. Some of these lords, such as O'Brien and O'Melaghlin were the descendants of Irish high kings while others such as Butler and Fitzmaurice were of settler stock.

29 Kelly, *Sheela-na-gigs. Origins and Functions*, pp. 44–6.
30 Ibid., p. 46.
31 R. Stalley, 'Gothic Art and Architecture', in *The Illustrated Archaeology of Ireland*, ed. M. Ryan (Dublin, 1991), pp. 172–6 (p. 172).
32 D. Newman Johnson, 'Later Medieval Castles', in *The Illustrated Archaeology of Ireland*, ed. Ryan, pp. 188–93 (p. 191).

Fig. 7.8 The sheela-na-gig over a yard gate at Moate castle, Co. Westmeath, may be among the latest in the series of Irish stone carvings. The figure is in an oval area sunk in a slab and it has unusual proportions, most notably the enormous face. (National Museum of Ireland)

The carving of stone sheela-na-gigs appears to have ended with the final defeat of Irish Gaelic society during the seventeenth century, and a sheela-na-gig at Moate castle, Co. Westmeath, erected on a wall rebuilt in 1649 may represent the end of the Irish series of stone carvings (Fig. 7.8).[33] There was, however, a final late manifestation of the tradition using different media that may have been a reflux from the Low Countries during the seventeenth and eighteenth centuries.

The figures in question occur on pipe tampers or pipe stoppers of which there are five examples (four bronze and one ivory) in the collections of the National Museum of Ireland. Each has an elaborate handle and a cylindrical projection that, once a tobacco pipe was lit, the smoker used to tamp tobacco in the bowl to compact it for more efficient burning. No provenance is recorded for the copper alloy examples but the ivory example[34] is docu-

[33] Guest, 'Irish Sheela-na-Gigs in 1935', p. 120.
[34] Dublin, National Museum of Ireland, Reg. no. NMI SA1901:33.

Fig. 7.9 Ivory pipe tamper recorded as having been found beside a castle in Co. Tipperary. The pose is similar to that found in a number of stone sheela-na-gigs. (National Museum of Ireland)

mented as having been found 'in a dug field at Castle, Co. Tipperary'.[35] The ivory figure is that of a female wearing a dress gathered at the waist exposing the buttocks and genitalia (Fig. 7.9). The right hand grasps the right buttock and the left hand gestures towards the genitalia. The legs are flexed, with the knees together, and the figure appears to be defecating. The head is missing. Two bronze tampers were acquired as part of a collection together with two bowls from seventeenth-century tobacco pipes and what appear to be two Dutch tobacco boxes of the eighteenth century, although no direct connection between any of the objects can be demonstrated.[36] One tamper[37] is plain on one side and on the other there is a standing naked female, bent over fully so that the head peers backwards from between the splayed legs (Fig. 7.10). A second similarly posed example,[38] shows a backward-looking female whose buttocks and genitalia are exposed. However the opposite side depicts a male figure with enlarged phallus and testes (Fig. 7.11). A third bronze tamper[39] shows a couple copulating while the final example is of a naked cherub standing with the right arm flexed, the hand resting on the stomach.

[35] Science and Art Museum Irish Antiquities Register, 1898–1928, p. 54.
[36] Dublin, Royal Irish Academy Museum, Register of Antiquities (1859–1886), pp. 103–6.
[37] Dublin, National Museum of Ireland, Reg. no. NMI R.560.
[38] Reg. no. NMI R.561.
[39] Reg. no. NMI R.2088.

Fig. 7.10 Copper alloy tamper depicting a woman looking backwards through splayed legs in a revealing pose. The reverse is plain. (National Museum of Ireland)

Fig. 7.11 Copper alloy tamper depicting a well-endowed man looking backwards through splayed legs. The reverse shows a woman in the same pose as figure 10. (National Museum of Ireland)

Tampers were one of the pipe smoker's most important tools, and examples with elaborately ornamented handles were cast from at least the year 1660 onwards.[40] The tamper bearing the figure of a naked boy or cherub is identical to a tamper found in North America for which a seventeenth- or eighteenth-century date has been proposed.[41] All of the National Museum of Ireland tampers may be either of Dutch or English origin, and they may reflect renewed contacts with England and Holland arising from the Williamite war (1689–91). The designs and themes employed to decorate the handles were inspired frequently from those of an earlier age[42] and the lewd or erotic examples suggest a background in the Low Countries. The themes may derive ultimately from the erotic and exhibitionist figures represented on tin/lead alloy badges that were particularly prevalent in the Netherlands and Flanders during the fourteenth and fifteenth centuries.[43] To a lesser extent similar erotic badges were to be found in the surrounding countries, including England.[44] The erotic badges can, in turn, be linked to the Romanesque sculptural tradition where similar themes are frequently found and, to a lesser extent, to the details of manuscript illustration.[45] In turn, it is the Romanesque tradition that gives rise to the Irish series of sheela-na-gigs.

Coming first to antiquarian attention during the nineteenth century, academic interest in sheela-na-gigs has grown steadily since then and, following the publication in 1977 of Dr Jørgen Andersen's important book *The Witch on the Wall. Medieval Erotic Sculpture in the British Isles*, the sculptures have found a general audience. A growing interest in feminism, Celtic spirituality and New Age beliefs has served to promote further interest in the carvings. While academics debate the meaning and significance of the figures, sheela-na-gigs continue to be powerful images that generate strong passions and public controversy. Most contemporary popular interest in the carvings tends to lay stress on the reproductive function of female sexuality, viewing the figures in a positive light. However, interpretation of the figures is clearly a complex matter and, perhaps most importantly, their significance and function appear to have changed across space and time.

40 I. N. Hume, *A Guide to the Artifacts of Colonial America* (New York, 1976), p. 310.
41 Ibid., Fig. 98.3, p. 311.
42 Ibid., p. 310.
43 A. M. Koldeweij, 'A Barefaced *Roman de la Rose* (Paris, B.N., ms. Fr. 25526) and some Late Medieval Mass-Produced Badges of a Sexual Nature', in *Flanders in a European Perspective: Manuscript Illumination around 1400 in Flanders and Abroad*, ed. M. Smeyers and B. Cardon (Leuven, 1995), pp. 499–516.
44 Ibid., p. 500.
45 Ibid., pp. 503–16.

8

Diet, Defecation and the Devil:
Disgust and the Pagan Past

Carolyne Larrington

[D]isgust arises from the fetid ooze of what I call life soup, the roiling stuff of eating, defecation, fornication, generation, death, rot and regeneration. Yet even in the midst of unpleasant sensation, of bodies and their wastes and orifices, the larger cultural and moral orderings intrude and animate the ooze with spirit.[1]

[There is] a path of development in individuals and cultures that extends from a presumed origin of disgust as a rejection response to bad tastes, in the service of protecting the body, to the full range of elicitors listed above, more appropriately described as in the service of protecting the soul.[2]

The first edition of the *Oxford English Dictionary* in 1933 gives 'obscene' as, firstly, 'offensive to the senses, or to taste or refinement; disgusting etc.', a definition marked as archaic. The second meaning of 'obscene', 'offensive to modesty or decency, unchaste or lustful ideas, impure, indecent', is indeed the more familiar to us. However, fifty years later, the second edition of the *Dictionary* indicates the first definition cited above as no longer archaic; our contemporary usage allows once more the interchangeability of 'obscene' and 'disgusting' in certain contexts.[3] It is this understanding of 'obscene' as 'offensive to the senses, disgusting' that I want to explore in detail in this essay, in relation to the process psychologists of emotion have labelled 'moralization', the transfer into the domain of disgust of an activity that has previously been thought innocuous. The essay will examine how one such activity – listening to stories of the pagan past – is rendered disgusting in the context of the Christianization, and the consequent re-envisioning of the pagan past, of the Scandinavian north, primarily in Icelandic and Norwegian contexts.

1 W. I. Miller, *The Anatomy of Disgust* (Cambridge MA, 1997), p. 18.
2 P. Rozin, J. Haidt and C. R. McCauley, 'Disgust', in *Handbook of Emotions*, ed. M. Lewis, J. M. Haviland-Jones et al., 2nd edn (New York, 2000), pp. 637–53 (p. 637).
3 *The Oxford English Dictionary*, ed. James M. Murray et al., 13 vols (Oxford, 1933); *The Oxford English Dictionary*, 2nd edn, ed. J. A. Simpson and E. S. C. Weiner, 20 vols (Oxford, 1989), *s.v.* obscene.

Christianity came relatively late to these countries: Norway was converted piecemeal in the early decades of the eleventh century, while the Icelanders converted en masse at the Assembly in 999 or 1000. In both countries, overt practice of pagan ritual appears to have been quickly extirpated. Myths, legends and history from the pagan past remained available to poets and scholars, but their deployment was a highly specialized and carefully contained art; learned strategies such as euhemerization were used to distance and contain the potentially disruptive pagan material.[4] In works such as the early thirteenth-century Icelandic historian Snorri Sturluson's *Heimskringla*, a history of the kings of Norway, the pagan past is marked off by an ignorance of divine truth, which is remedied by the coming of Christianity. Icelandic family sagas, which recounted stories of the pre-Christian inhabitants of Iceland, often made use of the 'wise pagan' topos to suggest that the ancestors anticipated the coming of the new religion with respect and enthusiasm.[5]

Sanitization of pre-Christian narrative is by no means unique to Scandinavia; St Jerome concluded in his *Epistle* 22 that pagan literature could not be of service to Christianity, though he modified this position by *Epistle* 70. Drawing on the image of the foreign slave-woman who must have her hair shaved and nails trimmed before she is fit for intercourse in Deuteronomy 21. 10–13, Jerome suggests that the classics can similarly be made fit for Christians to read, strikingly anticipating the discourse of disgust that is the subject of this essay.[6] Augustine too, in *De Doctrina Christiana*, discusses the problem, asking whether it was possible to 'take the gold out of Egypt' as the Children of Israel had done.[7] From the twelfth century onwards, extensive Christian commentary and allegorization converted such authors as Ovid into wholesome reading for the literate devout.[8] This was necessary: the Icelandic

4 The *Prologue* to Snorri Sturluson's *Edda*, composed around 1230, for example, identifies the Norse pantheon as refugees from Troy: see Snorri Sturluson, *Edda: Prologue and Gylfaginning*, ed. A. Faulkes (London, 1988), pp. 4–6.
5 See Snorri Sturluson, *Heimskringla*, ed. B. Aðalbjarnarson, 3 vols, Íslenzk Fornrit 26–8 (Reykjavík, 1941–51) and L. Lönnroth, 'The Noble Heathen: A Theme in the Sagas', *Scandinavian Studies* 41 (1969), 1–29.
6 Generally on the recuperation of the classical pagan inheritance, see J. Seznec, *The Survival of the Pagan Gods*, Bollingen Institute 38 (New York, 1953); Jerome, *Epistola XXII: Ad Eustochium, Paulae Filiam* 22.30, PL 22, 416–17 and *Epistola LXX: ad Magnum Oratem Urbis Romae* 70.2, PL 22, 665–6. See also N. McDonald, 'Divers folk diversely they seyde: A Study of the Figure of Medea in Medieval Literature' (unpublished D. Phil. thesis, University of Oxford, 1994), pp. 62–6. I am indebted to Nicola McDonald for these and other references to early and twelfth-century instances of Christian sanitization of pagan narrative.
7 Augustine, *De Doctrina Christiana* II.xl.60, *Corpus Christianorum series Latina* 32 (Turnhout, 1962), 73–4.
8 On the Ovidian inheritance, see McDonald, 'Divers folk', pp. 62–94; Arnulf of Orléans, *Allegoriae super Ovidii Metamorphosin*, ed. F. Ghisalberti, *Un culturo di Ovidio*

bishops' sagas record how in the twelfth century Bishop Jón Ögmundarson had to chastise one of his pupils, a certain Klœngr Þorsteinsson, caught reading Ovid's *Ars Amatoria* in the original; Klœngr went on to become bishop of Skálholt in northern Iceland.[9]

Laymen could not necessarily be trained in, or trusted with, learned strategies such as allegorization or euhemerization; for the Church it was simpler to induce a cultural aversion to the retelling of those tales suggesting that pagan belief could be either valid or efficacious. The annexation of disgust to morality is a strategy frequently employed by the Church to create aversion to a range of behaviours. Much of what Christianity regards as sinful, such as the corporeal sins of gluttony, lust and sloth, appear already to have been viewed as socially unacceptable in pre-Christian Scandinavian culture; excessive eating and drinking, womanizing and failure to get out of bed in the morning are all criticized in the Old Norse gnomic poem *Hávamál*, which analyses desirable behaviour in terms of *mannvit* ('common sense') and undesirable behaviour as *óvítr* ('foolish').[10] The penalty for stigmatized activities in *Hávamál* is, however, social ridicule and loss of face, rather than eternal damnation. The Church recategorized these activities as sinful and, in a number of contexts, incorporated them within a discourse of obscenity and disgust. In many medieval hell visions, corporeal sins are punished by disgust-inducing torments: the sinner's body is violated in every orifice by adders and reptiles, foul or burning substances are poured down the glutton's throat, the body is immersed in excrement, or partially dismembered, and the whole scene is pervaded by the sulphurous and miasmic stink that brings home to the body the filthy behaviour in which it has previously wallowed.[11] The disgusting also makes its appearance in sermon exempla, by

nel secolo xii, in *Memorie del reale instituto Lombardo di scienze e lettere* 24 (1932), pp. 201–34, and R. Hexter, *Ovid and Medieval Schooling: Studies in Medieval School Commentaries on Ovid's* Ars Amatoria, Epistulae ex Ponto *and* Epistulae Heroidum, Münchener Beiträge zur Mediävistik und Renaissance Forschung 36 (Munich, 1986).

9 *Biskupa sögur*, ed. J. Sigurðsson and G. Vigfússon, 2 vols (Copenhagen, 1858), I, 238.

10 *Hávamál* in *Edda: Die Lieder des Codex Regius*, ed. G. Neckel and H. Kuhn, 2 vols, 4th edn (Heidelberg, 1962), I, vv. 1–103; see also C. Larrington, *A Store of Common Sense: Gnomic Theme and Style in Old Icelandic and Old English Wisdom Poetry* (Oxford, 1993), pp. 15–72.

11 For an overview of medieval vision poetry, see P. Dinzelbacher, *Vision und Visionsliteratur im Mittelalter*, Monographien zur Geschichte des Mittelalters 23 (Stuttgart, 1981). Influential and widely disseminated vision texts include 'Tractatus de Purgatorio Sancti Patricii', in *St. Patrick's Purgatory*, ed. R. Easting, EETS OS 298 (Oxford, 1991), pp. 121–54, which features reptiles (pp. 131–2), stinking rivers (p. 135) and the suspension of sinners by the genitals (p. 132). *Visio Tnugdali: Lateinisch und altdeutsch*, ed. A. Wagner (Erlangen, 1882) describes sinners' genitals as putrid and corrupt with worms (p. 24); fornicators are impregnated by beasts and their bodies are ruptured in giving birth to monsters from their arms or legs (p. 28). *Visio Thurkilli, relatore, ut videtur, Radulpho de Coggeshall*, ed. P. G. Schmidt (Leipzig, 1978)

which the Church sought to produce aversion to sin and repentance before it was too late. Again the body's desires were linked with the disgusting, with leprosy or other disfiguring and putrescence-producing diseases, with body products and with more generalized unpleasant smells, tastes and textures.[12] Scholars have suggested that the grotesques in architecture and manuscript illumination point to a similar metonymic juxtaposition of sinful behaviour with both shameful and disgusting appearances, cannibalism graphically depicted in the margins of a treatise on vice, for example.[13] Elsewhere, figures expose buttocks and genitalia, defecate or play the 'testicular bagpipes', sharing a grotesqueness of form or subject.[14] All these have a strongly didactic purpose, attempting to instil aversion to sinful behaviour by showing it as proximate to the disgusting. Corporeal sins particularly lend themselves to such stigmatization; though this is an easily made conceptual leap, other activities, as we shall see below, which have no necessary connection with the primary elicitors of disgust, can become moralized as disgusting through reiterated association with disgusting things.

Theories of disgust

Is there a theoretical basis for the assumption that what elicits disgust in us moderns would have elicited disgust in a medieval audience? Can present-day concepts of disgust be so easily mapped on to past cultures? The belief that human emotion is universal can be traced back to Charles Darwin's study of emotion and behaviour, *The Expression of Emotion in Man and Animals*, first published in 1872.[15] From the observation of facial expressions and behaviour in particular contexts, Darwin assumed that certain emotions

depicts the avaricious swallowing, vomiting and then reswallowing of red-hot coins (p. 24).

12 See *Index Exemplorum: A handbook of medieval religious tales*, ed. F. C. Tubach, Folklore Fellows Communications 204 (Helsinki, 1969), especially nos 2267, 3377 for genitals; 1949 for eyes devoured by worms; 5038 for usurer eaten by toads; 2108 for fine food on a dirty dish; 3051, 1410 for leprosy. The *Lambeth Homilies* and the collection of five *Kentish Sermons* listed in J. E. Wells, *A Manual of the Writings in Middle English 1050–1400* (New Haven, 1926) and discussed on pp. 280 and 283 give further examples of the disgusting in homiletic contexts.

13 See M. Camille, *Image on the Edge: The Margins of Medieval Art* (Cambridge MA, 1992), p. 51.

14 Camille, ibid., passim; for 'testicular bagpipes', see p. 33.

15 C. Darwin, *The Expression of Emotion in Man and Animals* (London, 1872). See now, 3rd edn with introduction, afterword and commentaries by P. Ekman (London, 1999). For a strongly somatic understanding of emotion, see W. James, 'What is an Emotion?', *Mind* 9 (1884), 188–205. K. Oatley and J. M. Jenkins, *Understanding Emotions* (Oxford, 1996) is the best recent introduction to the study of emotion in psychology.

are common to all humans across different cultures and time periods, and that these emotions must thus be genetically produced. In the mid-twentieth century, however, much human behaviour began to be analysed as socially constructed. Social constructionist theories of emotion are broadly described as componential theories, that is, they hypothesize several subsystems working in tandem. Three distinct subsystems are identified by social constructionists as operating in the cognitive, physiological and behavioural domains. Thus emotion consists in:

(i) a social situation, which the subject perceives as, for example, happy, as anger-inducing, or as surprising;
(ii) a physiological reaction – a rush of adrenaline, for example, or nausea;
(iii) a range of possible behaviours, produced both consciously and unconsciously, such as laughter, violence, shrieking, or weeping.[16]

Clearly cognitive systems, (i) above, and behavioural systems, (iii) above, are more likely to be open to social conditioning than physiological reactions, (ii) above. For example, although all humans are capable of feeling anger if they or their immediate interests are threatened, it is very much less socially appropriate to behave in an angry fashion in modern Japan than in contemporary America.[17] The strictly social constructionist understanding of emotion that was dominant in psychology in the 1980s made problematic the interpretation of emotion in literary and historical texts of the past, particularly of the medieval past. How was it possible to assume that people, real, or imagined, felt as we do when faced with the same situations?[18]

The 1990s saw an 'evolutionary turn' in psychology, a climate of research that emphasized those genetically transmitted psychological mechanisms that evolved over hundreds of generations to protect humans and their primate ancestors. This has encouraged a refocusing on the 'basic emotions' as universal.[19] The basic emotions are variously defined, but there is general

[16] See, for example, the essays in *The Social Construction of Emotions*, ed. R. Harré (Oxford, 1986).

[17] See H. R. Markus and S. Kitayama, 'Culture and the self: implications for cognition, emotion and motivation', *Psychological Review* 98 (1991), 224–53 and H. R. Markus and S. Kitayama, 'The cultural construction of self and emotion: implications for social behaviour', in *Emotion and Culture: Empirical Studies of Mutual Influence*, ed. H. R. Markus and S. Kitayama (Washington, 1994), pp. 89–130.

[18] On the emotions and medieval history, see the special issue of *Early Medieval Europe* 10.2 (2001); for a discussion of the psychology of emotion, see C. Larrington, 'The psychology of emotion and the study of the medieval period', in ibid., pp. 251–6.

[19] A. Ortony and T. J. Turner, 'What's basic about basic emotions?' *Psychological Review* 74 (1990), 431–61; R. M. Nesse, 'Evolutionary explanations of emotions', *Human Nature* 1 (1990), 261–83; J. Tooby and L. Cosmides, 'The past explains the present: Emotional adaptations and the structure of ancestral environments', *Ethology and Sociobiology* 11 (1990), 375–424.

agreement that anger, disgust, happiness, surprise, sadness and fear can be demonstrated to be universal in human societies, while more cognitively complex emotions, such as resentment, embarrassment or contempt, are less easily identified across different cultures. For the purposes of this essay, I shall assume that cross-cultural psychologists have successfully demonstrated the existence of disgust as a human universal, but that, nevertheless, there remain powerful cognitive and behavioural components in disgust that may vary between cultures and historic periods.

The social psychologist Paul Rozin has been investigating disgust for a decade or more; his research has confirmed that modern societies universally recognize the emotion of disgust, distinguishing it from contempt and anger in a variety of situations.[20] Rozin and colleagues have now moved away from an initial concentration on disgust as fundamentally engendered by food, and associated with the mouth and oral incorporation, to the identification of eight further primary domains in which disgust operates. These nine areas are: food, body products, animals, sexual behaviour, contact with death and corpses, violations of the exterior envelope of the body, poor hygiene, interpersonal contamination, and certain moral offences.[21] Rozin's earliest explanation of disgust was thus primarily as an adaptive mechanism: protecting the organism from ingesting noxious substances, a reflex that can be seen clearly in new-born babies if something bitter is placed in their mouths. An adaptive aetiology for the kinds of disgust associated with food and body waste products seems plausible, but it does not easily account for disgust's extension into the other domains. Rozin and his associates' later theorization of the presence of disgust in these domains contains a strongly cognitive element: humans do not like to be associated with the animal, or to be reminded that they are animals.

The kind of empirical research undertaken by social and cross-cultural psychologists is not possible across historical eras. Nevertheless, in *The Anatomy of Disgust*, the legal historian W. I. Miller investigates disgust in its broadest manifestations both in contemporary western society and in earlier western cultures. Miller's work deliberately recalls Burton's *Anatomy of Melancholy*, not just in its title, but in its aim of returning to the broader discursive possibilities of a past where the psychological had not yet been

20 P. Rozin, L. Lowery, S. Imada and J. Haidt, 'The CAD Triad Hypothesis: A Mapping Between Three Moral Emotions (Contempt, Anger, Disgust) and Three Moral Codes (Community, Autonomy, Divinity)', *Journal of Personality and Social Psychology* 76 (1999), 574–86.

21 See P. Rozin, J. Haidt and C. R. McCauley, 'Disgust: The Body and Soul Emotion', in *Handbook of Cognition and Emotion*, ed. T. Dalgleish and M. J. Power (Chichester, 1999), pp. 429–45, and Rozin, et al., 'Disgust', in *Handbook of Emotions*, pp. 637–53. There is a good match between Rozin's disgust domains and the employment of the disgusting in medieval visions of hell and sermon exempla, as outlined above.

divorced from the moral and the social.[22] Thus he employs a broader defini-
tion of the emotion than the strictly physiological and behavioural criteria of
psychologists, namely the evincing of 'the disgust expression, nausea and a
distancing behavioural tendency'.[23] Miller finds Rozin's account of disgust
insufficient in its reliance on the refusal of humans to identify themselves
with animals, arguing for a much broader social and cognitive understanding
of the emotion. As the first epigraph to this essay illustrates, Miller's book
moves from a consideration of the sensual and bodily as disgust-eliciting, to
more abstract, moral, social and political ramifications of disgust, noting:
'disgust has other powerful communalizing capacities and is especially
useful and necessary as a builder of moral and social community'.[24] Miller's
book was published in 1997; around the same time, Rozin began to extend his
work on disgust away from a somatic and cognitive explanation to examine
aspects of the communalizing capacities to which Miller attends here. In
particular, Rozin has become interested in the 'moralization' process, as he
terms it, the process by which a previously unstigmatized behaviour becomes
no longer pleasurable, no longer even tempting, but, rather, disgusting.[25] He
demonstrates how over the last thirty or so years smoking has become an
elicitor of disgust for non-smokers, and how, most typically for those whom
Rozin labels the 'conviction vegetarian', the eating of meat products very
soon becomes nauseating; it is the *idea* of eating meat, rather than a taste that
might previously have been enjoyed, which disgusts.

Neither Miller, in his chapter 8 'The Moral Life of Disgust', nor Rozin are
able to specify at all clearly a mechanism for the extension of disgust into an
abstract domain, the precise means by which moralization comes about.
Rozin suggests, somewhat vaguely, that it requires 'the growth of a large or
politically powerful collection of individuals who accept and promote such a
moralization'.[26] His main focus is on North American health politics; identi-
fying the effectiveness of the lobby group, he indicates how the discourse of
disgust moves from an individual and physiological level to a collective and
ideological plane: 'in the end, disgust is a powerful tool for negative socializa-
tion; a very effective way to get people to avoid something and to have this
avoidance internalized is to make the entity disgusting'.[27] Thus the mental
constructs that are experienced as disgusting are socially constructed in a
way that the physical elicitors are not. In the main body of this essay I shall
show how a fourteenth-century Old Norse king's life contains some striking

22 Miller, *Anatomy*, p. 6.
23 Rozin, et al., 'Disgust: The Body and Soul Emotion', p. 429.
24 Miller, *Anatomy*, p. 194.
25 See P. Rozin, 'The Process of Moralization', *Psychological Science* 10.3 (1999), 218–21.
26 P. Rozin, 'Moralization', in *Morality and Health*, ed. A. Brandt and P. Rozin (New
York, 1997), pp. 379–401 (p. 383).
27 Ibid., p. 384.

examples of the 'moralization' process: the mobilization of disgust to make an apparently innocuous socio-cultural activity seem repellent for ideological purposes. The means by which this is achieved is through association with primary elicitors of disgust at a somatic level: food and excrement.

Folk wisdom in a large number of cultures suggests that you are what you eat. Cross-culturally, the most favoured, but also most tabooed, food sources are animals. Very few of the range of animals that humans could eat are eaten; which animals social groups will and will not eat is a major component of social differentiation.[28] While at a physiological level, eating a decaying apple may be unpleasant, but probably will not do an individual much harm, decaying meat can infect one with a range of illnesses from salmonella to botulism. Wariness about meat makes good adaptive sense therefore; indeed, bad meat seems to be universally disgusting. Medieval Norse sailors were aware that eating contaminated whale meat could make those who consumed it very sick indeed. In *Eiríks saga ins rauða* a group of explorers run short of food in North America.[29] A stubbornly pagan member of the crew prays to Þórr and soon a whale is washed up, of a type which Karlsefni, the Christian skipper who is an expert on different kinds of cetacean, does not recognize. The starving sailors eat the meat and are punished by severe illness; when Þórr is revealed as the donor the crew throw the whale meat over a cliff and put their trust in God. The weather lifts and they are able to row out fishing once more. Bad meat, and even more so, strange meat that comes in answer to pagan prayers, is clearly envisaged as disgusting. Þorhallr, the devotee of Þórr, invokes the god's favour in a manner that is presented as bizarre and ridiculous: 'hann lá þar ok horfði í lopt upp ok gapði bæði munni ok nösum ok þuldi nökkut' ('he lay there and looked up in the air with both his mouth and nostrils gaping and he was mumbling something').[30] The disrespectful treatment of pagan worship here is unsurprising in a saga primarily concerned with the adventures of the ancestress of Bishop Þorlákr, Iceland's patron saint, but it also indicates an association between pagan practices, specifically the invocation of a pagan deity, and the disgustingness of contaminated food, a connection explored further below.

As against the innate disgust elicited by certain foodstuffs, disgust at faeces, urine and other body products, appears to be absent in very young children. This type of disgust is socialized, usually extremely successfully, in humans through toilet training. The failure of disgust in the body product

[28] See Miller, *Anatomy*, pp. 46–8; S. J. Tambiah, 'Animals are good to think and good to prohibit', *Ethnology* 8 (1969), 423–59. M. Douglas, *Purity and Danger: An Analysis of the Concepts of Pollution and Taboo* (London, 1966), which does not deal with disgust, analyses food taboos on pp. 41–57.

[29] *Eiríks saga ins rauða*, in *Eyrbyggja saga*, ed. M. Þorðarson, Íslenzk Fornrit 4 (Reykjavík, 1935), pp. 224–5.

[30] Ibid., p. 224.

domain in our culture is symptomatic of mental illness or of a sexual psychopathology.[31] Excretion is not much referred to in Scandinavian texts; however, when the inhabitants of one farmhouse in northern Iceland in *Laxdœla saga* are prevented by an enemy from leaving the main building to use the external privy for three days, the outcome is regarded as both disgusting and shameful:

> Kjartan lét þar taka dyrr allar á húsum ok bannaði öllum mönnum útgöngu ok dreitti þau inni þrjár nætr. . . . þeim Laugamönnum líkar illa ok þótti þetta miklu meiri svívirðing ok verri en þótt Kjartan hefði drepit mann eða tvá fyrir þeim.

> Kjartan secured all the doors on the buildings and prevented everyone from going outside and they had to defecate inside for three nights. . . . The people at Laugar were very displeased and thought it was a much greater disgrace and worse than if Kjartan had killed one or two of them.[32]

Miller discusses this episode at some length, noting that the shame engendered by the disgust adheres to the besieged, not the besieger, and that the tactic must have been reasonably frequently employed since the phrase *dreita inni* (defecate inside) is used (once) elsewhere without the elaboration of the *Laxdœla saga* account.[33] However, it has recently been suggested by Stefanie Würth that the *Laxdœla saga* episode is in fact modelled on this single occurrence mentioned in passing in a contemporary saga, *Íslendinga saga*. In this episode all that the saga reports is that a certain Ketill Eyjólfsson and his son Ljótr fall out with their neighbour Markús Skeggjason, 'and the father and son made Markús defecate inside' ('ok dreittu þeir feðgar Markús inni'). Würth suggests that the more elaborate explanation in *Laxdœla saga* is necessary precisely because this was an infrequent practice.[34]

Suggestive also in this regard, neatly linking together the twin domains of food and excretion, is the Old English letter to Brother Edward, identified with increasing certainty as being the work of Ælfric and composed around 1002–5. This complains vigorously – using however the vocabulary of shame rather than of disgust – about the disgusting habits of northern English people. These eat and drink to excess at feasts, to the extent that the womenfolk, who feast separately from the men, are to be found sitting together in, and on, communal privies, presumably to facilitate both evacuation and

[31] See Miller, *Anatomy*, p. 51 and references there.

[32] *Laxdœla saga*, ed. E. Ó. Sveinsson, Íslenzk Fornrit 5 (Reykjavík, 1934), p. 145.

[33] Miller, *Anatomy*, pp. 144–7 (p. 147); the other reference is in *Íslendinga saga*, ch. 7 in *Sturlunga saga*, 3 vols, ed. J. Jóhannesson, M. Finnbogason and K. Eldjárn (Reykjavík, 1946), I, 235.

[34] S. Würth, 'Die Temporalität der Laxdœla saga', in *Sagnaheimur: Studies in Honour of Hermann Pálsson on his 80th birthday*, ed. Á. Egilsdóttir and R. Simek, Studia Medievalia Septentrionalis 6 (Vienna, 2001), pp. 295–308 (p. 297).

vomiting.[35] Although the author of the letter does not specify what kinds of non-disgusting behaviour go on at such feasts ('gebeorscipum' as he calls them), it seems possible to infer, since the same word is employed in the West Saxon translation of Bede's *Historia Ecclesiastica* for the feast that Cædmon leaves, that singing about and listening to stories of the pagan past might well have been part of the social activity.[36]

It is these two domains of disgust, the food-related and the faecal, on which I want to concentrate particularly in this essay, showing how their extension into the final domain listed by Rozin and his colleagues – the morally offensive – serves to moralize an apparently innocuous, but ideologically undesirable, social practice: listening to pagan stories. As Rozin suggests in 'Moralization', it takes a large and/or politically powerful interest group to bring about the change in social acceptability that moralization entails. Historically, the most effective lobby group in western Europe has undoubtedly been the Church. During the various campaigns of conversion in Anglo-Saxon England, and in Scandinavia, the Church sought to ban activities associated with pagan belief and cult practice. These ranged from the eating of horse-meat, still under some degree of taboo in Britain today, to the exposure of infants in Iceland, as well as actual sacrifice. According to Bede, and the Icelandic historian Ari Þorgilsson writing in *Íslendingabók*, these practices were quite swiftly and efficiently extinguished, though the accounts of the various stages of Norwegian conversion in Snorri Sturluson's history of the Norwegian kings, *Heimskringla*, suggest a series of more prolonged and problematic battles, particularly over sacrifice in the context of eating at ritual feasts.[37]

However, one habit that does appear to have been hard to break, so apparently harmless and so deeply culturally ingrained, was uncritical listening to those stories that celebrated the heroic feats of Germanic ancestors. Beyond Alcuin's famous rebuke to the monks of Lindisfarne, 'Quis Hinieldius cum Christo?' ('What does Ingeld have to do with Christ?'), made in 797, we know little of Anglo-Saxon attitudes to pagan story-telling.[38] We may note that Ælfric is ready to rehearse the disgusting behaviour of Jove, Saturn and

35 The letter is published by F. Kluge, 'Fragment eines angelsachsichen Briefes', *Englische Studien* 8 (1885), 62–3. Pope discusses and attributes it to Ælfric in the introduction to his *Homilies of Ælfric*, ed. J. C. Pope, 2 vols, EETS 259–60 (Oxford, 1967–8), I, 56–7. See also N. Barley, 'The Letter to Brother Edward', *Neuphilologische Mitteilungen* 79 (1978), 23–4, and now also M. Clayton, 'An Edition of Ælfric's *Letter to Brother Edward*', in *Early Medieval English: Texts and Interpretations: Studies Presented to Donald C. Scragg*, ed. E. Treharne and S. Rosser (Tempe AZ, 2002), pp. 263–84.

36 *Old English Version of Bede's Ecclesiastical History*, ed. T. Miller, EETS OS 95–6 (London, 1890–1), p. 342.

37 Bede, *Ecclesiastical History of the English People*, ed. and trans. B. Colgrave and R. A. B. Mynors (Oxford, 1969); Ari Þorgilsson, *Íslendingabók* in *Íslendingabók, Landnámabók*, ed. J. Benediktsson, 2 vols, Íslenzk Fornrit 1 (Reykjavík, 1968), I, 17; Snorri Sturluson, *Heimskringla*, I, 170–2.

38 'Letter to Speratus', *Alcuini Epistolae*, ed. E. Dümmler, MGH Epistolae 4 (Karolini

Venus in *De Falsiis Diis*, in terms of incest and cannibalism; by identifying the classical pagan gods with figures from the Norse pantheon, he may have been successful in implying to his audience that Óðinn, Þórr and Frigg were equally degenerate, though in fact the home life of the Æsir – the group of Norse gods to whom these three belong – is relatively blameless.[39] In the 'Letter to Brother Edward', mentioned above, Ælfric – if he is the author – elides the consumption of animal blood with the adoption of Danish haircuts as part of the scandal of heathen practices, before he launches on his condemnation of women holding 'gebeorscipum' in the privy. Reprehensible pagan customs and disgusting behaviour are tellingly juxtaposed here.

We may speculate that the only extended Old English treatment of heroes of the pagan past that has survived, *Beowulf*, may owe its preservation to the nuanced way in which paganism is mediated in that poem, in particular the apparent employment of the topos of the 'wise pagan', which to some extent foregrounds the question of the characters' salvation.[40] While uncritical nostalgia for the pagan past may have been eliminated in Anglo-Saxon culture, Scandinavian sources indicate that the habit of listening to tales of the past died hard. Rozin's concept of moralization suggests one way in which curiosity about, and nostalgia for, the pagan past may have been replaced by aversion to unmediated pagan material.

The *þættir* of Flateyjarbók

This analysis focuses on two short anecdotes or, in Old Norse, *þættir*, in *Saga Óláfs Tryggvasonar in mesta* ('The Longer Life of Olaf Tryggvason'), contained in the Icelandic manuscript compendium Flateyjarbók.[41] Óláfr Tryggvason, king of Norway between 995 and 1000, was an energetic proselytizer for

Aevi, 2 vols) (Berlin, 1895), II, 183. See also D. A. Bullough, 'What has Ingeld to do with Lindisfarne?', *Anglo-Saxon England* 22 (1993), 93–124.

[39] Ælfric, *De Falsis diis* in *Homilies of Ælfric*, ed. Pope, II, 682–6. The Vanir gods, on the other hand, whom Ælfric does not mention, distinguish themselves from the Æsir by permitting brother–sister incest.

[40] See Lönnroth, 'The Noble Heathen'; for a summary of the debate about the staus of the *Beowulf* characters, see E. B. Irving, Jr, 'Christian and Pagan Elements', in *A Beowulf Handbook*, ed. R. E. Bjork and J. D. Niles (Exeter, 1996), pp. 175–92.

[41] *Þættir* is the plural form of this word, *þáttr* is the singular. Text cited from 'The king and the guest', in *Flateyjarbók*, ed. S. Nordal et al., 4 vols (Akranes, 1944–5), I, 417–18; *Þorsteins þáttr skelks*, pp. 462–4. On the Flateyjarbók *þættir*, see S. Würth, *Elemente des Erzählens: Die þættir des Flateyjarbók*, Beiträge zur nordischen Philologie 20 (Basel, 1991). On *þættir* as a genre, see J. Lindow, 'Old Icelandic *þáttr*: Early Usage and Semantic History', *Scripta Islandica* 29 (1978), 3–44; J. Harris, 'Genre and Narrative Structure in some Icelandic *þættir*', *Scandinavian Studies* 44 (1972), 1–27; and J. Harris, 'Theme and Genre in some Icelandic *þættir*', *Scandinavian Studies* 48 (1976), 1–28.

Christianity. It was his boast that he brought Christianity to six nations, Norway, Iceland, Greenland, Orkney, Shetland and the Faroes, less by dint of moral persuasion than by threat of violence. Flateyjarbók's *Saga* is a late example, compiled between 1387 and 1395 on the basis of a number of earlier lives.[42] Thus we can by no means use it as a guide to late tenth-century thinking about pagan behaviour and Christian moralization; it does not have the contemporary resonance of Ælfric's discussion of the Danish gods in *De Falsis Diis*. Rather these stories illuminate a later understanding of how moralization might have worked in the conversion period. They do not offer solid historical evidence that Christian missionaries in the north deliberately suppressed pagan story-telling, but rather dramatize the historical moment when pagan tradition had apparently first to be suppressed, and then assimilated to new contexts in which its pagan implications could be contained, and the tales rendered innocuous.[43] In Flateyjarbók's *Saga Óláfs Tryggvasonar in mesta* pre-Christian story-telling is reframed as an undesirable social practice within an essentially hagiographical environment; strong generic influence from sermon exempla, in the first *þáttr*, and from folk-tale, in the second *þáttr*, may be detected.[44]

The first of the two stories, 'The King and the Guest' may be summarized briefly. It belongs to a familiar story pattern, found with some variation elsewhere in this and in other lives of Óláfr Tryggvason, notably in Snorri Sturluson's *Heimskringla*.[45] In the Flateyjarbók version under consideration here, an old one-eyed man, wearing a low-brimmed hat (both Odinic characteristics), appears as a guest in the hall at Ögvaldsness where the king is staying one Easter. In response to the king's questioning, the guest tells him about the old days, giving details of Ögvaldr, the pagan warrior-king for whom the locality was named, and his sacred cow.[46] The guest keeps the king

42 The basis of the Flateyjarbók life is *Saga Óláfs Tryggvasonar in mesta*, composed around 1300, which exists in two redactions, and is itself based on Snorri Sturluson's *Óláfs saga Tryggvasonar* in *Heimskringla*. See Würth, *Elemente*, p. 31.

43 See most recently K. E. Gade's discussion of the (temporary) disappearance of kennings based on pagan mythological referents in the earliest Christian poetry in 'Poetry and its changing importance in medieval Icelandic culture', in *Old Icelandic Literature and Society*, Cambridge Studies in Medieval Literature 42 (Cambridge, 2000), pp. 61–95 (pp. 73–5), and R. Frank, *Old Norse Court Poetry: the Dróttkvætt Stanza*, Islandica 42 (Ithaca NY, 1978), pp. 65–7.

44 *Þorsteins þáttr skelks* is easily assimilated to Icelandic folk-tales in which the hero is threatened by a supernatural being, typically a troll, and must keep it talking until rescue comes, by sunrise, which turns the troll into stone, or by divine intervention.

45 See also Snorri, *Heimskringla*, I, 312–14, where the episode follows the adventure of Eyvindr and the sorcerers. Snorri identifies the 'gestr' (guest) as Óðinn himself, not as the devil in the form of Óðinn, as the Flateyjarbók author does. For discussion of this type of story, see J. Harris and T. D. Hill, 'Gestr's "Prime Sign": Source and Signification in *Norna-Gests þáttr*', *Arkiv för nordisk filologi* 104 (1989), 103–22.

46 King Ögvaldr, though not his cow, appears also in *Hálfs saga ok Hálfsrekka*, ed. H. Seelow, Rít 20 (Reykjavík, 1981), p. 170.

up late; the bishop has to remind the king twice that it is time to go to sleep. After a brief doze the king wants to talk to the guest again, but he has disappeared. Investigation reveals that the guest had visited the kitchens the day before, made disparaging remarks about the quality of the meat there, and had donated two fine sides of beef for the king's feast. The king orders the meat to be burned and thrown into the sea: 'eigi skal fjandinn svá svíkja oss, at nokkurr minna manna eti hans eitrfulla fæðu' ('the fiend shall not so deceive us that some of my men may eat his poisonous provisions'). Óláfr suspects that the visitor was the devil in the guise of Óðinn, intending to make him oversleep and miss divine service. The same day a magical attack by Eyvindr *kelda*, an enemy employing a number of sorcerers, is divinely foiled; the unnatural darkness they conjure up serves only to bewilder them so that they wander about in circles. In the manner of a homily, the king comments at length on the power of God against both the devil in Odinic form and the sorcerers. All his opponents, who refuse nonetheless to convert to Christianity, are shipped to a nearby skerry and drowned at high tide. Óláfr breaks open the two burial mounds on the headland, where human, and indeed cattle, bones are discovered, thus effecting a kind of exorcism, and departs.

Notable in this story is the indirection with which the author treats the pagan practices of the past. The king lays himself open to temptation by evincing curiosity about King Ögvaldr; the guest obliges by stating that he was 'hermaðr mikill' ('a great fighter') and that he was accompanied by his sacred cow wherever he went, that he drank its milk, and that this gave rise to a proverb, presumably still current, that man and cow should go together, 'allt skal fara saman, karl ok kýr'. At Ögvaldr's death, he and the cow were honoured together with the erection of memorial stones over their burial mounds. The guest himself maintains some critical distance when rehearsing these facts: Ögvaldr is said to have believed that drinking the cow's milk was auspicious, though this is not endorsed by the guest. Nor does the cow appear to have protected Ögvaldr in his final battle against King Dixin, presumably by the usual panic-inducing bellowing, as evidenced in *Ragnars saga loðbrókar* in which the Swedes have a sacred cow, Síbilja, as their secret and ultimate weapon.[47] However, the currency of the proverb the narrative voice cites, 'at margir menn hafa' ('that many men have'), appears to endorse and naturalize Ögvaldr's practice, suggesting that domestic animals ought naturally to be close to humans. Affection for the family cow is one matter however, ritual burial with a sacred beast quite another. The king craves more of this kind of talk, 'konungi þótti orðs vant, er annat var talat' ('he thought that other subjects of conversation were less satisfying'); the guest

[47] *Ragnars saga loðbrókar*, in *Fornaldar sögur Norðurlanda*, ed. G. Jónsson and B. Vilhjálmsson, 4 vols (Reykjavík, 1943), I, 113, 118.

sits on his bed and chats to him, until the bishop reminds him of the need for sleep. When he wakes again, the king's first thought is to call for his interlocutor, who is now missing; fortunately for him, for it is time for Mass.

The tale opposes two different kinds of discourse, the intriguing and in some ways addictive tales of the pagan past, of kings, battles and cult animals, and the singing of divine service in the Christian present, to which the bishop recalls the king by his repeated interventions. Yet the king intuitively knows that the diabolical attack is not over, and that his cooks must be interrogated before they get much further in the food preparation for the Easter feast. Sure enough, the Odinic visitor has been in the kitchens, denigrating the quality of contemporary meat, and offering a tasty and high-quality alternative. We infer that the sides of meat he supplies are, in some sense, derived from the long-dead cult cow of King Ögvaldr, centuries old, long buried in the earth, but made to look 'fat and meaty' ('feitar ok digrar'). The king's curiosity about the pagan past has exposed him and all his men to the risk of the worst form of diabolic food-poisoning during the Easter feast. Though it is not explicitly stated, there is surely an implication that Eyvindr's sorcerers might have enjoyed some success against Ólafr, had the king missed Mass that morning and ingested the diabolic meat as the Odinic visitor had intended.

The second tale, *Þorsteins þáttr skelks*, unique to Flateyjarbók, is broadly humorous in tone, drawing, as Ólafr himself remarks, on the familiar stereotype of the independent-minded Icelander who takes risks and disobeys the king, yet who proves his courage and devotion, and is consequently cherished by the monarch.[48] Apparently sensing diabolical forces in the offing, Ólafr commands that no one visit the privy alone in the night after an evening of heavy drinking. Þorsteinn the Icelander wakes up, has not the heart to rouse his bunk-mate, and so creeps out to the magnificent twenty-two-seater privy alone. He has been sitting there for a little while on the seat closest to the door when a demon pops up through the innermost seat. The revenant turns out to be a heathen warrior, one Þorkell the thin, who had fought in battle with the pagan Danish king Haraldr Battle-tooth. John Lindow characterizes Haraldr as 'an unsavoury character, a cantankerous old monarch who finally fell to Óðinn himself'.[49] Haraldr Battle-tooth is obviously no Ólafr Tryggvason. Þorsteinn engages the demon in conversation about hell, and learns that even men as brave as the most famous pagan heroes, Sigurðr the dragon-slayer and Starkaðr the Old, are yelling in torment there. These two heroes, Lindow speculates, represent respectively the best

48 For discussion of this story in terms of narratives of the supernatural, see J. Lindow, '*Þorsteins þáttr skelks* and the verisimilitude of supernatural experience in saga literature', in *Structure and Meaning in Old Norse Literature*, ed. J. Lindow, L. Lönnroth and G. W. Weber, Viking Collection 3 (Odense, 1986), pp. 264–80.

49 Ibid., p. 271.

and the worst of pagan heroism: Sigurðr killed the dragon Fáfnir, avenged his father on his killers, the sons of Hundingr, and succeeded in crossing the flame-walls surrounding the hall of Brynhildr in order to win her as the bride of his brother-in-law, Gunnarr. The noble Sigurðr was only defeated by the treachery of his brothers-in-law and the lies of Brynhildr. Starkaðr, on the other hand, was fated to live for three lifetimes and commit a shameful deed in each one of them; he finally expired when, badly injured in battle, he managed to provoke the son of a man he had killed into putting him out of his misery by cutting off his head. Although the executioner was doing Starkaðr a favour, he narrowly escaped serious injury from the severed head's gnashing teeth as it fell to the ground.[50]

Þorsteinn makes an excellent straight man: when he hears that the hero Sigurðr's torment is to kindle an oven, he remarks that that doesn't sound so bad. ' "It is though . . . since he himself is the kindling" ' quips the demon (' "Eigi er þat þó . . . því að hann er sjálfr kyndarinn" '). Likewise, Starkaðr is in fire up to his ankles. Þorsteinn thinks that doesn't sound too bad either. The demon's punch-line, that Starkaðr is upside-down, has perfect comic timing. Realizing that he is likely to be dragged down via the privy to join these heroes, Þorsteinn persuades the demon to imitate Starkaðr's howls. The noise is bad enough to induce unconsciousness, and with each of three howls the demon springs closer by three seats – the fact that the privy has eleven seats on each side thus becomes crucial. Þorsteinn somehow endures until at the last minute – after the third howl and with the demon now positioned next to him – the church bells suddenly begin to ring. The fiend vanishes, and Þorsteinn is saved. With the Icelander's habitual insouciance, he admits the next morning to the king that he had disobeyed orders, that he had ingeniously induced the howling in order to wake the king, in the hope of rescue, and that he had not been particularly frightened, though with the final unconsciousness-inducing howl he concedes that something like a shudder had run up his spine. Þorsteinn is given a nickname, Þorsteinn *skelk* ('shudder'), is presented with a fine sword, and he serves the king until the day of his death and Óláfr's disappearance at the battle of Svölðr.

This story is less homiletic than the story of the king and the guest, where, once he has grasped the situation, the king takes the opportunity to expatiate at length on the deviousness of the devil and the power of Christ. Here the dominant tone is comic: the repartee between Þorsteinn and his near-namesake Þorkell the thin is beautifully timed, reminiscent of nothing so much as Chaucer's *Friar's Tale*, another narrative strongly rooted in folk-tale. However, the comedy plays also with ideas of terror; the trip to the privy in darkness lays one open to supernatural forces, visiting a place that is both

[50] For Starkaðr's biography, see Saxo, *History of the Danes*, ed. H. Ellis Davidson, trans. P. Fisher, 2 vols (Cambridge, 1996), I, 171–95, 247–52.

necessary and unwholesome, a building that is separate from yet part of the farm. The privy as liminal space is encountered in *Eiríks saga ins rauða* also, where the spirits of those who have died in an epidemic throng its threshold; the Icelandic wisdom poem *Hávamál* warns against going out at night, unless you absolutely have to visit the privy.[51] The privy is a gateway to hell; the revenant – *draugr* – claims to have come straight from there. The hell he describes is a place of fire and unbearable noise, not, as we might expect, a cesspit of filth and corruption. Yet, I suggest, the story taps into an understanding that above and below are not so dissimilar. What Lars Lönnroth has called the 'double scene' ('dubbla scenen') effect, the identification of the place where the audience (Þorsteinn) is situated with the place narrated (hell), contributes an immediacy that conveys a kind of truth.[52] Þorsteinn's interest in the pagan old days is purely theoretical; his pagans are already detached from the apparatus of the heroic and pagan past of battles, burial mounds and cult animals, and are in their proper place in hell, where their heroic endurance avails them nothing. The narrator of the *þáttr* tellingly juxtaposes the warrior of the past, who fell in battle, with the disreputable and pagan hero-king Haraldr Battle-tooth and the warrior of the present, who will fall in battle, with the Christian hero-king Óláfr.

In 'The king and the guest' the king is tempted to listen to stories of the pagan past in which an alternative model of the warrior-king is presented by his interlocutor. No direct recommendation is made to persuade Óláfr to apostatize, to get himself a holy cow, in contrast with another example of this story-type later in Flateyjarbók where the Odinic tempter persuades king Óláfr the Stout, later to become Óláfr the saint, to admit his admiration for the legendary Danish hero-king Hrólfr *kraki*.[53] In the present story, however, the author deliberately distances himself from a nuanced discussion of pagan practices, suggesting, perhaps satirically, that paganism boils down to little more than regular milk-drinking and undue and ineffectual attachment to a cow. The tempter too is cautious in his advocacy of the pagan past, merely demonstrating the insufficiency of the present by a metonymic contrast of the two different meats. The king's readiness to listen to the guest's stories, however, has laid him and his men open to exposure to contaminated and contaminating meat, imbued with the putrescence of the long-dead holy cow. Uncritical interest in the pagan past is yoked with the close brush with the disgusting food, boiled up with the king's other meat and ready for eating, for actual incorporation into the bodies of Óláfr and his men at the most

51 *Eiríks saga*, p. 215; *Hávamál*, v. 112.
52 L. Lönnroth, *Den dubblan scenan: muntlig diktning från Eddan til Abba* (Stockholm, 1978).
53 See Harris and Hill, 'Gestr's "Prime Sign" ', for illuminating discussion of this episode.

sacred feast of the Christian calendar, at a time when they are about to come under a targeted supernatural attack.

In *Þorsteins þáttr skelks*, the disgusting is kept firmly below the level of the seat where Þorsteinn encounters his devilish double. Þorsteinn may, like Óláfr, invite a disquisition on pagan heroes, but this is to save himself – to keep himself out of the shit, we might colloquially say – rather than from idle curiosity; he is an unwilling and sceptical listener. Once again metonymy operates to invest pagan heroes, indirectly, with the disgusting. Down below the privy seat from which Þorkell the demon emerges, the heroes of the past suffer unendurable torment. Excrement is effaced from the hell that Þorkell describes, but it remains present to the reader or listener's imagination.[54]

In these two stories, then, the compiler of Flateyjarbók recruits the emotion of disgust to imagine the moralization of the apparently innocuous activity of listening to stories about heroes of the pagan past. Elicitors of the most primary type of core disgust – contaminated meat, the malodorous contents of a privy – are evoked to stigmatize requests for and narration of heroic material. The relation between the two is not one of direct causation; more subtly, the one denotes the other in an indirectness that works at the level of suggestion. That one of the primary intentions of *Þorsteins þáttr skelks* appears to be comic does not contradict this argument, for, as Rozin et al. note, 'disgust is often evoked in humor, and laughter is a common response (as opposed to the disgust face) in some disgust-eliciting situations'.[55]

Rozin's own account of the moralization process is vague at best, invoking a lobby politics as explanation for the successful stigmatization of unhealthy activities in North America today. Yet his speculations are productive when applied to the problematic interpretation of the heroic past by the newly Christianized and in the imaginations of later generations. Tenth-century Christians certainly did not shrink from crude invective when attempting to stigmatize the pagan gods: Hjalti Skeggjason notably called the goddess Freyja a bitch,[56] and the missionaries may well have worked to extend the sense of what is disgusting to new domains that have no obvious relation to traditional disgust elicitors. Though this cannot be proven, it seems likely

[54] The disgusting stench of hell, as discussed above, is well attested in medieval visions of the Other World, for example in the 'Vision of Dryhthelm' in Bede's *Ecclesiastical History*, ed. Colgrave and Mynors, pp. 488–99, where the 'fetor incomparabilis' ('unparalleled stink') appears on pp. 490–1; cp. *Old English Version of Bede's Ecclesiastical History*, ed. Miller, pp. 422–37. The *Elucidarius in Old Norse Translation*, ed. E. Scherabon Firchow and K. Grimstad, Stofnun Árna Magnússonar á Íslandi 36 (Reykjavík, 1989), p. 123, notes the 'hateful stink' ('leiðiligvr daun') and the 'terrifying serpents and dragons' ('hræðiliger ormar og drekar') in hell. See also the Icelandic translation of *Visio Tnugdali*, *Duggals Leiðsla*, ed. P. Cahill (Reykjavík, 1983), which refers to the 'foul stink' ('fulan daun') of hell at pp. 29–30, 70, 77, 82.
[55] Rozin, Haidt and McCauley, 'Disgust', p. 639.
[56] Ari, *Íslendingabok*, p. 15.

that the fourteenth-century compiler of Flateyjarbók saw that the folk-narratives that clustered around Óláfr Tryggvason, and which incorporated a discourse of disgust, served to underline the king's implacable hostility to the paganism he was engaged in extirpating. The compiler of Flateyjarbók, like Snorri and other authors of earlier lives of Óláfr Tryggvason and Óláfr the Saint, aimed to incorporate hagiographical and sermonizing elements, as well as folk-tale motifs, into his account of the saint, and no doubt he had already encountered the juxtaposition of the disgusting with the diabolical in other forms of Christian discourse closely related to the hagiographical. Straight-forwardly narrative presentations of heroic material are possible within other genres in the fourteenth century; *fornaldarsögur* (sagas of ancient times) such as *Völsunga saga* and *Þiðreks saga af Bern* narrate the stories of Germanic heroes without overt Christian moralizing. It is the combination of hagiography and history that creates the need for moralization in the two *þættir*; the author of the saga aims both to dramatize and historicize the encounters between the Christian king and the pagan traditions that he has come to supersede.

Thus the obscene and the disgusting, foul food and faeces, are recruited in these *þættir* to stigmatize uncritical and nostalgic attachment to old heroic stories. Such attachment, the tales warn, threatens to end in incorporation of the unclean, contamination, and, finally perhaps, with Starkaðr and Sigurðr, inversion in the corrosive fires of hell, a euphemistic treatment of the stinking excrement that lies piled up below Þorkell's seat. Disgust has indeed moved, as Rozin and his associates suggest, from the service of protecting the body to mobilization 'in the service of protecting the soul'.

9

From *Coilles* to *Bel Chose*:
Discourses of Obscenity in Jean de Meun
and Chaucer

Alastair Minnis

'Obscenus' is made up from *ob* (on account of) and *cenum* (dirt or filth), explains Giovanni de'Balbi of Genoa in his thirteenth-century Latin dictionary, the *Catholicon*.[1] Or, he continues, it relates to *cena*, i.e. *scena*, the stage, here invoking an etymology that is found as early as Varro's *De Lingua Latina*.[2] Yet another alternative relates to *canendo*, singing or making sound. 'For *obscenus* is properly said of an utterance (*vox*, meaning a sound, word, utterance). A *vox* is obscene which is harsh and vile (*dura et turpis*),' although the term may also be said of some other thing that is impure and vile (*de alia re immunda et turpi*). The idea that things rather than words may be termed 'obscene' is reinforced by Isidore of Seville's summary statement that the love of wives is just (*justus*), of children, pious (*pius*), and of prostitutes, obscene (*obscenus*).[3] The connection between dirty words and dirty things is at the centre of the following discussion, which seeks to describe different discourses of obscenity in relation to three outspoken female figures, Raison and La Vielle in Jean de Meun's part of the *Roman de la Rose*, and Chaucer's Wife of Bath. My interest is in obscene language uttered by and about women, particularly old women, who themselves were often described as obscene. Chaucer's accomplishment in the *Wife of Bath's Prologue and Tale*, wherein an ageing woman constructs an aged woman who offers moral doctrine of the highest standard, is quite remarkable given the strength of cultural prejudice against the *vetula* – seen variously as an expert in the

[1] Joannes Balbus, *Catholicon* (Mainz, 1460, rep. 1971), s.v. *obscenus*. See further Robert Maltby, *A Lexicon of Ancient Latin Etymologies* (Leeds, 1991), p. 421.

[2] 'Anything shameful is called *obscaenum*, because it ought not to be said openly except on the *scaena* "stage" ': M. T. Varro, *De lingua latina*, VIII.96, ed. R. G. Kent, 2 vols (London, 1938), II, 351.

[3] *Differantiarum, sive de proprietate sermonum*, lib. 1: *De differentiis verborum*, in *Patrologia Latina*, 83, col. 10A.

highly dubious art of love, a corrupter of the morals of youth, and a receptacle of poisonous humours.

Jean de Meun's part of the *Roman de la Rose* offers what is arguably the most famous reaction to a perceived obscenity in medieval vernacular literature. In the course of her account of the 'golden age' in which Justice reigned – brought to an abrupt end by Jupiter's usurpation of Saturn – Lady Reason uses the dubious term *coilles*, which I here translate as 'balls' to recreate the vulgar shock-effect that the poet seems to want:

> cui [i.e. Saturnus] Jupiter coupa les coilles,
> ses filz, con se fussent andoilles,
> (mout ot ci dur filz et amer)
> puis les gita dedanz la mer (5507–10)

> . . . Saturn, whose balls Jupiter, his hard and bitter son, cut off as though they were sausages and threw into the sea[4]

It takes some time for her interlocutor Amant, the Lover and first-person narrator, to express shock at this word. But, over a thousand lines later, he does get around to it:

> Si ne vos tiegn pas a cortaise
> quant ci m'avez coilles nomees,
> qui ne sunt pas bien renomees
> en bouche a cortaise puchele. (6898–901)

> I do not consider you courteous when just now you named the balls to me; they are not well thought of in the mouth of a courteous girl.[5]

The fact that Amant addresses a young woman (*puchele*) here is significant, given that, as Jan M. Ziolkowski puts it, 'over the past two millennia one particular class of people has conventionally embodied modest speech in western Europe', i.e. 'young women and especially young virgins. One common measure of the propriety or impropriety of a given word or topic has been to see if it brings a blush to the cheeks of an innocent girl.'[6] Amant is

4 All citations of the *Rose* are from *Le Roman de la Rose*, ed. F. Lecoy, 3 vols (Paris, 1965–70). Throughout this paper I draw on the translations – though with occasional alterations – by Charles Dahlberg (Hanover NH and London, 1971, rep. 1983) and Frances Horgan (Oxford, 1994).

5 On this passage, see further David Hult's discussion, which argues for the possibility of an innuendo relating to fellatio – the words *or* the things are not well thought of 'in the mouth of a courteous girl': D. Hult, 'Language and Dismemberment: Abelard, Origen, and the *Romance of the Rose*', in *Rethinking the 'Romance of the Rose': Text, Image, Reception*, ed. K. Brownlee and S. Huot (Philadelphia, 1992), pp. 101–30 (p. 116).

6 J. M. Ziolkowski, 'The Obscenities of Old Women. Vetularity and Vernacularity', in

being somewhat selective here, however, since Raison, on her first appearance, had been described as 'neither young nor old, neither too tall nor too short, neither too thin nor too fat' (2964). Here Guillaume de Lorris' text clearly evinces the influence of Boethius's description of Dame Philosophy: 'her complexion was fresh with an ever-lively bloom, yet she seemed so ancient that none would think her of our time. It was difficult to say how tall she might be . . .'.[7] But Raison is using words that are far from the decorous registers of the *Consolatio philosophiae*, and indeed from those deployed in that later prosimetrum, Alan of Lille's *De planctu naturae*, which was one of Jean de Meun's most significant sources. Alan's Dame Nature, while accepting 'there should be at times an uncouthness of style to conform to the ugliness of the subject-matter' ('rerum informitati locutionis debet deformitas conformari'), gives priority to the principle that offence should not be caused. Therefore, to prevent anything foul finding a place on a virgin's lips (*in ore uirginali*) she will place 'a mantle (*pallium*) of fair-sounding words' upon the 'monsters of vice'.[8] Far from expressing concern about such matters, however, Jean de Meun has his Raison 'talk dirty' some more:

> mist Dex en coillons et en viz
> force de generacion
> par merveilleuse entencion (6936–8)

> God in his wonderful purpose put the generative power into the pricks and cocks

> Coilles est biaus nons et si l'ains,
> si sunt par foi coillon et vit (7086–7)

> 'Balls' is a good name and I like it, and so, in faith, are 'prick' and 'cock'[9]

And she forcefully defends her chosen words as being quite appropriate. This is no ordinary woman talking here, but Raison: and presumably she is talking reason. You want me to gloss ('me requierz de gloser', 7052), she tells Amant scornfully, but why shouldn't I designate such parts of the human anatomy directly and without obfuscation? They are the works of my Father, and

Obscenity: Social Control and Artistic Creation in the European Middle Ages, ed. J. M. Ziolkowski (Leiden, 1998), pp. 73–89 (p. 73).

7 *De consolatione philosophiae*, I pr. 1, 6–8, in Boethius, *The Theological Tractates and the Consolation of Philosophy*, ed. H. F. Stewart, E. K. Rand and S. J. Tester (Cambridge MA, 1973), p. 133.

8 I have used the edition of the Latin text by N. M. Häring, *Studi medievali*, 3rd ser., 19.2 (1978), 797–879, and the translation by J. J. Sheridan (Toronto, 1980).

9 Here I alter Frances Horgan's translation, by using 'balls', 'pricks' and 'cock' in preference to her terms 'testicles', 'testes' and 'penis', to bring out the deliberately obscene force of Jean's language.

therefore can be named 'properly' (*proprement*; 7095, cf. 7049). This term refers to linguistic rather than moral 'propriety', Raison's point being that she is perfectly entitled to use words that are straightforwardly significative of the things to which they refer, lacking in circumlocution, metaphor or euphemism. Amant had remarked how even nurses, 'many of whom are bawdy and ignorant', use euphemisms when referring to the genitalia of the babies entrusted to them, as they hold and bathe their charges (6907–12). Raison proceeds to lecture him on the then-current theory of linguistic signification *ad placitum*, i.e. the belief that the meaning of words is determined arbitrarily by the will of the institutor or 'imposer', and fixed through human custom or institution.[10] If Raison had used the term 'relic' rather than 'balls' to designate the male genitalia, and the term 'balls' to designate relics, we would now be calling balls 'relics' and relics 'balls' (7076–85). Perhaps custom or habit is what is lacking in the case of those Frenchwomen who have problems with the words that Amant had found offensive: 'They would have liked the proper name if it had been made familiar to them,' she declares, 'and in giving them their proper name they would certainly have committed no sin' (7101–6). If the terms in question were used more they would become more common and so a custom would be established; hence any element of embarrassment would vanish. Such is the power of *acoutumance:*

> Acoutumance est trop poissanz,
> et se bien le sui connoissanz,
> mainte chose desplest novele,
> qui par acoustumance est bele. (7107–10)

> Habit is very powerful, and if I am any judge, many things that offend when they are new become beautiful through habit.

Raison then indulges in antifeminist satire about the hypocrisy of women, which is revealed by their use of 'improper' (i.e. indirect) speech in designating the male genitalia:

> Chascune qui les va nomant
> les apele ne sai conmant,
> borses, harnais, riens, piches, pines,
> ausint con ce fussent espines;
> mes quant les sentent bien joignanz,
> els nes tienent pas a poignanz. (7111–16)

> The women who name them call them all sorts of things: purses, harness, things, torches, pricks, as though they were thorns, but when they feel them very near they do not find them painful.

10 See L. M. de Rijk, *Logica modernorum. A Contribution to the History of Early Terminist Logic*, 2 vols (Assen, 1962-7), II.1, 191–2.

Women like the things even though they refuse to use their 'proper' names, substituting many kinds of euphemism. Raison has no intention of following such practice; it would seem, therefore, that her recourse to terms like *coilles*, *coillon* and *vit/viz* is perfectly justified.

At this point it must be admitted that not all the *Rose*'s modern readers have perceived Raison's remarks as dirty talk. Indeed, D. W. Robertson and John V. Fleming have highlighted the intellectual currency of her theory of words and things, and pilloried Amant for his failure to comprehend her doctrine, this being seen as a consequence of his surrender to concupiscence. More specifically, Fleming has argued that 'the etymological history of Latin *culleus* in the Romance languages' justifies his view of *coilles* as the 'proper name' for testicles.[11] Douglas Kelly has critiqued this view, on the grounds that 'the phonological and morphological development alone of the word into the Romance languages will tell us nothing about its usage proper or improper'.[12] 'If he [i.e. Fleming] means by "etymological history" the history of usage and semantic range, he should cite his sources.'[13] Kelly goes on to cite instances of the 'obscene juxposition' of *coilles* and *andoilles* (meaning 'sausage chitterlings', cf. *Rose*, 5507–8) in fabliaux and in what he describes as a 'blatantly obscene' passage in François Villon's *Testament*.[14] An (apparently) more polite French word was available to Jean, namely *genitaires*, which is used in the accounts of the castration of Saturn found in the *Ovide moralisé* and Christine de Pizan's *Epitre Othea*. It may be added that the term 'membres' is used by Evrart de Conty when he discusses the same *fabula* in his commentary on a poem that owes much to the *Rose*, the *Eschez amoureux*.[15]

Even more telling is the fact that, in alternative versions and certain revisions of the *Rose*, the *coilles* have been excised. The B-text group of manuscripts display considerable variation among themselves, but agree at least in suppressing Raison's defence of plain speaking; the term *coilles* has disappeared along with Jean's account of their owner, Saturn.[16] Far more extensive revision was carried out by the cleric Gui de Mori, who added substantial interpolations but also deleted thousands of lines. Among the lines deleted are those containing Raison's racy speech, the entire Pygmalion episode, and the more graphic elements of Amant's plucking of his virgin Rose.[17]

[11] J. V. Fleming, *Reason and the Lover* (Princeton, 1984), p. 106.

[12] Here as elsewhere in modern criticism, the waters are muddied by confusion between moral 'propriety' (ethical speech behaviour) and linguistic 'propriety' (literal and straightforward referentiality).

[13] D. Kelly, *Internal Difference and Meanings in the 'Roman de la Rose'* (Madison, 1995), p. 47.

[14] Ibid., pp. 49, 169–70nn.

[15] *Le Livre des eschez amoureux moralisés*, ed. F. Guichard-Tesson and B. Roy, Bibliothèque du moyen français 2 (Montreal, 1993), p. 66.

[16] S. Huot, *The 'Romance of the Rose' and its Medieval Readers* (Cambridge, 1993), pp. 131, 132, 140.

[17] Ibid., p. 89.

I myself think that, as used by Raison, the words in question *had* to appear shocking, or else the fuss made of them in the *Rose* would have seemed inexplicable. The fact that Jean de Meun is drawing on quite impeccable linguistic theory here, as current in the University of Paris in his day, should not obscure the fact that a highly provocative choice of language has deliberately been made in illustrating it. In seeking a modern analogy, one may recall the famous sentence that Noam Chomsky, the founding father of 'generative grammar', used to make the point that a sentence can be 'grammatical' in terms of its conformity to syntactic 'deep structure', even though it may be meaningless: 'colourless green ideas sleep furiously'. Imagine, if you will, the reaction of Chomsky's appreciative audience had he said, 'colourless green ideas fuck furiously'. The argument that Chomsky was teaching impeccable linguistic theory would not, I suspect, have settled all qualms. And so it is, or was, with Jean de Meun. As David Hult has said, he was 'acutely aware both of the incendiary nature of his writing, and of the linguistic means by which it is carried out'.[18]

The situation is further complicated, however, by the fact that, according to medieval literary theory, identifying certain terms as being obscene need not necessarily destroy the ethical credentials of the texts in which they appear. On the face of it that seems a surprising proposition, but it is fully justified by medieval discussion concerning one of the major constituent genres of the *Roman de la Rose*, namely satire. The Roman satirists, Horace, Juvenal and Persius, were believed to have cut through falsehood and subterfuge to reveal facts about society that were unobscured by poetic invention or ornamentation.[19] Hence, a representative twelfth-century commentator on Juvenal can declare that 'satire is naked . . . because it censures the vices of the Romans nakedly, and openly, and clearly, and without circumlocution and periphrasis, and without an *integumentum*',[20] i.e. the veil or covering that was characteristic of poetic myths and was to be interpreted allegorically in the case of such works as Plato's *Timaeus*, Virgil's *Aeneid* and Ovid's *Metamor*-

18 D. Hult, 'Words and Deeds: Jean de Meun's *Romance of the Rose* and the Hermeneutics of Censorship', *New Literary History* 28 (1997), 345–66 (p. 352).

19 On the medieval literary theory of satire, see especially: *Medieval Literary Theory and Criticism, c.1100–c.1375: The Commentary Tradition*, ed. A. J. Minnis and A. B. Scott with D. Wallace, rev. edn (Oxford, 1991), pp. 116–18; P. S. Miller, 'The Mediaeval Literary Theory of Satire and its Relevance to the Works of Gower, Langland and Chaucer' (unpublished Ph.D. thesis, The Queen's University of Belfast, 1982); P. S. Miller, 'John Gower, Satiric Poet', in *Gower's 'Confessio Amantis': Responses and Reassessments*, ed. A. J. Minnis (Cambridge, 1983), pp. 79–105; U. Kindermann, *Satyra: Die Theorie der Satire in Mittellateinischen: Vorstudie zu einer Gattungsgeschichte* (Nuremberg, 1978).

20 *Vier Juvenal-Kommentare aus dem 12 Jh.*, ed. B. Löfstedt (Amsterdam, 1995), p. 4. Cf. *Medieval Literary Theory*, ed. Minnis and Scott, p. 116.

phoses.[21] The satirists' language was therefore plain, blunt, and got straight to the point, even to the extent of being quite rude on occasion. Hence their discourse could be described as *fetidus, turpis* – and *obscenus*.[22] When commentators speak of 'obscene' satiric language they seem to mean, on the one hand, direct rather than oblique (what Jean de Meun would have called 'improper') reference to the sexual organs and sexual activities; on the other hand, they may have in mind offensive moral behaviour which itself is *fetidus, turpis et obscenus*. Juvenal's sixth satire, wherein the poet was deemed to 'reprehend many vices of women' and their lewdness (*impudicia*),[23] amply illustrates the latter. It begins with a lament for the demise of Chastity, which may have stayed with us in the time of Saturn's golden age – here one may note an analogy with the passage that prefaces Raison's utterance of the controversial term *coilles* – but nowadays, where can an honest woman be found? A long attack on female crimes and misdemeanours follows, with promiscuity, vanity of many kinds, superstition and abortion being singled out for special attack. All this adds up to one simple piece of advice to men – don't get married. Of particular interest here is Juvenal's criticism of the linguistic affectation of certain women, who describe 'their fears and their wrath, their joys and their troubles', in Greek rather than Latin. 'All this might be pardoned in a girl', but not in an old woman: 'That tongue is not decent in an old woman's mouth.' Hearing words that are intended to be sexually provocative from the mouth of a woman in her eighty-eighth year is quite inappropriate – 'you are using in public the language of the bed-chamber' – and is anything but titillating, since the *vetula's* 'years are counted up upon [her] face'.[24]

Juvenal's sixth satire was a favourite with Jean de Meun; on four out of the five occasions when 'Juvenaus' is mentioned by name this is the text in question.[25] And, as I have argued elsewhere, Jean was influenced by at least some aspects of medieval theory of satire.[26] That great defender of Jean de Meun in the *querelle de la Rose*, Jean de Montreuil, could describe him as a 'very severe satirist' (*satiricum perseverum*); the fact that de Meun is performing the 'office of satirist' (*officio satirici*) means that he is 'permitted many things which are

[21] On *integumentum* as 'improper' speech (in the technical sense of the term as explained on p. 159 above), see A. J. Minnis, *Magister amoris: The 'Roman de la Rose' and Vernacular Hermeneutics* (Oxford, 2001), pp. 135–7.

[22] See the quotations assembled by Miller, 'Literary Theory of Satire', p. 382, n. 70.

[23] Here I quote from two anonymous twelfth-century Juvenal commentaries, as edited by Löfstedt, in *Vier Juvenal-Kommentare*, pp. 74, 321.

[24] Juvenal, *Satura* VI.184–99 in *Juvenal and Persius*, ed. G. G. Ramsay (London, 1979), pp. 98–9.

[25] Jean draws on the sixth satire at 8257, 8677, 8705 and 9113; at 21409 he follows the first satire's account of the rewards of courting an old woman.

[26] Minnis, *Magister amoris*, pp. 90–103.

prohibited to other writers'.[27] This could be taken as meaning that de Meun was permitted to use language that was *obscenus*. But the 'satire justification' seems to have made no impact whatever in the debate on the meaning and morals of the *Rose*. Neither of the poem's two attackers, Christine de Pizan and Chancellor Jean Gerson, thought its challenge was important enough to merit a vigorous refutation. In any case, their critique of the *Rose* robustly refuses to make any concessions to either genre or *persona*, i.e. the principle that certain characters (an Old Woman, a Jealous Husband) can say things that are not to be equated with the views of the author. In their view, Jean de Meun was morally responsible for everything that he had said in his poem.

What the *querelle de la Rose* does offer is a powerful attack on Raison's dirty talk, the brilliant contribution of Christine de Pizan. This is a crucial document for the 'history of obscenity', the diachronic and synchronic study of how certain words come to be regarded as 'impure and vile' (to return to de'Balbi's definition). But Christine's intervention has proved almost as controversial as Jean's dubious language itself. Sheila Delany has found in it stifling self-righteousness and prudery.[28] Elsewhere I have argued that this misrepresents the position of obscenity within Christine's overall agenda in the *querelle*.[29] Besides, she was not at all averse to the notion that sometimes an ugly thing is appropriately designated by an ugly word (an idea affirmed in satiric theory and conceded by Alan of Lille's Nature).[30] But here I want to concentrate on the way in which Christine moves away from arguments relating to the referentiality of language to focus on its public performance, how words function in social exchange. The way in which she deploys the principle of 'reasonable shame' (*honte raisonnable*) in her onslaught on Pierre Col, who had defended Jean de Meun's doctrine of plain speech, is quite remarkable. She dares him to name the genitalia 'plainly' in his own writing. You are not a very good pupil, she taunts Col, 'for you do not follow well at all the doctrine of your master, who teaches you to name them'. Why do you not do so? Because you would be ashamed to write in this way. 'Ha! Par Dieu! autremant va! Tu ne le pues nyer' ('Ha! My God! You do not do so. You

27 *Le Débat sur le Roman de la Rose*, ed. E. Hicks (Paris, 1977), pp. 38, 42; *La Querelle de la Rose: Letters and Documents*, trans. J. L. Baird and J. R. Kane, North Carolina Studies in the Romance Languages and Literatures 199 (Chapel Hill NC, 1978), pp. 154, 44.

28 S. Delany, ' "Mothers to think back through": Who are they? The ambiguous example of Christine de Pizan', as reprinted in S. Delany, *Medieval Literary Politics: Shapes of Ideology* (Manchester, 1990), pp. 88–103 (p. 98, cf. p. 91).

29 Minnis, *Magister amoris*, pp. 146–7n.

30 As when Christ applies the word *meretrix* to the women sinners at Matthew 21. 31–2 and Luke 15. 30. An even baser word could have been found in Latin, Christine declares, the idea being that such a word would have been quite appropriate in describing such a base thing. *Le débat*, ed. Hicks, p. 14; *La Querelle*, trans. Baird and Kane, pp. 48–9.

cannot deny that shame keeps you from it.').[31] Given the emphasis placed on *acoutumance* and *coustume* in the crucial *Rose* passage and Col's defence thereof, why doesn't Col contribute to the establishment of the custom that his master had advocated? This might be difficult at first, Christine remarks, but if he persists in proper naming of private parts then no doubt he will eventually be praised for it! But of course, Col will not do so; he is as much bound by the existing *coustume* of linguistic decency as is anyone else.

> ... je t'ayme pour ton bon sens et le bien que on dist de toi . . . : si ne voulroie ta deshonnour. Car parler honneste avec les vertus moult advient en bouche de louable personne.

> I love you for your good sense and the good that people say of you . . . : I do not wish you the dishonour. For honourable and virtuous speech is the mark of a praiseworthy person.[32]

So much, then, for Jean's Raison, who can easily be defeated by such a feeling of shame! The effectiveness of this challenge was recognized and praised by Jean Gerson: Christine has shrewdly pointed out to Col that 'your own writings, whether you like it or not, show that you have the same sense of shame: for your naturally good disposition would not permit you to utter obscenity (*obscenum loqui*) therein'.[33]

Along with this argument fails the attempt to single out women as being inhibited by hypocritical prudery in their use of language. As Christine said in an earlier letter (to Jean de Montreuil), *nobody* who loves virtue and honour will listen to the *Rose* without being totally 'confounded by shame and abomination at hearing described, expressed, and distorted in dishonourable fictions what modesty and reason should restrain well-bred folk from even thinking about'.[34] Hence, the reactions of virtuous women in particular are quite justified:

> Et dont que fait a louer lecture qui n'osera estre leue ne parlee en propre forme a la table des roynes, des princesses et des vaillans preudefemmes – a qui convendroit couvrir la face de honte rougie?

> Who could praise a work [i.e. the *Rose*] which can be neither read nor quoted at the table of queens, of princesses, and of worthy women, who would surely, on hearing it, be constrained to cover their blushing faces?[35]

31 *Le Débat*, ed. Hicks, pp. 123–4; *La Querelle*, trans. Baird and Kane, p. 123 (with minor alterations).
32 *Le Débat*, ed. Hicks, p. 124; *La Querelle*, trans. Baird and Kane, p. 123 (with minor alterations).
33 *Le Débat*, ed. Hicks, p. 168; *La Querelle*, trans. Baird and Kane, p. 148.
34 *Le Débat*, ed. Hicks, p. 20; *La Querelle*, trans. Baird and Kane, p. 53.
35 *Le Débat*, ed. Hicks, p. 20; *La Querelle*, trans. Baird and Kane, p. 54.

Implicit in this remark is the belief that respectable people are the best judges of what kind of speech is to be condemned as obscene. Indeed, at one point Christine remarks that 'people who do not delight in such carnality' rightly find the *Rose* offensive.[36] With this one may compare a core principle of the 1979 report of the Williams Committee on obscenity, as set up by the British government. Obscenity is defined here as material that is 'offensive to *reasonable people*' by reason of 'the manner in which it portrays, deals with or relates to violence, cruelty or horror, or sexual, faecal or urinary functions, or genital organs'.[37] Christine saw herself as the spokesperson for women who as 'reasonable people' reacted against obscenity, and was concerned about how women's reputations might suffer by what 'reasonable people' thought about their language – and indeed, about the defamatory language that *un*reasonable people often use of women.

An acute awareness of the part language plays within the socio-economically vulnerable position of so many women marks Christine's later treatise *The Treasure of the City of Ladies*. The wise princess should avoid coarseness of speech in dealing with servant-girls and others; publicly she will read 'instructive books' but 'those about indecency and lubricity she will utterly hate' and refuse to have at court. 'She will not permit them to be brought into the presence of any girl, female relative or woman in her court, for there is no doubt at all that the examples of good and evil influence the minds of those men or women who see or hear them.' Two classes of women are singled out for special mention, widows and the aged. Widowed women are 'at the mercy of abusive language', and should be careful not to give cause for 'defamation or slander'; 'their expressions, conduct and clothing ought to be simple, modest and decent'. Furthermore, the speech of the wise elderly woman 'ought to be entirely controlled by discretion. She must be careful that foolish, vulgar words do not issue from her mouth, for foolish and crude language in old people is extremely ridiculous.'[38] In other words, the wise old woman should behave in a manner directly opposed to that of Jean de Meun's Vielle.

Jean de Meun and Christine de Pizan could agree on at least one matter – the importance of the designated *thing* in determining one's attitude to the designating *word*. According to Jean's Raison, since 'my heavenly Father' made the male sexual organs, along with the other instruments (*estrumens*) by which human nature is sustained, they are 'nobles choses' (6923–34): hence

36 *Le Débat*, ed. Hicks, p. 121; trans. Baird and Kane, p. 123. An excellent discussion of the belief in the 'reader's moral vulnerability' that Christine and Gerson shared is provided by R. Brown-Grant, *Christine de Pizan and the Moral Defence of Women* (Cambridge, 1999), pp. 43–9.

37 *Obscenity and Film Censorship: An Abridgement of the Williams Report*, ed. B. Williams (Cambridge, 1981), p. 124; cf. p. 122.

38 *The Treasure of the City of Ladies, or the Book of the Three Virtues*, trans. S. Lawson (Harmondsworth, 1985), pp. 58, 159–60, 163.

they may be named *proprement* (i.e. plainly and openly). This recalls standard language theory; for instance, Raoul Ardent's *Speculum universale* explains that a word is 'shameful or honest' only 'according to the shamefulness or the honesty of the thing signified'.[39] In similar vein, Christine assured Jean de Montreuil that 'Le nom ne fait la deshonnesteté de la chose, mais la chose fait le nom deshonneste' ('the name does not make the thing dishonourable, but the thing, the name'). Hence there is no point in trying to avoid the indecent name by substituting the word 'relics' for it. Here Christine echoes the example Raison had offered while explaining the conventional, *ad placitum*, nature of language – and no doubt had in mind the fact that Jean makes such a substitution when describing Amant's sexual consummation.[40] It would seem, then, that any name for certain body parts, no matter how euphemistic or polite they may be, would offend against decency. By the same token, any words that describe things that are disgusting and immoral are an offence against decency.

This attitude seems to be at the heart of the response by Christine de Pizan and Jean Gerson to Jean de Meun's other formidable female figure, La Vielle. If it was something of a surprise to find dirty words on the lips of a *cortaise puchele*, it was quite expected for them to be associated with a *vetula*. As Ziolkowski says, if 'any collection of individuals was implicated strongly in obscene language and was perceived to be habitual offenders, that group was old women'.[41] And La Vielle does not disappoint. Behind this construct lie ideas and images culled from Juvenal's sixth satire (already discussed above), but of course the dominant influence is Ovid. In the *Amores* Jean encountered the witch-like figure of Dipsas, ironically credited with powers of sorcery and necromancy. The first-person narrator angrily realizes that this *vetula* is encouraging his mistress to better herself by entrapping one or more wealthy lovers. Poor men are worth nothing, she advises her young pupil; have nothing to do with them. Make sure that the man who wants you is rich, and get as many presents as you can from him. If someone is from a very good family but has no assets, get rid of him. Once you have caught your wealthy lover, keep him interested. Don't have sex with him every night, in case he gets tired of you. Make sure you keep several lovers in tow: jealousy will ensure that they work hard to win you, and the more lovers you have the more profitable it is for you.[42] Here, then, is the construction that Jean de

[39] Cited by C. Casagrande and S. Vecchio, *Les Péchés de la langue: Discipline et éthique de la parole dans la culture médiévale*, trans. P. Baillet (Paris, 1991), p. 282.

[40] *Le Débat*, ed. Hicks, p. 14; *La Querelle*, trans. Baird and Kane, pp. 48–9. Cf. H. Bloch, 'Modest Maids and Modified Nouns: Obscenity in the *Fabliaux*', in *Obscenity*, ed. Ziolkowski, pp. 292–307 (pp. 304–5).

[41] Ziolkowski, 'Obscenities of Old Women', p. 73.

[42] Summarized from *Amores* I.8, as translated by P. Green, *Ovid: The Erotic Poems* (Harmondsworth, 1982), pp. 99–100.

Meun amplified with additional material from Ovid's *Ars amatoria* and *Remedia amoris*. Keep your heart in several places, never in one, La Vielle tells the Rose's 'Fair Welcome'. And sell it to the highest bidder. Gather as many rosebuds as possible before getting old, for then men will not break down your door. Take everything and give very little. Don't love one man alone; women who have been obsessed with one man have come to tragic ends. Feel free to deceive men: they will try to deceive you, so it's important to get your retaliation in first. And so on and so forth.

Predictably, Christine de Pizan and Jean Gerson were disgusted. 'What reprehensible teachings are recorded in the chapter about the Old Woman!,' exclaims Christine. 'In God's name, what can one find there but sophistical exhortations filled with ugliness (*laidure*) and things villainous to recall.'[43] Elsewhere she condemns the 'great dishourableness' (*grant deshonnesteté*) in this passage, declaring that 'one can find nothing there but total filth and vile teaching (*toute laidure et vil ensaingnement*).'[44] Jean Gerson's *Traité contre le Roman de la Rose* describes La Vielle as an 'accursed old woman worse than the devil' who 'teaches, shows and exhorts all *jeusnes filles* to sell their bodies quickly and dearly without fear or shame'; according to her, they shouldn't hesitate to abandon themselves 'to every dishonour and carnal filth' (*a toutes villainnes ordures de charnalité*).[45]

This purveyor of *toute laidure et vil ensaingnement* was the model for the Wife of Bath. Chaucer's debt to La Vielle in particular, and negative representations of the *vetula* in general, is enormous. However, the English poet made one major change that has not received the attention it deserves. The Wife of Bath is an ageing widow-woman rather than an aged woman. The figure of the *vetula* does appear in the Wife's tale, this being a version of what modern scholarship has called the 'loathly damsel' narrative. Here we meet an 'olde wyf', a 'fouler wight ther may no man devyse' (III(D), 998–1000):[46] presumably she could be termed *obscenus*. But in the Wife's prologue, Chaucer diverges from Jean de Meun by presenting her as the much-married widow, with the aid of material drawn from Jerome's *Against Jovinian*, wherein multiple marriage is condemned: in the first hundred lines or so of the

43 *Le Débat*, ed. Hicks, p. 15; cf. *La Querelle*, trans. Baird and Kane, p. 49 (here altered).

44 *Le Débat*, ed. Hicks, p. 130; *La Querelle*, trans. Baird and Kane, p. 129. She goes on to condemn La Vielle's 'immoral lessons' (*disolucions*), and finds a 'wasteful display of crude words' (*gastement de paroles maugracieusses*) in Jean's portrayal of both the Old Woman and the Jealous Man. In defence of Jean de Meun, Pierre Col argued that each *persona* must speak according to his or her nature, hence the Old Woman talks like an old woman (*La Querelle*, trans. Baird and Kane, p. 103; cf. pp. 109, 113).

45 *Le Débat*, ed. Hicks, p. 61; *La querelle*, trans. Baird and Kane, pp. 71–2. Later Gerson calls her a 'damned Old Woman, who ought to be judged to the punishment of the pillory' (*Le Débat*, ed. Hicks, p. 86; *La Querelle*, trans. Baird and Kane, p. 90).

46 All Chaucer quotations are from *The Riverside Chaucer*, ed. L. D. Benson et al., 3rd edn (Boston, 1987).

Prologue, opinions from this treatise are cited and cheekily refuted. References to Alisoun's age are indeterminate and tend to express her long experience rather than her longevity, as when she claims to be 'expert in al myn age' (173–4, cf. 113–14), although of course the two are connected. Chaucer does say that, when she married Jankyn, the Wife of Bath was forty years old while he was twenty (600–1). However, no indication is given of the amount of time that has passed between that event and the Canterbury pilgrimage. And this apparently precise allusion to the Wife's age is problematized when, only a few lines later, she remarks that she was 'lusty', 'faire', 'riche' and '*yong*' (605–6) – apparently at the time she gave Jenkyn her heart, though it's just possible that this is to be taken as a meandering harking-back to an even earlier period, when she was, or now feels she was, in her prime.

According to some medieval schemes of 'the ages of man' a person was deemed old at forty, and there was a deeply embedded belief that women matured and died earlier than men. However, Shulamith Shahar has warned us against putting too much literal trust in such schemes, since the Latin term *senectus* 'did not have the same meaning for all the writers' in question.

> Some applied it to the period following the stage of youth (roughly equivalent to our 'middle age'), as well as to the elderly and senescent stages. Others applied it only to the 'middle aged' and elderly stages, and applied the term *senium* for the stage of extreme old age. Still others applied the term *senectus* only to the elderly stage (again, using the term *senium* for extreme old age). There can be no doubt that the wide discrepancies between the ages defined in the various divisions as the onset of old age make it impossible to argue that people were considered old from their forties, or to use these divisions in support of this argument. There can be no justification for relying on a particular scheme in which old age begins at 40, while ignoring all the others in which it starts later (or even earlier, 35!).[47]

Given this terminological confusion, we are on safer ground in considering the significance of a point at which Chaucer draws directly on Jean de Meun's treatment of the age of La Vielle. Here is part of what may be termed her *je ne*

[47] S. Shahar, *Growing Old in the Middle Ages*, trans. Y. Lotan (London, 1997), p. 18. Shahar emphasizes the wide differences between the various schemes by noting that old age can begin 'at 35, 40, 45, 58, 69 and 72' (p. 17). According to the *De amore* of Andreas Capellanus, women may love until they are fifty, but Froissart's *Le Joli Buisson de jonece* asserts that a person is too old for love at thirty-five. Pope Innocent III, in his *De miseria condicionis humane* (the Chaucerian translation of which is no longer extant), stated that the human condition was so wretched that few reach the age of forty, and very few survive until sixty. My best guess is that Alisoun is in the early phase of her *aetas diminuendi* ('age of decline'); Vincent of Beauvais, following Avicenna, judged that to start around thirty-five or forty and extend until sixty, when the *aetas minuendi* ('the age of enfeeblement') began. Cf. Shahar, *Growing Old*, pp. 16–17.

regrette rien speech (but it should be noted that she does harbour many bitter regrets):

> Mes riens n'i vaut le regreter:
> qui est alé ne peut venit. . . .
> Par Dieu, si me plest il oncores
> quant je m'i sui bien porpensee;
> mout me delite en ma pensee
> et me resbaudissent li menbre
> quat de mon bon tens me remembre
> et de la jolivete vie
> dom mes queurs a si grant envie;
> tout me rejovenist le cors
> quant h'i pens et quant jou recors;
> touz les biens du monde me fet
> quant me souvient de tout le fet,
> qu'au mains ai je ma joie eüe,
> combien qu'il m'aient deceüe. (12894–5, 12902–14)

But it is pointless to regret it; what's done is done. . . . And yet, by God, the memory of my heyday still gives me pleasure, and when I think back to the jolly life that my heart so desires, my thoughts are filled with delight and my limbs with new vigour. The thought and the recollection of it rejuvenates my whole body; it does me all the good in the world to remember everything that happened, for I have at least had my fun, however I may have been deceived.

Chaucer transmutes this passage as follows:

> But – Lord Crist! – whan that it remembreth me
> Upon my yowthe, and on my jolitee,
> It tikleth me aboute myn herte roote.
> Unto this day it dooth myn herte boote
> That I have had my world as in my tyme
> But age, allas, that al wole envenyme,
> Hath me biraft my beautee and my pith. (469–75)

While Alisoun looks back with pleasure on her youth, there is no gloomy recognition that life is no fun any more; 'the flour [flour] is goon' but she still has 'the bren' (bran) to sell, and she will continue to be 'right myrie' (477–9). True, this could be dismissed as an old woman putting the best face on things. But the difference in tone between the two passages quoted above is marked. La Vielle regrets the tricks she missed while young, and teaches her young pupil to 'deceive men before they deceive you' out of revenge. In Chaucer, there is no reference to how previous lovers have deceived her; indeed, this passage features in Alisoun's triumphalist account of her five husbands, prefacing her recollection of number four. The Wife of Bath is predominantly the much-married wife, whereas neither Dipsas nor La Vielle

169

talk of husbands. They are unhealthily obsessed with the past; Alisoun looks forward to the future, the impression being given (at least to me) that, despite the effects and sadness of ageing, she has a future to look forward to. Age, she remarks in a passage that has no precedent in the *Rose*, will envenom. That could be taken as literally true, in the light of the belief (as attested by the *De secretis mulierum*) that in the bodies of old women who cannot purge their 'evil humors' dangerous poisons build up; thus their glance can 'poison the eyes of children lying in cradles'.[48] But there is no evidence that the envenoming process has reached that stage in the case of the Wife of Bath.

This lack of specificity about Alisoun's age helps Chaucer's text to focus on her widowhood rather than her possible or partial vetularity. Of course, making her a widow did not necessarily make her less 'obscene', given the strong negative traditions relating to this group of women. While in medieval society at least some widows enjoyed a large measure of social and economic independence – little wonder that Christine de Pizan remarked that remar-riage is 'sheer folly' for 'those who have already passed their youth and who are well enough off and are not constrained by poverty'[49] – in medieval litera-ture they tend to be typecast as sexually over-experienced and rapacious creatures who move from one man to another in a vain attempt to slake their insatiable lusts. This tradition may be exemplified by a fabliau with which the Wife of Bath's prologue is often compared, the thirteenth-century *La Veuve* by the *jongleur* Gautier le Leu.

Gautier tells the tale of a widow who, having buried her husband, soon forgets about him as her appetites demand satisfaction:

> Une dolçors al cuer li point,
> Qui le soslieve contremont;
> Et li doiens le resomont,
> Qui desire a mangier car crue
> Qui n'est de paon ne de crue
> Ains est de l'andolle pendant
> U les plusors sont atendant. (134–40)

> A sweet sensation pricks her heart and lifts up her spirit, and arouses the bearded counselor under her skirts an appetite for meat, neither peacock nor crane, but that dangling sausage for which so many are eager.[50]

[48] H. R. Lemay, *Women's Secrets: A Translation of Pseudo-Albertus Magnus'* 'De secretis mulierum' *with commentaries* (Albany NY, 1992), p. 129. One of the commentaries on this treatise notes that 'old women ought not to be permitted to play with children and kiss them, because they poison them to such a degree that sometimes they die' (p. 131).

[49] *Treasure of the City of Ladies*, trans. Lawson, p. 159.

[50] *Le Jongleur Gautier le Leu: Étude sur les fabliaux*, ed. C. H. Livingston (Cambridge MA, 1951), p. 169. In this discussion I cite the translation of Robert Hellman and Richard

She takes a young husband – or, as Gautier puts it, 'her hairy Goliath so pricks and excites her and the fire burns so high in her that at last she succeeds in getting a man' (382–4). He tries long and hard to please her, but all in vain: 'Goliath gapes too often. I can't satisfy him; I'm likely to die before I do!' (436–80). He is simply not man enough for the ball-breaking *veuve*.

> Dame, vos avés un gloton
> Qui trop sovent velt alaitier;
> Il a fait Bauçant dehaitier.
> Je l'ai ioan de lui retrait
> Tot hasqueret et tot contrait.
> On ne puet pas faire tos tans
> C'on ne soit lasset et estans. (462–8)

> Lady, you have a greedy mouth in you that too often demands to be fed,' he exclaims. 'It has tired my poor old war-horse out. I've just withdrawn him all shrunken and sore. One cannot work so much without getting weary and limp.

The Wife of Bath's account of how she made her old husbands 'pitously a-nyght . . . swink' (202) is very mild by comparison, and she has no complaints about the sexual prowess of her two young husbands. Innuendo there certainly is in the *Wife of Bath's Tale*, though its nature and extent is a matter of some controversy in contemporary criticism. It is, I hope, uncontroversial to claim that whatever innuendo may exist in Chaucer's text is a lot subtler than what Gautier has to offer.

And this brings us to the crucial question; can we identify any 'obscene' language in the Wife of Bath's prologue and tale? Once again, the answer depends on what definitions are applied. If dirty deeds make the language that describes them dirty, then we could answer in the affirmative. From the moral high ground it may be said that Alisoun discusses 'obscene' things in the manner of her predecessors Dipsas and La Vielle; this argument may be supported with reference to possible obscene puns.[51] However, if we are looking for blatantly offensive language in the tradition of Jean de Meun's *coilles* and *vit/viz*, there is little if anything to be found.

The Middle English form that most closely approximates to *coilles* is 'coillons'. It is used by the Host in his vigorous response to the Pardoner who has just singled him out as being the most enveloped in sin among the Canterbury pilgrims: 'I wolde I hadde thy coillons in myn hond / In stide of relikes . . .' (VI(C), 952–3). (Here we may detect a distant echo of Raison's declaration that, were the linguistic custom different, 'balls' could denote

O'Gorman, conveniently reprinted in *The Canterbury Tales: Nine Tales and the General Prologue*, ed. V. A. Kolve and G. Olson (New York, 1989), pp. 320–6.
51 Here I have particularly in mind the modern scholarly controversy concerning the term 'queynte', on which see p. 174 below.

relics and 'relics' could denote balls.) This is the only occasion on which the term appears within the surviving Chaucerian corpus; indeed the *Middle English Dictionary* gives only two entries for this term, the abovementioned *Pardoner's Tale* passage and a medical discussion in Benedict Burgh's continuation of Lydgate's version of the *Secreta secretorum*, the *Secrees of Old Philisoffres*.[52] It certainly does not appear in the mouth of the Wife of Bath. True, in the *Riverside Chaucer*'s edition of the *Wife of Bath's Tale* she refers to the male genitalia as a 'nether purs' (III(D), 44b) and remarks that she has the 'mark of Mars' on her face 'and also in another privee place' – which is followed by a declaration of her indiscriminating appetite (622–6). However, these expressions occur in lines that do not feature in all the earliest manuscripts. John Manly and Edith Rickert argued that they are genuinely authorial, Chaucer having added them in a process of revision.[53] But in Norman Blake's view it is more 'satisfying' and 'reasonable' to assume that 'the passages were introduced by a scribe or editor during the early fifteenth century'.[54]

The two occasions on which Alisoun calls her sexual organ a *bel chose* (447, 510) are, however, textually well-attested, as is the passage in which she puts her personal spin on the clerks' reasons for the creation of the human genitalia, here called 'thynges smale' (121); both the male and female members are designated as 'instruments' (132, 149). Neither of these expressions seems offensive in itself, 'thynge' being the vaguest of terms (and frequently used in Middle English where a more precise word was unavailable to, or unusable by, the writer or speaker), and 'instrument' being a term that was applied to a wide range of body parts and bodily agencies, as the *Middle English Dictionary* attests. The Wife also remarks that 'every wight' who has 'such harneys' as she has been describing, is obliged to use them 'in engendrure' (135–7). Raison had argued that since the private parts were created by God they were created good and honourable and hence can be named directly; the Wife of Bath agrees that they were created good – and they should be put to the specific uses for which they were created, one of these being 'engendrure' (115ff.). The tone and tenor of this discussion of the 'membres . . . of generacion' (116) – the term 'membre' itself being the most decorous possible

[52] *Lydgate and Burgh's Secrees of Old Philisoffres*, ed. R. Steele, EETS ES 66 (London, 1894), p. 56. Burgh is discussing signs of disease in the genitals. Cf. the *Middle English Dictionary*, ed. H. Kurath and R. E. Lewis (Ann Arbor MI, 1954–99), which I consulted in the online version.

[53] However, their unease with the passages in question is evident in their hypothesis that Chaucer inserted them in a single manuscript of the (already circulating) *Wife of Bath's Prologue*, 'to meet the taste of some friend': *The Text of the Canterbury Tales studied on the Basis of All Known Manuscripts* (Chicago, 1940), II, 193.

[54] N. Blake, 'The Wife of Bath and Her Tale', *Leeds Studies in English* 13 (1982), 42–55 (pp. 45, 47). Blake believes that the *Wife of Bath's Prologue* is 'the most altered piece' in the entire poem.

– is generally academic, with a veneer of medical and theological discourses, which is hardly surprising, given that Chaucer's primary source for the first part of this prologue is Jerome's *Against Jovinian*. Furthermore, with her use of *bel chose* may be compared a passage in some versions of the Middle English *Knowing of Woman's Kind in Childing*, wherein the vagina is said to be called 'in Frenche' a 'bele chose or ellys a wykket of þe wombe'.[55]

Here one may recall Christine de Pizan's attempt to find body language of a kind that could combine precise referentiality with respectability. If she fell ill and, in trying to describe her condition, referred to the 'secret members (*secrés membres*) or whatever else' by a certain name that was other than the 'proper name' (*propre non*), then that name would not become dishonourable because her purpose was not dishonourable.[56] It is not altogether clear what Christine means here by names other than 'proper' names, but I presume she has euphemisms in mind. However, Christine continues, if on such an occasion she were to designate the private parts by their proper names, then anything that was dishonourable about those words would continue to exist. They could not escape the taint of dishonour, since 'la premiere entencion de la chose a ja fait le non deshonneste' ('the primary associations of the thing have already made the name dishonourable').[57] But Christine herself would not be to blame, given her own good intention. If I have interpreted this passage correctly, it could be inferred that, *pace* Jean de Meun's Raison, it's better to use euphemisms in diagnostic contexts, because those names are neither dishonourable nor do they become dishonourable by association with the *secrés membres*. The further inference could then be drawn that since terms like *bel chose* and *instrument* can hardly be regarded as 'proper' names, their use by the Wife of Bath could be regarded as perfectly honourable.

To which the response could be offered: that argument works only if it is assumed that the Wife of Bath's intention is purely medical and/or scientific, an assumption that certainly cannot be made! A similar point may be made in respect of one of the most-discussed of Alisoun's dubious terms, namely *queynte*, which occurs twice in the *Riverside Chaucer*'s edition of her tale ('Ye shul have queynte right ynogh at eve'; 'Is it for ye wolde have my queynte

55 *The Knowing of Woman's Kind in Childing: A Middle English Version of Material derived from the 'Trotula' and Other Sources*, ed. A. Barratt (Turnhout, 2001), p. 44. In the version in Cambridge University Library, MS Ii.6.33, the passage reads, 'callid a cunte or priuyte of the wombe' (*The Knowing*, ed. Barratt, p. 45). On this text, see further M. Green, 'Obstetrical and Gynecological Texts in Middle English', *Studies in the Age of Chaucer* 14 (1992), 53–88 (esp. pp. 66–7). I am grateful to Professor H. A. Kelly for bringing the *bele chose* reference to my attention. It is not included in the *Middle English Dictionary*, which presents Chaucer's usage of the term as unique; however, the *MED* does cite three occurrences in scientific contexts of 'priue chose'.

56 *Le Débat*, ed. Hicks, p. 117; *La Querelle*, trans. Baird and Kane, pp. 117–18.

57 In other words, the impact of those 'proper' words would be determined by custom and the common usage of speech, which no individual speaker can overthrow.

allone?' [332, 444]).[58] L. D. Benson, in an oft-cited article which challenges what he regarded as the excessive and often linguistically baseless quest for Chaucerian innuendo, argues that *queynte* functions as a euphemism in the early fourteenth century *Sir Tristrem* ('Hir queynt abouen hir kne, / Naked þe kniʒtes knewe' [2254–5]) and also in line 3276 of the *Miller's Tale*, where Chaucer describes how 'hende Nicholas . . . caughte' Alisoun 'by the queynte'.[59] In each case, Benson believes, the author is trying to avoid the obscene word *conte*.[60] Joseph A. Dane has responded with the argument that in the *Miller's Tale* passage *queynte* should be read here 'not as a euphemism but as a word with an independent meaning'; as a noun rather than an 'absolute adjective' (as Benson had proposed).[61] To put it in Jean de Meun terms, the issue here – as in the *Wife of Bath's Prologue* – is whether the problematic word is a 'proper' or an 'improper' term. The matter may be complicated even further with the argument that the word that Benson deemed obscene (and thus avoided by Chaucer) occurs in contexts that do not support any suggestion of offensiveness. Lanfranc's art of surgery (written *a.* 1400) contains the statement that 'in wymmen þe necke of þe bladdre is schort & is maad faste to the cunte',[62] and the Latin–English dictionary known as the *Medulla grammatice* (written *a.* 1425) defines *vulva* as 'a count or a wombe'.[63] It would seem, then, that certain technical and/or scientific contexts justified the use of the 'proper' term *conte* just as much as the 'improper' term *bel chose*. But the *Middle English Dictionary* (which I have been drawing on here) also documents what may be called the 'offensive' use of *cunte/conte*, i.e. an application that violates the principle of 'reasonable shame' (*honte raisonnable*). The most elaborate example features in a poem included in the Lincoln Thornton manuscript, which likens inadequate husbands to the old horse 'Lyarde', who has his shoes removed and is put out to pasture because he is unable to 'wele drawe' any more.[64] Similarly, any man who cannot 'serve' his wife should

> . . . be geldid or he go of bathe his balloke stonys,
> And pulled of his schome, and putt to the pasture

[58] In one manuscript, Oxford, Corpus Christi College, MS 198, the term replaces *quoniam* in 608, 'I hadde the beste *quoniam* myghte be'.
[59] L. D. Benson, 'The "Queynte" Punning of Chaucer's Critics', in *Reconstructing Chaucer: Studies in the Age of Chaucer, Proceedings*, 1, ed. P. Strohm and T. J. Heffernan (Knoxville, 1985), pp. 23–47. A substantial critique of Benson's argument has been offered by J. V. Fleming, *Classical Imitation and Interpretation in Chaucer's 'Troilus'* (Lincoln NE, 1990), pp. 1–74.
[60] In Cambridge University Library, MS Ii.3.26, *queynte* is actually replaced with *conte*.
[61] J. A. Dane, '*Queynte*: Some rime and reason on a Chaucer[ian] Pun', *Journal of English and Germanic Philology* 95 (1966), 497–514.
[62] *Lanfrank's Science of Cirurgie*, ed. R. V. Fleischhacker, EETS 102 (London, 1894), p. 172.
[63] *Middle English Dictionary*, s.v. *cunte*.
[64] *Reliquiae antiquae*, ed. T. Wright and J. O. Halliwell, 2 vols (London, 1845, rep. New York, 1966), II, 280–2.

The poet proceeds to fantasize about a 'parke' filled with impotent men, which comes under attack from a group of friars who are incensed because one of their number (who, the park-master claims, 'myghte noghte do bot once in a ʒere') has been corralled therein. No 'counte betyne' (cunt-beaten, impotent) man will be their brother, they cry, and proceed to destroy the enclosure. This action does women a considerable disservice, because, having been set free, the park's denizens marry wives who soon are utterly dissatisfied with their sexual performance. When all else fails, concludes the poet, beat the *cownte* with your fists!

The tone and tenor of this outlandish little piece are very different from those of the *Wife's Prologue and Tale*. As already noted, the Wife of Bath's sexual discourse is relatively restrained. Why is this so, since the material obviously lends itself to more racy presentation? In the *Miller's Prologue* Chaucer famously warns that the Miller, Reeve 'and othere mo' are churls, and so it's to be expected that they should speak 'harlotrie', tell dirty stories (I(A), 3182–4). Why not the much-married Wife of Bath? One possible explanation is that, far from being a churl, she is a clothier; Chaucer imagined her as engaged in a highly respectable and profitable profession. Outspoken and sometimes outrageous she may be, but she is governed by the dictates of bourgeois respectability, and very mindful of her social position – hence, for example, her anger when someone gets ahead of her at the 'offrynge' during Mass (449–52).

This suggestion follows D. W. Robertson's argument that it is 'quite likely' that 'most members of the audience would have concluded immediately that the Wife's prosperity was the result of her participation in the thriving rural cloth industry, not as a mere weaver . . . but as a clothier'.[65] However, Robertson's position has recently been challenged by Susan Crane, who finds the secret of Alisoun's success in her serial widowhood. 'Clothmaking is not, in fact, how she lives; rather, she wins money by marrying repeatedly and cajoling, browbeating, or outliving her husbands.'[66] It may be added that the Wife of Bath's latest choices of husband put at risk everything she has gained. Her fourth husband is a 'revelour' or profligate who keeps a mistress (III(D), 453),[67] and so besotted is Alisoun with Jenkyn that she gives him total control of everything that her old husbands had given her:

[65] D. W. Robertson, ' "And for my land thus hastow mordred me"? Land Tenure, the Cloth Industry, and the Wife of Bath', *Chaucer Review* 14 (1980), 403–20 (p. 410).

[66] S. Crane, 'The Writing Lesson of 1381', in *Chaucer's England: Literature in Historical Context*, ed. B. Hanawalt (Minneapolis, 1992), pp. 201–21 (pp. 214–15). For these reasons, Crane believes that 'we cannot understand her as a private subjectivity, nor does she so understand herself' (p. 214).

[67] However, such statements must be carefully considered in light of the 'renumbered husbands' variants that are a feature of the transmission of the Wife's prologue; the interpretive problems they raise are well brought out by B. Kennedy, 'Cambridge MS. Dd.4.24: A Misogynous Scribal Revision of the *Wife of Bath's Prologue*', *Chaucer*

> . . . to hym yaf I al the lond and fee
> That evere was me yeven therbifoore.
> But afterward repented me ful soore;
> He nolde suffre nothyng of my list. (630–3)

Hardly the action of a good businesswoman! Here Chaucer's text raises the spectre of the wealthy widow who uses her financial assets to buy a young husband, as exemplified by the hapless heroine of Gautier le Leu's *La Veuve*, a creature obsessed with making love rather than with making money. And Alisoun's sentimentalization of her action – the claim that she married Jenkyn for love – only serves to highlight what traditional misogyny would regard as typically feminine weakness.

For Crane the Wife of Bath is a figure 'powerfully constructed by estates ideology and clerical antifeminism'.[68] This thesis may be supported with the argument that Alisoun's euphemisms are to be read as evidence of female hypocrisy, instances of that type of linguistic equivocation that was attacked so fiercely by Jean de Meun's Raison. Indeed, three of the 'improper' (i.e. indirect) words assigned to her in the *Riverside Chaucer* – purses, harness, and things – feature in Raison's list of verbal evasions that demonstrate women's refusal to name those parts of the male anatomy that in fact give them great pleasure. True, the first of these terms may be the addition of a fifteenth-century scribe. And it is also true that the Wife of Bath does not talk as dirty as some of her literary predecessors and peers had done, or serve as the occasion for much authorial dirty talk. But in at least some respects she seems to be cut from the same cloth as Jean de Meun's 'devilish, dishonourable and filthy' Vieille (those adjectives are supplied from the fulminations of Christine de Pizan and Jean Gerson). The passage, which declares that she 'evere folwede' her 'appetit' with every kind of man, 'Al were he short or long, or blak, or whit' (623–4), could well have been added by the scribe of Cambridge MS Dd.4.24. But its removal, along with that of the other passages not found in all the early manuscripts, does not, *pace* Beverly Kennedy, leave us with a text that offers 'a thoroughly ambiguous representation of her sexual morality'.[69] For many other passages in Chaucer's text are deeply permeated with similarly antifeminist assumptions. The Wife's corporeality and corporeal desires feature prominently in her Prologue, undeterred by the distancing

Review 30 (1995–6), 343–58, and B. Kennedy, 'The Rewriting of the *Wife of Bath's Prologue* in Cambridge Dd.4.24', in *Rewriting Chaucer: Culture, Authority and the Idea of the Authentic Text, 1400–1602*, ed. T. A. Prendergast and B. Kline (Columbus OH, 1999), pp. 203–33.

68 Crane, 'Writing Lesson', pp. 214–15.

69 B. Kennedy, 'The Variant Passages in the Wife of Bath's Prologue and the Textual Transmission of *The Canterbury Tales*: The "Great Tradition" Revisited', in *Women, the Book and the Worldly*, ed. L. Smith and J. H. M. Taylor (Cambridge, 1995), pp. 85–101 (p. 86). See further her two later articles, which are cited in n. 67.

effect of the academic and technical vocabularies on which she draws and despite or perhaps even because of all those euphemisms. Many of the negative connotations of vetularity and widowhood operate quite forcefully.[70] The Wife of Bath thus manifests what Foucault has termed the hysterization of women's bodies, i.e. the process whereby the female form is analysed as being thoroughly saturated with sexuality. It was not just the 'Victorians' who 'regarded serial marriage as tantamount to promiscuity'[71]; similar views are expressed in Jerome's *Against Jovinian*, which features in Jenkyn's book of wicked wives (cf. 674–5) and whose sentiments are recalled by the Wife of Bath herself, in her very attempt to refute them. The textual legacy of Jerome – and Juvenal and Jean de Meun – weighs more heavily in Chaucer's text than any cultural tolerance concerning remarriage that was current in Chaucer's England.[72] Alisoun may easily be read as every misogynist's worst nightmare.

Of course, that is not the whole story. Although constructed from antifeminist antecedents of a kind that may easily be identified and catalogued, nevertheless she manages to 'turn on them to attempt an argument against the position of inferiority they posit for women'.[73] Furthermore, the Wife of Bath moves far away from the embittered solopsism of the *Rose*'s La Vielle, in presenting a challenging homily on the nature of true gentility, the advantages of poverty, and the superficiality of physical ugliness (the moral disfiguration of the aristocratic rapist who is the main moral target of her tale being far more offensive). And yet: Alisoun does not escape utterly from her antecedents in Ovid and Jean de Meun. However much we may argue over the specific semantics of obscenity, in the final analysis much of her discourse may be deemed 'obscene' because of the nature of many of the things described therein, including the private parts of men and women and her own sexual feelings and exploits (which, if they do not bespeak adultery, certainly exemplify dangerous female desire). *Le nom ne fait la deshonnesteté de la chose, mais la chose fait le nom deshonneste.* A culture that generally was supportive of this dictum of Christine de Pizan's could scarcely allow otherwise. However, this fact of medieval life was grist to Chaucer's mill. The poet who dared to present a blatantly immoral man – the Pardoner – telling a

70 Moreover, if the 'satire justification' be invoked in defence of Chaucer's use of dubious language, that would emphasize even further the misogynistic valence of the text, given that the wiles of women (including old women) were a traditional target of such satire, as noted above (pp. 161–3).

71 Kennedy, 'Variant Passages', p. 87.

72 As proposed by Kennedy, who affirms a 'huge moral difference between committing acts of adultery (a mortal sin) and marrying five times (no sin at all so long as one remains faithful to each spouse'); Kennedy, 'Variant Passages', p. 98. Many misogynistic textual constructions fail to recognize such a distinction; both these types of action are frequently taken as evidence of the lustful ways of women.

73 Here I borrow another phrase from Crane, 'Writing Lesson', pp. 214–15.

highly moral tale, was quite willing to make a figure who combined negative qualities of both *vielle* and *veuve* into the voice of reason, as she tells her tale of a loathly damsel; perhaps even into the voice of Raison, that fair but foul-mouthed creation of Jean de Meun. At the very least, Chaucer's French forebear showed him that discourses of obscenity and authority can be brought together, to startling effect, within the contours of a single character.

Latin Literature, Christianity and Obscenity in the Later Roman West

Danuta Shanzer

Late Antiquity (here understood as the period from the second to the sixth century AD), like all periods of social and political transition, witnessed striking changes in attitude towards sex, sexuality and to literary obscenity.[1] Before the second century there existed a Greco-Roman society that accepted the extravagances of Greek Old Comedy, Latin satire or of material culture, such as erotica on vases and the 'secret' Pompeian collections of pornographic frescos.[2] Ithyphallic statues of Hermes adorned classical Athens, and phalluses imperial Roman cities in ways that would eventually be unimaginable. Artistic verse in Latin included works such as Catullus's *Carmen* 97 (where the reader is invited to consider whether one Aemilius's arse or mouth was the cleaner orifice) and some of Juvenal's *Satires* (including 9.44 where a homosexual prostitute complains of encountering yesterday's dinner while buggering a client). Sexually explicit or obscene material was an integral part of high culture.

There is vastly less obscene material from the early Middle Ages than from the later Roman Empire; by the sixth century AD such writing was largely unthinkable in the Latin West. The fourth century had seen the peace of the Church and the emergence of Christianity as the dominant religion; society

1 For interesting studies of later Roman attitudes to the body and sexuality, see for example A. Rousselle, *Porneia: On Desire and the Body in Antiquity* (Oxford, 1988); P. Brown, *The Body and Society* (New York, 1988) and now K. L. Gaca, *The Making of Fornication: Eros, Ethics, and Political Reform in Greek Philosophy and early Christianity* (Berkeley CA, 2003).

2 There is a considerable and (sometimes) sober literature on obscenity in the classical world, including K. J. Dover, *Greek Homosexuality* (Cambridge MA, 1989); J. N. Adams, *The Latin Sexual Vocabulary* (London, 1982); E. C. Keuls. *The Reign of the Phallus: Sexual Politics in Ancient Athens* (Berkeley CA, 1993); J. Henderson, *The Maculate Muse: Obscene Language in Attic Comedy* (New York, 1991); A. Richlin, The *Garden of Priapus: Sexuality and Aggression in Roman Humor* (New York and Oxford, 1992). F. K. Forberg, *Manual of Classical Erotology* (De figuris veneris) (New York, 1966; first published Manchester, 1884) is a classic.

was no longer polytheistic, but largely Christian. Many ancient theological writers would have their audiences believe that Christianity brought an end to obscene sexual rites and ritual obscenity and with it a new era of virginity before marriage, monogamous chastity within it and clean thinking.[3] Modern scholars in turn, themselves often legatees of Paul and Augustine, see the classical world as one that tolerated both the sexual and the obscene and Christians as those who restricted, censored and controlled sexuality and obscenity.[4]

This essay will examine the survival and transformation of the rich classical tradition of literary obscenity, concentrating on Western Late Antiquity, from the second to the sixth century, the long period of transition that would eventually usher in the Middle Ages. It aims to show what happened to the often sexually explicit literature of Greco-Roman society with the advent of repressive Christian mores and Christianity's distinctive social control of sexuality. A long time-period, many authors, and many literary genres need to be addressed in order to delineate continuities and discontinuities, transformations and innovations. My purpose here is to survey a vast and often complex body of provocative material, to identify landmark texts and writers and to stimulate further research. I will concentrate on the following five topics: (i) the survival of obscenity in various secular genres in Late Antiquity; (ii) learned patristic satire of the pagan gods as a vehicle for the transmission of obscene material; (iii) the treatment of sexual material in the exegesis of the Old Testament and in the translation of the Bible; (iv) how some Christian writers, both obviously and not-so-obviously, embraced the sexual; and (v) how hagiography proved a venue for a heady mixture of sex and violence.

Let us begin, though, by outlining some of the practical and methodological difficulties that face the researcher. It must be noted at the outset that if by 'obscene' and 'obscenity' one means the *intentionally* sexually explicit intended to titillate, shock or amuse, the pornographic, the risqué, what is 'dirty' or 'perverted', Late Antiquity provides little and poor material. Searches for words like the primary obscenities – *mentula* (penis),[5] *cunnus*

3 For a sensible corrective, see B. Caseau, 'Christian Bodies: The Senses and Early Byzantine Christianity', in *Desire and Denial in Byzantium*, ed. L. James (Aldershot, 1999), pp. 101–9 (pp. 101–2), warning us not to assume that ascetic discourse had a generalized social effect.

4 Work by Brown and Rousselle as well as E. Pagels, *Adam, Eve, and the Serpent* (New York, 1988) help illustrate and explain Christian attitudes towards the body and sexuality.

5 The former is fairly common in Catullus, Martial, and the *Priapea*, and appears in the occasional Pompeian inscription, yet there seem to be virtually no occurrences from the later Roman Empire, and it survives only sporadically in Romance. See W. Meyer-Lübke, *Romanisches etymologisches Wörterbuch* (Heidelberg, 1935), no. 5513: 'mentula' for 'minchia' in Italian and 'minkra' in Logudorese. Note, however, that the *Thesaurus Linguae Latinae* (*TLL*) article is misleading, omitting as it does Maximianus, *Elegies* 5.87. There must be more omissions.

(cunt),[6] or *futuo* (to fuck)[7] – yield little. But obscenity is not confined to dirty words alone: art lies in avoiding them. One might chart allusions to obscene acts as did Forberg: *fututio, pedicatio, irrumatio, masturbatio, cunnilingus,* tribadism, bestiality and *spintriae* in 'daisy-chains'.[8] Here, one would get no further than invective, graffito and epigram. Instead, given the constraints of Christian propriety in the later Roman Empire, such an inquiry is only meaningful if one looks at what *contemporary* sources considered 'obscene'. What is *denoted* by the term is relative. Much of the matter to be discussed may thus seem sexual rather than obscene to modern sensibilities.

Survival and continuity in secular genres

It is best to start with survival and continuity. Obscenity was tolerated in its customary homes: graffito, epigram, elegy, invective, biography, anecdote and epithalamium. The obscene epigram survived in, for instance, Ausonius, Luxorius, the poets of the *Anthology*, and Ennodius.[9] There was, however, a considerable decline in the use of primary obscenities and a vogue for scholastic subjects, matter that could, in other words, be dignified as art or learning. Take Ausonius's poem on Eunus the Syrian grammarian who practised cunnilingus and saw different letters of the Greek alphabet in his mistress's genitalia: the joke lies in the pedant looking for triangular deltas or circles intersected by lines (phi's) between his lady's legs.[10] Or, take Luxorius,

6 *Cunnus*, attested in Horace *Satires* 1.2, the *Priapea*, and *Carmina Epigraphica* from Pompeii and Martial, *is* to be found after AD 284. See Soranus, *Gynaecologica*, ed. Rose, p. 9.4, who speaks of the 'sinus muliebris quem vulgo cunnum appellant'. It also appears in Luxorius (*Anthologia Latina* [*AL*] 297.11–12): 'novi quid libeat chirurge / conspectos animum videre cunnos / vis ostendere te minus virum esse / cum arrectos satis est mares videre'; *AL* 148.7: 'cunnumque caballae atterit assiduo pene fututor hebes' and in Claudian, *Carmina Minora* 4.8: 'cunnum lambere'. Its widespread survival in Romance speaks for the lost spoken record. See Meyer-Lübke, *Romanisches etymologisches Wörterbuch*, no. 2399: 'cunnus'. Again, the *TLL* is unreliable in that it fails to list occurrences of the word in Luxorius, *AL* 312.3: 'furente cunno' and 312.6: 'cunnum'.

7 After Martial, attested only in Priscian. See *TLL* 'futuo' 1663.35–1664.36. But see Luxorius, *AL* 292.5.

8 The list corresponds to the table of contents in Forberg, *Manual of Erotology*.

9 Ausonius, *Epigrams*, ed. Green, 43 (a symplegma), 50, 73, 74, 75, 82–7 (Eunus), 100; Luxorius, *AL* 290, 292, 297, 304, 312, 317, 335, 353, 358; *Magni Felicis Ennodi opera*, ed. F. Vogel, Monumenta Germaniae Historica, Auctores Antiquissimi 7 (Berlin, 1885), 132–3, 136, 136a–b, 180 ('de adultero et molle'), 180 a–c, 190 (on the eunuch Tribunus), 193 ('de malo homine qui equos amabat'), 217 ('de anu quadam'), 233, 238 ('de quodem incerti propositi et vitae turpis'), 265 ('de caeco quodam et luxurioso'), 329, 329a–c, 339 ('de Boetio spatha cincto'). All subsequent references to Vogel's edition will be in the form 'Vogel 329', etc.

10 *Epigram* 87. See J. N. Adams, 'An epigram of Ausonius (87 p. 344 Peiper)', *Latomus* 42 (1983), 95–109.

Latin poet among the Vandals, who wrote a paradox-ridden epigram on an hermaphrodite.[11]

An ecclesiastical exception

The tolerance of churchmen varied. In the later Roman period most did not write erotic or obscene poetry. Indeed, like Sidonius Apollinaris, they often self-consciously gave up poetry after becoming bishops; but there is a notable exception from Ostrogothic Italy. Ennodius (born *c.* 473), bishop of Pavia from 510/511, wrote homophobic epigrams,[12] graphic abuse of the failing and post-menopausal physiology of an old woman who wants to marry a young man[13] and epigrammatic slurs on the sexual dissolution of his friend, the great Boethius.[14] His poems invite direct comparison with similar efforts by Horace or Martial.[15] *Urbanitas*, 'being a man of the world', was clearly still prized. After a severe illness at about the time he became bishop,[16] Ennodius repented of his poetry in Vogel 438. 5–7:

> Puffed up by my empty successes I made myself one of the troop of poets, when I was unaware of my venerable profession. Poems fashioned with nicely squared off elements and firmed with an orderly variety of feet gave me pleasure. An ephemeral or sexy poem made me one with the choruses of angels, and, if it had come about that I had made fine verses and kept to the law, I would have seen whatever is covered by the arch of the sky beneath my feet. My mortal life long turned over this silly stuff and the certain blindness of my miseries removed it from the false happiness of rhetoric.

There are serious problems in determining the chronology of Ennodius's oeuvre, but it seems probable that, although he had given up obscene verse when he became bishop of Pavia, he was almost certainly still writing it while a deacon at Milan (until AD 512). If one looks at Vogel 350, a hymn to the Virgin, one is struck by what seems to be an unusual, excessive, perhaps even unhealthy interest in her physiology, the 'clausa' and the 'patens porta' ('closed' and 'open door'), conception through the ear, 'what the tongue threw in was seed', 'the word is clenched ('stringitur') by flesh', the closed

[11] *AL* 312.
[12] See E. d'Angelo, 'Tematiche omosessuali nella letteratura di età teodoriciana. Il caso Ennodio', in *Teodeorico il Grande e i Goti d'Italia: Congresso internazionale di studi sull'alto Medioevo* (Milan, 1992), pp. 645–54.
[13] See Vogel 217 ('seminis et custos refugit cruor utilis inguen') with S. Kennell, *Magnus Felix Ennodius: a Gentleman the Church* (Ann Arbor MI, 2000), p. 121.
[14] Vogel 339. See D. R. Shanzer, 'Ennodius, Boethius, and the Date and Interpretation of Maximianus's Elegia III', *Rivista di filologia e istruzione classica* 111 (1983), 183–95.
[15] A. Dubois, *La Latinité d'Ennodius* (Paris, 1903), p. 37: 'Il y en a qui sont impures, licencieuses, dignes de Martial.'
[16] See Vogel, p. xxi comparing Vogel 401 and 402.

fountain, and the excessively tight 'crack' ('rima artior') opened up by birth.[17] One easily connects this poet and the author of 'De anu quodam' (Vogel 117). Ennodius is a throw-back to a much earlier figure, Ausonius. How did he manage to do this as a churchman in the early sixth century? It is hard to reconstruct circles and tastes and tolerances, but it may be worth remembering that Ennodius was a key supporter of Pope Symmachus who had been accused of consorting with 'rouged lady friends', including a courtesan called Conditaria (Spicy).[18] The pope was accused of doing it; the deacon wrote about it. Only after 'l'affaire Symmaque' did Ennodius in his 'praeceptum de cellulanis' warn against the possibility of being thought to have done it when one could have done it.[19]

Biography and anecdote

Suetonius's scandalous gossip about the Roman emperors is familiar, from Tiberius's shenanigans on Capri to Caligula's and Nero's misdeeds. Here little changed. Imperial biographers continued to provide splendid smutty anecdotes, exciting vices for voyeuristic readers.[20] In the late fourth century, the grosser inventions of the *Historia Augusta* catered to the tastes of its reading public. Amusingly enough, the *Vita Elagabali*, which furnishes the most sexual extravagances, is dedicated to Constantine![21] Elagabalus allegedly used all of his orifices for sexual purposes, employed scouts to identify

17 Cf. Claudian, *Carmina Minora* 48. See T. Gregory, 'The Remarkable Christmas Homily of Kyros Panopolites', *Greek, Roman and Byzantine Studies* 16 (1975), 317–24 for conception through hearing in Eastern Christianity.

18 H. Chadwick, *Boethius: the Consolations of Music, Logic, Theology, and Philosophy* (Oxford, 1981), p. 32. For the Laurentian fragment, see *Patrologia Latina* (PL) 62, 47: 'cumque ibidem cum suis clericis aliquantis permoratur, post meridianis horis super littus maris ambulans, vidit mulieres inde transire, cum quibus accusabatur in scelere, quae comitatum potebant, regia jussione. Dissimulans ergo se scire, quod viderat, nocte media, dormientibus cunctis, cum uno tantum conscio fugiens, regreditur Romam, seque intra beati Petri apostoli septa concludit. . . . Symmachum vero postmodum quamvis victorem, de multis rebus fama decoloravit; obscenior et maxime de illa, quam vulgo Conditariam vocitabant.' For Ennodius's 'mulierum turbas', see Vogel 49.65.

19 'Praeceptum de cellulanis' (Vogel 8.7): 'convicti loco deputatur incautus et fecisse scelus creditur qui potuisse facere perhibetur'. The final sentence, 'nullus secum extraneas habeat mulieres praeter personas canonibus designatas, ne agendo taliter, etiamsi vita sit innocens, damnum opinionis incurrat', may refer to the slanders about Symmachus's female companions.

20 For example Suetonius, *Tiberius* 43–45; *Caligula* 24, 36; *Nero* 28–29.

21 See A. Chastagnol, *Histoire Auguste* (Paris, 1994), pp. 491–545. The *Vita Elagabali* must have been 'dedicated' to Constantine (2.4, 34.1, 35.5) with intentional malice. See Chastagnol, *Histoire Auguste*, p. 499. Note also the pretence of modesty in selection that introduces the more exciting vices at *Vita Elagabali* 18.4. It is amusing to note that the text of Ausonius's *Caesares* is defective for Heliogabalus. Were the final two lines of the tetrastich edited out?

the 'well-hung' (the baths were a favoured hunting-ground), gave them positions of power, and smothered his parasites in violets and flowers.[22] The jokes of the *Saturnalia* provide risqué anecdotes[23] safely anchored in politics or high culture,[24] including the fine witticisms ascribed to the Elder Julia,[25] only one of which is explicitly sexual, the famous explanation of why her children looked like Agrippa: 'I never take on a passenger unless the ship is laden.' All of this material is tame and safely antiquarian.

The last erotic elegist

Playful obscenity and the risqué survived as late as the sixth-century elegist Maximianus, who may well be the last debonair Latin author. His love-elegies contain sexual material, presented as philosophical parody, and legitimized, as were Ausonius's scholarly dirty jokes, by reference to higher literary forms. In *Elegy* 3 the philosopher Boethius appears as a panderer,[26] and in *Elegy* 5 a Constantinopolitan prostitute both laments over and prays to the authorial persona's flaccid penis ('mentula' – surprisingly invoked as such).[27] Her speech parodies a quasi-philosophical hymnic aretology:

> the penis creates the human race, the race of birds and cattle and wild beasts, and whatever breathes throughout the world. Without it there is no concord between the sexes, the consummate pleasure of marriage dies. . . . Its power is remarkable, so too its patience. It loves the conquered and it also rejoices to be conquered. When it lies there overcome, it recovers its forces and courage, and again loves both to be conquered and to conquer.[28]

But even this failed to revive the uncooperative member.

22 *Historia Augusta*, Heliogabalus 5: 'quis enim ferre posset principem per cuncta cava corporis libidinem recipientem, cum ne beluam quidem talem quisquam ferat?' Almost certainly based on Suetonius, *Nero* 29. Cf. Also Procopius, *Anecdota* 9.18; *Historia Augusta*, Heliogabalus 5: 'Romae denique nihil egit aliud, nisi ut emissarios haberet, qui ei bene vasatos perquirerent eosque ad aulam perducerent, ut eorum conditionibus frui posset'; Heliogabalus 8.6 (sc. 'balneum'): 'ut ex eo condiciones bene vasatorum hominum colligeret'; Heliogabalus 9.8: 'prodebatur autem per eos maxime, qui dolebant sibi homines ad exercendos libidines bene vasatos et maioris peculii opponi'; Heliogabalus 21.5: 'oppressit in tricliniis versatilibus parasitos suos violis et floribus, sic ut animam aliqui efflaverint, cum erepere ad summum non possent'.
23 See Macrobius, *Saturnalia* 2.2.5 (Caesar's sex-life), 2.2.6 (Galla), 2.2.9 (Fausta and the *fullo* and Macula), and 2.2.10 (Mallius the *pictor*, father of ugly children; the paintings were painted by day, the children fashioned in the dark). There is a hint in Servius's modesty at *Saturnalia* 2.2.12: a youth might find those who told such jokes 'impudentes'.
24 *Saturnalia* 2.2.11 concerns Demosthenes.
25 *Saturnalia* 2.5.1–9.
26 Maximianus, *Elegies* 3 and Shanzer, 'Ennodius, Boethius', pp. 183–95.
27 Maximianus, *Elegies* 5.87–106.
28 At *Elegies* 5.110–52, especially 147–50.

So in these customary homes there is some continuity from the classical to the later Roman period. There is however a notable decrease in the use of *primary* obscenities, words, such as *mentula* and *cunnus*, that signify the thing itself (and nothing else) and are not metaphorical. Another feature that emerges from this census is an apparent difference between Italy and, to some extent, Africa and the rest of the Roman world. More seems to be permitted later in Italy than, say, in Gaul, despite the fact that the northern province had a high literary culture and by far the greatest number of surviving texts. The ascetic movement emanating from Lérins may well have been stronger in Gaul than in central and northern Italy, and probably imposed a stricter 'politically correct' culture on Gallic churchmen than on their Italian counterparts.[29]

Two faces of epithalamium

Epithalamium had always encouraged the risqué.[30] But little survives from the classical period,[31] so it is hard to study the genre diachronically. Later Roman epithalamia seem to reflect not so much real literary changes as individual tastes. In the ancient world, poetasters reassembled half-lines of Homer and Virgil to form new poems, called centos, or 'patchworks'. In Ausonius's 'Nuptial Cento' Virgil is prostituted[32] to describe a defloration.[33] Those who read this poem will have trouble thinking of various famous passages from *Aeneid* 6 with a straight face: namely the golden bough that lay concealed in the Sibyl's dress ('ramum qui veste latebat')[34] and the 'gleaming fiery crack' ('ignea rima micans').[35] This piece, written at the request of Valentinian I, who had himself written something similar, presupposes an urbane milieu.[36] The game continued to entertain. Luxorius's epithalamium

29 See now R. Bartlett, 'Aristocracy and Asceticism: The Letters of Ennodius and the Gallic and Italian Churches', in *Society and Culture in Late Antique Gaul: Revisiting the Sources*, ed. R. W. Mathisen and D. R. Shanzer (Aldershot, 2001), pp. 201–16. Also *Vita Caesarii* 1.9, a passage that recalls Jerome's dream and illustrates Gallic hostility to secular reading: Caesarius, after reading a classical text provided by Julianus Pomerius, was punished by a dream in which the arm with which he held the codex was gnawed by a snake. He awoke to renounce and condemn secular wisdom and reading.

30 See P. Brown, 'Bodies and Minds: Sexuality and Renunciation in Ancient Christianity', in *Before Sexuality: The Construction of Erotic Experience in the Ancient Greek World*, ed. D. M. Halperin, J. J. Winkler and F. Zeitlin (Princeton, 1990), pp. 479–93 (p. 488) on the 'frank eroticism associated with the marriage-procession'.

31 Catullus 61, 62 and 64 and Statius, *Silvae* 1.2.

32 'Cento Nuptialis', Ausonius to Paulus: 'piget equidem Vergiliani carminis dignitatem tam ioculari dehonestasse materia.'

33 *Epigram* 75.8 reuses *Aeneid* 4.415 to similar effect.

34 'Cento Nuptialis' 105.

35 'Cento Nuptialis' 111.

36 'Cento Nuptialis', Ausonius to Paulus: 'Imperator Valentinianus, vir meo iudicio

for Fridus, written during the Vandal occupation of Africa, if not actually copied from Ausonius, shows similar disrespect for the Golden Bough.[37]

Pagan and Christian poets such as Claudian[38] and Dracontius[39] continued to use the pagan mythological apparatus in poems for Christian audiences. But then there were many who sterilized the genre. Sidonius Apollinaris in his two epithalamia virtually eliminated the sexual, but maintained the myth-ological apparatus and included catalogues of sages rather than gods of love.[40] The humourless Paulinus of Nola strikes a particularly ominous note in his anti-epithalamium for Julianus of Eclanum and Titia,[41] which begins rather unpromisingly: 'concordes animae casto sociantur amore / virgo puer Christi, virgo puella dei' ('let souls in harmony be associated in chaste love, the boy a virgin of Christ, the girl a virgin of God').[42] There follows a *praeteritio* of deities that may not take part,[43] and rites that are not to be performed.[44] Paulinus inveighs against conspicuous consumption, describes Salome at great length as an exemplum of *luxuria* and Mary as one of purity.[45] But what would one expect from a nobleman who elected to live with his wife in continence subsequent to his ascetic conversion? In short, after its epithalamic *recusatio*, this poem becomes a sermon and a celebration of chastity.

Ennodius's epithalamium for Maximus, which postdates the latter's diaconate and conversion,[46] comes as a surprise to the literary historian. It revives the genre with seductive and uninhibited descriptions of the beauties of nature in springtime and the naked goddess Venus. Ennodius lamented the chilling effect of asceticism on the amusements of the erotic Olympians:

> Nowhere does the name Cytherea sound; the legend of the *Amores* is derided, nor is there sufficient issue to staff the new generation. Icy virginity has con-

eruditus, nuptias quondam eiusmodi ludo descripserat, aptis equidem versibus et compositione festiva.'

37 *AL* 18 and *Poetiae latini minores* 4.237. At 64–6: 'Illum turbat amor; ramum qui veste latebat / Eripit a femine et flagranti fervidus infert. / It cruor inque humeros cervix conlapsa recumbit.'

38 *Carmen* 10 ('Epithalamium Honorio Augusto et Mariae'), *Carmina* 11–15 ('Fescennina') and *Carmina Minora* 25 ('Epithalamium Palladio et Celerinae').

39 *Romulea* 6.22 ff. has an invocation to Venus, but a pious list of nuptial attendants at 61 ff. At 94–5 a weeping Virginity retires. *Romulea* 7.

40 *Carmen* 11 for Ruricius and Hiberia and *Carmen* 14 for Polemius and Araneola. There may be one hint in *Carmen* 11, *praefatio* where the nymph Thetis is described as fearing the 'membra' of her clothed husband: 'vestiti coepit membra timere viri'.

41 *Carmen* 25, Corpus scriptorum ecclesiasticorum latinorum (CSEL) 30. See J. Bouma, *Het Epithalamium van Paulinus van Nola* (Amsterdam, 1968). To be dated 400/405.

42 *Carmen* 25.1.

43 *Carmen* 25. 9–10.

44 *Carmen* 25.30–40.

45 *Carmen* 25.113–36 and 153–66.

46 Dubois, *La Latinité*, p. 35.

sumed and possessed the limbs of many men; lofty vows dominate the flesh with a new fervour, . . . everywhere there is a general strike – it is a sin to have mentioned bedchambers to a chaste man.[47]

Here, at the end of the ancient world, epithalamium rose from the dead. Even a deacon could on occasion openly regret the stifling of sexual impulses and their free expression.[48] Again comparison of various epithalamia from different provinces shows fewer inhibitions in Ostrogothic Italy than in fifth-century Gaul or Africa.

Patristic satires of the pagan gods

So far we have examined clear cases of literary continuity in the deployment of literary obscenity. Satire, on the other hand, constitutes an interesting case of a genre in transition, for it was a genre that tolerated both primary obscenity and sexually explicit material. This is evident in early fragments of Lucilius that grossly contrast the relative defects of boys and women as lovers: 'the former stain one with their excrement, the latter with menstrual blood'.[49] Persius's effeminate literary aristocrats rolled their eyes and wriggled on their benches and had orgasms at readings as the verse titillated their loins.[50] In Juvenal a prostitute heaps scorn on hypocritical closet homosexuals with moral pretensions: the doctor laughed when he came to lance their piles and found their back passages depilated.[51]

Latin hexameter satire seems to end with Juvenal.[52] At the end of the fourth century, however, satire entered *history* and re-emerged as a prose form in two formal satirical excurses on the vices of Rome in Ammianus Marcellinus.[53] Jerome used both satirists and satirical techniques throughout

47 'Iam nusquam Cytherea sonat, ridetur Amorum / fabula, nec proles nascenti sufficit aevo. / Frigida consumens multorum possidet artus / Virginitas fervore novo, sublimia carnem / Vota domant, mundus tenui vix nomine constat / . . . servatur ubique / Iustitium; culpa est thalamos nominasse pudico' (Ennodius, Vogel 387. 55–9, 66–9).
48 Note, however, Ennodius's more traditional attitude towards pagan eloquence in Vogel 43, vv. 1–29. For Maximus's wedding and its aftermath see Vogel 356. But he is true to form when he characterizes virginity as an 'onus' at Vogel 2.26: 'Ad matrem iungens virginitatis onus.'
49 Lucilius, Fragment 1182, ed. Warmington.
50 Persius, *Satires* 1.17–21.
51 Juvenal, *Satires* 2.11–13.
52 Note, however, allusions to satires in Sidonius Apollinaris. See *Epistula* 1.11.1: 'petis . . . satiram nescioquam'; *Epistula* 4.18.6: 'versibus satirographus'; and *Epistula* 5.8.3: 'tu tamen nihilo segnius operam saltem facetis satirarum coloribus intrepidus impende'.
53 Ammianus Marcellinus 28.4.14. See also *Scholia in Juvenalem Vetustiora*, ed. Wessner, 4.53, p. 57.

his writings.[54] In *Epistle* 117 he deliberately compared himself to Lucilius – 'multo sale urbem defricans' ('scrubbing down the city with a great deal of salt'). The same applies to Arnobius and Augustine, especially the latter's treatment of pagan religion in the *De civitate Dei*.[55] In a sense the church fathers became the new satirists. Both Augustine and Arnobius used satirical techniques to handle (and legitimize) improper subject matter that they professed to despise; in both cases they worked from sources we fortunately still have. One instantly sees what represents a change and is 'marked' (and hence in some way significant) and what is simply picked up whole from the source (and hence 'unmarked'). We are thus in a position to evaluate how Augustine improved Arnobius and how Arnobius worked from Clement of Alexandria.

The specialization of the Roman gods had been a subject of jokes as early as Plautus. In the *Bacchides* (115–16), Pistoclerus lists the deities that inhabit Bacchis's house: 'Amor, Voluptas, Venu', Venustas, Gaudium/Iocu', Ludus, Sermo', culminating in the comic 'Suavisaviatio'. This sort of thing was still good for a laugh in the fifth century. In *De civitate Dei* 6.9 Augustine poked fun at pagan marriage-ritual by listing the sequential activities of divinities such as Iugatinus, Domiducus, Domitius, Manturna, Virginensis, deus pater Subigus, Prema, Venus and Priapus. The culmination of the series is 'dea Pertunda' ('the Penetrator'): 'What is she doing here? She should be ashamed! Let her go outside. Let the husband do something too!'[56] The passage is close to Arnobius, *Adversus Nationes* 4.7, which lists Militaris Venus, Perfica, Pertunda and Mutunnus Tutunnus.[57] But Augustine does not merely cite four gods. Through a whole indigitation of deities he depicts a defloration. This is his satirical 'epithalamium for a *superstitiosus*'.

Pagan gods as vehicles for the sexual
Augustine's divine voyeurs at the human ceremony lead to the next satirical opportunity: the pagan gods who gave Christian writers scope for their imag-

[54] D. S. Wiesen, *St. Jerome as Satirist* (Ithaca NY, 1964), passim. A. de Vogüé, *Histoire littéraire du mouvement monastique dans l'antiquité*, 2 vols (Paris, 1993), 1.1, 259–60 links Jerome's penchant for satire with Tertullian. For satire in prose, see Wiesen, *Jerome as Satirist*, p. 249.

[55] In *Confessiones*, Augustine criticized the Manichees exploiting Persius's recondite language. See *Confessiones* 4.1.1: 'nobis in officina aqualiculi sui fabricarent angelos et deos', echoing Persius, *Satires* 1.56. The word 'aqualiculus' was also picked by Tertullian, *De Ieiuniis* 16: 'deus . . . tibi venter est . . . et aqualiculus altare' and by Jerome, *Epistulae* 38.5; 66.5; 107.10 and *In Ieremiam* 13.12.

[56] 'Ibi quid facit? Erubescat, eat foras; agat aliquid et maritus.'

[57] 'Etiamne militaris Venus castrensibus flagitiis praesidet et puerorum stupris? Etiamne Perfica una est e populo numinum, quae obscenas illas et luteas voluptates ad exitium perficit dulcedine inoffensa procedere? Etiamne Pertunda, quae in cubiculis praesto est virginalem scrobem effodientibus maritis? Etiamne Tutunnus, cuius inmanibus pudendis horrentique fascino vestras inequitare matronas et auspicabile ducitis et optatis.'

inative, erotic and satirical talents, while letting them convince themselves
that they were providing sound apotropaic sermons, or at least helpful
anthropology. Arnobius exploited this strategy. In his *Adversus Nationes* 3.10,
he began with a favourite Christian poser: do the gods have genitals? The rest
of the chapter is an explicit and gross *reductio ad absurdum*. If they do, then
gods have orgasms, menstruate, have abortions and miscarriages. The
passage culminates in an imagined scene in heaven: slow-moving pregnant
goddesses weighed down by their bellies, screaming to Iuno Lucina for
release from their pain. Arnobius (*Adversus Nationes* 5.25) is one of the few
sources for Baubo, that rare thing,[58] a female exhibitionist, who shaves her
pubic area, fashions a child's face on her stomach and genitalia and slaps and
fondles it to make the mourning Demeter laugh.[59]

Male gods also provided material. Prosymnus, 'in nefarias libidines satis
pronus' ('highly inclined to depraved lusts'), [60] promised to show Dionysus
the entrance to the underworld, in return for certain 'uxoriae voluptates'
('wifely pleasures') from the god. He showed Dionysus the way and 'stood
for sale on the very threshold of hell'.[61] When Dionysus returned, Prosymnus
was dead and buried, so to fulfil his vow Dionysus took a stout branch of a
fig-tree, and 'hewed it, planed it, smoothed it, and fashioned it into the shape
of a human penis'.[62] He fastened it to the grave-mound and

> baring his bottom approached, and sat on it. With the lasciviousness of one in
> heat he wriggled his buttocks this way and that and practiced suffering from
> the stake what he had in fact promised [to undergo].[63]

This remarkable tale allowed Arnobius to describe surrogate necrophilia as
well as buggery in words that would not subsequently be used by more polit-

58 There is no trace of *anasyrma* in Greek ritual. See M. Olender, 'Aspects of Baubo:
Ancient Texts and Contexts', in *Before Sexuality*, pp. 83–113 (p. 93). But he also notes
the horrific effects of *anasyrma* on p. 104, citing Plutarch, *Virtues of Women* 9.248b and
5.246a.
59 For more on Baubo, see C. Picard, 'L'Épisode de Baubo dans les mystères d'Éleusis',
Revue de l'histoire des religions 95 (1927), 220–54; M. Marcovich, 'Demeter, Baubo,
Iacchus, and a Redactor', *Vigiliae Christianae* 40 (1986), 294–301; T. Karaghiorga-
Stathacopoulou in *Lexicon iconographicum mythologiae classicae*, s.v. 'Baubo', pp.
87–90, and M. Olender, 'Aspects of Baubo', pp. 83–113. See also Clement of Alexan-
dria, *Protrepticus* 2.20.1–2.20–2, paralleled by Eusebius, *Praeparatio Evangelica*
2.3.31–35.
60 Arnobius, *Adversus Nationes* 5.28.
61 'In limine ipse prostituit infernorum.'
62 Arnobius, *Adversus Nationes* 5.28: 'dolat, runcinat, levigat, et humani speciem
fabricatur in penis'.
63 *Adversus Nationes* 5.28: 'postica ex parte nudatus accedit, subdit, insidit. Lascivia
deinde surientis adsumpta huc atque illuc clunes torquet et meditatur ab ligno pati
quod iamdudum in veritate promiserat.'

ically correct Christian writers.[64] Again one can evaluate some of the sugges-
tive ways in which Arnobius has cast the story, by comparing his fairly
neutral Greek source: Clement of Alexandria's *Protrepticus*.[65] 'Stood like a
prostitute on the very threshold of hell' does not appear in the Greek at all.
Instead of just mentioning a branch of a fig-tree Arnobius qualifies it as
'validissimum' ('very stout').[66] He embellished the end of the story too. In
Clement, Dionysus cuts the branch ('ἐχτέμνων'), shapes it and sits on it.
Arnobius tells of his hewing it off ('dolare', something one can only do with a
fairly substantial piece of wood), planing it, smoothing it (the thought is
suggestive) and finally depicts the god naked behind, executing an unseemly
sexual squirm ('ceuentem')[67] on the improvised phallus. *Dolare* ('hew')
appears in the *Priapea* as the verb used to describe the making of a wooden
Priapus.[68] Arnobius is the only Latin patristic author to write in such explicit
and graphic, though *not* highly obscene,[69] language about sexual themes.
Jerome described him as 'inaequalis et nimius' ('patchy and excessive').[70] His
licence may be a function of his recent paganism, rhetorical profession and
lay status,[71] but it also betrays his readings in Latin poets and evident delight
in amplifying descriptions of sexual activities.[72] It may be no coincidence that
his transmission hangs on one manuscript, and that he is virtually unknown
after the end of antiquity.[73] Above all, he and Augustine show how the gods
provided a welcome chance to deploy dormant writing talents.

Old Testament exegesis and Biblical translation

So far we have looked at continuity as well as generic evolution in genres that
feature obscenity. But new problems faced the Christian author in the form of
a new key text to translate and interpret: the Bible. This was particularly true

64 E.g. 'clunes' = 'nates'. See *TLL* 'clunis' 1362.49–53. Apparently in Arnobius alone
among the fathers.

65 *Protrepticus* 2.34.3–5. A. Röhricht, *De Clemente Alexandrino Arnobii in irridendo
gentilium cultu deorum auctore* (Hamburg, 1893).

66 *Adversus Nationes* 2.34.4: 'χλάδον συχῆς'.

67 In later Roman grammarians and the *Scholia* on Persius. See *TLL* s.v. 'ceuo' 982.27–49.

68 *Priapea* 10.4: 'sed lignum rude vilicus dolavit'; *Priapae* 63.10: 'manus sine arte rusticae
dolaverunt'.

69 Adams, *Latin Sexual Vocabulary*, p. 36: 'Arnobius in particular employed a highly
decent sexual vocabulary.'

70 Jerome, *Epistula* 58.10.2.

71 See M. B. Simmons, *Arnobius of Sicca: Religious Conflict and Competition in the Age of
Diocletian* (Oxford, 1995), pp. 6–10, who argues against any apologetic intent on
Arnobius's part.

72 Marcovich, 'Demeter, Baubo', sees an intermediate redactor of Clement as respon-
sible for what I suspect to be embroiderings by Arnobius.

73 The *Decretum Gelasianum* (PL 59, 163) called the *Adversus Nationes* 'opuscula Arnobii,
apocrypha'.

of the Old Testament, a document of complicated provenance that featured sexual content in places where Christian fathers were loath to see it. But it also contained enigmatic material, or material that was puzzling in Latin translation, on which church fathers would occasionally impose a wilfully sexual interpretation.

Jerome faced by the Old Testament

It is worth looking at two examples, as tackled by Jerome. First, Jacob's fight with the mysterious opponent in Genesis,[74] in the course of which the man 'touched the hollow of his thigh; and Jacob's thigh was put out of joint as he wrestled with him'. The Vulgate's text could be translated 'touched the sinew of his leg and immediately he began to fade'. As he left the scene of his fight, Jacob limped, so it would be consistent to regard the injury as one to the leg. This was not, however, how post-Hieronymian interpreters saw it.[75]

Jerome, in the course of convincing Eustochium that the devil invades both men and women through their private parts,[76] made an unpromising start with the second passage to be examined, Job 40.16, a description of Behemoth: 'Virtus eius in lumbis eius et potestas eius in umbilico' ('See the strength in his loins, the power in his massive belly').[77] He cited various biblical passages where 'lumbus' may refer to the male genitalia. The principle of euphemism is invoked: 'it is only fit that men's and *women's* genitalia should be referred to by other names'.[78] Jerome then adduces an allusion to women's genitalia in the phrase 'in umbilico'. This is not *pure* fantasy. The *Septuagint* has 'ἐπ'ὀμφαλοῦ γαστρός' (both sexes have navels), and the Hebrew word is apparently the same as that used in Song of Songs 7.3 to mean vulva.[79] The interpretation is based on Origen,[80] but *in context* it was clearly wrong, and Jerome also falsely

74 Genesis 32.25: 'tetigit nervum femoris eius et statim emarcuit'; and 32.31–2: 'ortusque est ei statim sol, postquam transgressus est Phanuel: ipse vero *claudicabat pede*. Quam ob causam non comedunt filii Israel nervum, qui emarcuit in femore Iacob, usque in praesentem diem; eo quod tetigerit nervum femoris eius, et obstupuerit.'

75 All Greek exegeses of the passage that I have located concentrate on the nature of the being that Jacob fought and on God's appearances to men. For Ambrose, *De Iacob* 2.30 (*CSEL* 32.2, pp. 49–50) the touching of the thigh prefigures the birth of Christ. In Augustine, *Quaestiones in Genesim* 104, Jacob is said to be 'claudus in latitudine femoris tamquam in multitudine generis'.

76 The passage under discussion is *Epistula* 22.11.

77 Marvin H. Pope, *Job* (Garden City NY, 1965), p. 323.

78 'Honeste viri mulierisque genitalia immutatis sunt appellata nominibus.'

79 See Marvin H. Pope, *Song of Songs* (Garden City NY, 1977), p. 617: The word used means 'umbilical cord' at Ezekiel 14.4.

80 *Enarrationes in Job* 40.16 (*Patrologia Graeca* [PG] 17, 100 D): 'Αὕτη πρώτη δύναμις κατὰ τοῦ ἀνδρός. πόρνον ποιεῖν ἐντεῦθεν ἄρχεται. τοῦ αὐτοῦ ἵνα τὸ θῆλυ σημάνῃ, ἵνα δείξῃ, ὅτι στρατεύεται οὐ μόνον κατὰ τῶν ἐχόντων τὰ σπέρματα. πάνυ δὲ εὐπρεπέστατα ὠνόμασεν ὀσφὺν ἐπὶ ἄρρενος καὶ ὀμφαλὸν γαστρὸς ἐπὶ γυναικός.' ('This is the first

adduced Ezekiel 16.4, 'non est praecisus umbilicus tuus', a clear allusion to the umbilical cord, as an example of *umbilicus* meaning *pudendem muliebre*. In this he yet again followed Origen, here his *Homily* 6.4 on Ezekiel.[81] Origen had claimed that *umbilicus* and *lumbus* were euphemisms for the female and male genitalia, and used the Job passage[82] to elucidate Ezekiel: 'And see how properly scripture mentioned the genitals of men and women through concealed names, lest it might signify impropriety through using those words that are to hand.'[83] Jerome thereby coined a new Latin sexual term (*umbilicus* for vulva) that would subsequently be used by Augustine in his euphemistic account of his attachment to 'Babylon': 'the more tenaciously I stuck in her *umbilicus*, the invisible enemy trampled on me and seduced me'.[84] The interpretation then spread widely.

Jerome then continued with Jacob from Genesis, 'seventy-five souls entered Egypt who came from Jacob's "leg",[85] and after fighting with God, when the breadth of his "leg" was weakened, he stopped having children'.[86] Jacob was punished with impotence and/or infertility after presuming to fight God. Paulinus of Nola and Cassian both used the passage to promote chastity.[87] More interestingly, Prudentius adopted a variant of Jerome's

force directed against man, for the commission of fornication starts thence. "Of the same one": to signify the female to show that he (sc. the devil) campaigns not only against those who have sperm. He most appropriately mentions the groin in the case of the man and the umbilicus of the belly in the case of the woman.') Also Origen *In Psalmum* 37, *Homilies* 1 (PG 12, 1379 A ff.): 'Virtus ergo diaboli praecipue circa lumbos hominis est, unde fornicatio adulteria procedunt, unde puerorum corruptio, unde omnis spurcitia generatur. Ita sane etiam mulierum circa umbilicum ventris est culpa, quod honestiore voluit indicare sermone, in quibus utrisque draconis diaboli virtutem potentiamque esse designat.' The passage is also used in the general context of the mortification of the flesh by Gregory of Nazianzus, *Oratio.* 40.40 (*Sources chrétiennes* 358, p. 290.12 ff.).

[81] *Die griechischen christlichen Schrifsteller der ersten Jahrhundert* 33, pp. 381.13–382.21.

[82] In the form 'virtus eius in umbilico et fortitudo eius super umbilicum ventris'. Ibid., p. 383.2.

[83] Ibid., p. 382.12.

[84] *Confessiones* 2.8.29: 'et in umbilico eius quo tenacius haererem, calcabat me inimicus invisibilis et seducebat me'.

[85] See Exodus 1.5: 'erant igitur omnes animae eorum qui egressi sunt de femore Iacob septuaginta'.

[86] *Epistula* 22.11.

[87] Paulinus of Nola *Epistula* 24. 8 9: 'Sed nihilominus et nobis cavendum est, ne steriles appareamus in conspectu Domini, neve debili pede in ejus itinere claudicemus: et ut potius corporeis fructibus infecundi, illum de divinae manus ictu femoris paterni stuporem ad continentiae rigorem trahamus: ut enerves cupiditatibus, quibus virtus fidei subnervatur, confirmemus animam castitate: quam, ut Apostolus docet.' Cassian *Collationes* 12.1.11: 'Quisquis ergo intellectualis illius Jacob, id est, supplantatoris transcenderit gradum, ab illa continentiae colluctatione ac supplantatione vitiorum, obstupefacto femoris nervo, ad Israelis meritum perpetua cordis directione conscendet.'

exegesis[88] and used it in *Cathemerinon* 2, a hymn for daybreak. The 'femur' is identified with the 'inguen'. He tells Jacob's story, ending with an unusual *makarismos*.

Nutabat inguen saucium quae corporis pars vilior longeque sub cordis loco diram fovet libidinem.	The wounded groin wavered, the viler part of the body that far beneath the heart encourages deadly lust.
Hae nos docent imagines hominem tenebris obsitum, si forte non cedat deo, vires rebelles perdere.	These images teach us that man enmeshed in shadows loses his rebellious strength, if by chance he does not give in to God.
Erit tamen beatior intemperans membrum cui luctando claudum et tabidum dies oborta invenerit.[89]	More blessed he, however, whose intemperate member the rising day will find lame and weak from wrestling.

Prudentius' poem does not quite work.[90] In fact, it suggests various unfortunate activities, namely solitary vice or sexual exhaustion.[91] But it shows a well-educated Christian poet's concern with the nocturnal activities of the male member,[92] and how allegorical exegesis and Biblical translation made it all possible and permissible.

Hidden matters:
finding out where Christian writers embrace the sexual

We have seen some examples of what one might call 'consensual obscenity'. It survived in various genres, and the development of satirical prose introduced and legitimized the sexual topics of satire in religious polemic. But

88 R. Harris, 'Allegory in the *Cathemerinon* of Prudentius' (unpublished Ph.D. dissertation, University of North Carolina, 1961), p. 19, n. 16 wrongly thinks Prudentius's interpretation unparalleled.

89 Ibid., pp. 89–92.

90 R. Herzog, *Die allegorische Dichtkunst des Prudentius* (Munich, 1966), p. 57 expresses puzzlement. The problem is as follows: Prudentius clearly sees the fighting and the exhaustion of the 'inguen' as desirable. Yet there follows this curious passage that seems to suggest that someone whose 'intemperans membrum' will be found lamed and weak with wrestling will be *even* happier. Than whom?

91 The weakened 'membrum' is somehow desirable. 'Nutabat' suggests impotence, but 'luctando claudum ac tabidum' (unless 'luctando' is to be construed with 'cui' – in which case the distinction between this and the previous stanza is unclear) suggests some sort of sexual exhaustion, whether masturbation, nocturnal emission or sexual intercourse.

92 The theme may lie hidden in Ambrose, *Hymn* 2.25–6: 'Exuto sensu lubrico / te cordis alta somnient.'

there are also hidden matters, an extensive and woolly area, where repressed sexual and obscene material lurks tellingly in the pages of some patristic authors. One could call this displacement the Pillow Principle – push it down in one place and it rises up in another. Such material can be detected, but only through close and careful reading.

Jerome

Jerome, the doyen of the cult of virginity, is a key exhibit. He berated matrons who kept tame resident clergymen,[93] yet also reveals that he was forced to leave Rome for the Holy Land in 385 because of scandal arising from his relations with the noble widow Paula.[94] (One scholar has been known to refer to her informally as Jerome's 'common-law wife'.) After travelling with *his own* mother-and-daughter pair, Paula and Eustochium, to Jerusalem, he blithely wrote a rhetorical exercise[95] in which he begged two women, widow and virgin daughter, not to live separately as 'subintroductae' ('cohabiting females') with their 'brothers', and spiritual advisors, but to live together instead as a pair, or as a threesome or foursome with the man or men (*Epistle* 117, c. 405).[96] The situation of the anonymous Gallic women looks suspiciously like a reversal of his own ménage with Paula and Eustochium. Jerome lacked self-awareness.

Similarly, his letter of 384 to Eustochium 'de virginitate servanda' featured a curiously explicit passage in which a cento of the Song of Songs describes the virgin's relations with Christ:[97]

> Let the secrecy of your bedchamber always guard you and let the Bridegroom always sport with you within.... When sleep oppresses you, He will come behind the wall[98] and put his hand through the hole[99] and will touch your belly

[93] See, for example, *Epistula* 50.3 for the visitor of virgins and widows.
[94] *Epistula* 45 and *Epistula* 54.2: 'me seductorem clamitans'.
[95] *Epistula* 117.12: 'et quasi ad scholasticam materiam me exercens'. The letter can be seen as an example of the sort of persuasory or dissuasory rhetoric practised in Roman declamation. Such speeches often involved improbable or mythological situations. J. Lössl, 'Satire, Fiction and Reference to Reality in Jerome's *Epistula* 117', *Vigiliae Christianae* 52 (1998), 172–92 now suggests that the piece may be a topical satire where names have been suppressed or social class altered. At p. 174 he explains the difficulty in interpreting Jerome's own allusion to *Epistula* 117 in the *Contra Vigilantium*.
[96] *Epistula* 117.11 details the possible combinations.
[97] *Epistula* 22.25. For a later example, see Baudonivia, *Vita Radegundis* 2.20: Radegund has a vision of Christ as a very seductive young man, whose feelings are hurt when she initially repels him. Her two confidantes were, not unexpectedly, told to keep the matter to themselves until she died.
[98] *Canticum canticorum* 2.9: 'en ipse stat post parietem nostrum'.
[99] *Canticum canticorum* 5.4: 'dilectus meus misit manum suam per foramen'.

194

('venter'),[100] and, all aquiver ('tremefacta') you will rise and say, 'I am wounded with love.'[101]

Note the word 'tremefacta' and the way Jerome has transposed and arranged the passages, changing the indirect speech of Song of Songs 5.8 to the orgasmic exclamation 'I am wounded with love.'[102] Here he uses the *Vetus Latina* 'vulnerata caritatis ego sum'.[103] In the Vulgate, he would eliminate the Greek calque and make the expression more explicit: 'quia amore langueo'. The suggestion is not even subliminal.[104] Yet in 393 he would insist in the *Adversus Jovinianum* that there was nothing about marriage in the Song of Songs. It exalted virginity.[105]

One catches a glimpse of the man's private reading and fantasies in his fictitious hagiography.[106] The first ascetic's life was Athanasius's *Life of Antony*, translated into Latin in 375. In the 380s to 390s Jerome published three short and mostly fabulous *vitae* that herald the new Christian battle of asceticism, not martyrdom: 'maintaining chastity also involves martyrdom', as one of his heroes would say.[107] Their aim was to outdo Athanasius's desert hermit.

The opening of the *Vita Pauli* (chapter 3) describes a martyr anointed with honey and left to be eaten by flies. It may betray knowledge of Apuleius's tale of the adulterous bailiff who was, appropriately, tied to a fig-tree, 'melle perlitum', and left to the ants.[108] The next martyr story is even more suggestive. A young man was tied up in a pleasance, and a prostitute came to torture him by embracing him and fondling his private parts so that she could then have her pleasure of him. We are not told so, but it is clear that his body responded despite the better inclinations of his mind: 'quem tormenta non vicerant, superabat voluptas' ('him whom tortures had not defeated lust overcame'). In desperation, the martyr bit off his own tongue and spat it in her face – a parody of the older version of this story in which Zeno of Elea

100 *Canticum canticorum* 5.4: 'et venter meus intremuit ad tactum eius'. The *Septuagint* has 'koilia'.

101 *Canticum canticorum* 5.4: 'Semper te cubiculi tui secreta custodiant, semper tecum sponsus ludat intrinsecus . . . et cum te somnus oppresserit, veniet post parietem et mittet manum suam per foramen et tanget ventrem tuum et tremefacta consurges et dices: "Vulnerata caritatis ego sum" '.

102 The quotation could also come from *Canticum canticorum* 2.5.

103 A calque of the *Septuagint*'s 'τετρωμένη ἀγάπης'.

104 The double entendres are present in the Hebrew: see Pope, *Song of Songs*, pp. 517–21.

105 *Adversus Jovinianum* 1.30.

106 For its fictitious character, see M. Fuhrmann, 'Die Mönchsgeschichten des Hieronymus', in *Christianisme et formes littéraires de l'antiquité tardive en occident*, ed. M. Fuhrmann, *Entretiens Hardt* 23 (Vandoeuvres, 1976), 41–99.

107 *Vita Malchi* 6.

108 *Metamorphoses* 8.22.

defied a tyrant[109] – but also a quasi-Freudian displacement from below upwards.

The *Vita Malchi*, whose plot is heavily based on romance, features a scene (chapter 6) where the hero, captured by Saracens, has been forced at sword-point to marry a (married) co-captive. Night comes, darker and sooner than he would like, an inversion of the topos of the eager *sponsus* who longs for his nuptial evening.[110] Malchus takes his spouse into a cave,[111] and has just drawn his sword to kill himself, when the woman interrupts and begs him not to, but, if he must, to turn his point against her first.[112] Then they can be joined in death. She suggests that if they *pretend* to have had sex they will easily convince people that they are married: 'facile suadebimus nuptias'. The scene irresistibly suggests another famous ritual wedding in a cave, the nuptials of Dido and Aeneas, where one party to a copulation called it a marriage.[113] Here a would-be *martyr* becomes a *maritus*,[114] and the stage-play with the suggestive sword replaces what ought to be happening inside.

Jerome relates a terrifying nightmare he experienced in the desert in Chalchis. He was haled before the heavenly throne after some furtive reading of the classics, and told that he was a Ciceronian, not a Christian.[115] He was then beaten until he promised never to betray God by reading classical literature. But, however much he was punished in his dreams, he had read the racier bits of his Virgil closely – and remembered them. The *Vita Malchi* not so subtly suggests that one can co-habit with a woman in chastity – a topic Jerome knew a great deal about. As he would put it: one 'tectulum' ('one little [common] roof') need not imply one 'lectulum' ('one little bed').[116]

More unapproved reading

Unawares, theological writers often betray secular reading through their

109 See Boethius, *De Consolatione Phililosophiae* 2.6.8 with J. Gruber, *Kommentar zu Boethius De Consolatione Philosophiae* (Berlin and New York 1978), p. 208. Also de Vogüé, *Histoire littéraire*, 1.1, 157 who adds Ambrose, *De Virginibus* 1.17; Iamblichus, *De Vita Pythagorica* 31.194; Tertullian, *Ad Martyras*. 4.7 and *Apologeticum* 50.8; Valerius Maximus 3.3.4, and interprets the episode as an extreme example of the subjugation of the flesh rather than a desire not to speak.
110 'Tenebrosior solito et mihi nimium matura.'
111 'Pronubante nobis maestitia.'
112 'In me primum verte mucronem.'
113 *Aeneid* 4.160–72. De Vogüé, *Histoire littéraire*, 1.2, 91 reads the *Vita Malchi* in a similar fashion and rightly suggests that the whole piece is suspiciously autobiographical. See also S. Weingarten, 'Postliminium in Jerome: A Roman Legal Term as Christian Metaphor', *Scripta Classica Israelica* 14 (1995), 143–50 (p. 150).
114 'Habeto me martyrem potius quam maritum.'
115 See Jerome, *Epistula* 22.30 and D. R. Shanzer, 'Pearls before Swine: Augustine, *Confessions* 2.4.9', *Revue des études augustiniennes* 42 (1996), 45–55 (pp. 54–5).
116 *Epistula* 117.9: 'Separentur domus vestrae dividaturque convivium, ne maledici homines sub uno tectulo vos manentes lectulum quoque criminentur habere communem.'

language. Adams has suggested that some of Augustine's uses of 'vas' reflect the colloquial sexual vocabulary; for instance, *De civitate Dei* 14.23: 'ita genitale arvum *vas* in hoc opus creatum seminaret'[117] ('and so the vessel designed for the deed inseminated the fertile field'). It may not be true in this particular instance; the passage probably reflects a Biblical metaphor, the body as vessel of the soul, at 1 Thessalonians 4.4: 'sciens suum *vas* possidere in sanctificatione et honore'.[118] But others may indeed. Prudentius describes the ithyphallic god Priapus: 'stretching out his unconquerable and ever-ready spirit' ('*indomitum intendens* animum *semperque paratum*').[119] The expression is curious, because the word one expects, and indeed *almost* hears, given the homoeoarcton, is 'inguen' (groin, euphemistically used for 'penis')[120] not 'spirit' ('animus'). The line could be read as a paraprosdokian, a rhetorical surprise where one fails to hear the word one has been led to expect. One might compare the Teddy Hall Rugby Song (to the tune of 'Old Hundredth'): 'As I was walking through these halls, Canon K——y grabbed me by the – finger . . .'. This is much like the language that one finds in the *Priapea*. Prudentius also wrote 'turpiter adfixo pudeat quem visere *ramo*' ('whom one should be shamed to see with his *branch* disgustingly attached'), whose very language betrays familiarity with Latin slang, 'ramus' for 'penis'.[121] Similarly, Arnobius speaks of '*Hellespontiacum Priapum* inter deas virgines atque matres circumferentem *res illas proeliorum in expeditionem semper paratas*' ('Priapus from the Hellespont . . . carrying around those things always ready for [military] action').[122] The word 'paratus' ('ready') is familiar from sexual contexts.[123] The weapons and wars of love require no comment. One can even play a similar game with the pious Paulinus.[124]

Sex and violence in the saints' lives

Obscenity is notoriously linked to violence, and Christians could enjoy the latter in ever-gorier epic porn martyr-acts. One can again profitably compare two texts approximately 200 years apart. On 7 March 202/204 a young Chris-

117 See Adams, *Latin Sexual Vocabulary*, p. 42; cf. *Priapea* 68.24: 'grandia Dulichii vasa petisse viri'.
118 Quoted by Augustine at *De civitate Dei* 14.16. The context in 1 Thessalonians 4.3 is 'ut abstineatis vos a fornicatione'.
119 *Contra Symmachum* 1.109.
120 See Adams, *Latin Sexual Vocabulary*, p. 47.
121 *Contra Symmachum* 115. See Adams, *Latin Sexual Vocabulary*, p. 28.
122 *Adversus Nationes* 3.10. For the weapons of the gods, see *Priapea* 9, 20.
123 *Priapea* 46.7: 'nam quamvis videar satis paratus' and *TLL* 'paratus' 428.62–7.
124 See *Carmen* 25.155–8 for a description of Mary's conception in terms of a Danaean 'imber ab alta nube'. Human emulation of Jove's exploits was decried by Augustine at *Confessiones* 1.16.26.

tian woman called Vibia Perpetua and her maid Felicitas were executed in the arena in Carthage. Her trial, time in prison, and a series of remarkable dream-visions, were documented in a composite text called the *Passio Perpetuae*, part of which comprises her own prison-diaries. Another witness would record the deaths of the women exposed to beasts in the arena and ultimately dispatched by gladiators. Nicole Loraux has studied the literary deaths suffered by various sorts and conditions of women in Greek tragedy, including the married woman who hangs herself and the virgin whose throat is cut.[125] Yet even a text as early and as authentic as the *Passio Perpetuae* could have contributed to Loraux's discussion of Priam's daughter, Polyxena: Perpetua when she first falls, thrown by an animal, modestly takes special care to pull down her torn robe to cover her thigh. And in the final act she willingly guides the sword of the novice gladiator, hesitant to kill her, to her own throat. Even here in an otherwise authentic document appear clear literary conventions that recall the frisson of tragedy.[126]

Bearing that in mind, one may move ahead two centuries to Prudentius's *Peristefanon* 14.67 ff.

> When Agnes saw the grim man standing there with his naked [sword]-point, happier she said: 'I rejoice that such a man comes, crazy, cruel, wild, a bearer of arms, rather than if there were to come a languid, young, and effeminate youth doused with scent to destroy me through the death of my chastity. This lover, this one now, I confess, is pleasing. I shall go to meet his steps as he rushes forward, nor will I hold up his burning desires. I shall take in the whole length of his sword into my bosom, and I shall draw in the violence of the sword into the depths of my chest' After saying this, she worships Christ, a suppliant with bowed head, so that her bent neck should more readily undergo the imminent blow. And he . . . at one stroke cut off her head.

Here Agnes welcomes the soldier who will kill her with his 'bare point' ('mucrone nudo', v. 68), because he is not 'mollis' and 'languidus' (vv. 71–2), but has a fine hard weapon for the job. She bears her breast eagerly and refers to him as an 'amator' (v. 74). Prudentius worked to achieve this effect: we have his source, an Agnes-hymn by Ambrose of Milan, who *beheaded* his heroine.[127] But *that* imagery was less effective for Prudentius's purpose. Indeed he concentrated so hard on this particular choice that he left in an inconsistency. Agnes is eventually decapitated (v. 89), and the implied doublet is over-

[125] N. Loraux, *Façons tragiques de tuer une femme* (Paris, 1985).

[126] Of obvious relevance are *Passio Perpetuae* 20.4: 'et ubi sedit, tunicam a latere discissam ad velamentum femoris reduxit pudoris potius memor quam doloris' and 21.9: 'Perpetua autem, ut aliquid doloris gustaret, inter ossa conpuncta exululavit, et errantem dexteram tirunculi gladiatoris ipsa in iugulum suum transtulit'.

[127] This would appear to be the implication of Ambrose, *De Virginibus* 1.7.9: 'cervicem inflexit'.

looked.[128] The sexual double entendres are there. What is unclear is whether Agnes pronounces the jaw-droppers unawares, or whether she challenges authority with them ironically. Thus some obscenity was acceptable, indeed even desirable, in a martyr-hymn.[129] In the tenth century, comedies about martyrs were written by Hrothswitha of Gandersheim.[130] Phenomena such as Benigni's *La Vita è Bella* existed even in antiquity.

Literary obscenity did not survive into the early Middle Ages. But scatology and sexual violence are there, if one looks carefully and pays attention to the author's lexicon. I have elsewhere discussed a number of such 'para-obscene' passages in Gregory of Tours that concern scatology (the death of Arius) and sexualized violent death by impaling.[131] Impaling was metaphorically appropriate for female sexual offenders.[132] To the splendid off-colour death of St Agnes one could likewise add the all-too-explicit fate of Romilda in Paul the Deacon's *Historia Langobardorum* 4.37. Romilda had betrayed Friuli to the Kagan of the Avars on condition that he marry her. Once the town had been captured, the Kagan spent the promised night with her,[133] but on the morrow turned her over to twelve of his men to gang-rape. When she finally was impaled, the men said, 'talem te dignum est maritum habere' ('it is meet that you have this sort of husband'). The *palus* ('stake') is a deadly sharpened substitute for the *phallus*, and 'talem' points out the *talio*

128 Just as the image of Priam's corpse in *Aeneid* 2.557–8: 'Iacet ingens litore truncus, avolsumque umeris caput, et sine nomine corpus' anachronistically evoked Pompey's, so here Agnes's beheading and laughter at the *saeculum* as she ascends to heaven (*Peristefanon*, 14.96) likewise imitates Pompey's death, this time in Lucan, *Pharsalia* 9.12. For more on this, see D. R. Shanzer, 'Rhetoric and Art, Art and Ceremony, Martyrs and History, Martyrs and Myth: Some Interdisciplinary Explorations of Late Antiquity', *Envoi* 2.2 (1990), 231–68 (pp. 258–9). I am not convinced by the suggestion of V. Burrus, 'Reading Agnes; The Rhetoric of Gender in Ambrose and Prudentius', *Journal of Early Christian Studies* 3.1 (1995), 25–46 (p. 38), which says of the change to execution by the sword 'in a move so subtle we almost miss it, he silently substitutes a submissively bent neck for the breast Agnes has defiantly offered'. M. Malamud, 'Making a virtue of perversity: the Poetry of Prudentius', *Ramus* 19 (1990), 64–88 (pp. 81–2) suggests that 'Agnes is cheated of the death by phallic sword thrust she anticipates so eagerly'.

129 For some thoughts on hagiographical texts as sources for sex, see I. Ševčenko, *Observations on the Study of Byzantine Hagiography in the last Half-Century*, Canadian Institute of Balkan Studies (Toronto, 1995), pp. 3–20 (p. 10).

130 E.g. *Dulcitius*.

131 D. R. Shanzer, 'History, Romance, Love, and Sex in Gregory of Tours' *Decem Libri Historiarum*', in *The World of Gregory of Tours*, ed. K. Mitchell and I. Wood (Leiden, 2002), pp. 395–413 (pp. 408–10).

132 For a sexualized double impaling, see Numbers 25.8. Phineas impales a couple engaged in apostasizing intercourse, the woman through her womb.

133 *Historia Langobardorum* 4.37: 'Romildam vero quae totius malitiae caput exstitit, rex Avarum propter iusiurandum, sicut ei spoponderat, nocte una quasi in matrimonium habuit, novissime vero duodecim Avaribus tradidit, qui eam per totam noctem vicibus sibi succendentes libidine vexarent.'

('direct retribution'). Material awaits those who read with open eye and dirty mind. Scatology was acceptable if it had a theological point and could be associated with demons or heretics; and sexual material was acceptable if associated with violence, but not, apparently, if told for its own sake.

Conclusion

This is just a sampling of work that could contribute to the history of literary obscenity and the sexual in the later Roman Empire, and (with more limited results) the early Middle Ages. Dictionaries do not give reliable information, and the *Thesaurus linguae latinae* is still incomplete. One must read many far from titillating texts, particularly exegesis and Bible translations.[134] A 'sexual lexicon' for each Christian author should be established. The machine-readable *Patrologia Latina* opens up tremendous possibilities for word-searching. Even a quick search can yield interesting results: *penis*, for instance, does not occur more than nine times in the whole database.[135] The majority of uses are clustered in Arnobius, Lactantius and Jerome. *Cunnus* occurs once in Abelard and nowhere else. Hidden quotations need to be detected, in particular lexical items that betray unacknowledged reading.

Though there is a clear decline in the written deployment of primary obscenities, many, given their reflexes in modern Romance languages, *must* have persisted in the spoken language. Some genres that had harboured obscenity survived Christian *severitas*, like the epigram: it was small, and private and usually non-topical. Others faded. Successful *urbani* such as Ausonius avoided trouble by treading a narrow line and living as a layman in court circles. But opposed to him were increasing numbers of people such as Paulinus of Nola, who like their modern counterparts, would have said, 'I don't feel comfortable with that' or 'that isn't funny'.

Explicitly sensual language is rare in erotic contexts – indeed the contexts themselves become fairly rare. Petronius's Encolpius chastised his impotent member in the *Satiricon* (132.12), but disingenuously regretted conversing with it, and blushed for having broken an epic convention by talking to a part of the body that serious people disclaimed.[136] It was far more the case that for Christians such things, the 'vileness of genital members that it is wrong for modest lips to mention by their proper names', were not to be named.[137]

[134] It might be worthwhile to examine Jerome's adjustments of the *Vetus Latina* systematically.

[135] In Arnobius, Lactantius, Jerome, Isidore, John of Salisbury and Paul of Aquileia.

[136] *Satiricon* 132.12: 'paenitentiam agere sermonis mei coepi secretoque rubore perfundi, quod oblitus verecundiae meae cum ea parte corporis verba contulerim, quam ne ad cognitionem quidem severioris notae homines solerent'. On the literary conventions of speech to organs, see H. N. Pelliccia, *Mind, Body, and Speech in Homer and Pindar* (Göttingen, 1995).

[137] Arnobius, *Adversus Nationes* 3.10: 'Habent ergo dii sexus et genitalium membrorum

Jovinian had asked what the genitals were for, if not for sex.[138] Jerome played over-squeamish, at a disadvantage because such discussions made him blush. He elected however not to remain silent, but to fight with the eyes covered[139] and resort to expressions like 'hic (sc. meatus), qui sub ventre est' ('this [sc. conduit] which is below the belly').[140] None of this, however, prevented him from discussing awkward topics such as the post-partum virginity of the Virgin Mary.[141]

But sometimes specifics were required. The control of the ascetic body required some sort of 'naming of parts'. In pastoral texts an elaborate euphemistic vocabulary develops. Here are some sample disapproving and euphemistic terms for the now-regulated nocturnal emissions: 'carnis fluxus',[142] 'obscenus humor, fluxus ille',[143] 'concretiones obscenae'.[144] And here are some of Augustine's euphemisms for the sexual act: '*Opus* vero ipsum, quod libidine tali peragitur. . . . Quis enim nescit, ut filii procreentur, *quid* inter se coniuges agant?' (*De civitate Dei* 14.18: 'The work itself that is carried out to completion with this sort of lust . . . For who is unaware what spouses do with one another in order that children may be conceived?'); '*quod* fit in uxore' (*De civitate Dei* 14.20: 'what happens with a wife'); and, most famous of all, 'hoc et illud' (*Confessiones* 8.11.26). In polemical texts, an extensive abusive vocabulary lends the right tone of indignation, and shows that the author is on the Right Side; for a drink from a fire-hydrant, see the words with which Salvian deplores North African Roman mores at *De Gubernatione dei* 6.3: 'obscenitas; crimen; pollutio; sordidus; impudicus; improbus; flagitiosus; peccatum; turpitudo; foeditas; dedecus; dedecorosa; impudicitia; iniquitas; impuritas; spurcitia; labes; sordes; improbitas' ('obscenity, crime, pollution, filthy, shameless, wicked, depraved, sin, vileness, filthiness, disgrace, . . .' etc.). The righteous sputtering is palpable.

circumferunt foeditates, quas ex oribus verecundis infame est *suis appellationibus* promere?'

138 *Adversus Jovinianum* 1.36.

139 Ibid., 1.36: 'Periclitamur responsionis verecundia . . . hinc atque inde vel pudoris vel causae naufragium sustinemus. Si ad propositum respondeamus, pudore suffundimur. Si pudor impetrarit silentium, quasi de loco videbimur cedere et adversario feriendi occasionem dari.'

140 Ibid.: 'Poteram quidem dicere: quomodo posterior pars corporis et meatus per quem alvi stercora egeruntur relegatus est ab oculis et quasi post tergum positus, ita et hic qui sub ventre est ad digerendos humores et potus, quibus venae corporis irrigantur, a deo conditus est'.

141 See *Contra Helvidium* 18 on the mechanics of parturition.

142 *Confessiones* 10.30.42: 'ut in somnis etiam non solum non perpetret istas corruptelarum turpedines per imagines animales usque ad carnis fluxum, sed ne consentiat quidem'. Also Rufinus, *Historia Monachorum* 20 (*PL* 21, 442 D-443 A).

143 Cassian, *Collationes* 22.3: 'redundantia obsceni humoris; obsceni humores; fluxus illius egestione', etc.

144 *De coenobiorum institutis* 6.20.

201

As we have seen, church fathers reclaimed Virgil in Biblical epic, Roman satire in their polemic and romance in their hagiography. The most interesting feature, however, was the displacement of the sexual to new contexts and spheres of discussion, to such acceptable areas as the language of mystical union. It is a fit paradox that, before attacking the temptations of the senses in *Confessiones* 10,[145] Augustine used radiant and over-wrought imagery of the *spiritual* senses in his famous apostrophe to God, 'sero te amavi':[146] 'You called and cried out loud and shattered my deafness. You were radiant and resplendent, you put flight to my blindness. You were fragrant, and I drew in my breath and now pant after you. I tasted you, and feel but hunger and thirst for you. You touched me, and I am set on fire to attain the peace which is yours.'[147]

New rituals such as confession and the exigencies of the cure of souls *might* have led to more explicit discussion of the sexual: how many times did you do such-and-such? With yourself? With another? In what position? This was not the case. Augustine's youth was overgrown with pullulating vegetable matter and brambles,[148] but his description of his own visible pubescence is coy.[149] One will never be *quite* sure *what* he did in church during Mass,[150] and possible homosexuality in his friendships was only hinted at.[151] He laments past transgressions but provides no details.[152] Did he fear to name sins too explicitly or recall them too vividly?[153] Obscenity could lurk in the memory too and, perhaps especially in autobiographical texts, we encounter the sinful silences of the soul.

[145] *Confessiones* 10.30.41 ff.

[146] *Confessiones* 10.27.38. For the appeals to the senses in worship, see Caseau, 'The Senses', pp. 107–9.

[147] Translated H. Chadwick, *Saint Augustine, Confessions* (Oxford, 1991), p. 201.

[148] *Confessiones* 2.25.10: 'silvescere'; 2.25.29: 'ibam in sterilia semina'; 2.27.30: 'agri tui cordis mei'; 2.28.3: 'vepres libidinum'; 2.29.21: resecari ad vivum' (of 'coniugales affectus').

[149] See *Confessiones* 2.6.28: 'ubi me ille pater in balneis vidit pubescentem et *inquieta* indutum adulescentia, quasi iam ex hoc in nepotes gestiret, gaudens matri indicavit'. 'Inquieta' suggests that he refers to an erection. In 'hoc' we see one of his favourite vague pronouns, cf. above p. 201.

[150] *Confessiones* 3.3.5: 'ausus sum etiam in celebritate sollemnitatum tuarum intra parietes ecclesiae tuae concupiscere et agere negotium procurandi fructus mortis'.

[151] *Confessiones* 2.2: 'non tenebatur modus ab animo usque ad animum, quatenus est luminosus limes amicitiae, sed exhalabantur nebulae de limosa concupiscentia carnis et scatebra pubertatis et obnubilabant atque obfuscabant cor meum'.

[152] Paulinus of Pella's adventures with slave-girls are similarly concealed in vague language. See *Eucharisticon* 164: 'carumque memor servare pudorem / cedere et ingenuius oblatis sponte caverem / contentus domus inlecebris famulantibus uti / quippe reus culpae potius quam criminis esse / praeponens famaeque timens incurrere damna'.

[153] See Jerome, *Adversus Jovinianum* 2.8: 'ubi erit libertas, ubi fortitudo eius, ubi de deo cogitatio: maxime cum tactus depingat sibi etiam praeteritas voluptates et recordatione vitiorum cogat animum compati et quodammmodo exercere quod non agit?'

INDEX

This index contains the names of people and places and titles of works mentioned or quoted in the text. It does not include the titles of works or names of authors that are cited but not discussed.

YORK MEDIEVAL PRESS: PUBLICATIONS

God's Words, Women's Voices: The Discernment of Spirits in the Writing of Late-Medieval Women Visionaries, Rosalyn Voaden (1999)

Pilgrimage Explored, ed. J. Stopford (1999)

Piety, Fraternity and Power: Religious Gilds in Late Medieval Yorkshire 1389–1547, David J. F. Crouch (2000)

Courts and Regions in Medieval Europe, ed. Sarah Rees Jones, Richard Marks and A. J. Minnis (2000)

Treasure in the Medieval West, ed. Elizabeth M. Tyler (2000)

Nunneries, Learning and Spirituality in Late Medieval English Society: The Dominican Priory of Dartford, Paul Lee (2000)

Prophecy and Public Affairs in Later Medieval England, Lesley A. Coote (2000)

The Problem of Labour in Fourteenth-Century England, ed. James Bothwell, P. J. P. Goldberg and W. M. Ormrod (2000)

New Directions in later Medieval Manuscript Studies: Essays from the 1998 Harvard Conference, ed. Derek Pearsall (2000)

Cistercians, Heresy and Crusadse in Occitania, 1145–1229: Preaching in the Lord's Vineyard, Beverly Mayne Kienzle (2001)

Guilds and the Parish Community in Late Medieval East Anglia, c. 1470–1550, Ken Farnhill (2001)

The Age of Edward III, ed. J. S. Bothwell (2001)

Time in the Medieval World, ed. Chris Humphrey and W. M. Ormrod (2001)

The Cross Goes North: Processes of Conversion in Northern Europe, AD 300–1300, ed. Martin Carver (2002)

Henry IV: The Establishment of the Regime, 1399–1406, ed. Gwilym Dodd and Douglas Biggs (2003)

Youth in the Middle Ages, ed. P. J. P. Goldberg and Felicity Riddy (2004)

The Idea of the Castle in Medieval England, Abigail Wheatley (2004)

Rites of Passage: Cultures of Transition in the Fourteenth Century, ed. Nicola F. McDonald and W. M. Ormrod (2004)

Creating the Monastic Past in Medieval Flanders, Karine Ugé (2005)

St William of York, Christopher Norton (2006)

Medieval Obscenities, ed. Nicola F. McDonald (2006)

The Reign of Edward II: New Perspectives, ed. Gwilym Dodd and Anthony Musson (2006)

Old English Poetics: The Aesthetics of the Familiar in Anglo-Saxon England, Elizabeth M. Tyler (2006)

The Late Medieval Interlude: The Drama of Youth and Aristocratic Masculinity, Fiona S. Dunlop (2007)

The Late Medieval English College and its Context, ed. Clive Burgess and Martin Heale (2008)

The Reign of Henry IV: Rebellion and Survival, 1403–1413, ed. Gwilym Dodd and Douglas Biggs (2008)

Medieval Petitions: Grace and Grievance, ed. W. Mark Ormrod, Gwilym Dodd and Anthony Musson (2009)

St Edmund, King and Martyr: Changing Images of a Medieval Saint, ed. Anthony Bale (2009)

Language and Culture in Medieval Britain: The French of England c.1100–c.1500, ed. Jocelyn Wogan-Browne et al. (2009)

The Royal Pardon: Access to Mercy in Fourteenth-Century England, Helen Lacey (2009)

Texts and Traditions of Medieval Pastoral Care: Essays in Honour of Bella Millett, ed. Cate Gunn and Catherine Innes-Parker (2009)

The Anglo-Norman Language and its Contexts, ed. Richard Ingham (2010)

Parliament and Political Pamphleteering in Fourteenth-Century England, Clementine Oliver (2010)

The Saints' Lives of Jocelin of Furness: Hagiography, Patronage and Ecclesiastical Politics, Helen Birkett (2010)

The York Mystery Plays: Performance in the City, ed. Margaret Rogerson (2011)

Wills and Will-making in Anglo-Saxon England, Linda Tollerton (2011)

The Songs and Travels of a Tudor Minstrel: Richard Sheale of Tamworth, Andrew Taylor (2012)

Sin in Medieval and Early Modern Culture: The Tradition of the Seven Deadly Sins, ed. Richard G. Newhauser and Susan J. Ridyard (2012)

Socialising the Child in Late Medieval England, c. 1400–1600, Merridee L. Bailey (2012)

Barking Abbey and Medieval Literary Culture: Authorship and Authority in a Female Community, ed. Jennifer N. Brown and Donna Alfano Bussell (2012)

Christians and Jews in Angevin England: The York Massacre of 1190, Narratives and Contexts, ed. Sarah Rees Jones and Sethina Watson (2013)

Reimagining History in Anglo-Norman Prose Chronicles, John Spence (2013)

Henry V: New Interpretations, ed. Gwilym Dodd (2013)

York Studies in Medieval Theology

I *Medieval Theology and the Natural Body*, ed. Peter Biller and A. J. Minnis (1997)

II *Handling Sin: Confession in the Middle Ages*, ed. Peter Biller and A. J. Minnis (1998)

III *Religion and Medicine in the Middle Ages*, ed. Peter Biller and Joseph Ziegler (2001)

IV *Texts and the Repression of Medieval Heresy*, ed. Caterina Bruschi and Peter Biller (2002)

York Manuscripts Conference

Manuscripts and Readers in Fifteenth-Century England: The Literary Implications of Manuscript Study, ed. Derek Pearsall (1983) [Proceedings of the 1981 York Manuscripts Conference]

Manuscripts and Texts: Editorial Problems in Later Middle English Literature, ed. Derek Pearsall (1987) [Proceedings of the 1985 York Manuscripts Conference]

Latin and Vernacular: Studies in Late-Medieval Texts and Manuscripts, ed. A. J. Minnis (1989) [Proceedings of the 1987 York Manuscripts Conference]

Regionalism in Late-Medieval Manuscripts and Texts: Essays celebrating the publication of 'A Linguistic Atlas of Late Mediaeval English', ed. Felicity Riddy (1991) [Proceedings of the 1989 York Manuscripts Conference]

Late-Medieval Religious Texts and their Transmission: Essays in Honour of A. I. Doyle, ed. A. J. Minnis (1994) [Proceedings of the 1991 York Manuscripts Conference]

Prestige, Authority and Power in Late Medieval Manuscripts and Texts, ed. Felicity Riddy (2000) [Proceedings of the 1994 York Manuscripts Conference]

Middle English Poetry: Texts and Traditions. Essays in Honour of Derek Pearsall, ed. A. J. Minnis (2001) [Proceedings of the 1996 York Manuscripts Conference]

Manuscript Culture in the British Isles

I *Design and Distribution of Late Medieval Manuscripts in England*, ed. Margaret Connolly and Linne R. Mooney (2008)

II *Women and Writing, c.1340–c.1650: The Domestication of Print Culture*, ed. Anne Lawrence-Mathers and Phillipa Hardman (2010)

III *The Wollaton Medieval Manuscripts: Texts, Owners and Readers*, ed. Ralph Hanna and Thorlac Turville-Petre (2010)

IV *Scribes and the City: London Guildhall Clerks and the Dissemination of Middle English Literature, 1375–1425*, Linne R. Mooney and Estelle Stubbs (2013)

Heresy and Inquisition in the Middle Ages

Heresy and Heretics in the Thirteenth Century: The Textual Representations, L. J. Sackville (2011)

Heresy, Crusade and Inquisition in Medieval Quercy, Claire Taylor (2011)

Printed and bound by CPI Group (UK) Ltd, Croydon, CR0 4YY

09/06/2025

14685713-0001